ARCTIC VISIONS

PICTURES FROM A VANISHED WORLD

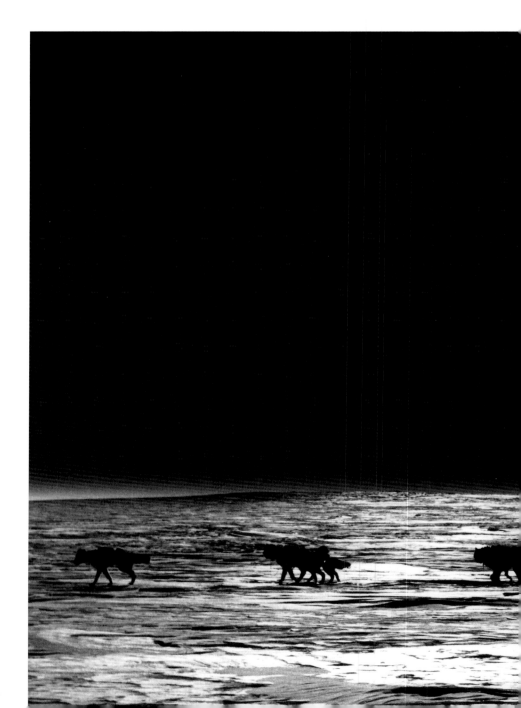

ARCTIC VISIONS

PICTURES FROM A VANISHED WORLD

FRED BRUEMMER

KEY PORTER BOOKS

OVS.
G
610
.B884
2008

Library and Archives Canada Cataloguing in Publication

Bruemmer, Fred
 Arctic visions : pictures from a vanished world / Fred Bruemmer.

ISBN 978-1-55470-092-9

 1. Arctic regions--Pictorial works. 2. Arctic peoples--Social life and
customs--Pictorial works. I. Title.
G610.B74 2008 909'.09130826 C20 08-902214-9

THE CANADA COUNCIL | LE CONSEIL DES ARTS
FOR THE ARTS | DU CANADA
SINCE 1957 | DEPUIS 1957

ONTARIO ARTS COUNCIL
CONSEIL DES ARTS DE L'ONTARIO

The publisher gratefully acknowledges the support of the Canada Council for the Arts and the Ontario
Arts Council for its publishing program. We acknowledge the support of the Government of Ontario
through the Ontario Media Development Corporation's Ontario Book Initiative.

We acknowledge the financial support of the Government of Canada through the Book Publishing
Industry Development Program (BPIDP) for our publishing activities.

Key Porter Books Limited
Six Adelaide Street East, Tenth Floor
Toronto, Ontario
Canada M5C 1H6

www.keyporter.com

Design: Martin Gould
Printed and bound in China

08 09 10 11 12 6 5 4 3 2 1

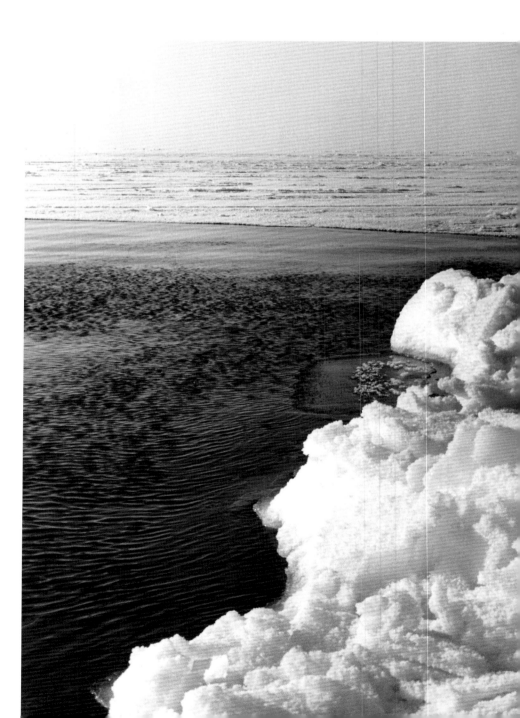

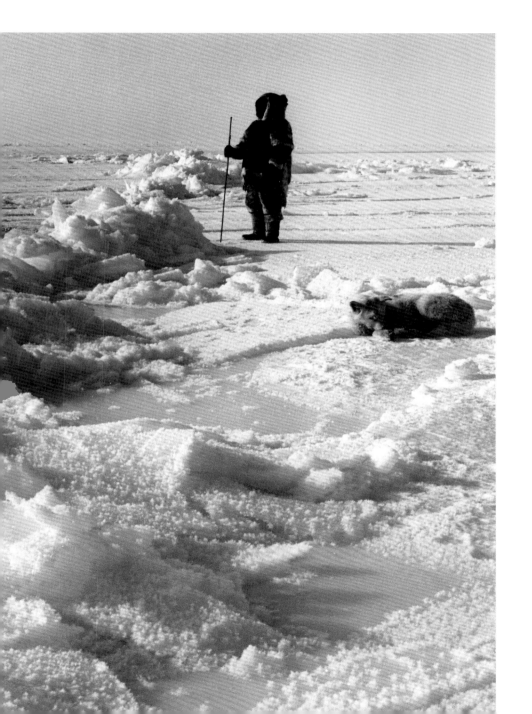

TABLE OF CONTENTS

Ekalun of Bathurst Inlet could remember a time when White men were merely a myth, strange beings living far away in another world. He was about 10 years old when he and his people were "discovered" by members of the 1913-1918 Stefansson-Anderson Canadian Arctic Expedition. I lived in Ekalun's tent for six months and sometimes, when he was in a reminiscent mood, he would tell me tales of Inuit life long, long ago.

ARCTIC VISIONS

INTRODUCTION

The Inuit call it "the old way of life," their traditional life, ancient and immutable, superbly attuned to the harsh conditions of the Arctic world. It flowed seamlessly through the ages, each generation following another.

Their survival in the harshest, most forbidding climatic region of Earth ever inhabited by humans depended on clever cultural adaptation and knowledge passed on from father to son, mother to daughter through endless generations.

Women created fur clothing so perfect in quality and design that it kept its wearer warm in the worst Arctic weather. The hunter had detailed knowledge of the seasonal game resources of his home region and knew how to exploit them most successfully. He had a nearly intuitive knowledge of animal behaviour acquired as a boy during childhood travels with his hunter-father. His ability to distinguish safe ice from unsafe ice, learned as a child while playing with older, experienced children on the sea ice near camp, was essential to his future survival as an Arctic hunter.

Their realm was vast, their way of life untouched by alien influences. No other people on Earth inhabited such an immense region. Similar in language and custom, in dress and mode of life, the Inuit, who in their totality could easily fit into a large football stadium, were spread over the Arctic from eastern Siberia to the east coast of Greenland, and from northern Ellesmere Island and Greenland to southern Labrador, distances of 10,000 and 5,000 kilometres respectively, equal to those from Rome to Capetown at the south tip of Africa, and from London east to the Ural Mountains and Asia.

They lived in small camp communities with from two to 20 families, tiny pockets of humanity scattered across the vastness of the Arctic. They were self-sufficient and self-reliant. They imported nothing, exported nothing, knew no other people and needed no other people. Unable to dominate their environment, they lived in harmony and balance with it. Theirs "is the story," wrote the American anthropologist Moreau S. Maxwell, "of a people living in a balanced state of equilibrium with their ecosystem for four millennia."

Their millennial isolation and independence ended when White men began to invade the Arctic: explorers, whalers, missionaries, traders, and members of the Royal Canadian Mounted Police. The whalers took from the Arctic much of its wildlife wealth, the basis of life of Inuit hunters, and Whites brought to the Arctic a Pandora's box of southern diseases to which the long-isolated Inuit had little resistance.

The Labrador Inuit population dwindled from about 3,000 in 1750 to 750 in 1946. Measles and smallpox epidemics wiped out the Mackenzie Inuit; of more than 3,000 less than 100 survived. In 1956, 1,600 Inuit suffering from tuberculosis were in hospitals in southern Canada, one-sixth of Canada's entire Inuit population!

Despite such disasters, which were terrible in major contact areas and minimal in the more isolated regions of the Arctic, traditional Inuit life, "the old way of life," persisted in their ancestral camp communities.

That changed abruptly in the 1950s when the government, paternalistic and powerful, decided to move the people off the land and resettle them in the newly built villages and towns of the North. In 1945, about 95 percent of all of Canada's Inuit lived in about 740 traditional camps, from the Alaska-Yukon

border to the coast of Labrador, in a fairly traditional way, each new generation acquiring the ancient, empirical Arctic hunting-survival knowledge from its experienced elders and passing it on to the next generation.

Twenty years later, more than 90 percent of all Canadian Inuit had moved or had been moved from the land into villages and towns. Big boarding schools were constructed in the main settlements where Inuit children were educated in the White man's language for a White man's world that had nothing to do with their past and their parents. "We grew up to feel ashamed of being Eskimo," a young Inuk, Rosemary Kirby, told the Thomas Berger inquiry into the North. The generation gap became a gulf, and the ancient, highly specialized hunting-survival culture of the Inuit was dying.

Far from the new Arctic towns with their promises and their problems, a few traditional camps persisted. There "the old way of life" continued, albeit in modernized and modified form.

It is at these Inuit camps, oases of independence and cultural continuum, from Greenland across Arctic Canada to Alaska and Little Diomede Island in the middle of Bering Strait, only about 2 kilometres from Siberia, that the pictures in this book were taken over a period of 30 years, starting in 1964 and ending in 1995.

I had learned photography by doing it, first at a studio in Kirkland Lake in northern Ontario and then as a press photographer, wielding a heavy plate camera and taking the standard static press pictures of the time.

That changed when I went to Europe in the late 1950s to see a lot and try to survive as freelance writer and photographer. In Holland I teamed up with the young American photographer Leonard Freed, who had learned his craft from the French master Henri Cartier-Bresson and who was then himself near the edge of fame (he later became one of the top photographers of the prestigious MAGNUM photo agency).

Watching Leonard work was utterly fascinating and very instructive. We went together to Berlin when the Soviet Union and its East German minions began to build the great wall that would forever, they hoped, seal off their glorious East from the evil but tempting West.

Soldiers, tanks, policemen, and politicians milled on either side of the rising wall. More than half a million people marched and yelled and waved placards in some of the many demonstrations. On October 25, 1961, American and Soviet tanks rumbled through Berlin and faced each other at Checkpoint Charlie.

Through all this threatening brouhaha Leonard meandered quietly, unobtrusive but extremely alert, taking many pictures and no one noticed him. His pictures captured the essence of a great historical event; they were an evocative mirror of that time.

I watched and learned, and the months I spent working with Leonard Freed at political hot spots all over Europe and the Middle East deeply influenced my future photographic work.

I married, returned to Canada, and worked as journalist for newspapers in Ontario and Montreal. But during my wandering years in Europe I had drunk too deeply from the cup of freedom to be really happy with an office job and regular hours.

After two years I began to freelance again. A magazine sent me north to do a story on one of the new towns of the Arctic. It was an instructive but disturbing experience. I met a people caught between two worlds: one dear but dying, the other alien

but alluring. However, far away from the new towns, I was told, traditional Inuit life still continued in isolated camps.

My scattered interests found a focus. That ancient way of life, I felt, should be recorded before it vanished forever. And so began my visits to Inuit camps, at first for a few weeks, then for months, and finally for six months of every year.

For 30 years I arrived at such camps, unannounced and uninvited, without food or shelter, and asked, "May I live with you?" and the answer, invariably, was a somewhat hesitant and worried "Yes," because who is really keen on having an utter stranger, who speaks very little of your language, move in with you and share your one-room shelter and your bed for an indefinite period of time?

Two things made this possible: a supportive and very tolerant wife in the South and the equally supportive and tolerant Inuit in the North. They had always been a hospitable people. To visit and be visited was one of the great joys of their lives. I arrived initially as a sort of guest and remained as a sort of fixture. Everyone on the fur-covered sleeping platform moved over a bit, I got a slot and was at home.

Camp life absorbed me and after a while I realized with amusement that the Inuit were treating, instructing, and forming me as they treated, instructed, and formed their children. They slowly, gently, and unobtrusively modified my behaviour to correspond more closely with the accepted norms of their society, and they were as protective of me as they were of their children, for I was ignorant and in the Arctic, ignorance can be fatal.

I learned to admire the diverse and vital knowledge of the Arctic hunter when I lived at one of my first camps with Pewatook and his family on remote Jens Munk Island in northern Foxe Basin.

It was March and extremely cold. Every morning, Pewatook, a man in his early sixties, harnessed his dog team and we drove two hours across rough ice and jumbled ice-block pressure ridges to the floe edge, the limit of land-fast ice, where he hunted seals.

The floe edge was not permanent. Storms sometimes shattered the ice edge and rolled it back hundreds of metres. And on calm, intensely cold nights, it could extend out into the sea for a kilometre or more.

Pewatook left me far from the edge with the dog team while he walked to the ice edge, trying with sounds and tricks to lure seals into shooting range. It was -40° C. He waited, alert and patient, all day and far into the luminous night for the seal was food and life.

A small flock of birds rushed through the dark frost vapour above the water, circled above the ice, and settled upon the sea. Ducks, no doubt, but which species? Intrigued, I walked to the ice edge.

A sharp yell stopped me. Pewatook, 90 metres away, semaphored urgently "STOP!"

He walked toward me with short, rapid, sliding steps, zigzagging across the grey ice, walked past me at a distance, came up from behind and stood beside me. He touched the ice in front of me with his harpoon. The point slid through the ice. It was a mere ice film. I was two steps away from certain death. Had I fallen in, I would have died within five to seven minutes of shock and hypothermia.

With his harpoon point Pewatook showed me the division between the safe ice on which we stood and the membrane of recently frozen frazil ice just in front of me. The difference was minute, the knowledge vital. The new ice was a slightly darker

shade of grey and the ice crystals were a bit smaller.

By living so long at each camp for months or even half a year, I became a part of camp, an oddity, perhaps, but an accepted oddity. Everyone in camp did his or her own thing: the men hunted, carved, repaired equipment, looked after sled dogs; the women sewed, cooked, or petted the latest camp baby, loved by all; the children played or helped their parents and learned from them; and I watched, listened to stories, tried to become more fluent in their language, asked questions, learned, kept detailed diaries, and took pictures, which became such a part of camp life that no one really noticed it any more.

My main problem was a lack of film. Since no government or other agency was willing to fund this project to record the remaining Inuit hunting culture, we had to fund it all ourselves and we simply could not afford to buy all the film that I so badly needed.

It was tempting, in a way, to return year after year to the same camp, whose people I knew and liked and where I knew I would be accepted. But each region had different traditions, the men used different hunting methods, and I heard new stories and was told ancient legends and beliefs. I joined two hunters from Ellesmere Island on a 2,000-kilometre, two-month polar bear hunt by dog team. It was the last such hunt ever made by Canadian Inuit.

I lived at narwhal hunting camps in northwest Greenland, travelled with the walrus hunters of Little Diomede Island in Bering Strait who still used *umiaks*, the large, leather-covered open boats of the Inuit, and I lived at the camps of the White whale hunters in the western Arctic. And wherever I lived, I tried to record as much as possible of the "old way of life," of the ancient Arctic hunting culture before it all faded away and vanished.

THE LAND AND THE PEOPLE

For 30 years I roamed the Arctic: its magic and majesty called me. I loved its rugged beauty, its haunting loneliness, its infinite space. It has the vastness of the sea, the grandeur of a Bach fugue.

In a world that is crowded, polluted, and sick, the Arctic remains an enchanted realm, a last great wilderness that is often harsh and forbidding, its ancient balance now threatened by global warming, but still a land of wondrous beauty and serenity. "It is more dreamlike and supernatural than a combination of earthly features," wrote the American explorer Elisha Kent Kane in 1855. "It is a landscape such as Milton or Dante might imagine—inorganic, desolate, and mysterious." The Inuit call it *Nunassiaq*, the Beautiful Land.

It was, and still is, an empty land, a land as big as the United States (without Alaska) with a total population in 1900 of about 30,000 Inuit. I had already seen parts of the Canadian and European Arctic, but this sense of awesome emptiness really struck me when, in 1967, I joined two Inuit hunters, the brothers Akpaleeapik and Akeeagok and their oldest sons, in Grise Fiord, Ellesmere Island, for a two-month, 2,000-kilometre polar bear hunt.

We travelled on two 8-metre sleds pulled by 29 huskies. We left Grise Fiord, Canada's northernmost community, on a brilliantly sunny day in April and for the next two months, except for a brief stop at the settlement of Resolute on faraway Cornwallis Island, we saw no other humans.

We normally travelled 30-40 kilometres every day. At least once a day the brothers climbed a frozen-in iceberg or steeply raftered floes and scanned the ice with telescopes, steadied with their harpoon shafts, for signs of their main prey, polar bears.

Toward the end of our travelling day, be it day or night, because at this time of the year in the High Arctic, days and nights were nearly equally bright and time as reckoned in the South had ceased to matter, we stopped to hunt our daily seal.

Akpaleeapik watched a seal basking upon the ice in the distance very carefully, then approached the animal hidden behind a white canvas shield (formerly made of pure-white, frost-bleached seal or caribou leather), his skilful upwind stalk synchronized with the sleep-wake rhythm of the seal. The moment the seal woke up, Akpaleeapik froze and crouched behind his white shield. The seal looked carefully around and saw only white. Satisfied that all was safe, it fell asleep and the hunter rushed toward it with quick, silent steps. The instant our sled dogs heard the distant rifle shot, they rushed off in a wild and joyous gallop. For them, too, that seal was supper.

If it was not too cold (-20° C or above) and there was not much wind, we set up our tent, spread our sleeping furs (caribou and polar bear), had a huge meal of seal meat and fat, drank many mugs of tea, talked for a while, and then, cozy among the furs, slept soundly.

If it was very cold or stormy, the men built an igloo, windproof and far warmer than a tent. It took an hour to build a snow house roomy enough for five people. We lugged in our furs and our food and, if the storm was bad, remained immured within our snow-block home for a day or two, safe and comfortable, talking of other trips and other hunts, hearing stories from "the olden days," lolling on the furs, drinking more tea, and being deliciously lazy.

Before leaving, we packed the long sleds with meticulous care, lashing the loads securely with sealskin thong, used the igloo, the perfect disposable dwelling, one last time as a sheltered

outhouse, harnessed the dogs, and we were off for another long day of travel.

And so the days and the weeks passed. We were always alone, just five humans and 29 dogs, travelling, searching for prey, suspended in time and space, living by hunting, self-sufficient, a tiny moving caravan upon a frozen ocean.

We travelled primarily upon sea ice because seals, our food and the food of the polar bears we hunted, live in the sea beneath the ice, and in spring when they moult, they like to bask upon the ice. That's when Inuit and polar bears hunt them in similar fashion: the stealthy stalk, timed precisely to the sleep-wake rhythm of the seal, the human hunter hidden by his white shield, the polar bear by his white fur.

On the ice we met no humans, and saw no trace of humans. That changed the moment we touched land, for it is one of the wonders of the "empty Arctic" that along tens of thousands of kilometres of coastline and even far inland, one finds the evidence of past human presence, mute witnesses to a vanished people who once lived and loved and laughed and hunted and fished there. There were stone weirs in rivers where they speared char with their leisters; circles of stone that once held the lower hem of their caribou or sealskin tents; inukshukit, human-shaped stone pillars that, on coasts, once guided Inuit seafarers, or inland were 'aligned to funnel caribou toward hidden hunters; box-like stone hearths where Dorset culture people, remembered as *Tunnit* in Inuit legends, cooked their meals perhaps 2,000 years ago; rows of 1-metre-high stone piles on a mountain slope, once connected by seal-thong lines from which hung sinew or baleen snares that captured Arctic hares; aligned flat rocks for the "jumping game,"

where Inuit children of long ago played an Arctic version of hopscotch.

On a large flat peninsula near the mouth of Ellesmere Island's Muskox Fiord, Akpaleeapik showed me the remains of an ancient village: about a dozen house circles of rock with a mass of large whale bones in their centre. These had once been the walls, ribs, and rafters of houses inhabited by prehistoric Thule culture people.

Ancestors of today's Inuit, the Thule culture people were master sea hunters. Using both kayak and the large, seal-or-walrus skin-covered open *umiak*, they pursued and killed everything from the small ringed seal to the giant bowhead whale and, according to the renowned Arctic archaeologist Robert McGhee, they had evolved "a technology more complex than that of any other pre-industrial society, which allowed not only an economically efficient but also comfortable way of life throughout arctic North America."

Their semi-subterranean houses, built of rocks and whale bones and covered with walrus skin and sod, plus snow in winter, were very heat-efficient and may have been reasonably comfortable.

I once lived in a similar house on Nunivak Island west of Alaska in the Bering Sea. It was a modern copy of the local Inuit's former homes, now used as shelter by the island's reindeer herders and muskox hunters living far from their village. The house had been dug deep into an island dune. Frame and roof rafters were of driftwood, the top covered with sod. The entrance sloped upwards to the first door. Then came a narrow passage, a cold trap, and a second door opened into a spacious room. Even with -20° C weather outside and a searing wind, this super-sheltered dwelling, heated only by a tiny stove, was so warm that

we usually stripped down to our underwear.

To survive so successfully in the Arctic for millennia, the Inuit and their forebears evolved a culture perfectly adapted to cold. While we talk endlessly of weather (without their weather talk the British would be nearly mute), the Inuit with whom I lived for 30 years very rarely did.

So it was cold. Of course it was cold! What do you expect in the Arctic? This was their home, their land and sea that provided them with the animals that made survival possible, for they supplied the Inuit with food and with furs for their clothing, with fuel for their seal-oil lamps, and with ivory, bone, baleen, and antler to be made into hunting weapons and into sewing needles, into tools and toggles and toys.

Inventiveness and ingenuity, as well as the learned skills, the infinite patience of the true hunter, and their knowledge of animal behaviour, helped them survive. Akpaleeapik, who liked to show me things, stopped near Cape Storm on Ellesmere Island. On a level rock shelf near the base of the soaring mountain bastion stood three peculiar beehive-shaped stone structures.

"Udlisau," Akpaleeapik said. "They are fox traps." Then he explained how they worked. The trap is conical with a half-metre opening at the top. Into the opening a flat stone was inserted so that it could swivel. Sometimes a piece of polished ice was used instead. Just beyond the stone or ice sheet a chunk of meat was suspended as bait. When a fox climbed the udlisau and stepped on the swivel-stone to reach the bait, it tipped forward and dumped him into the trap, or he stepped on the polished ice and slid in. In either case, once inside the fox could not possibly jump out of the conical stone trap, which was 2 metres high. With the

fox furs Inuit women made beautiful parkas for themselves and marvellously warm clothes for their children.

For weeks we and the dogs ate only seal and also the meat and fat of polar bears, for the brothers had been successful and after many difficult and exhausting hunts, had shot several bears. Nothing was ever wasted for the brothers still held to the ancient belief that to waste meat offended the immortal spirit of the dead animals and future hunts would be unsuccessful.

On our way home we crossed northwestern Devon Island and upon a vast, snow-covered plain saw several Peary caribou, the small, light-coloured caribou of the Far North (then numerous, but now rare and endangered).

Using a traditional Inuit stratagem, Akeeagok and his son approached the caribou, one with arms raised as "antlers," the other bent forward as the rear end of the animal, pretending to be a caribou. It was a poor imitation, but they behaved so convincingly and grunted so caribou-like that the caribou, myopic and fatally curious, stared and dithered and even approached. Akeeagok sensed instinctively the crucial instant when caution and fear began to outweigh curiosity and in that moment shot two of the caribou and the others fled.

After two months we returned to Grise Fiord. We were spotted from afar and families rushed down to the ice to meet us. The dogs, eager to be back, exploded into a last wild gallop, hauling the heavy sleds, now piled high with meat and the pelts of many seals and of seven polar bears, and all around us was the ancient joy that greeted the men of the Arctic when they came home from the hunt.

Along this stark, lonely, and majestic north shore of Frobisher Bay, Baffin Island, the men of Martin Frobisher's Expedition met Inuit in July of 1576.

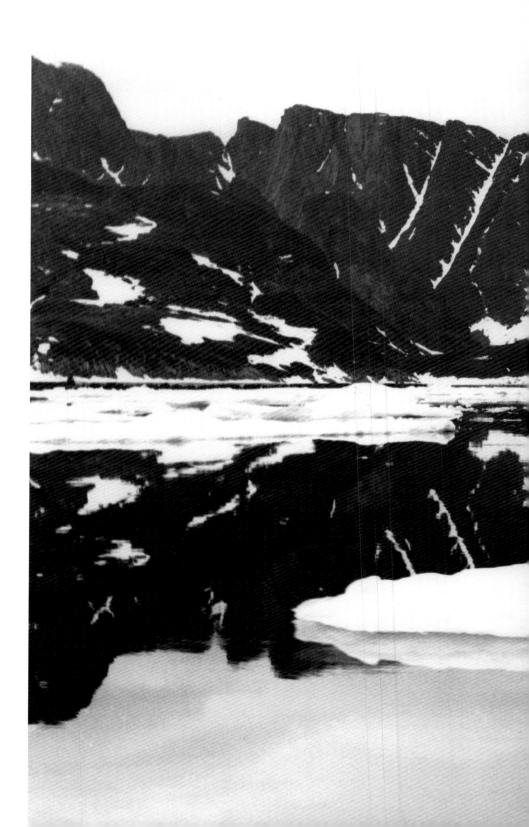

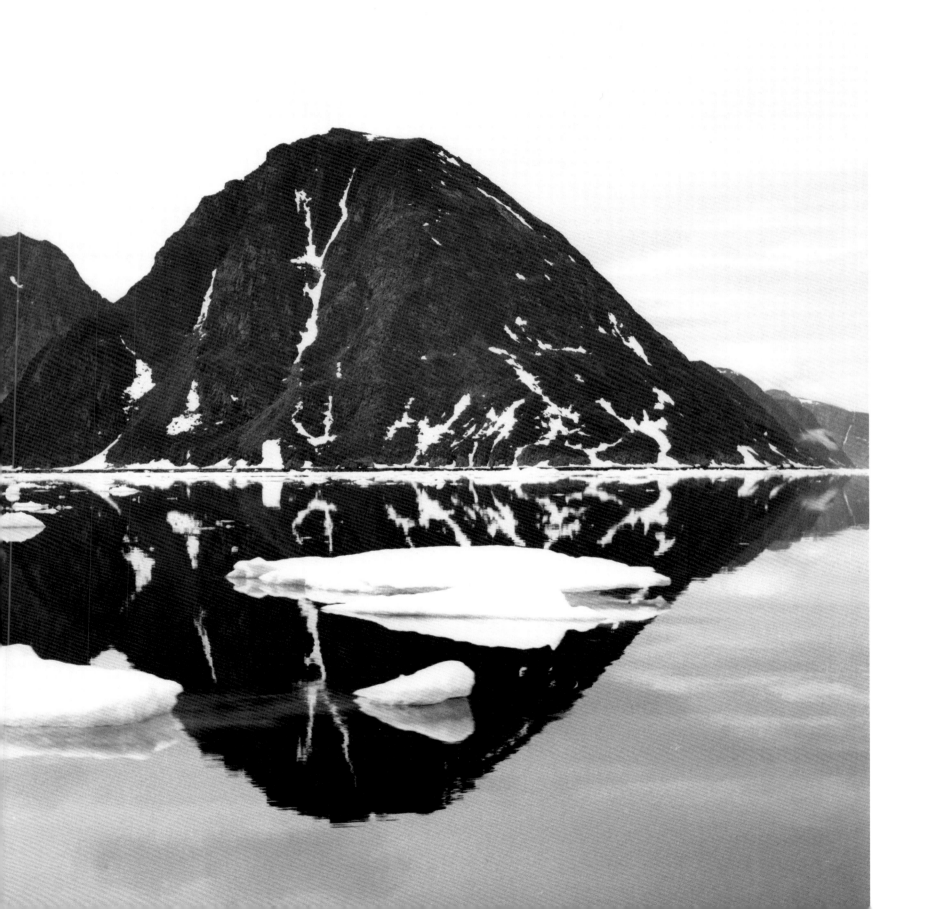

Icebergs, marvellously carved by wind and water, float in shining beauty past the dark Labrador coast. Born of Greenland glaciers, they are being carried south by the Labrador Current.

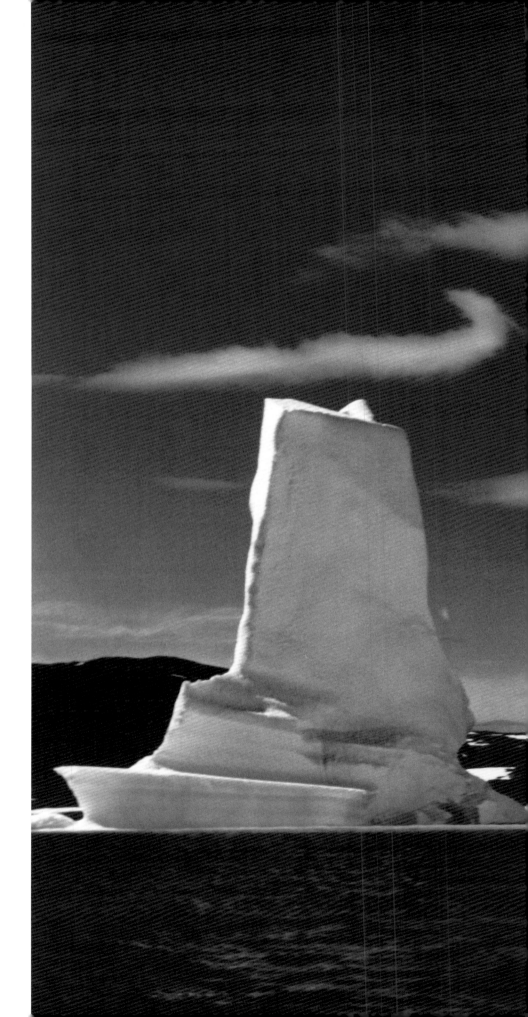

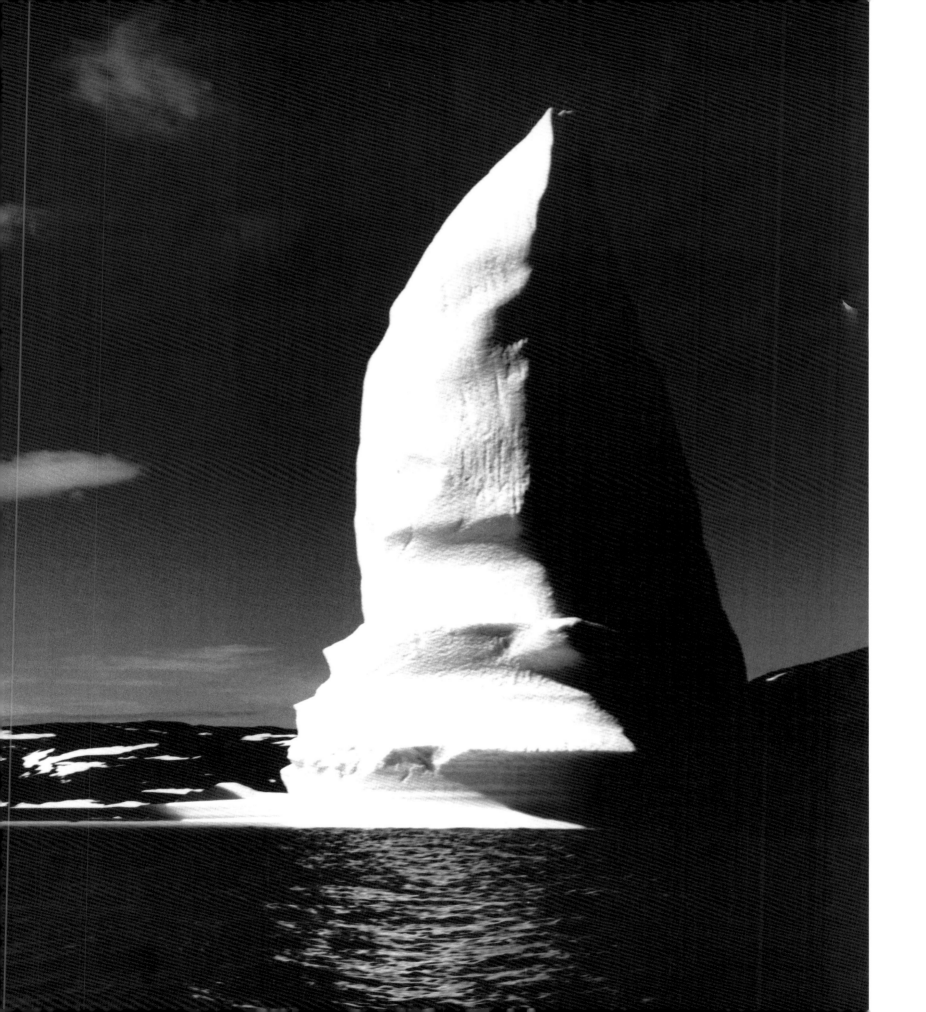

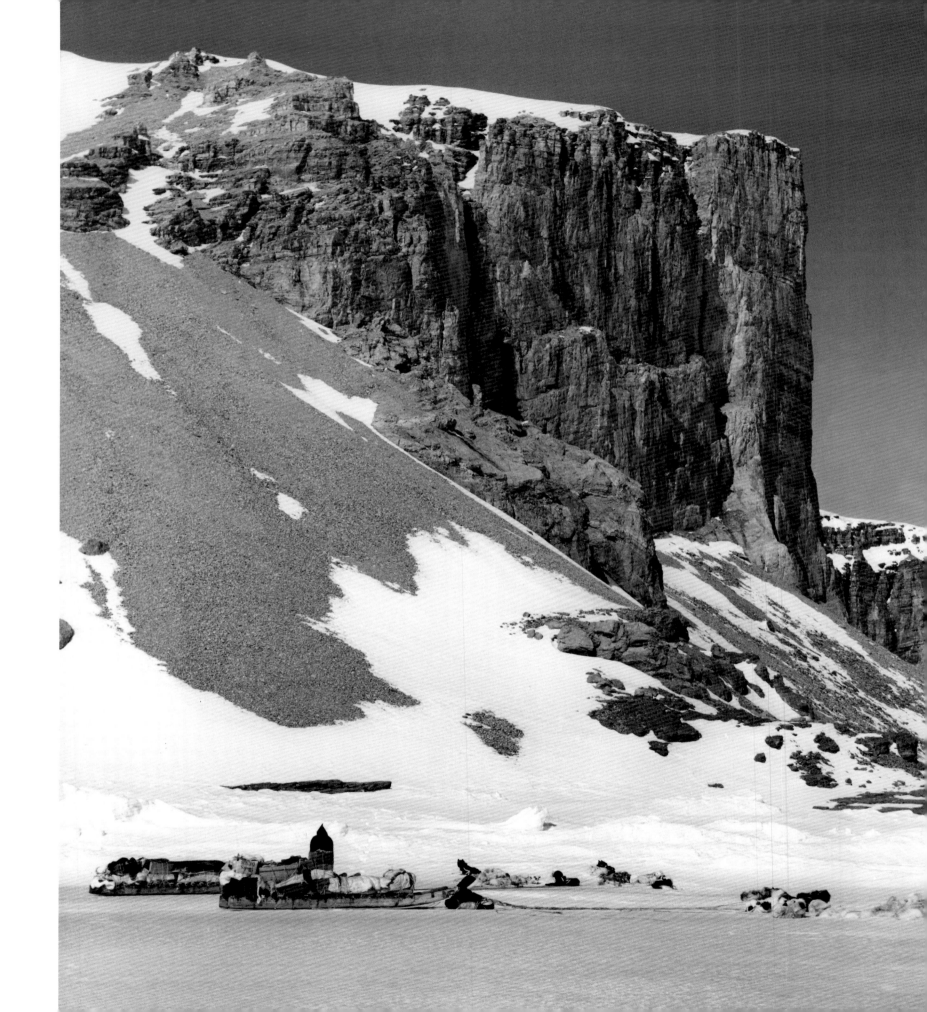

Left: Inuit hunters from Grise Fiord, Canada's northernmost settlement, rest their dog teams beneath the soaring cliffs of southern Ellesmere Island. They were near the start of a two-month, 2,000-kilometre polar bear hunt.

Below: George Hakungak hauls a sled load of stunted Arctic willows to our Bathurst Inlet camp, travelling on a frozen river. The wood was burned in 38-litre drums made into simple but efficient camp stoves.

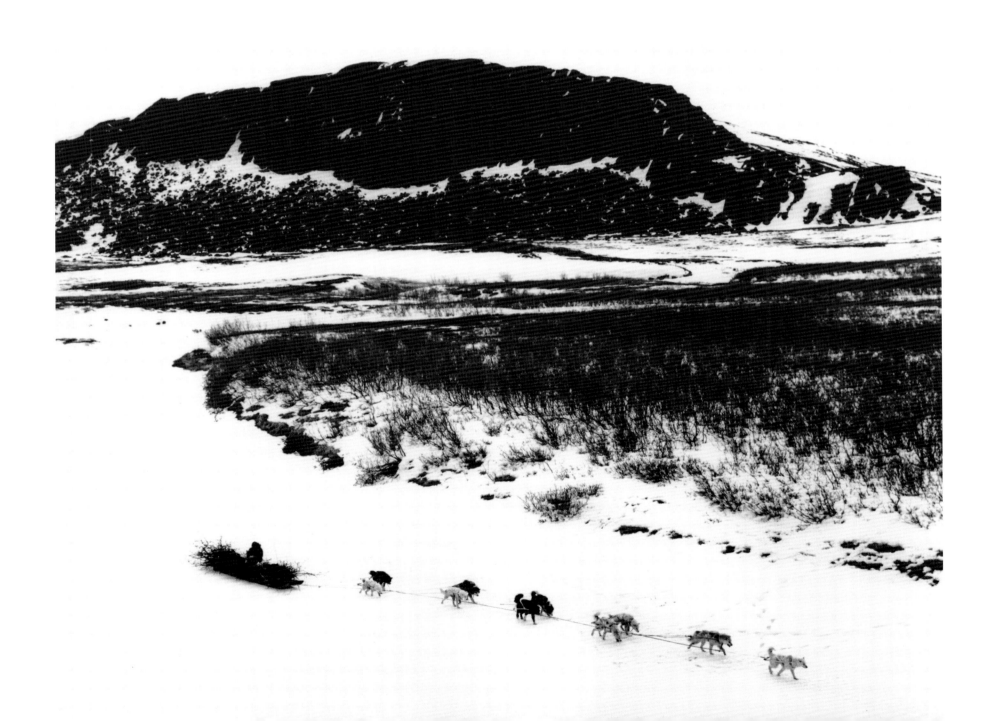

Below: Spring in the High Arctic. Children of Siorapaluk, Greenland, the northernmost village in the world, haul their sled up a coastal slope. Happy, hardy, and self- reliant, Inuit children learned early how to amuse themselves.

Right: Mighty cliffs dwarf the tents of Inuit fishermen on the shore of north Labrador's Nachvak Fiord. Long ago, the char catch was air-dried as winter provender. In 1968, when I lived with the Labrador Inuit, most fish were barrelled, salted, and sold.

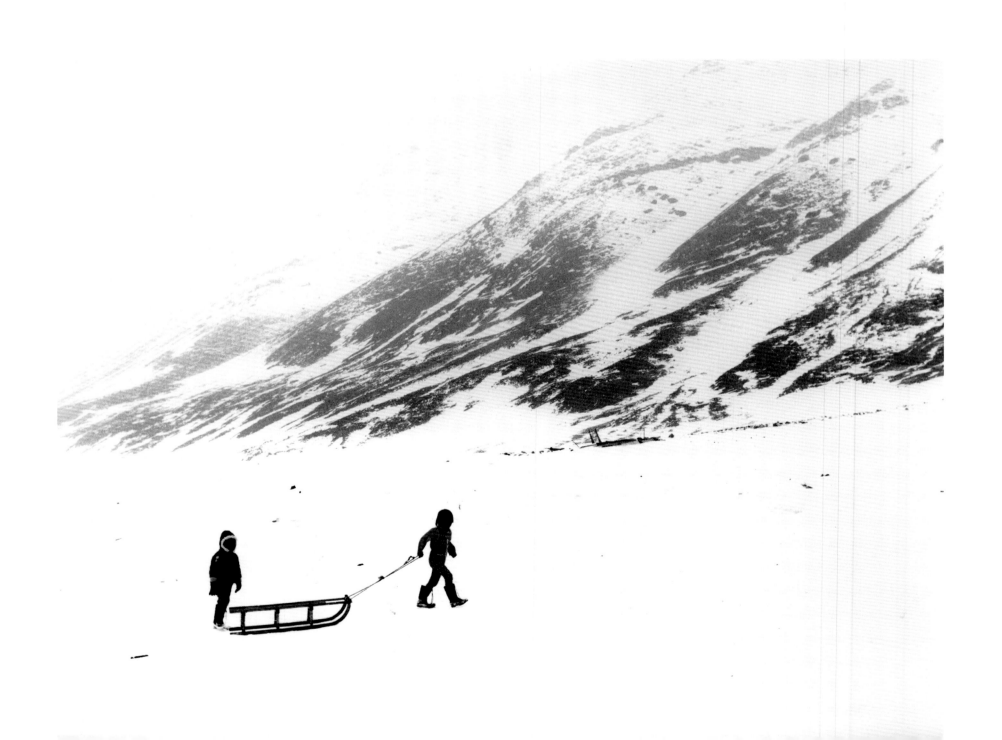

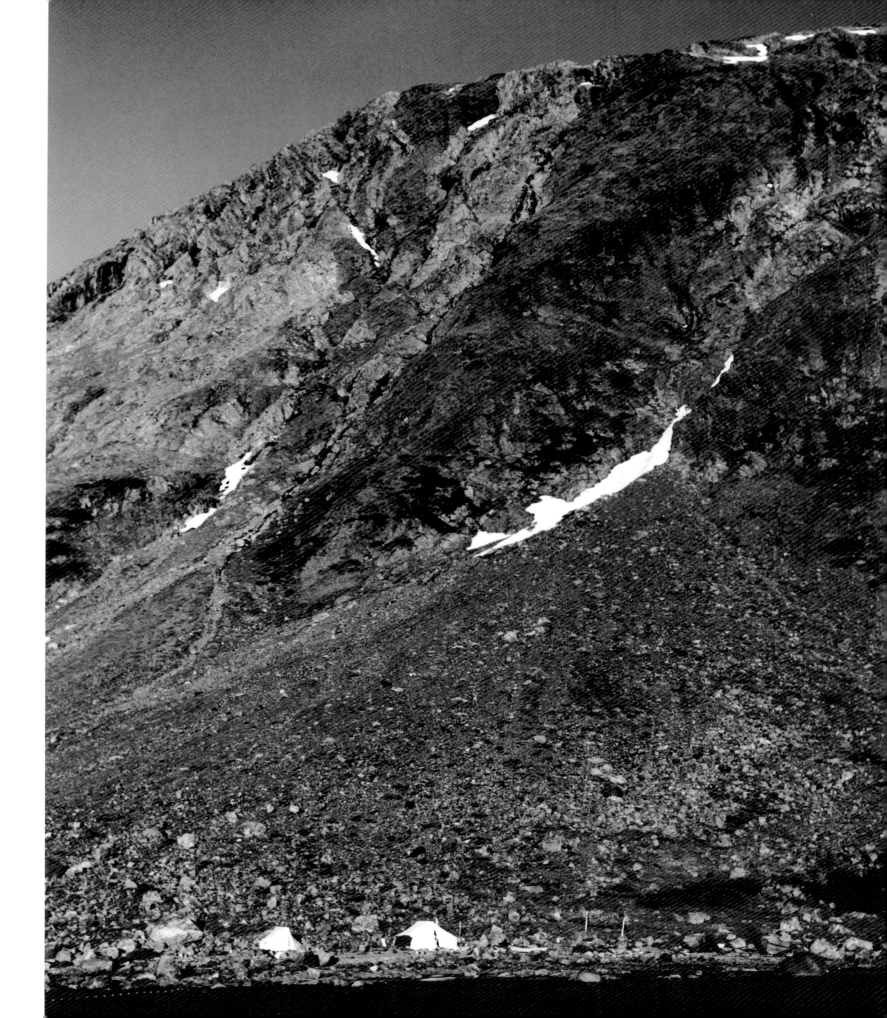

The grandparents of the Polar Inuit on the ice lived in this semi-subterranean stone house at Natsilivik, northwest Greenland. Such houses, my friends recalled in 1971, were small and dark, but when roofed with cantilevered stones and covered with sod and snow, they were comfortably warm in winter.

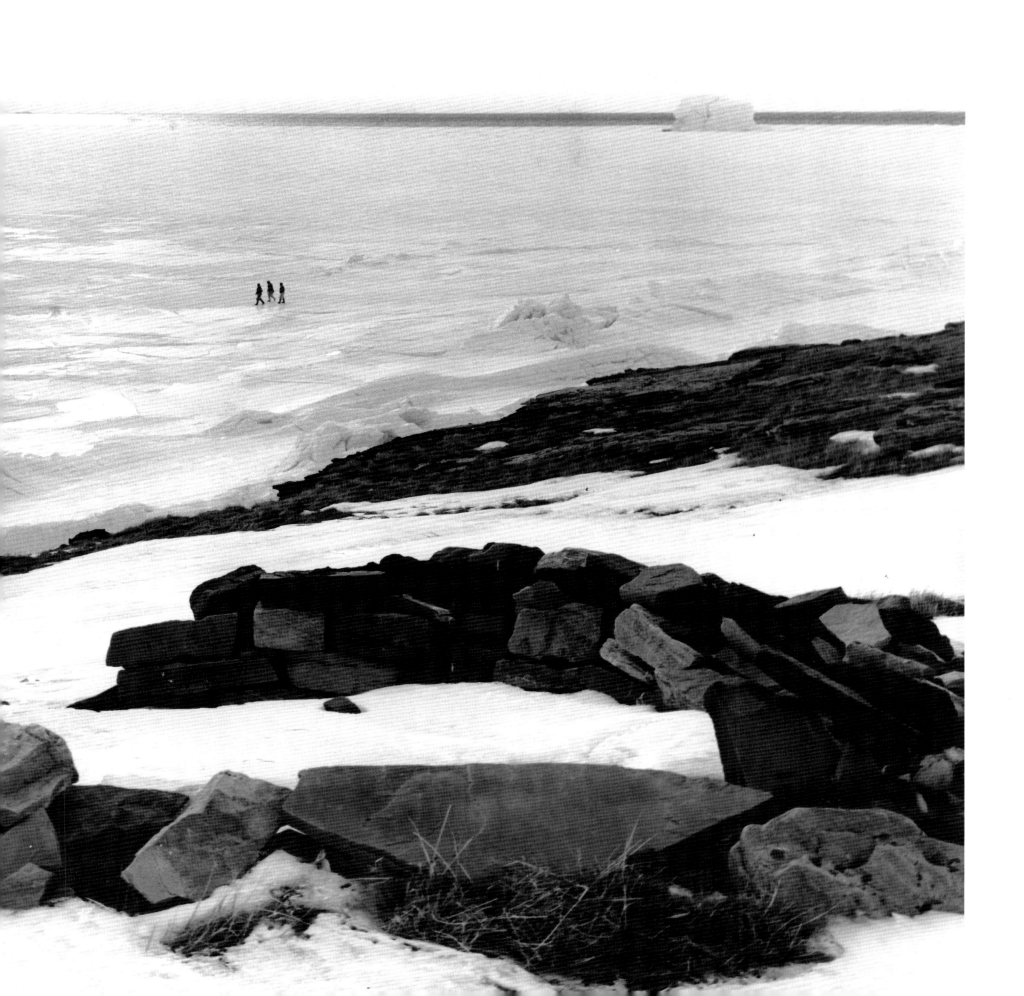

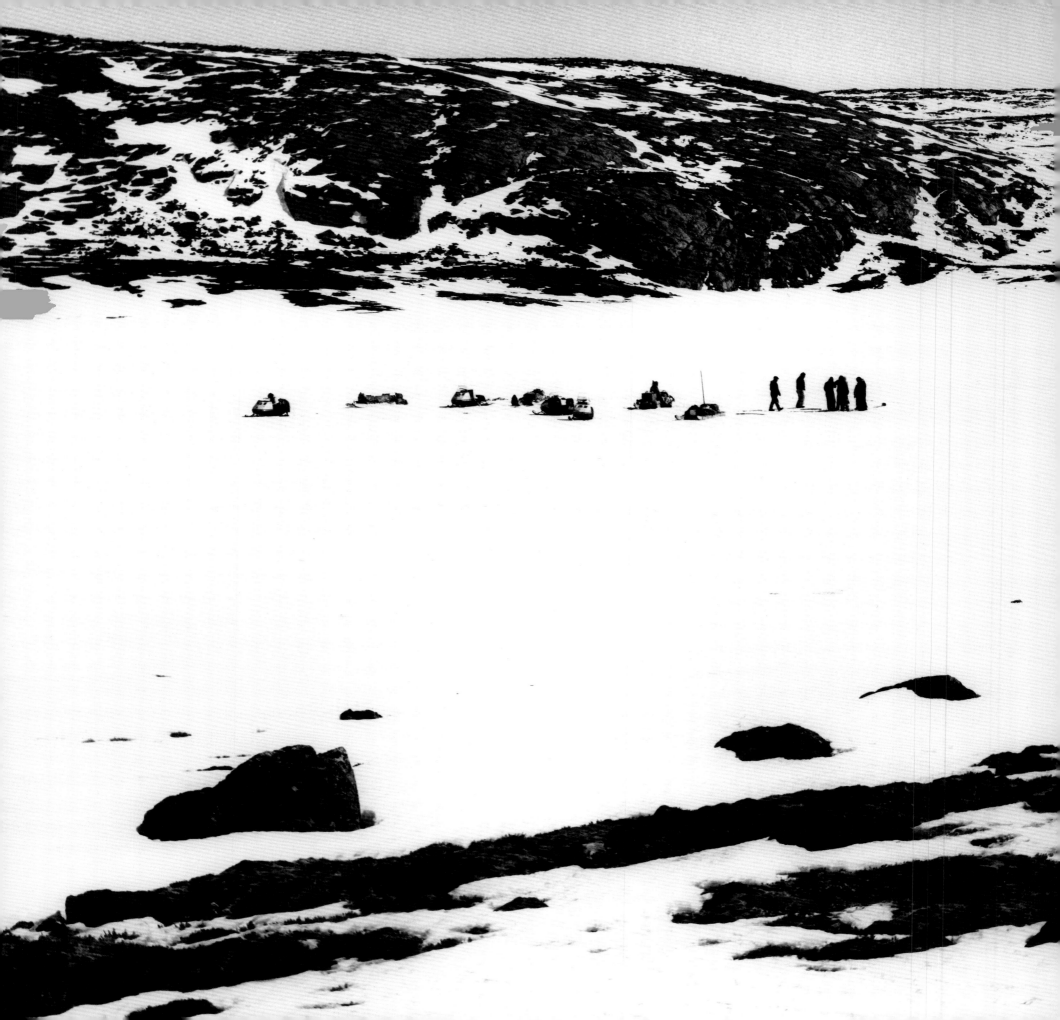

Left: We had travelled far that day in 1974 from the village of Repulse Bay, northernmost Hudson Bay, across Rae Isthmus to favourite fishing lakes. In the evening the Inuit stopped to set up camp on a frozen lake.

Below: The lone hunter. The Polar Inuk Masautsiaq walks in a remote valley, hoping to find Arctic hares. The lean hare meat was eaten with small pieces of seal blubber. The hare's down—soft, dense white fur—was used for very warm socks.

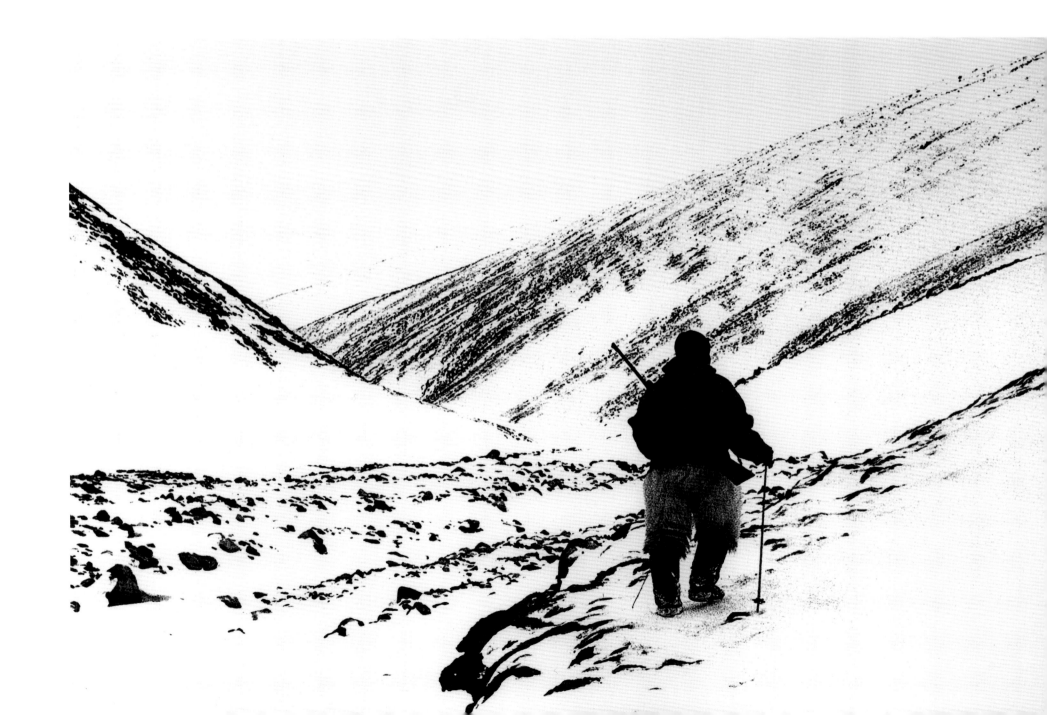

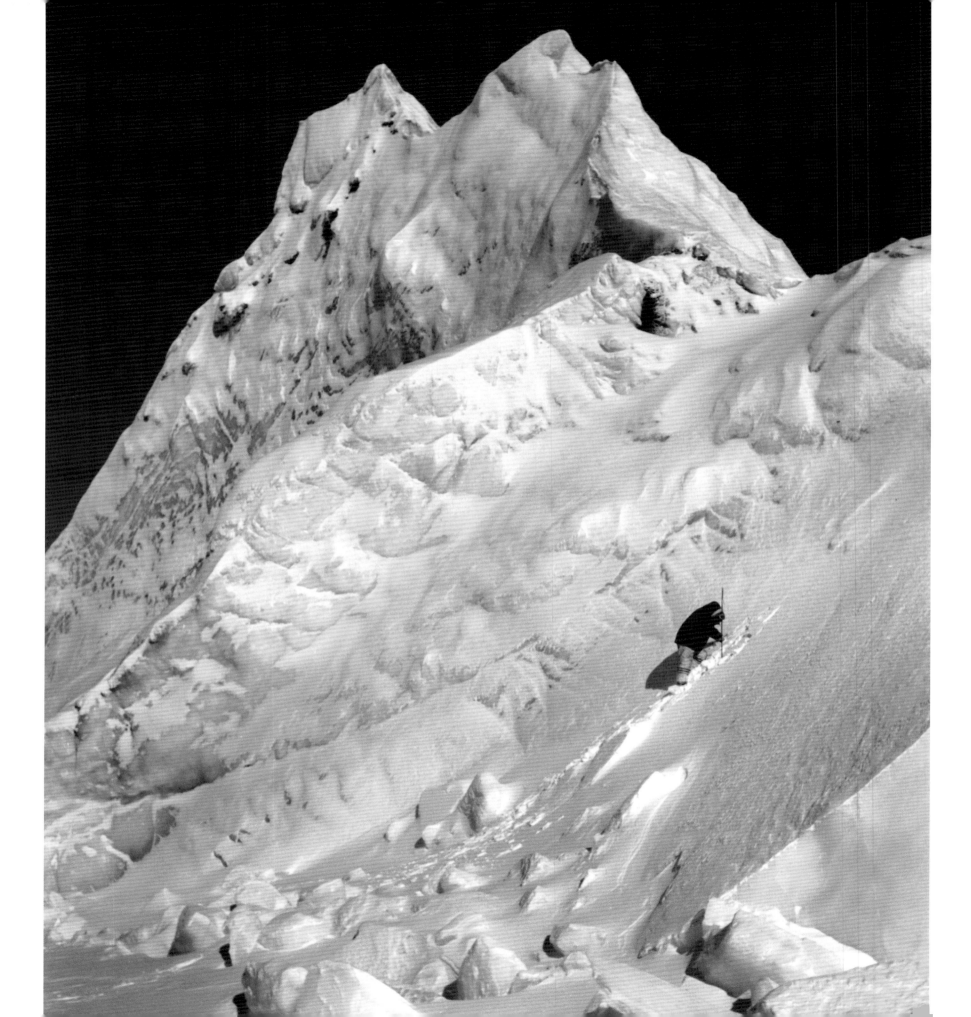

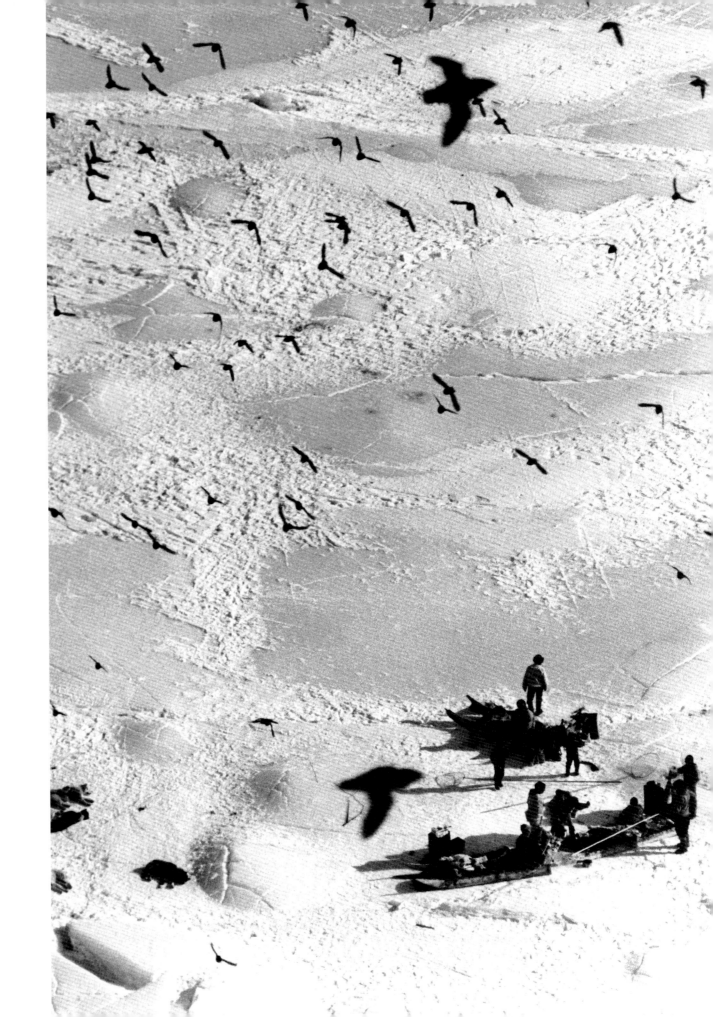

Left: With smooth-soled sealskin boots and great skill and assurance, using his harpoon shaft as ice pick, Akeeagok of Grise Fiord, Ellesmere Island, climbs a steep, frozen-in iceberg to look from its peak for polar bears.

Right: More than a million dovekies, fat little seabirds, nest on steep scree slopes near Siorapaluk, Greenland. Polar Inuit arrive by dog team to scoop birds out of the air with long-handled nets.

Inuit, their huskies harnessed in tandem with one lead dog, travel in spring to a neighbouring camp. In 1969, the 89 Bathurst Inlet Inuit, living in several small camps, inhabited a region larger than Belgium.

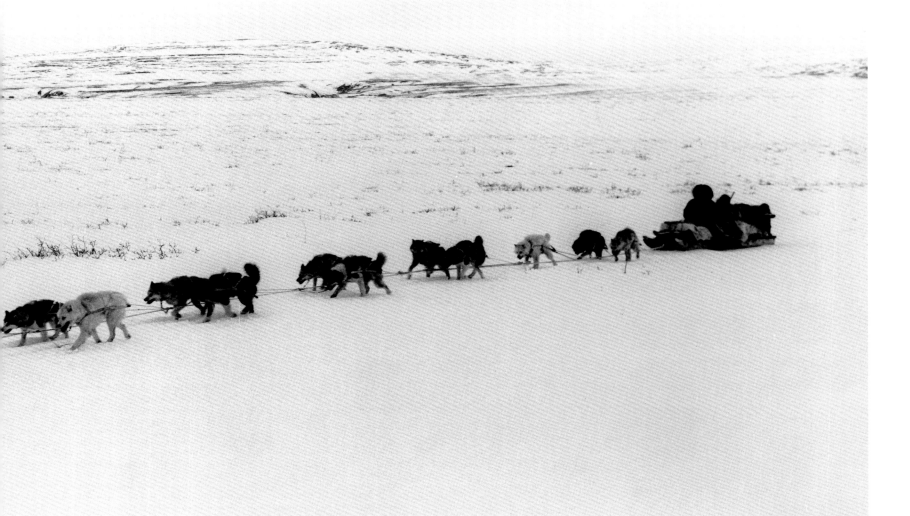

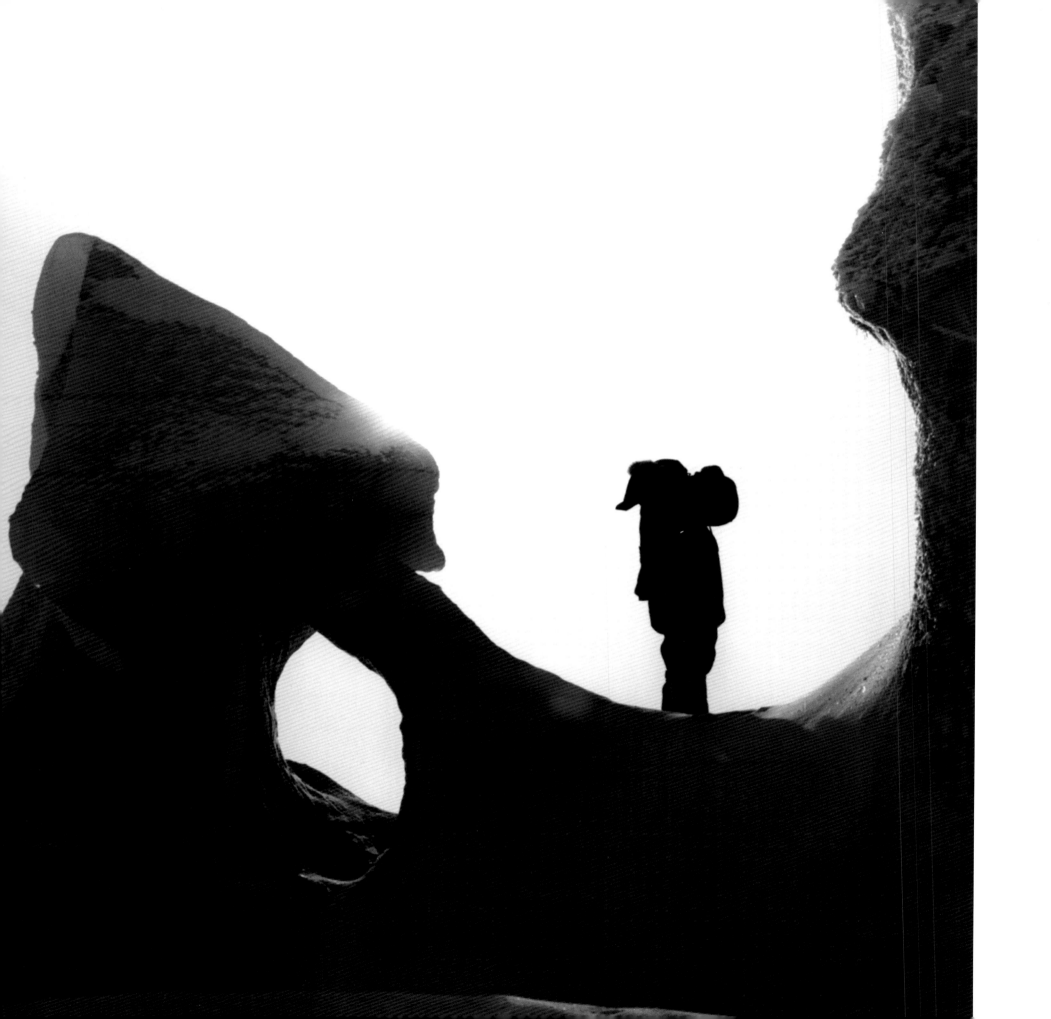

Left: The Inuk Sam Willy of Grise Fiord atop a beautifully carved iceberg frozen into Jones Sound scans the sea ice for seals. In April ringed seals moult and spend hours upon the ice, possible prey for Inuit hunters and polar bears.

Below: A little Inuit boy alone in a vast and lonely land, near Repulse Bay, Nunavut. He had spent the afternoon with his grandparents and now walked home across the snow-covered tundra broken by dark rock ridges.

HUNTING

For more than 99 percent of their existence on Earth humans have been hunters. Starting millions of years ago on the African veld, hominid hunters spread across the face of the Earth, hunting, fishing, and gathering. Only in a very recent little blip of our Earth-time, some 12,000 years ago, did humans invent agriculture, settled down, and clustered in ever larger villages, towns, cities, and megalopolises.

Hunting cultures persisted in many places on Earth, but were nowhere as widespread and contiguous as in the North American Arctic. It was the Arctic's great and diverse wildlife wealth that had lured human hunters into this climatically forbidding region in the first place and they succeeded in a multitude of different ways to exploit all the resources of land and sea, from Siberia to East Greenland.

Plants were the least important of their foods. By eating some of the meat, intestines, and internal organs of their game animals raw, the Inuit obtained all the vitamins and minerals other societies derived from fruits, roots, and vegetables.

Since living exclusively on meat did not strike me as a balanced diet, I arrived for my first many-months stay at a traditional Inuit camp with many bottles of vitamin pills. I never touched them, never needed them. Eating Inuit food the Inuit way—all meat, some raw, some cooked—I remained perfectly healthy.

Because eating meat morning, noon, and night can be a bit monotonous, the Inuit loved to gather and eat greens and berries wherever and whenever they were available.

I lived for many months on Little Diomede Island in Bering Strait, halfway between Asia and America, home to the Arctic's most daring and successful walrus hunters.

Their village, Ignaluk, tacked to a sloping mountain side, was ancient: it had been continuously inhabited for at least 2,000 years with an average population of 150 during all that time (121 during my first stay in 1975; 171 when I returned in 1990).

Traditional and isolated on their lonely rock in the Arctic sea, the islanders used great skill and the knowledge passed on by their ancestors to harvest the seasonal bounty of sea and land.

In winter the men hunted seals at the floe edge, the limit of land-fast ice a few kilometres from their village, with infinite patience and great cunning. When a seal surfaced in the distance, they lured it closer with scraping noises upon the ice. Sound travels far in water. To the seal it may have sounded like another seal scraping ice. Ever curious, the seal came closer and closer, its head bobbed up and the large dark eyes stared in fatal fascination. When the seal was near the ice edge, the hunter shot and, an instant later, flung out a long line with a grappling device, an oval piece of wood with many hooks, snagged the seal before it sank, and hauled it onto the ice.

A few of the older hunters were familiar with a very ancient, simple but lethal weapon they had used before guns: the sling. Loaded with a stone and whirled by an expert hunter, the long leather loop picked up such a fantastic centrifugal force that it hurled the stone with deadly speed. It could smash a seal's head at 45 metres, they said. Thus did young David, about 3,000 years ago, use his sling and one smooth stone to kill Goliath, the monstrously huge Philistine. The stone, says the Bible, smote him in the forehead and the giant keeled over stone-dead.

While the men hunted seals, women and children crabbed and fished through holes chiselled through the ice near the

village. The method was ancient, simple, and efficient. A stone sinker and two chunks of fish as bait were lowered on a thin line (now nylon, formerly made of baleen fibres) to the sea bottom. The feeding crab, loathe to lose food, hung on as it was gently pulled to the surface. The most patient crabbers, using several lines, caught 20-30 crabs a day, each one, including spindly legs, nearly half a metre in diameter. Others jigged for tomcod and sculpins, both popular for fish soup.

In May the seabirds arrived and men and boys rappelled down the island cliffs (now using ropes, formerly very strong bearded seal thong) and collected thousands of chicken egg-sized murre eggs. Some eggs we ate immediately. Most were stored, raw or boiled, in seal oil and could be kept for about a year.

Hidden behind ancient stone bulwarks on the island's steep scree slopes, men, using long-handled nets and great skill, scooped thousands of low-flying auklets out of the air. Some of the birds were boiled and stored in seal oil. Most were preserved in the islanders' "meat holes," spacious, stone-lined caverns, some of great age, dug far into the frozen mountainside, humankind's early refrigerators. In 1912, the American inventor Charles Birdseye, then a fur trader, saw similar freezers used by the Labrador Inuit. He adapted the Inuit idea, founded the General Foods Company, and became the very rich founder of the frozen food industry.

In summer, women, children, and some of the older men collected a great variety of greens, roots, shoots, and seaweed. With small bone mattocks they dug up the corms of spring beauty, which look like tiny potatoes. They were boiled and mixed with seal oil into a pleasant, if somewhat bland, paste.

After the frequent storms, women and children collected the thin, narrow, iodine-rich fronds of seaweed washed up on the beaches and coastal rocks, dried them, and ate them raw (they have a nice, salty flavour) or mixed them with soups and stews.

Salads were made from the radish-flavoured leaves of Kamchatka rock cress, the sourish leaves of mountain sorrel, and the leaves of Parry's wallflower, which grow in tight, bright green rosettes on the mountainsides and contain considerable amounts of vitamin C and provitamin A.

Willow shoots and young leaves, 10 times richer in vitamin C than oranges, were collected in large quantities in early summer and eaten either fresh or, like other greens, preserved in seal oil for future use. The inner portion of willow bark was used extensively by the Diomeders and other Inuit across the Arctic, raw or as an infusion, to alleviate the rheumatic pains of the elderly. The bark contains salicylic acid. In 1904, German chemists concentrated it into pills and called their product "Aspirin," which is now, according to a Guinness Book of Records, the most popular painkiller in the world.

In the fall, great quantities of cloudberries were collected on the moist, plateau-like island top. When kept frozen in leather pokes (by 1975 in plastic bags) in the meat holes, they retained their high vitamin C content for up to one year.

Berries and other plants were a pleasant and healthy addition to meat meals. Birds, crabs, and fish made for a nice diet change. Seals were important as their meat and fat were the main foods, and their oil was valuable as a preservative. But walruses were the sine qua non of the Diomeders' existence.

Walrus meat and fat were their staple foods; for more than

2,000 years it had guaranteed their survival on the bleak, storm-lashed island they call home.

Walrus ivory was their wealth. They made from it a multitude of tools and toys and traded surplus ivory for a few essential items their island did not possess: mainly reindeer skins (from Siberian tribes) or caribou hides (from Alaska) to be made into winter clothing.

Walrus stomachs were cleaned, inflated, and dried (while I lived on Diomede they hung on lines together with the washing) and were made into the heads of the large drums they used in ancient rituals and dances.

Five or six walrus hides were split, sewn together, and lashed as cover onto the umiak's driftwood frame with walrus thong, which the anthropologist Froelich Rainey has called "the strongest line before the invention of the steel cable." (Vikings brought walrus thong to medieval Europe. It was used for mooring hawsers and to haul aloft the giant stones to build Cologne's cathedral.) With their brilliantly designed walrus skin umiaks, wrote Edward W. Nelson, a Smithsonian Institution scientist, in the 1870s "these people sail fearlessly along their stormy coasts."

They still did this a century later when I lived with them. In June walruses (about 200,000 in 1975) migrate north through Bering Strait to the food-rich Chukchi Sea, and June, said the Diomeders, "is the month when people do not sleep."

The men set out in their superbly seaworthy umiaks into the nearly always stormy and fog-shrouded sea, heading into the dangerous maelstrom of drifting, shifting, grinding ice floes with great daring and a hunting experience that stretched back through more than 100 generations.

Only once did we run for home. It was an oddly calm day. We were two hours away from our village, travelling toward the ice and the walruses, when the umialik, our boat captain, Tom Menadelook, suddenly headed back. "Why?" I asked. Tom pointed at a few small elliptic clouds far to the west above Siberia. "Big storm coming," he said. Half an hour after we reached home, the Bering Strait region was hit by a typhoon-force gale.

Normally, the hunters spent days and nights among the moving ice searching for the walrus herds travelling north upon the ice floes and shot, harpooned, and killed the massive animals. Their boat laden with tons of meat, hides, and ivory, they returned. All the villagers helped to unload the boat. The men rested for an hour or two, drank tea, talked, and headed out into the ice again.

On shore the women of Ignaluk cut up the mounds of meat. The great, ancient driftwood racks were again covered with large slabs of drying meat. Some of the blubber was allowed to age until it was saffron yellow, then marinated in seal oil as a zesty condiment with the bland boiled walrus meat.

In early July, after a month of enormous effort and often danger, the great, most vital hunt of the year ended. The walrus migration had passed through Bering Strait, the umiaks returned to their island.

The ancient meat holes were once again crammed with food. The yearly cycle was complete and the ancient hunting pattern had been repeated: to take from each season what each season offered, and to harvest carefully and cunningly the animal wealth of their sea and their land.

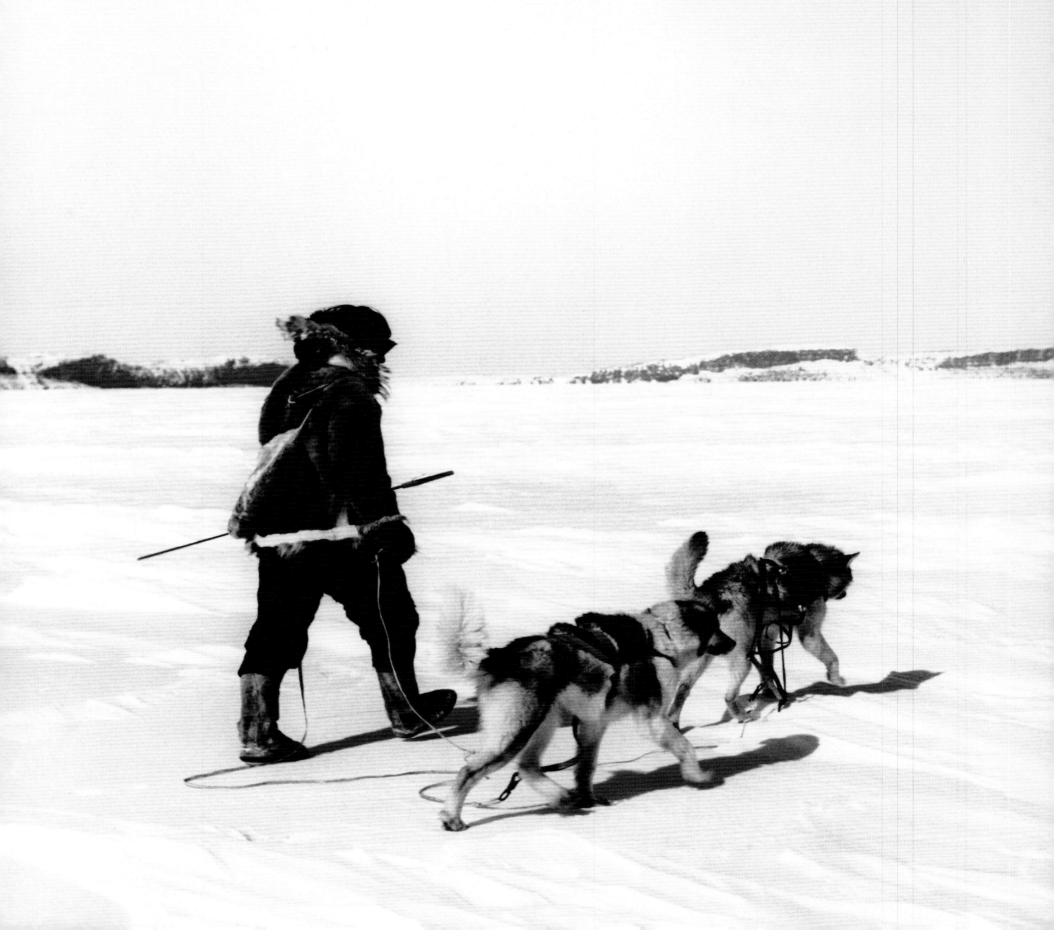

To most Inuit, in the past, seals meant life as they were the basis of their survival in the Arctic. In winter, seals were hunted at *agloos*, breathing holes scraped through the ice. Trained huskies help a hunter to find an *agloo* hidden beneath the snow.

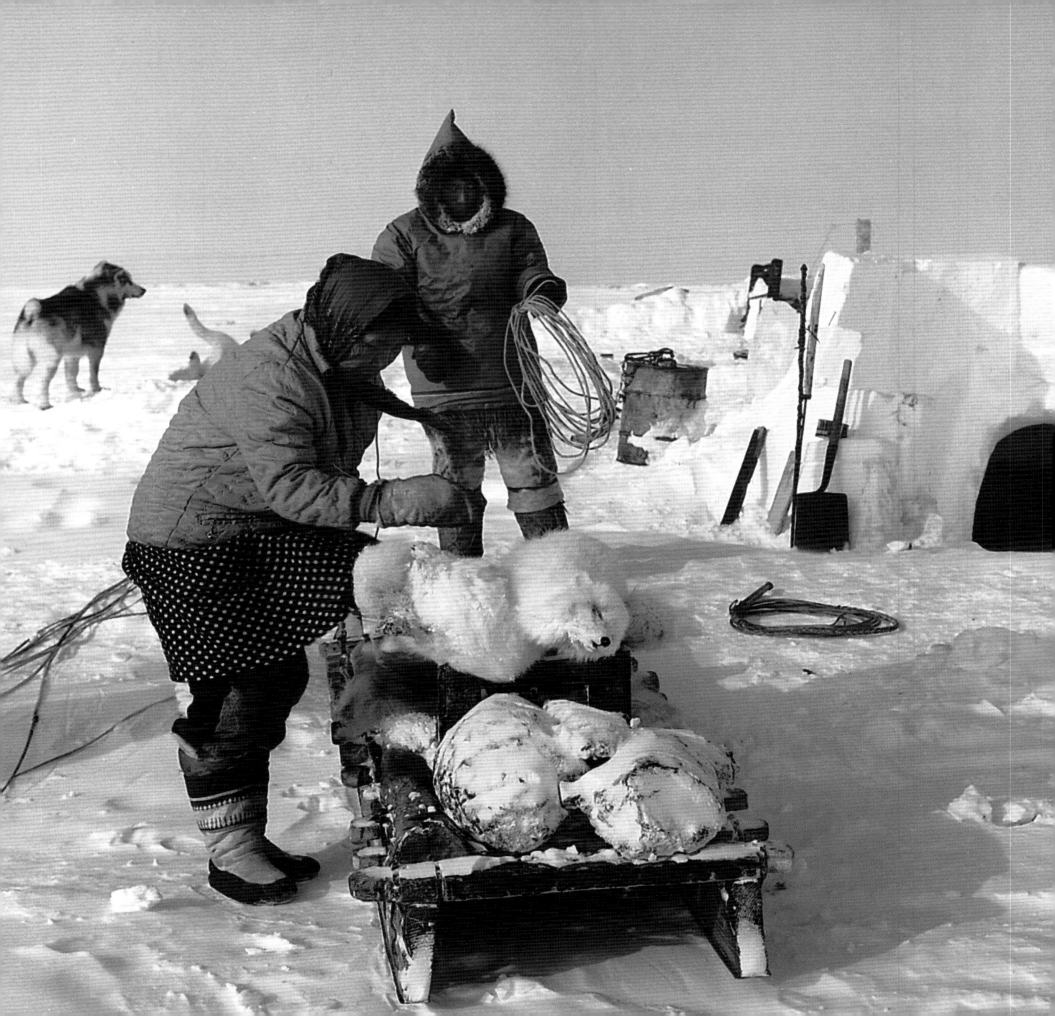

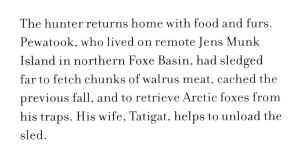

The hunter returns home with food and furs. Pewatook, who lived on remote Jens Munk Island in northern Foxe Basin, had sledged far to fetch chunks of walrus meat, cached the previous fall, and to retrieve Arctic foxes from his traps. His wife, Tatigat, helps to unload the sled.

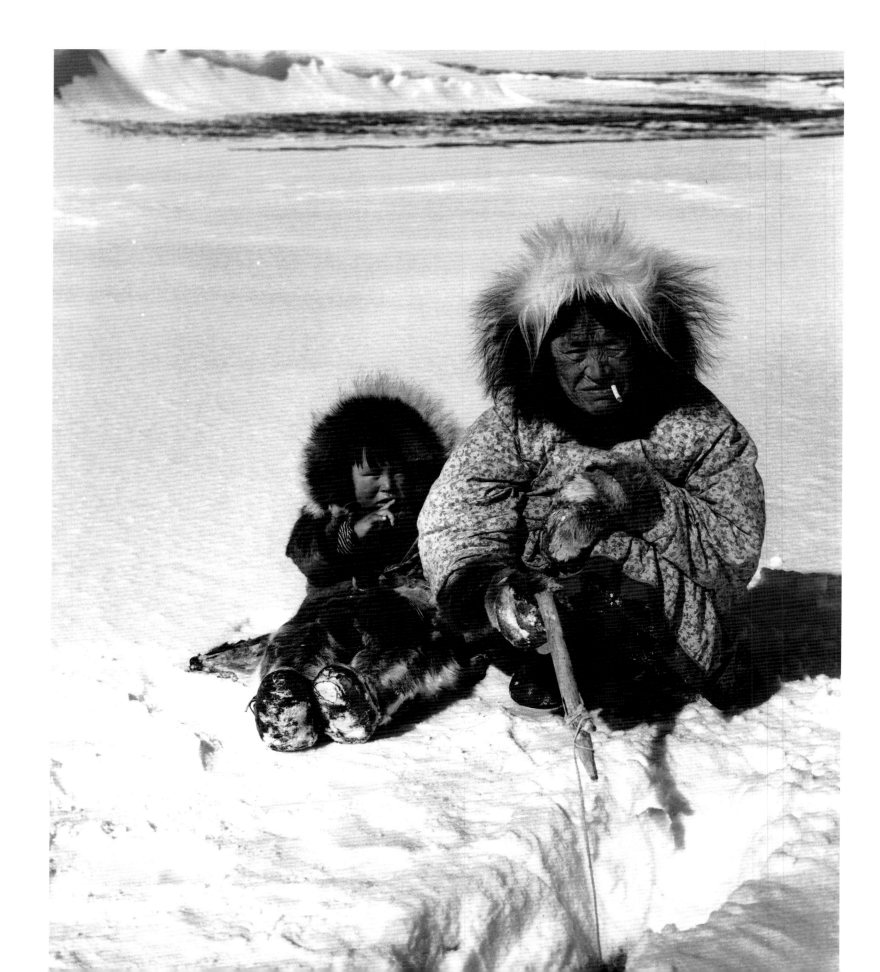

Left: Springtime was lean time at our Bathurst Inlet camp. The seal hunt had ended. The caribou herds had not yet arrived. Small fish and ground squirrels were our main food. Rosie Kongyona jigs patiently for polar cod. Her fur-wrapped grandson keeps her company.

Right: The seal is surfacing in its breathing hole beneath the snow. Moses Panegyuk, of Bathurst Inlet, after waiting motionless for many hours in -30° C weather, raises his harpoon to strike, kill, and haul out the seal, food for his family and his sled dogs.

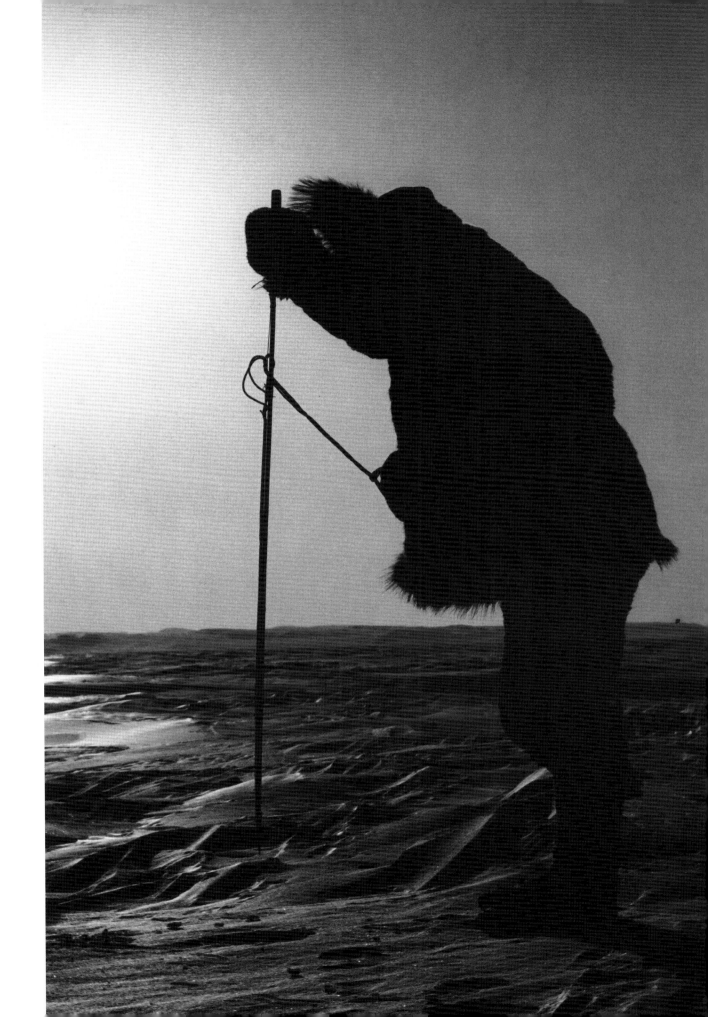

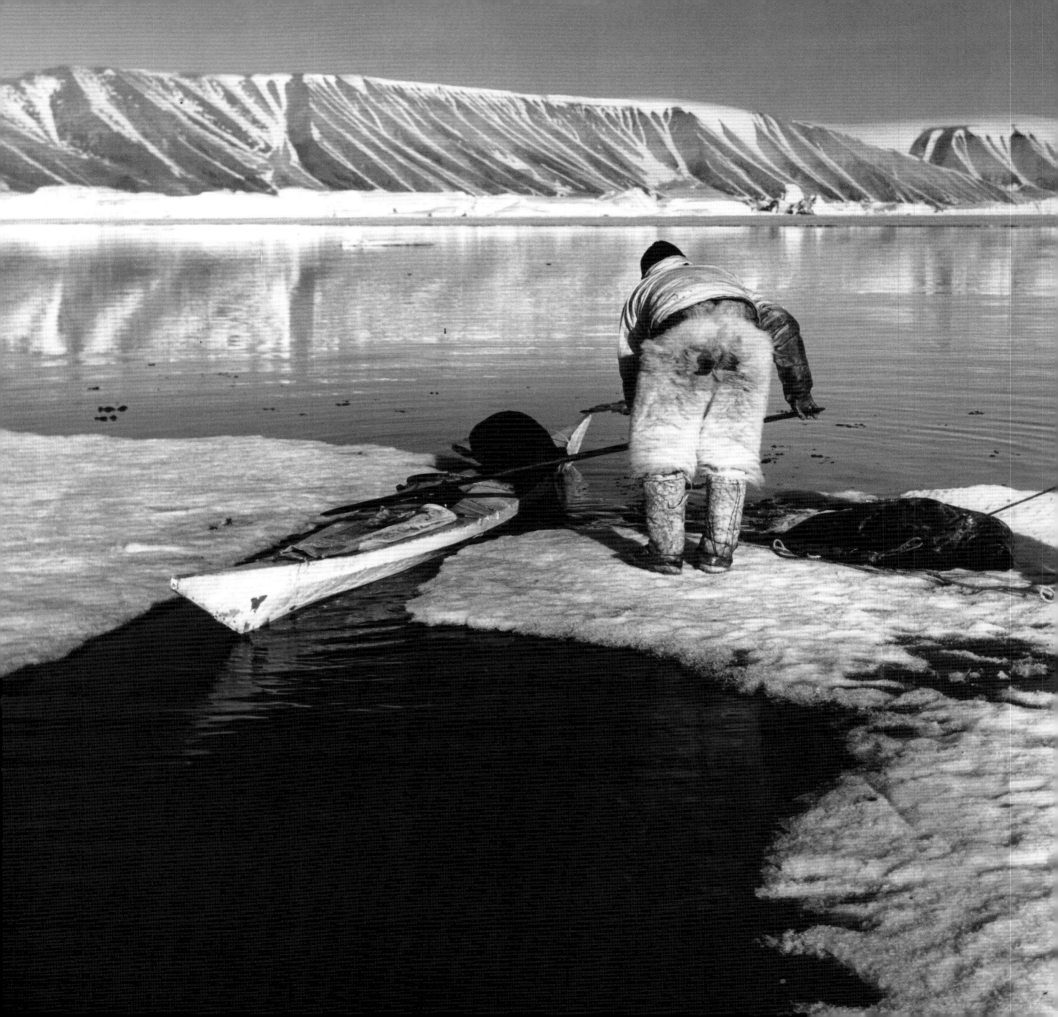

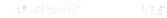

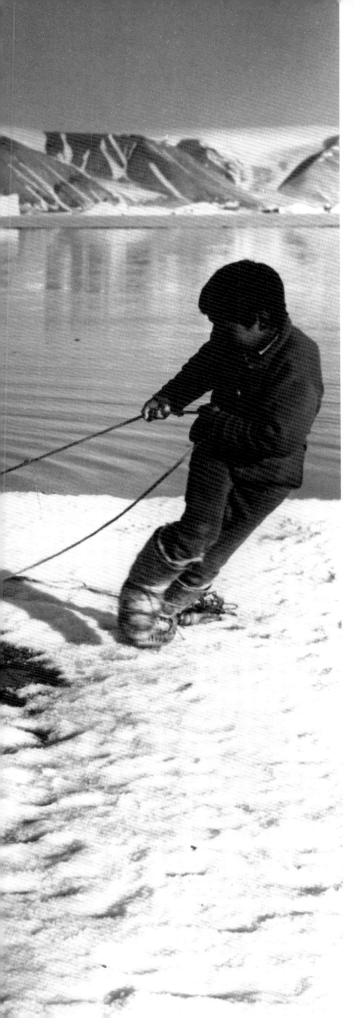

Helped by his son, a Polar Inuk of northwest Greenland unloads a seal from his kayak onto the melting ice of early summer. Such rotting ice is dangerous, yet the Inuit moved across it with skill and assurance.

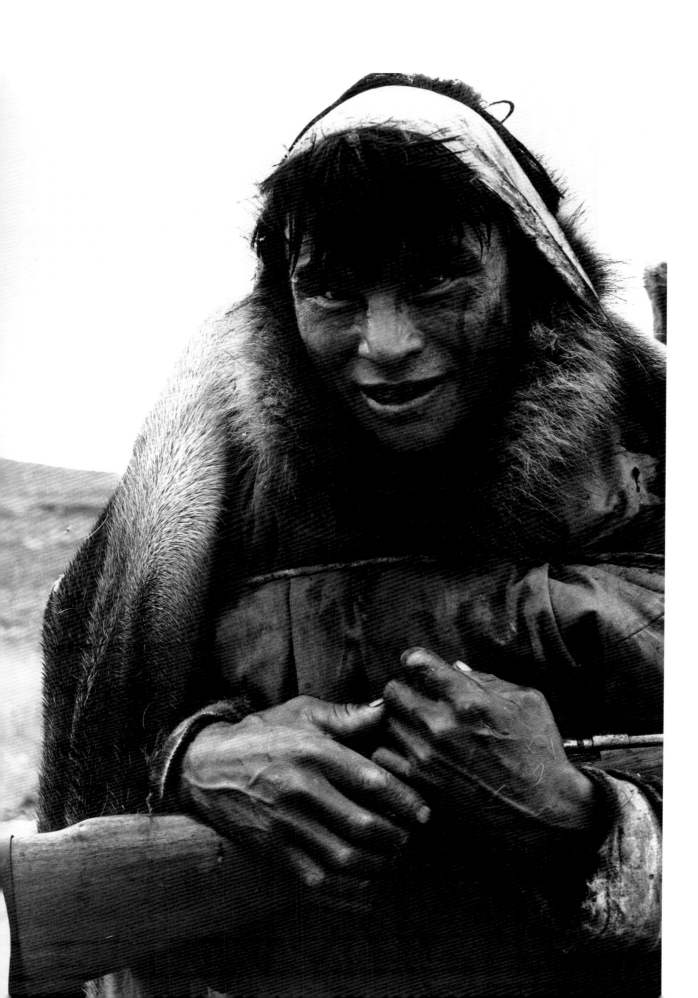

Left: His face streaked with blood and sweat, John Akana of Bathurst Inlet carries caribou meat back to camp, using the Inuit's traditional double tumpline across forehead and chest. Trained from childhood to carry heavy burdens, adult hunters walked great distances with loads of 45–68 kilograms.

Right: Our daily seal. On the 1967, 2,000-kilometre dog team trip to hunt polar bears, our 29 huskies, two Inuit hunters, their oldest sons, and I ate a 60-kilogram seal every day. After a long, patient stalk, Akeeagok has shot a seal and we pause to eat and drink many mugs of very hot tea.

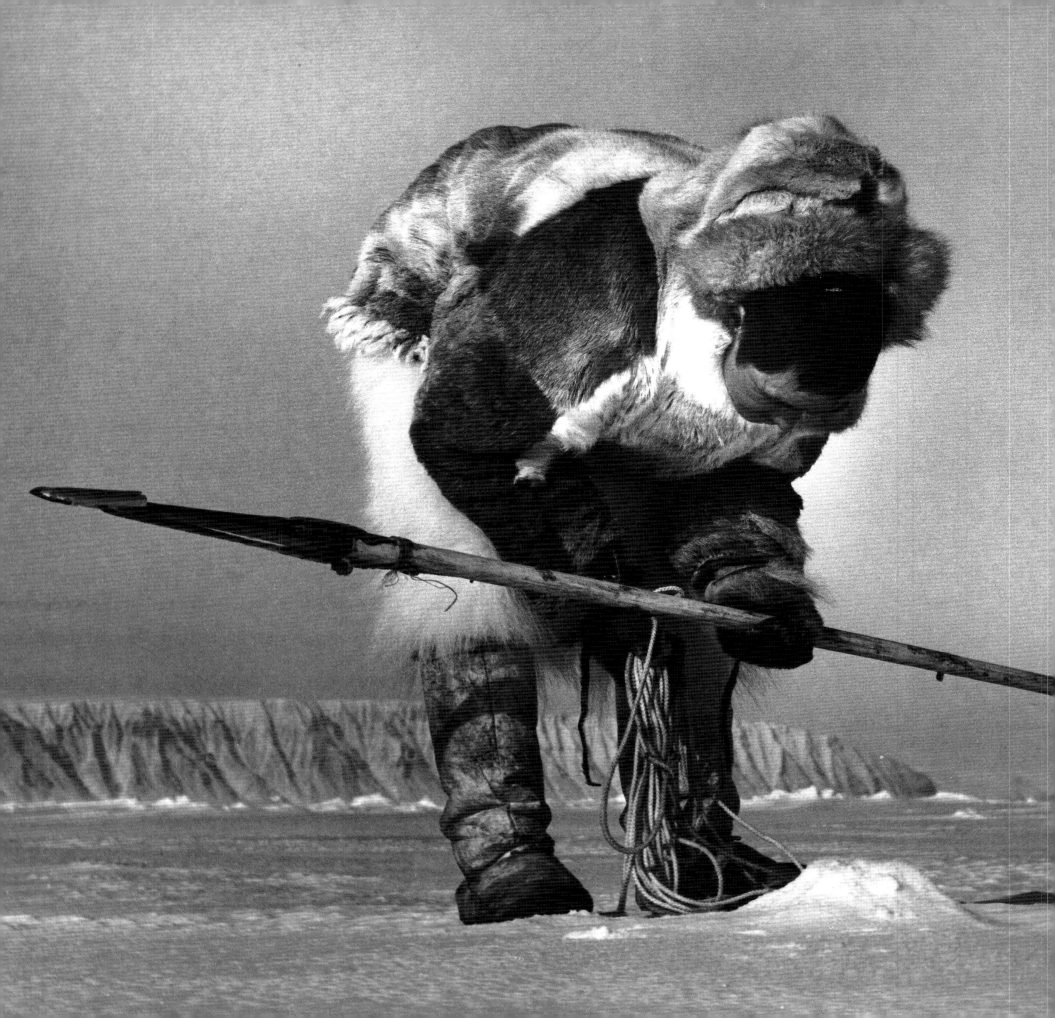

Infinite patience and total concentration are required to hunt seals at their breathing holes. The hunter stands statue-still, often for hours, sometimes for an entire day and even longer waiting for a seal to surface. This Polar Inuit hunter waited like this for 15 hours—and did not get a seal that day!

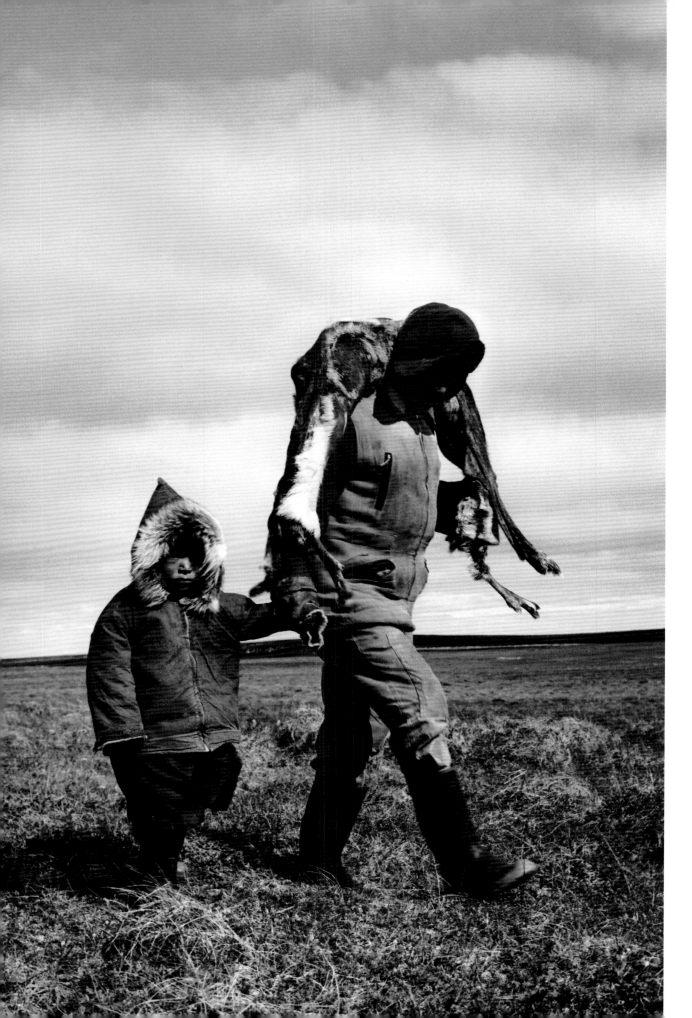

Left: In 1966, the year I lived at his camp, Samson Koeenagnak and his family were the last inhabitants of the central Barren Grounds, a region nearly as large as France. Lack of caribou and fear of famine drove the other inland Inuit into nascent settlements. Koeenagnak remained on the land, fished and hunted caribou, often accompanied by his son Kingnuktuk.

Right: Three-year old Karetak watches in fascination as his father, George Hakungak of Bathurst Inlet, skins a wolf. George had watched the wolf from a hill, surmised its route, hid, and shot the approaching animal. After wolverine, wolf fur was the most prized fur to make warm and beautiful parka ruffs, such as the one worn by his wife Jessie.

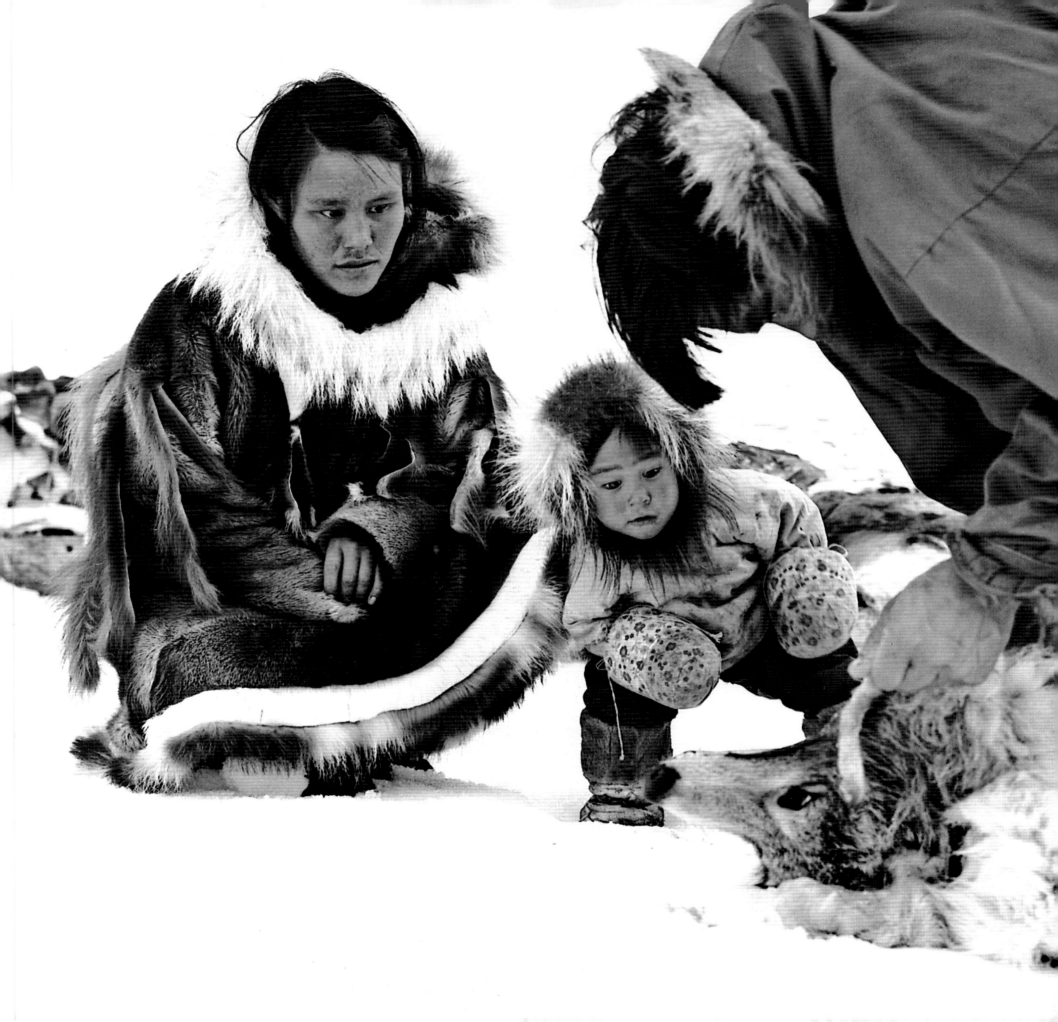

The killed polar bear is hauled in triumph
back to camp, food for the hunters, a feast for
their sled dogs. Allowed to gorge, each one of
our 29 sled dogs gulped down 5-7 kilograms
of bear meat and fat. Because polar bears
sometimes carry parasitic trichinae, which
cause the extremely painful and often fatal
trichinosis, we thoroughly boiled the bear
meat we ate.

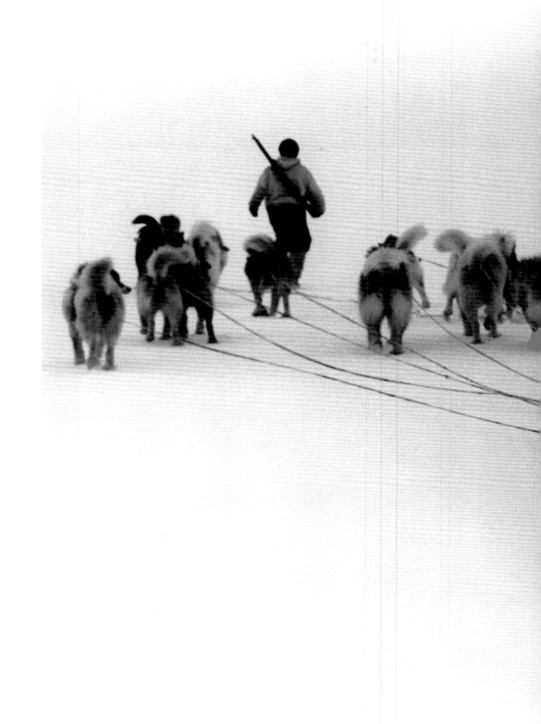

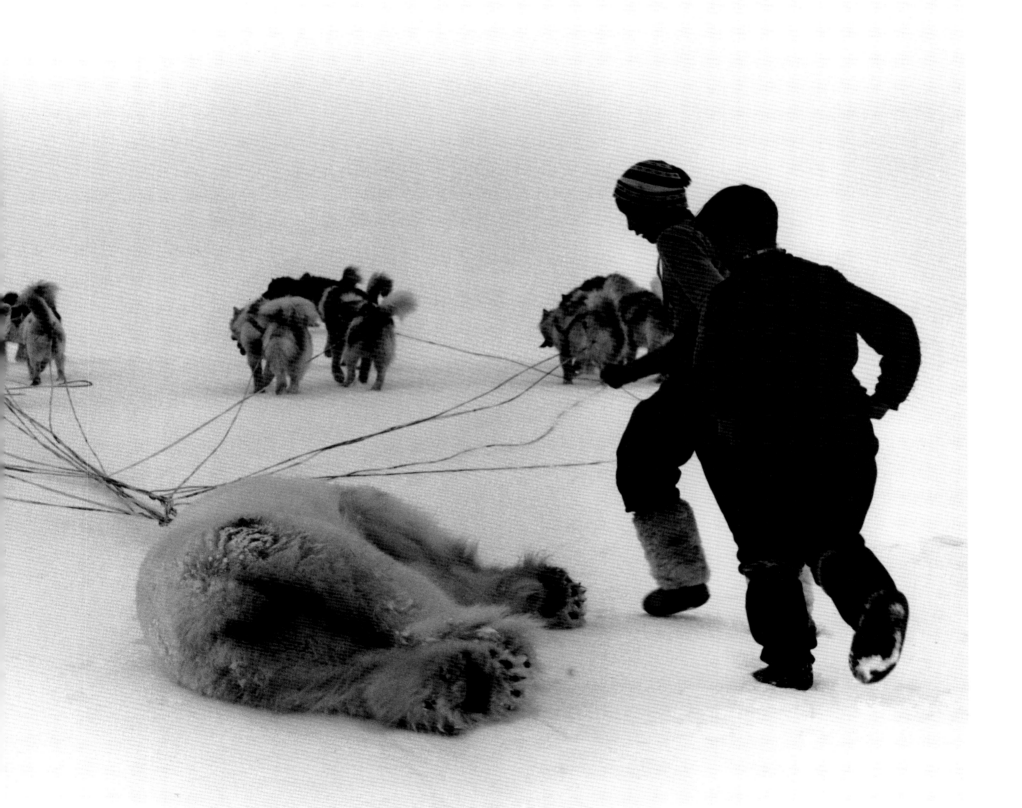

Tea break! Living nearly entirely on meat and fat, raw or cooked, travelling daily 12 hours or more in the dry, cold Arctic air, we had to drink litres of liquid every day. This was 1967, the last traditional polar bear hunt made by Canadian Inuit, a two-month, 2,000-kilometre trip by dog team. Akeeagok took the picture of his brother Akpaleeapik, right, their sons, and me and the tea.

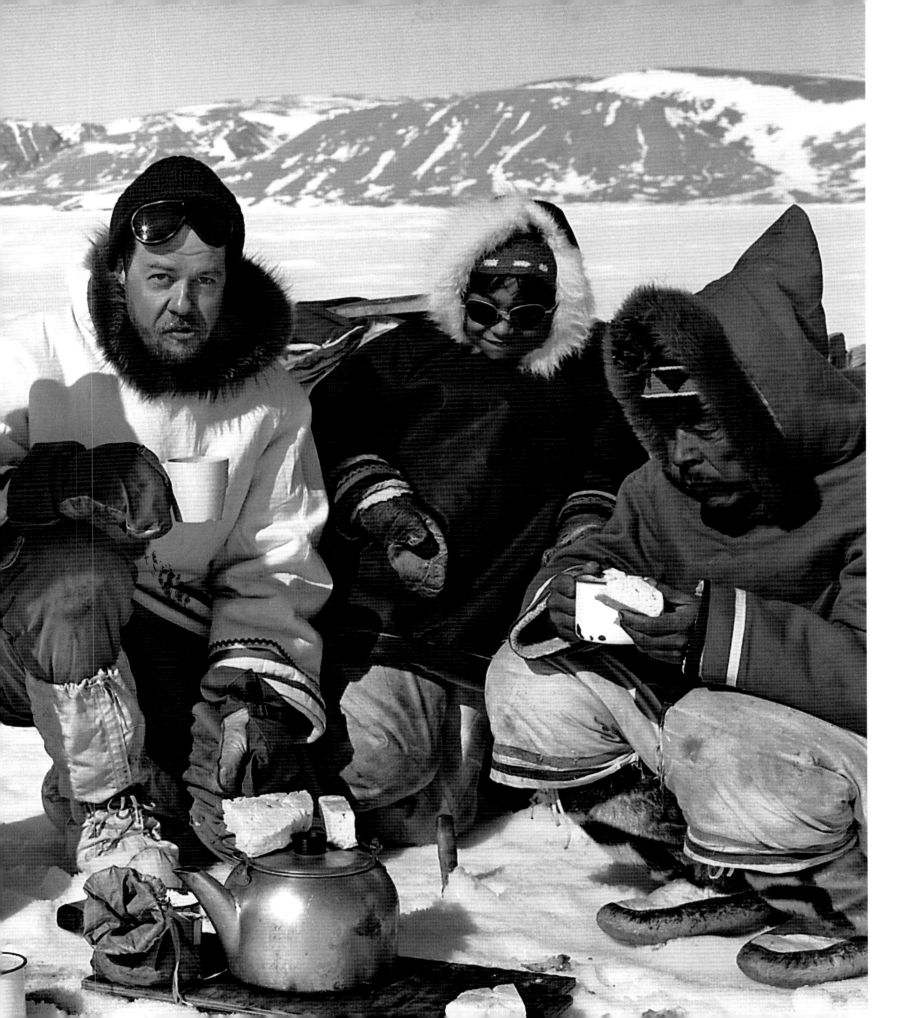

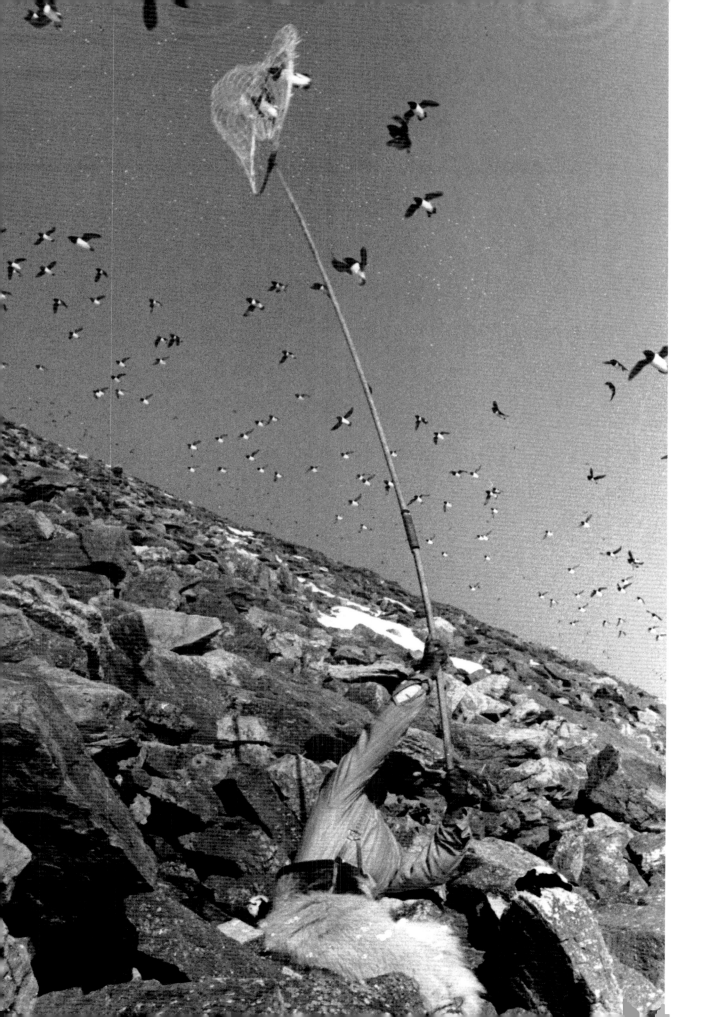

Using an *ipu*, a long-handled net, a Polar Inuk of far north Greenland, scoops dovekies out of the air. A skilful hunter, man or woman, can catch about 300 of the fat little seabirds a day. Some are eaten immediately. Others are preserved in blubber-lined sealskin bags and in time turn into the great delicacy known as *kiviaq*, fermented dovekies, which taste like very ripe cheese.

Her large sealskin bag full of dovekies, Naduq, elderly and a grandmother, but still an outstanding hunter, climbs cautiously down a steep scree slope. Dovekies, small fat seabirds, are an important Polar Inuit food. In the past, patient women cleaned the skins and sewed them together into *artiggis*, warm inner parkas. It took 60-80 dovekie skins to make such a parka.

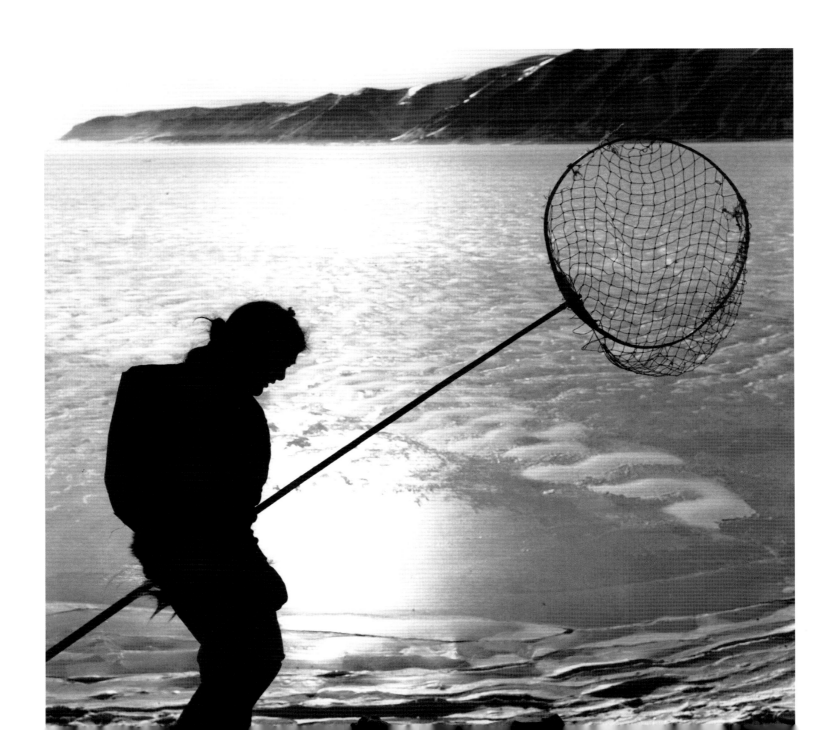

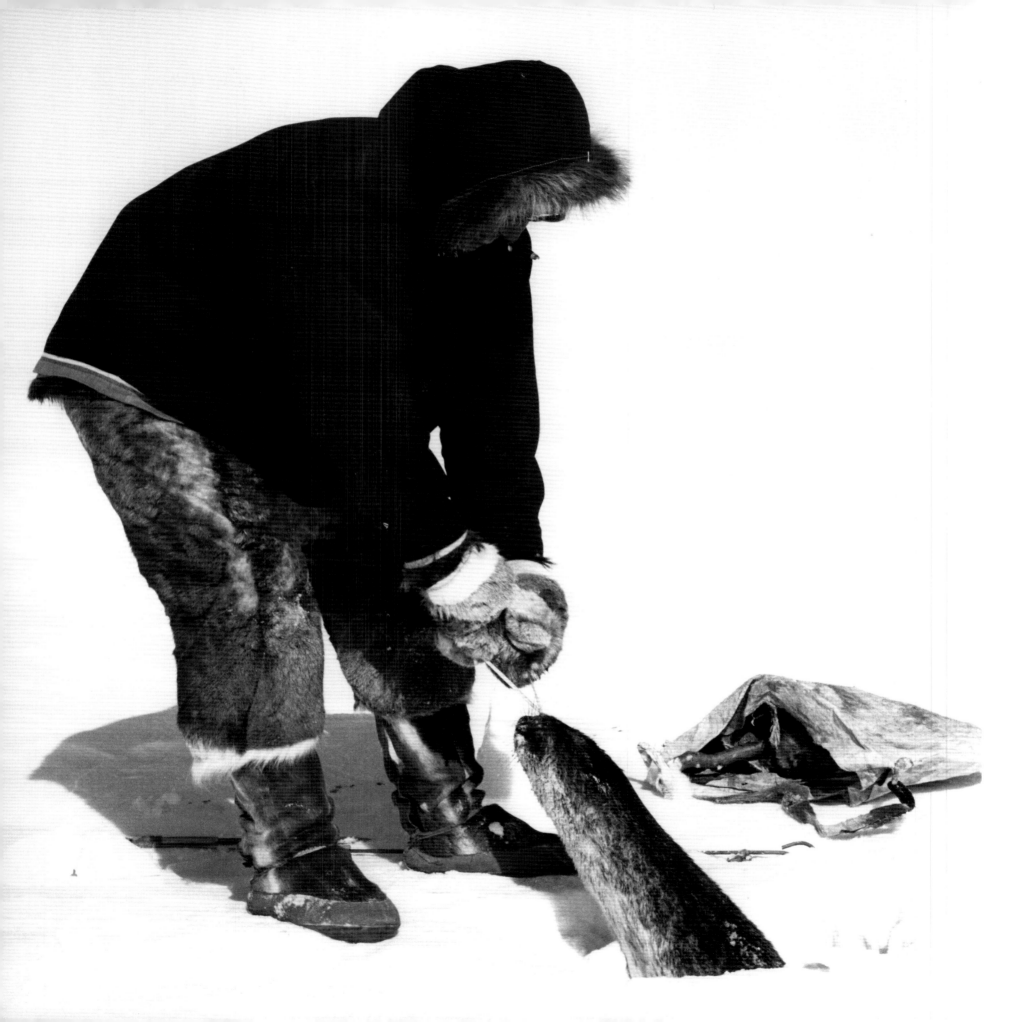

Left: After waiting motionless at an *agloo*, a seal's breathing hole, for seven hours, Ekalun of Bathurst Inlet harpooned the surfacing seal, killed it instantly, and now hauls the 64-kilogram carcass out of the constricted hole, vital food for his family and his sled dogs.

Below: Late spring and early summer are the seasons of the Polar Inuit's *utoq* hunt. Moulting seals bask upon the ice. Hidden behind a white screen mounted on a small sled, Jes Qujaukitsoq stalks a seal with infinite patience and caution, crawling across the water-soaked sea ice.

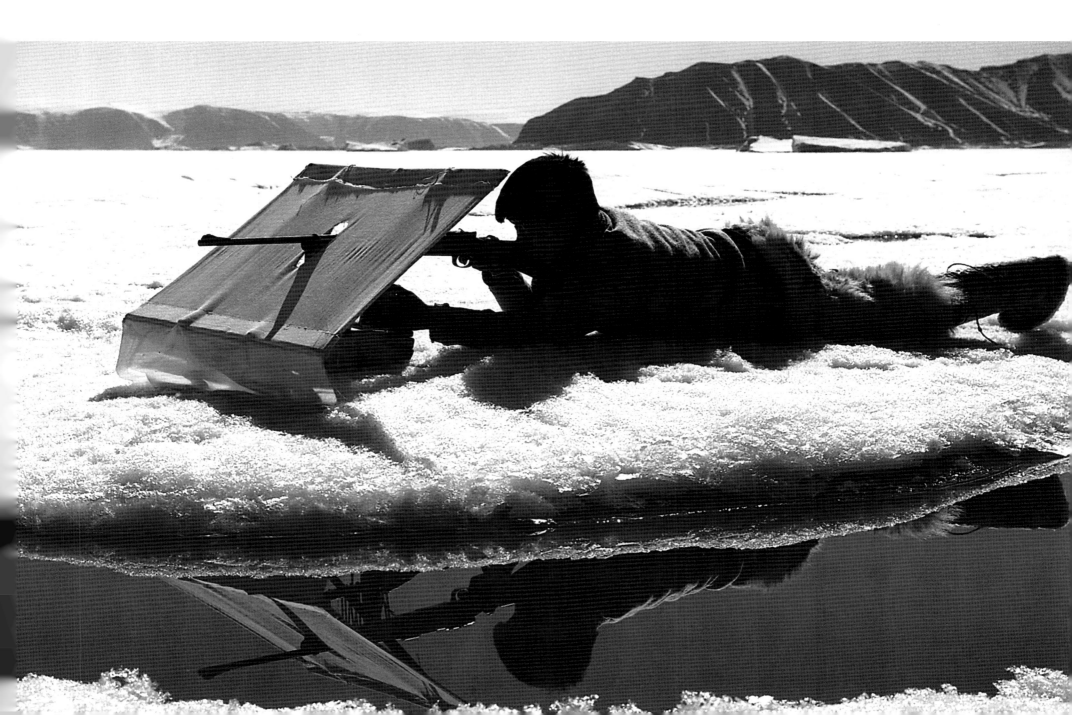

Every morning, fair weather or foul (mostly foul!) Pewatook drove from his camp on Jens Munk Island two hours by dog team to the floe edge, the limit of land-fast ice. There he waited, at temperatures of usually 30° C below zero, sometimes 40° C below zero, and a few times even colder, for 10-12 hours, hoping a seal would surface in shooting distance, for the seal meant survival for him and his family.

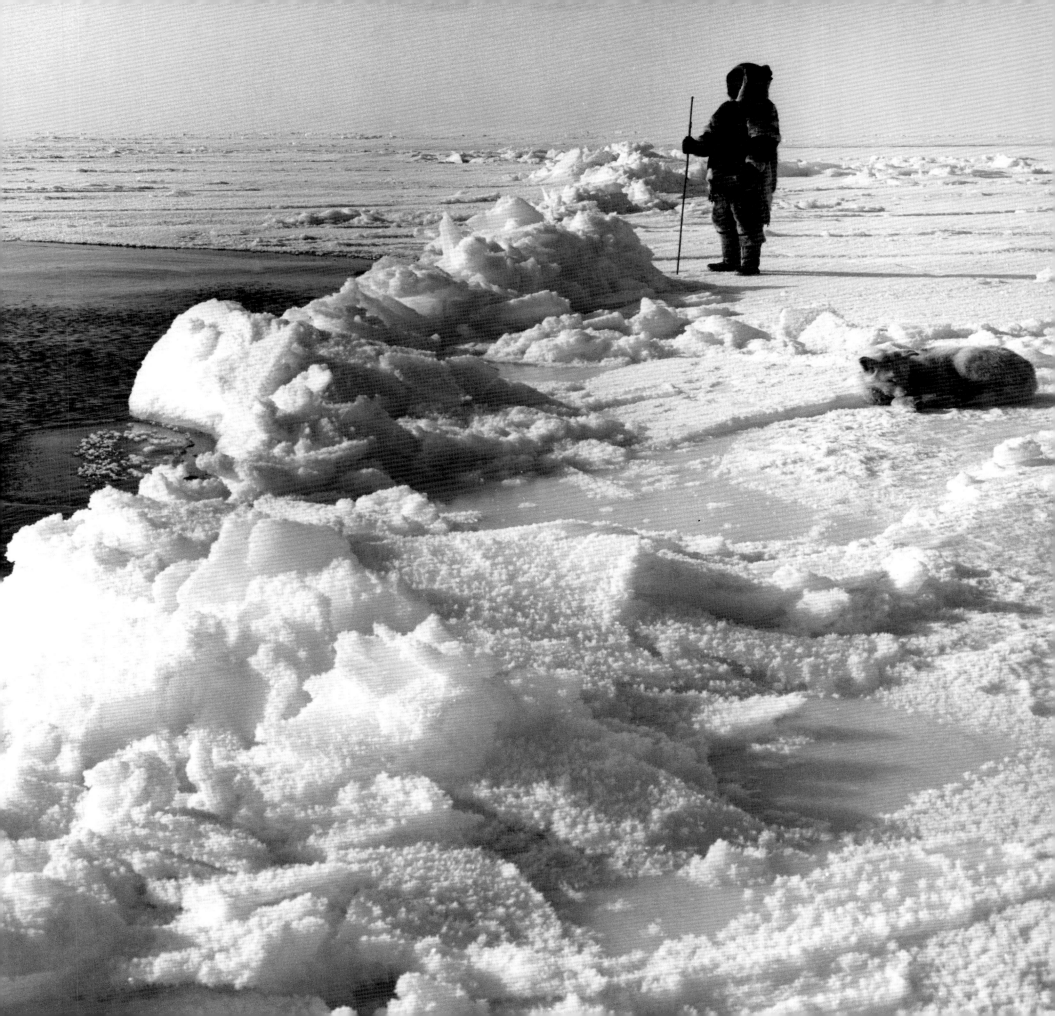

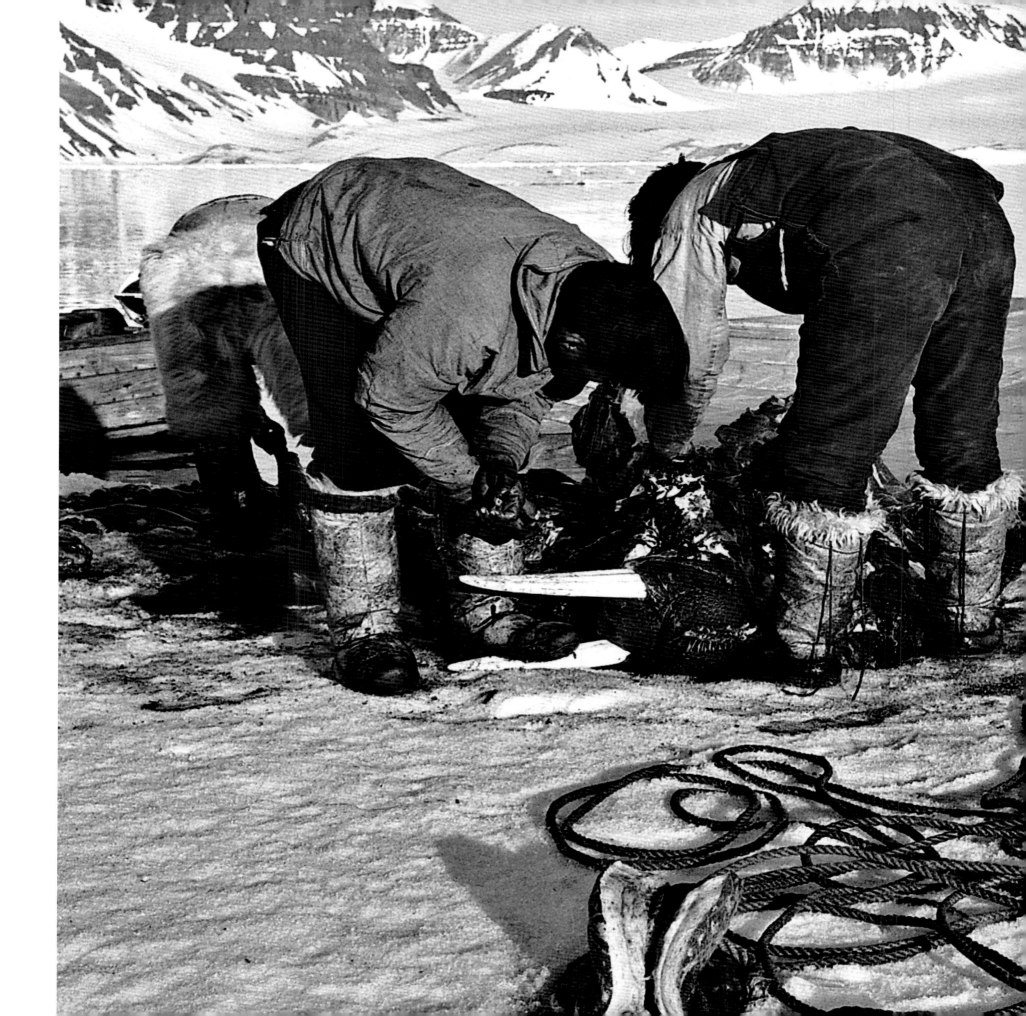

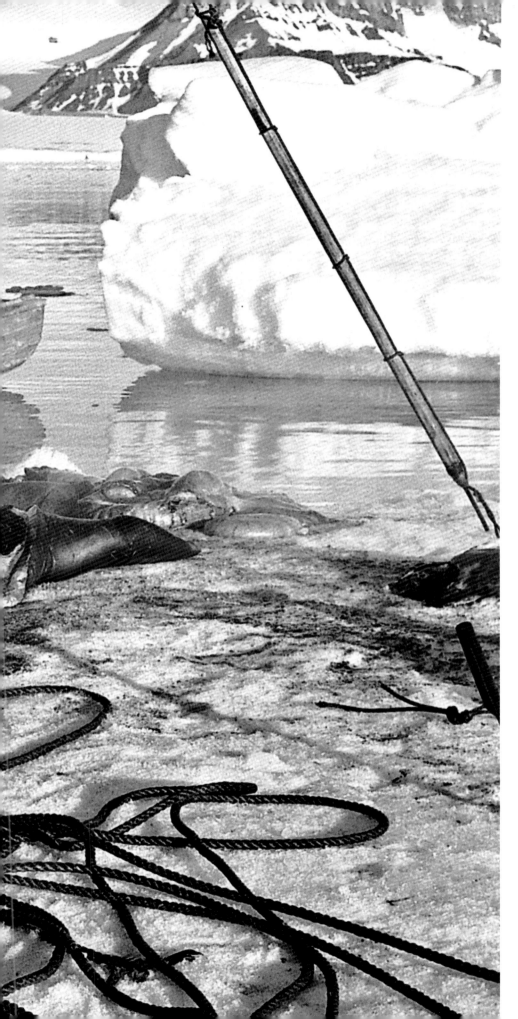

Left: How can two men heave a 1-tonne walrus out of the water and onto the ice? The Polar Inuit do it in an ancient and ingenious way. They chip out ice bollards, cut several parallel lines into the thick neck hide of the walrus, reeve a long thong or rope back and forth through bollards and skin loops and haul. It is a simple but very efficient block and tackle.

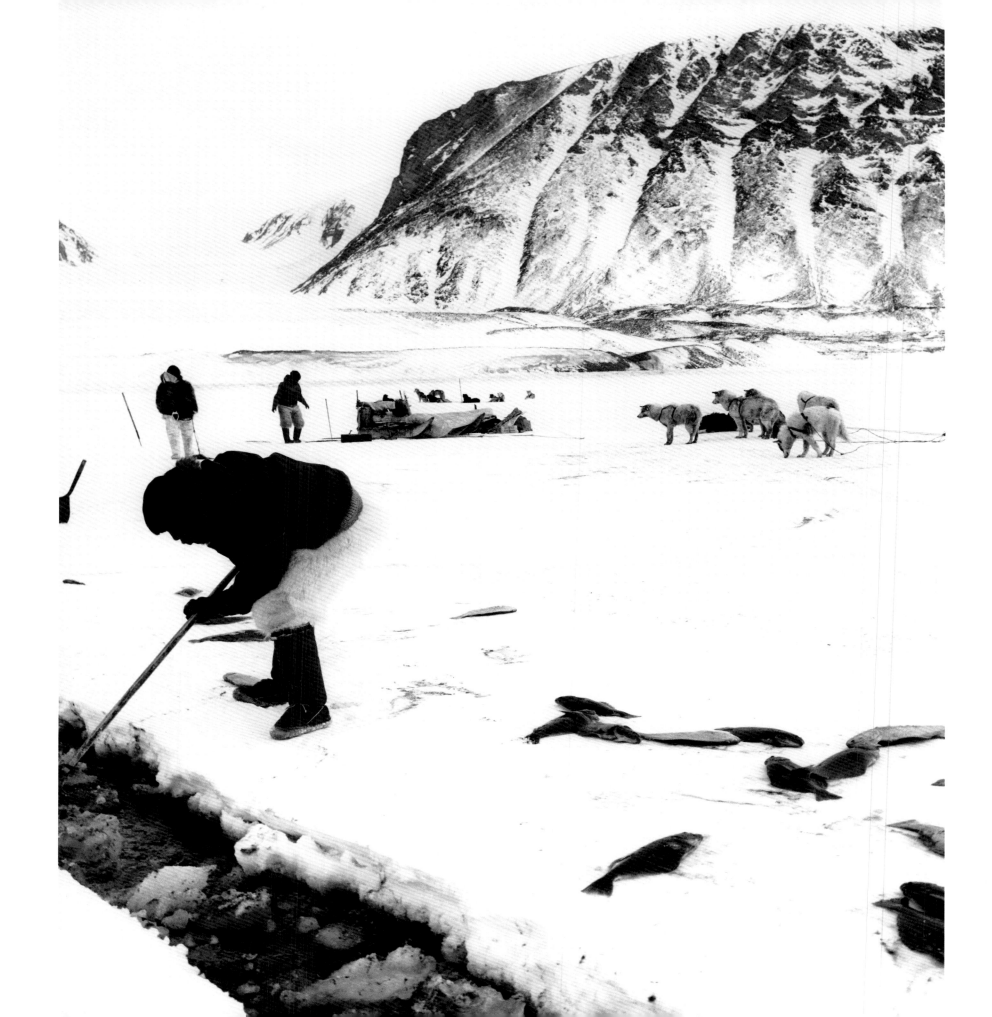

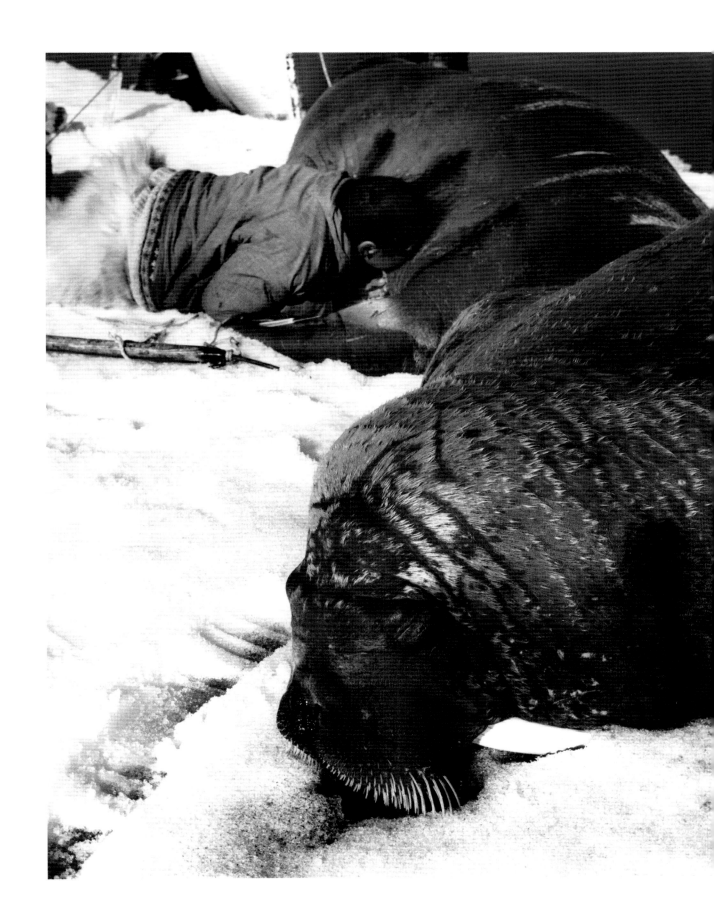

Left: Hundreds of Greenland halibut, clay-coloured, flounder-like fish that died of unknown causes, had floated up into a lead of open water. Polar Inuit, on their way to hunt at the floe edge, found the fish and gaffed them out of the water. We ate the reasonably fresh ones. The putrid ones were dog food. Hungry huskies are never fussy.

Right: Unless they are extremely fat, killed walruses sink. The Polar Inuit hunter Utoniarssuaq shot and harpooned several walruses and hauled them onto an ice floe. With a long, thin metal tube (formerly the hollow wing bone of a goose) he inflates the dead walruses so they will float when pulled by boat to a coastal cache.

Sled dogs and men haul the massive carcass of a shot walrus onto the ice. For the Polar Inuit of northwest Greenland, walruses, each one weighing more than a tonne, were a vital food for themselves and, above all, an essential food for their numerous sled dogs.

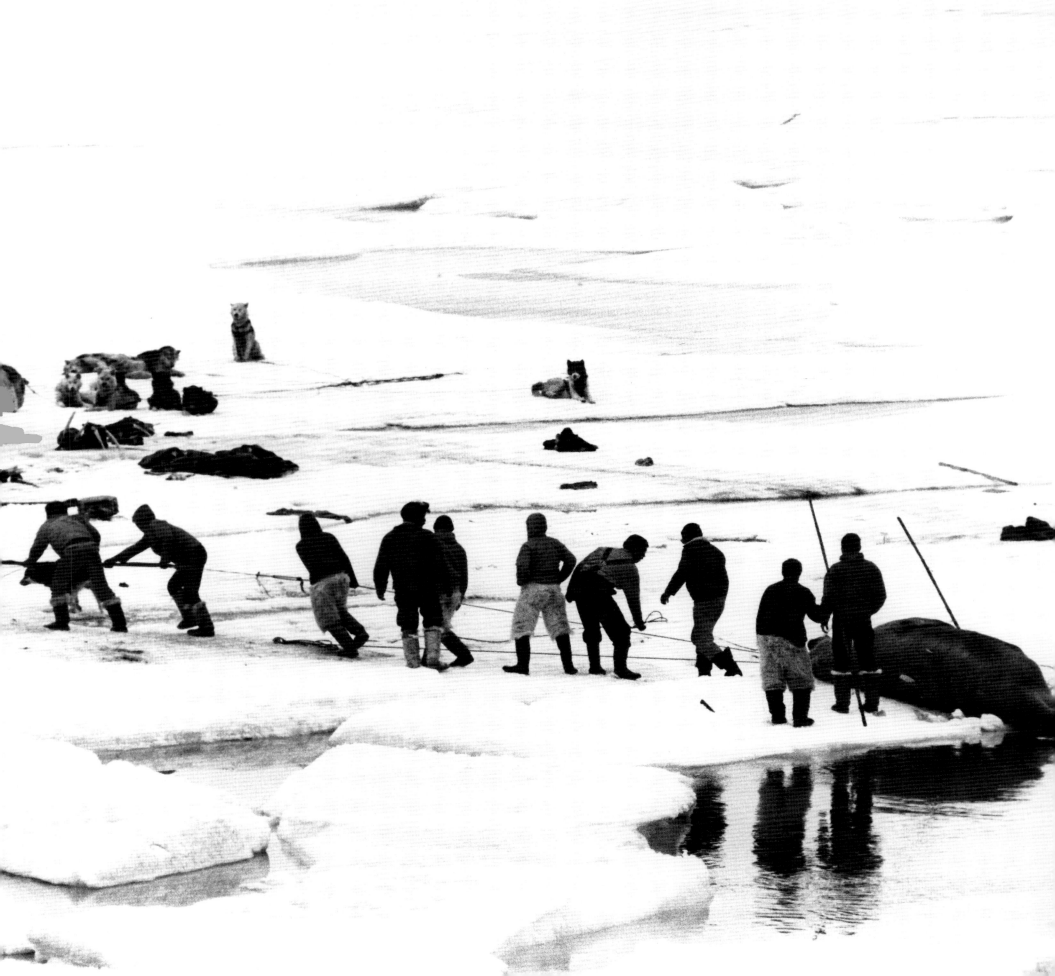

Their kayaks tied in tandem, Polar Inuit haul a
dead narwhal home. In early summer, narwhal
migrate into Inglefield Bay, northwestern
Greenland, where Inuit have hunted them
for thousands of years. The ivory tusk of the
male is valuable, the skin exceedingly rich in
vitamin C, the meat a vital food for the Inuit
and their sled dogs.

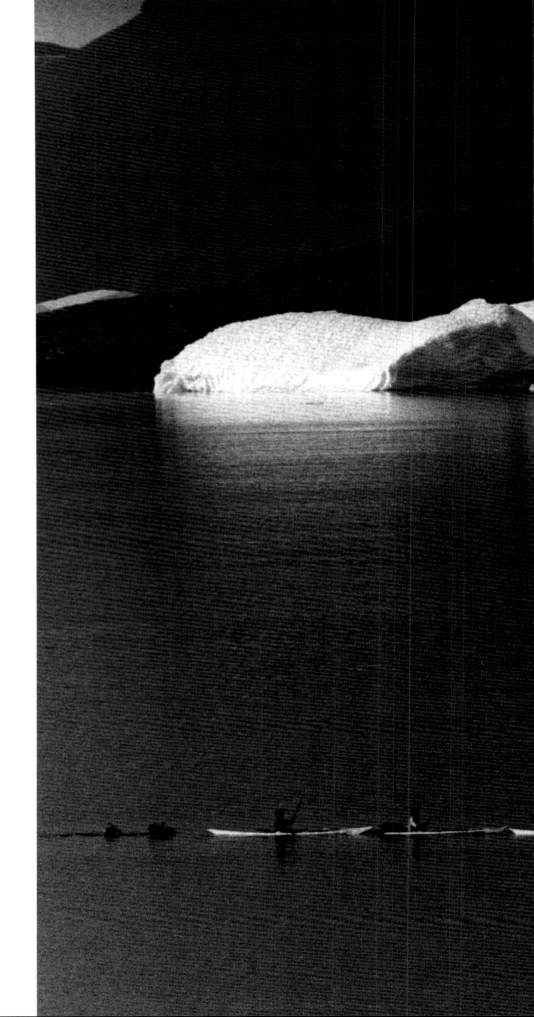

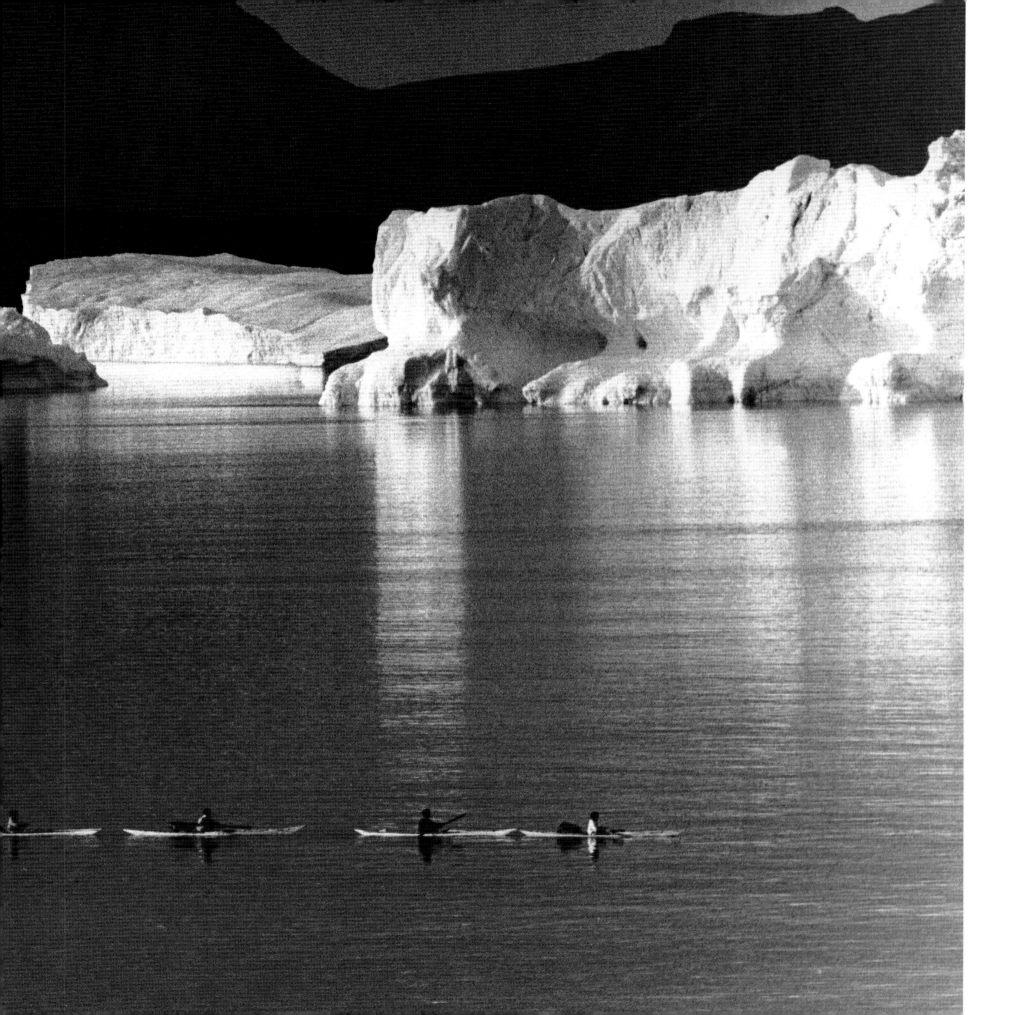

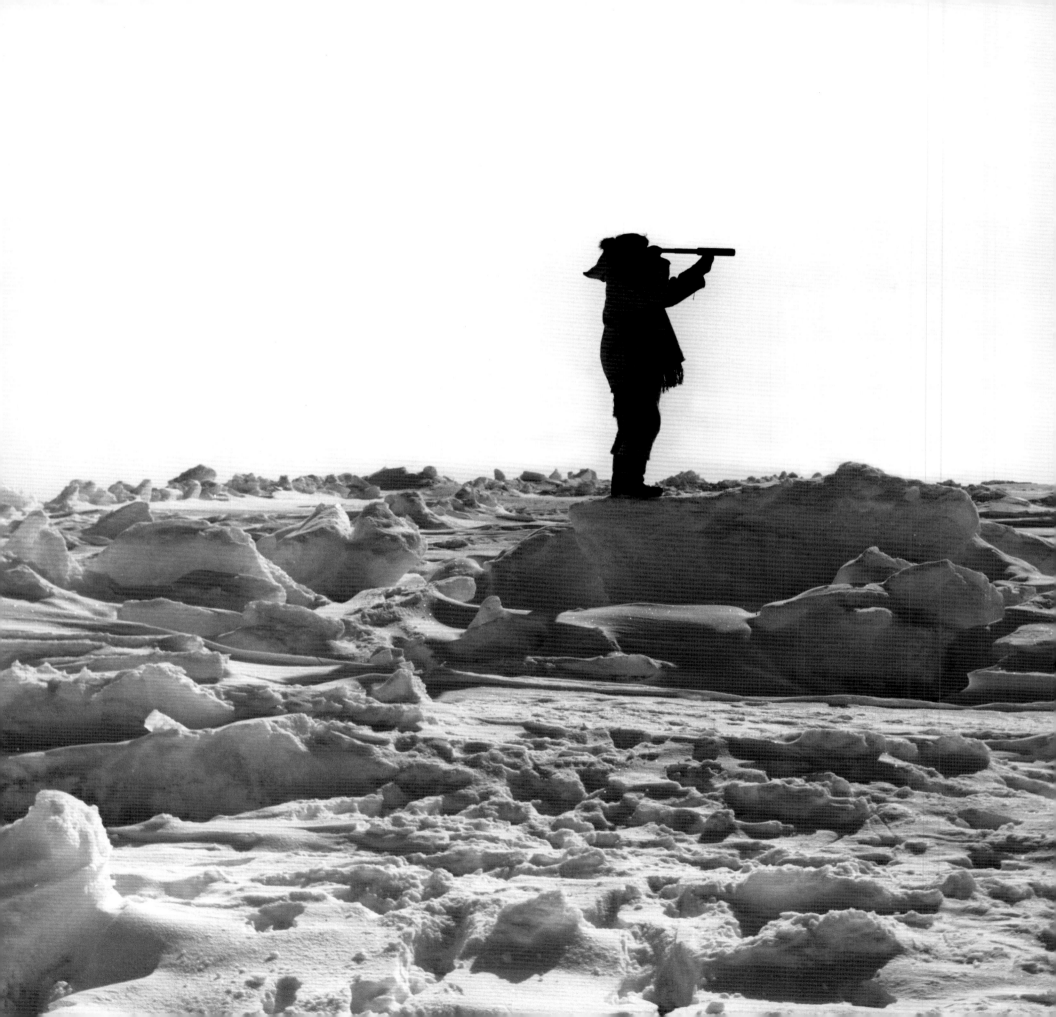

Pewatook of Jens Munk Island, northernmost Foxe Basin, looks for the best route to the floe edge, the limit of land-fast ice. That's where he hunted seal in late winter and in spring, but it was a long and difficult trip. Currents and wind piled the ice into high pressure ridges, great jumbles of ice blocks that barred our way.

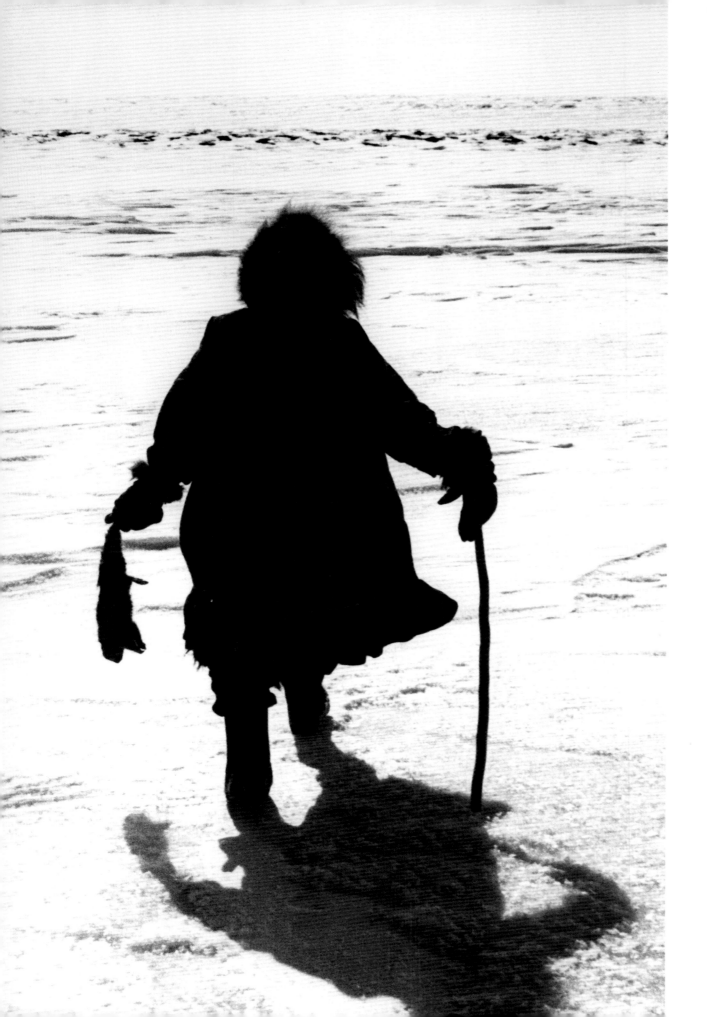

Left: An old woman carries supper home. At Bathurst Inlet, the seal hunt had ended, the migratory caribou had not yet arrived, the caches were empty, and we survived primarily by eating ground squirrels and small fish. Rosie Kongyona boiled the squirrels, small meals for many people, but delicious—the fat, yellowish and butter-soft, the meat, white and tender, tasted like chicken.

Right: For two months, while hunting polar bears in the High Arctic, the Inuit and I had eaten only seal and bear meat. When we crossed northwestern Devon Island, Akeeagok spotted a few light-coloured Peary caribou. Grunting convincingly like a caribou, he approached the animals. In this remote region they had perhaps never seen humans. He shot two caribou, carried them to our sleds, and later we feasted on caribou meat.

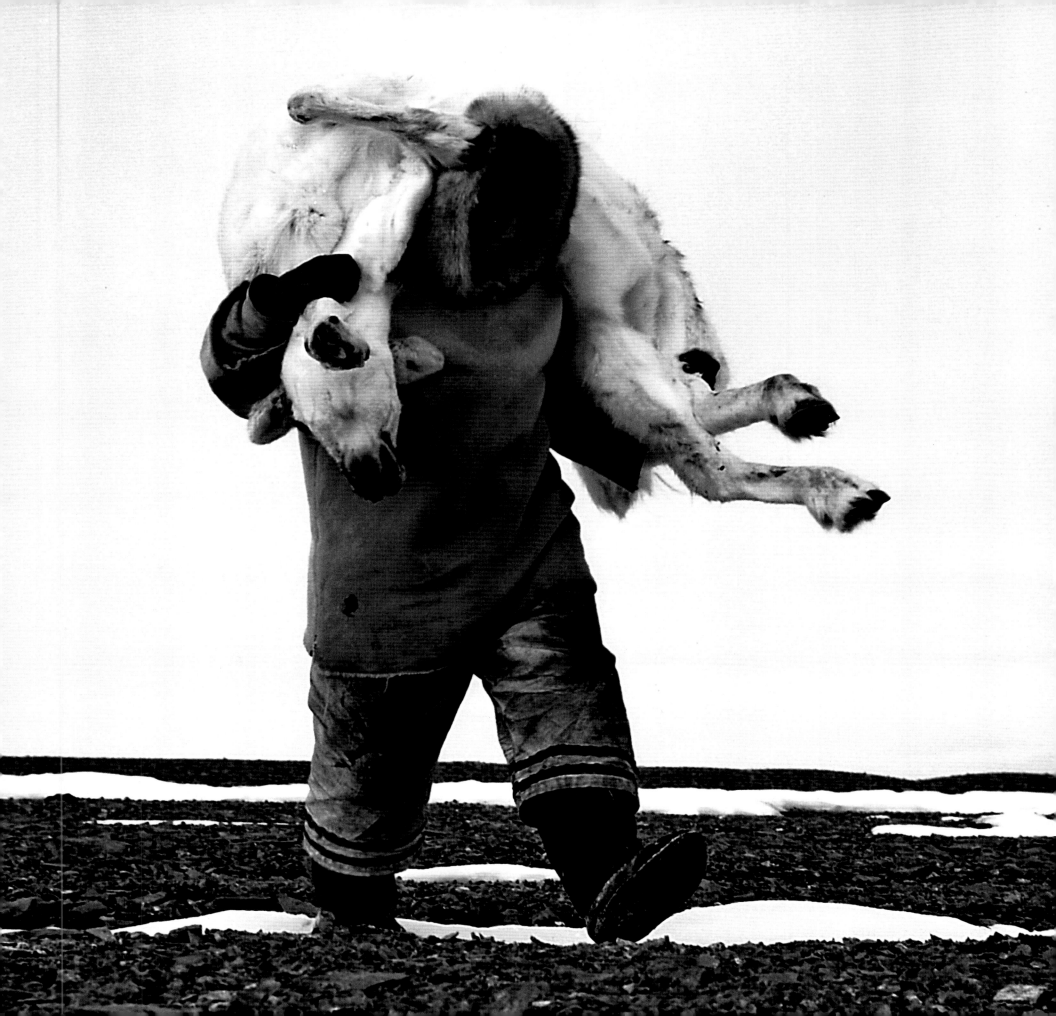

Left: From atop a wave-sculptured iceberg an Inuit hunter from Grise Fiord observes the sleep-wake rhythm of seals that bask upon the ice in spring when they are moulting. After a careful behaviour study, he picks the least wary, most sleepy seal in the vicinity and stalks it with great caution and a good chance of success.

Right: The Inuit of Little Diomede Island in Bering Strait between Alaska and Siberia love to eat crabs. They catch them with an ancient, simple, and ingenious method. A stone sinker, together with chunks of fish as bait, is lowered to the sea floor. A feeding crab, loathe to lose food, hangs on tightly to bait and stone as it is hauled to the surface.

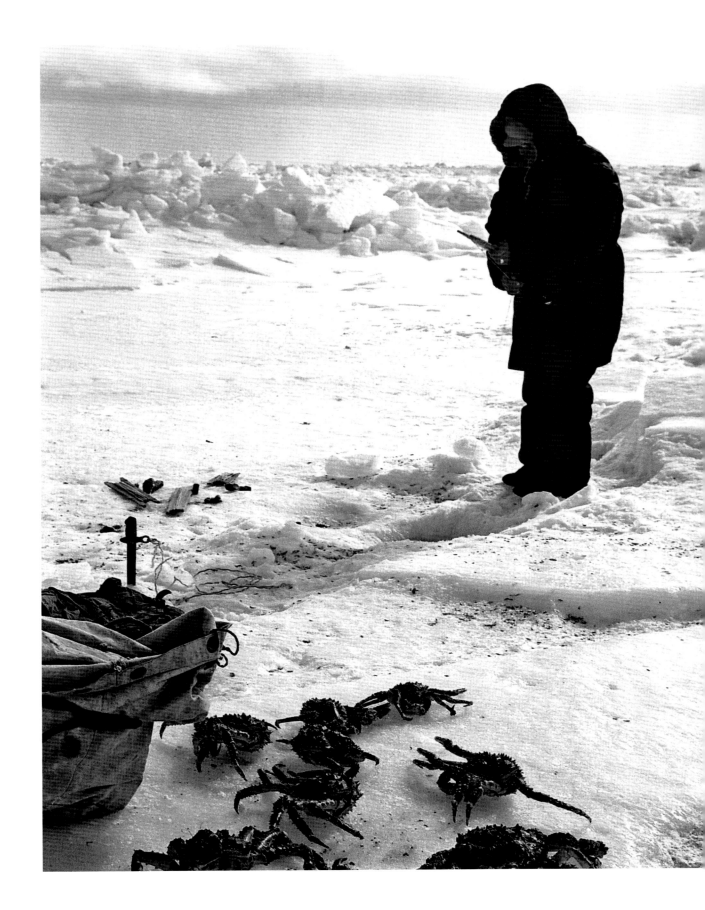

A fateful moment between life and death. The Polar Inuk Jes Qujaukitsoq had ventured out onto a large floe near the ice edge to harpoon a shot seal before it sank. The floe began to move, he raced back, and jumped onto firm ice. Seconds later, the floe drifted out into the Arctic sea.

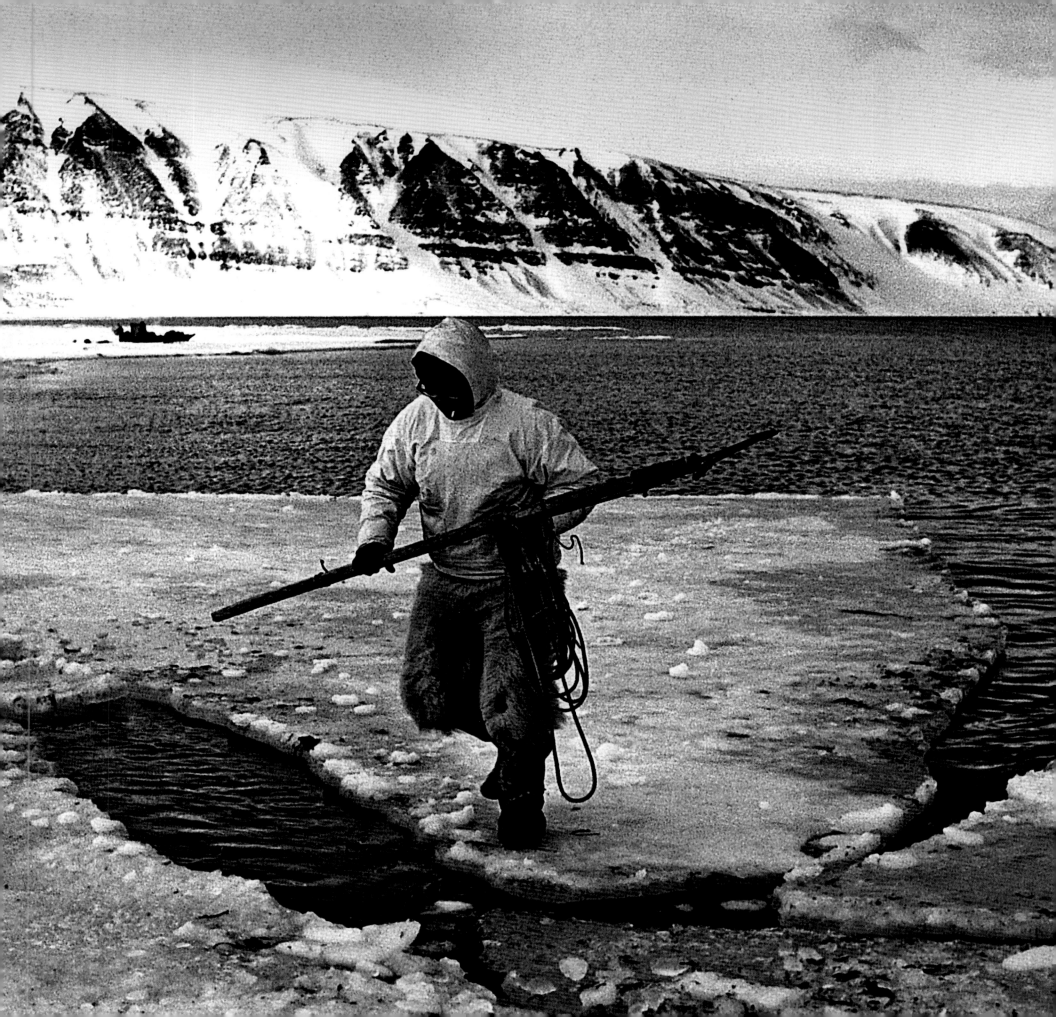

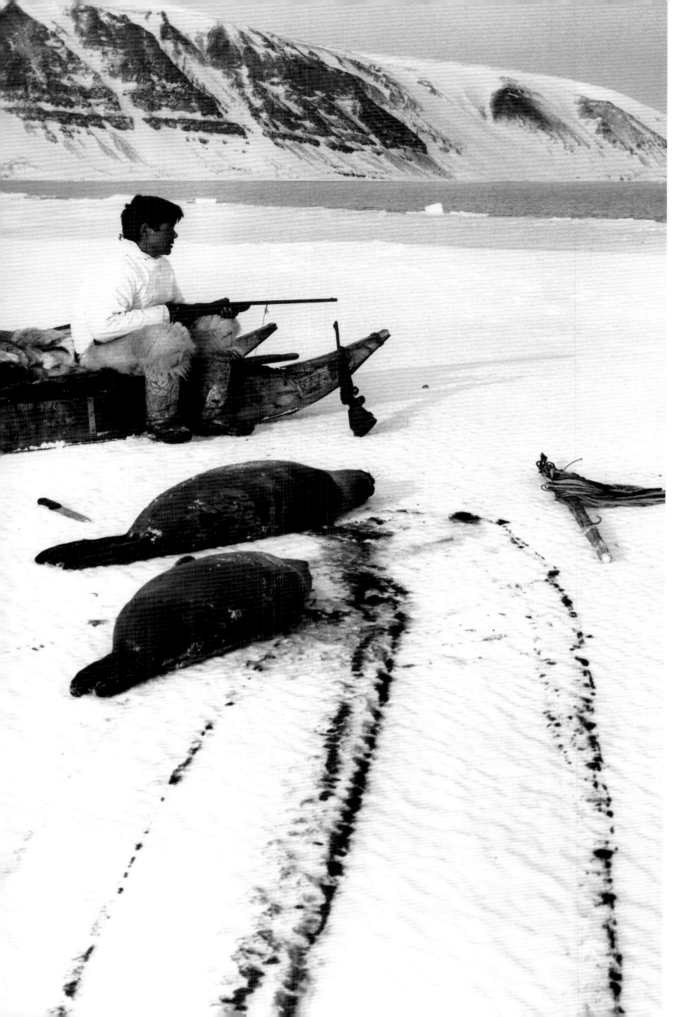

Left: Proud and hardy, Polar Inuit usually travelled to the floe edge, 100 kilometres from their village, without food or tent. To take either would have been an admission of weakness and inability to live by hunting. Jes Qujaukitsoq and I sledged a day and a night and spent three stormy days at -20° C without shelter or food. Finally Jes shot a seal, we slit it open, drank the warm blood, ate the raw liver with lots of blubber, and our bodies glowed with life and warmth.

Right: A patient Inuit kayak hunter in Inglefield Bay, northwestern Greenland, waits for seal and hopes for narwhal or white whale. On the kayak deck in front of him are his harpoons attached to the coiled harpoon line. Behind the hunter is the *avataq*, the inflated sealskin float.

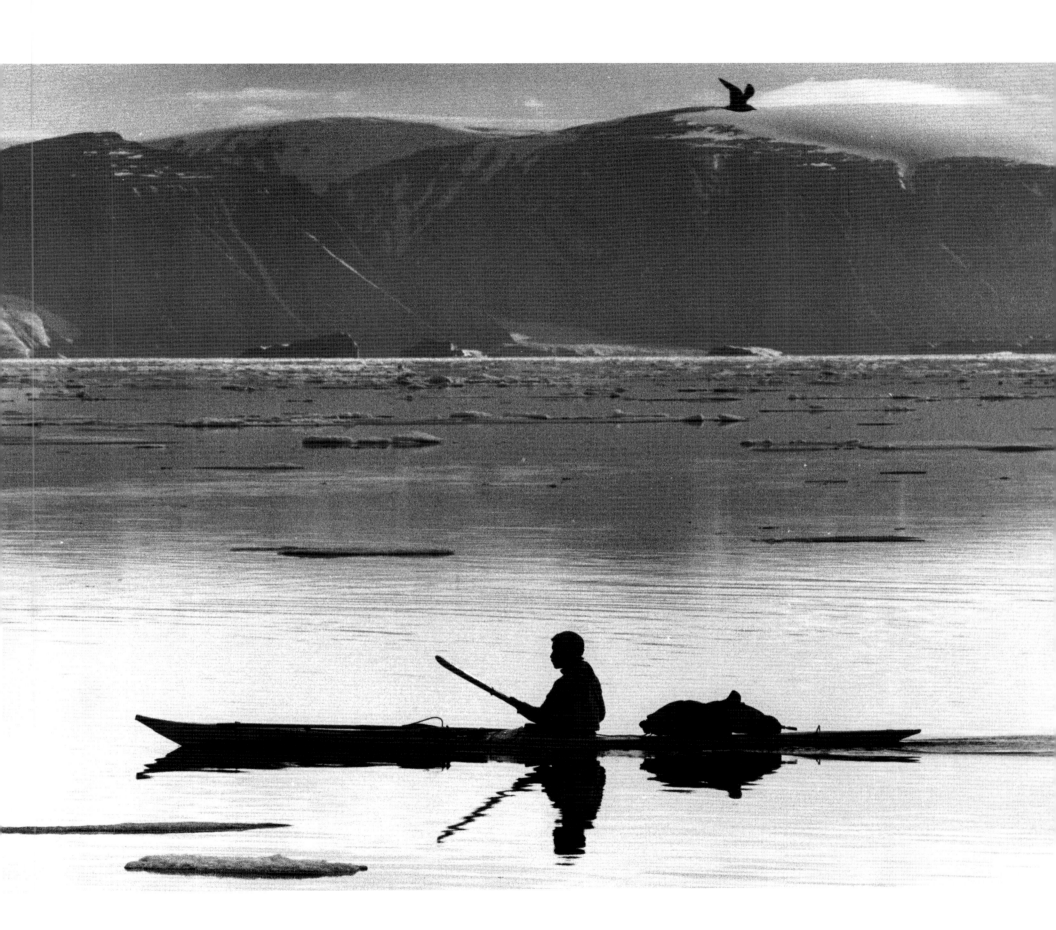

Two polar bears, the climax of a long hunt. The Inuit hunters travelled for weeks and did not see a bear. Then, on a blinding whiteout day, a bear emerged, phantom-like, a mighty male weighing more than 450 kilograms. Akeeagok shot it and moments later a second bear appeared, white in all that ghostly whiteness, and was shot. Our sled dogs feasted and we lived on bear meat and fat.

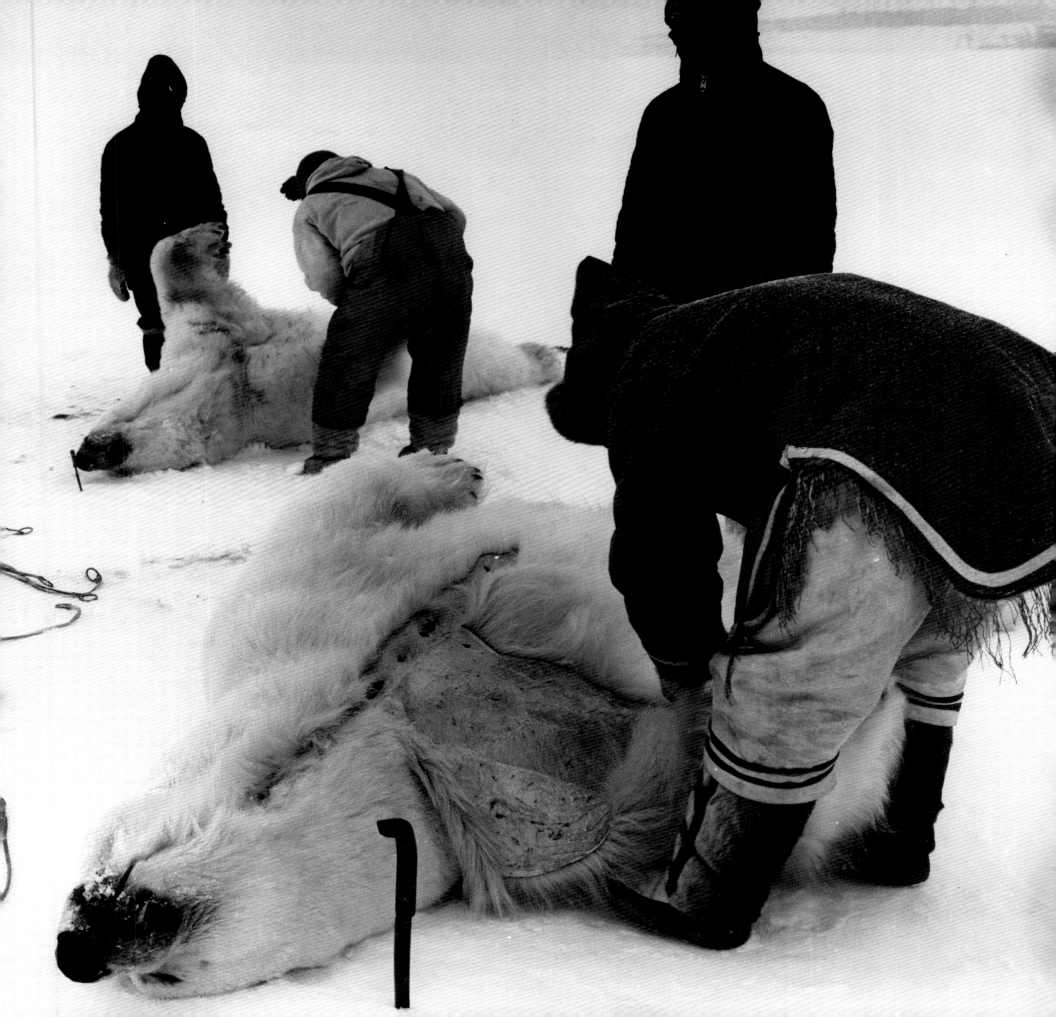

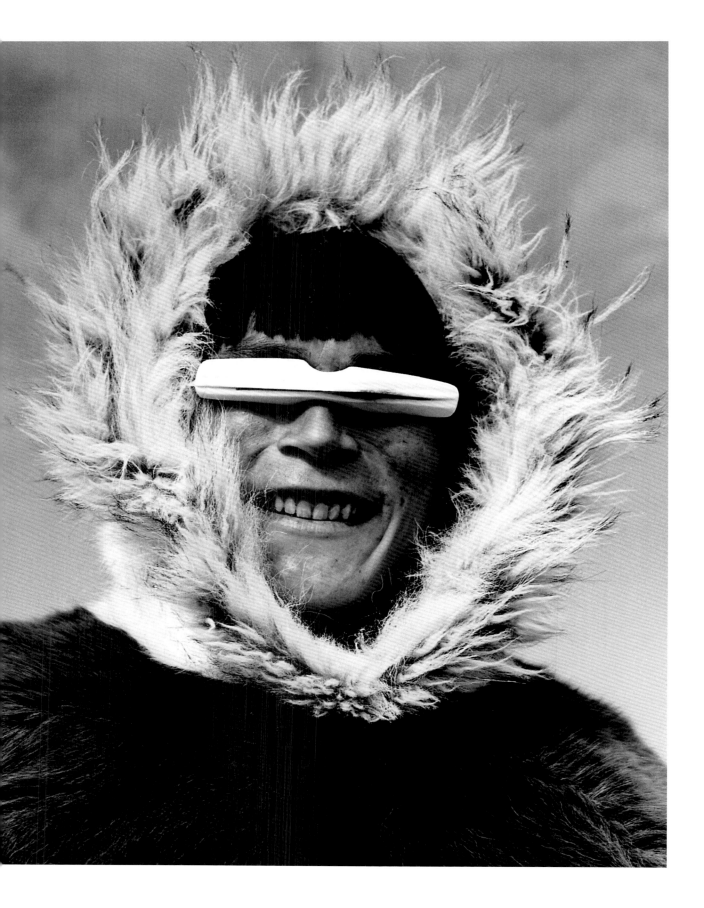

Left: In the Arctic spring, from March to June, the sun's glare off the snow is so intense that radiation can cause the extremely painful snow blindness. To protect himself, George Hakungak wears traditional Inuit snow goggles, carved from caribou bone, with long latitudinal slits. The design is ancient. Similar goggles, made 2,000 years ago, have been found in prehistoric Inuit dwellings.

Right: With the infinite patience and perseverance of the true hunter, Pewatook of Jens Munk Island waits near the floe edge. He scratches the ice with his harpoon shaft. The grating noise travels far in the water and may attract a curious seal. With luck, he got a seal or two. But many days, at -40° C, he waited 12 hours or more in vain.

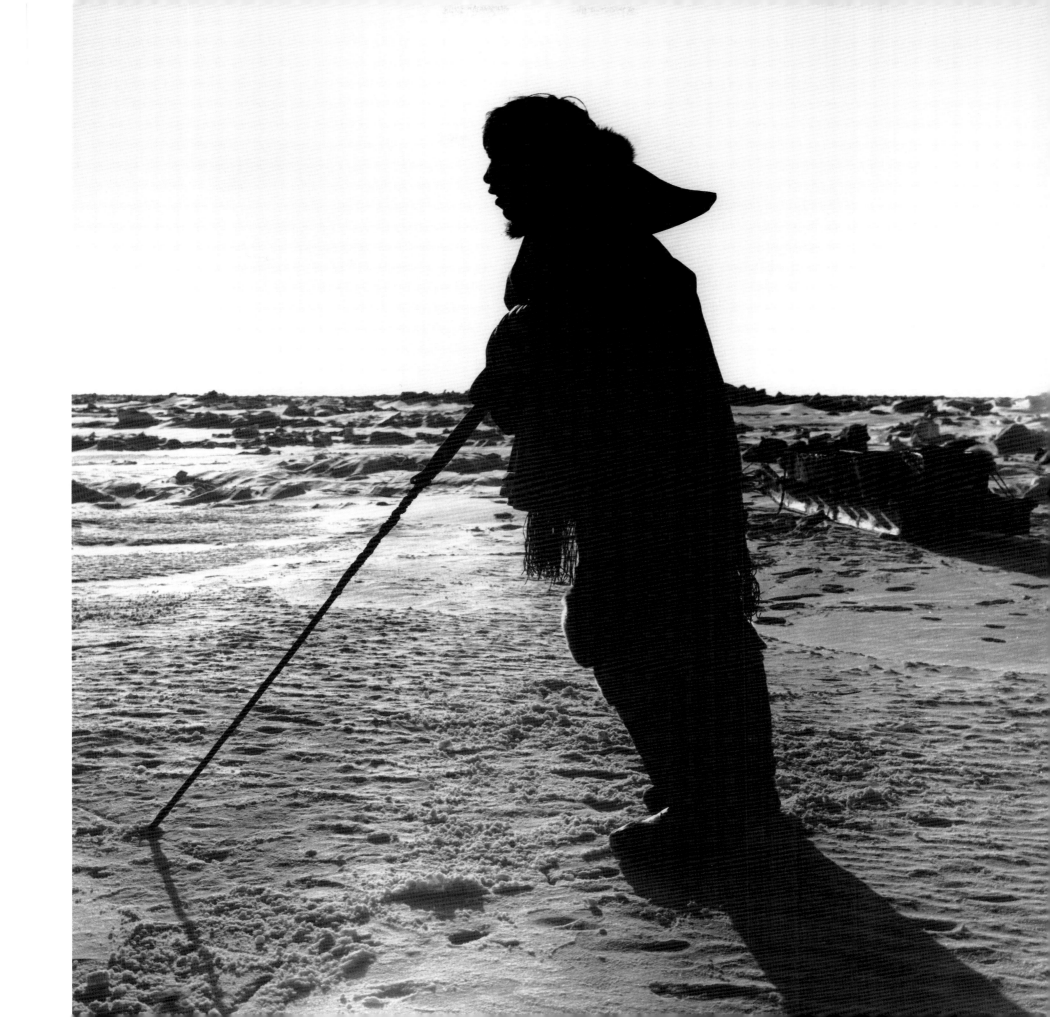

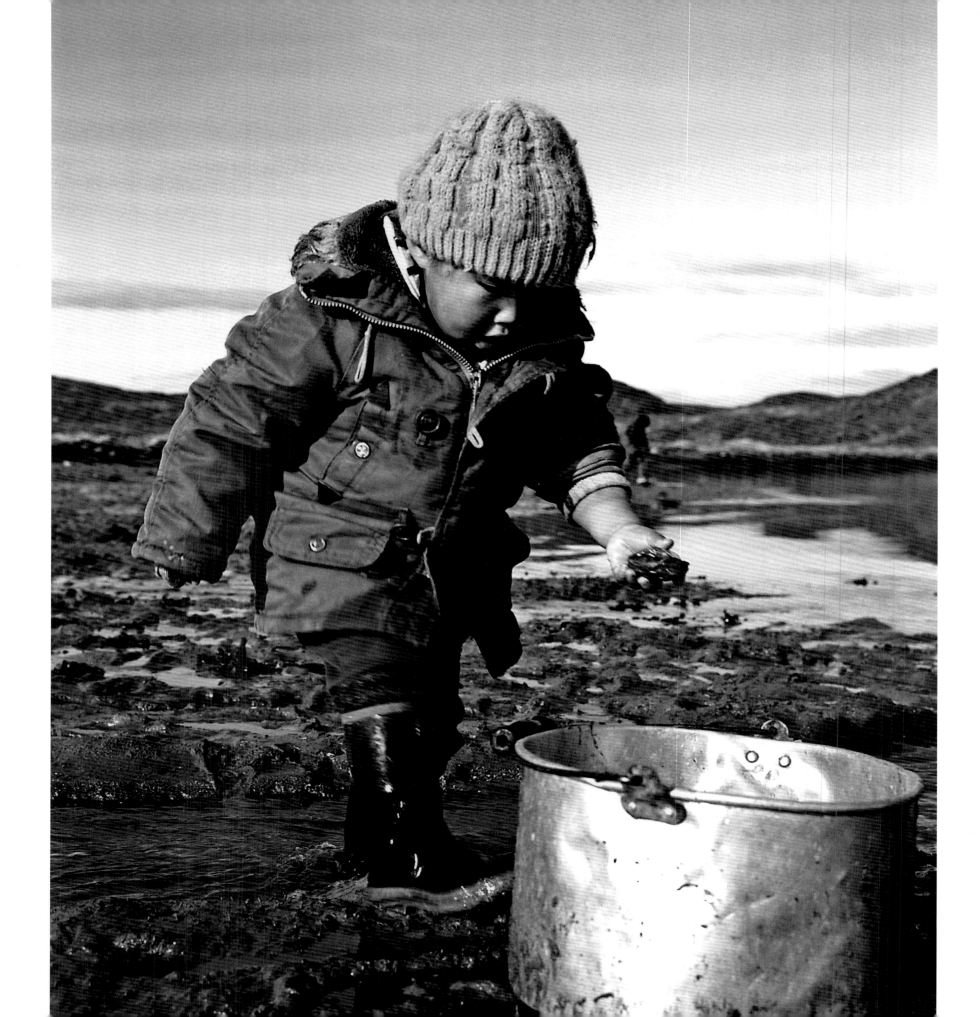

Left: Clam digging, in Inuit society, is usually a happy family affair. The bays of Hudson Strait have some of the highest tides in the world. At low tide vast mud flats are exposed and men, women, and even small children dig up the large, delicious clams, now with old spoons, formerly with digging sticks made of bone. At Aberdeen Bay an earnest four-year-old helps to collect food for the family.

Below: In the past, Inuit hunters were, to a degree we can barely comprehend, self-reliant and self-sufficient. When the brothers Akpaleeapik and Akeeagok of Grise Fiord set out on a two-month, 2,000-kilometre polar bear hunt, they took hardly any provisions along, confident in their ability to live by hunting, to procure enough food, mainly seals, for five people and 29 sled dogs.

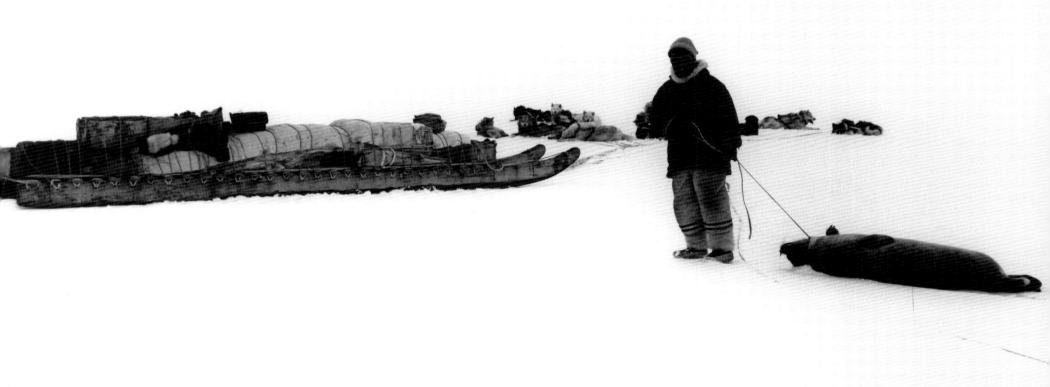

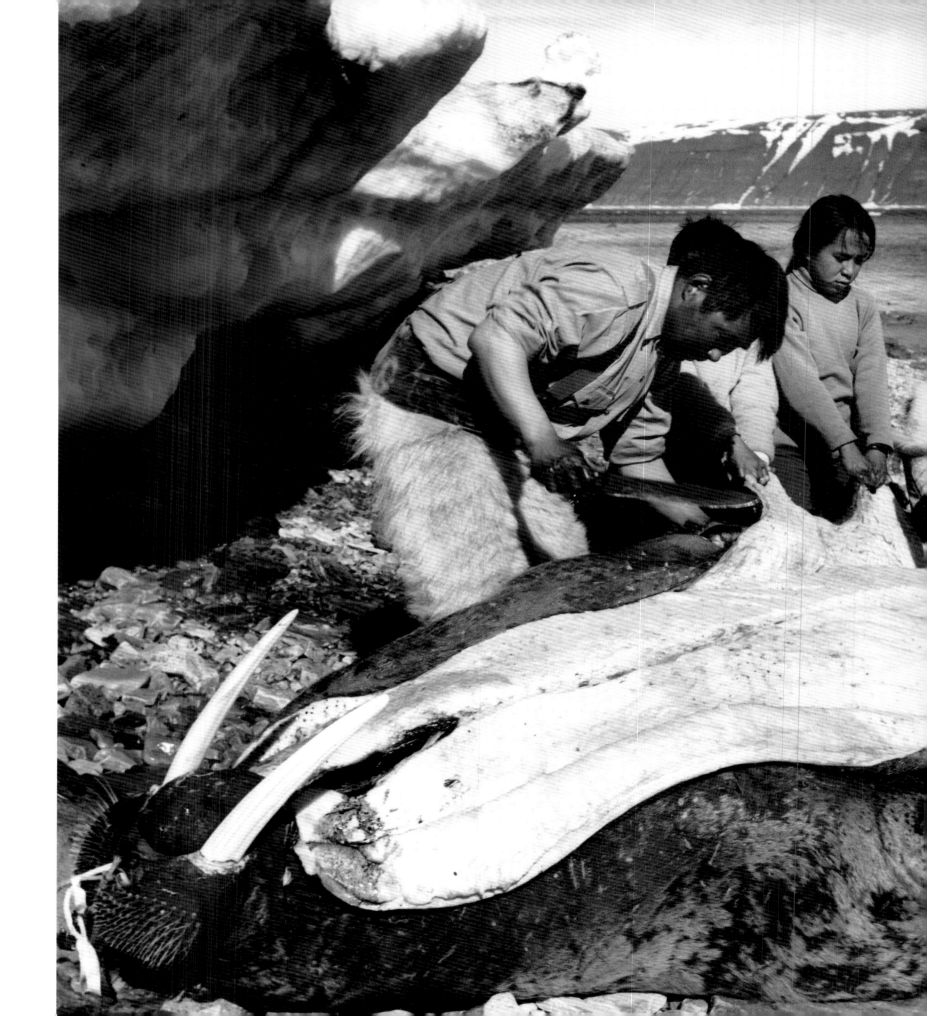

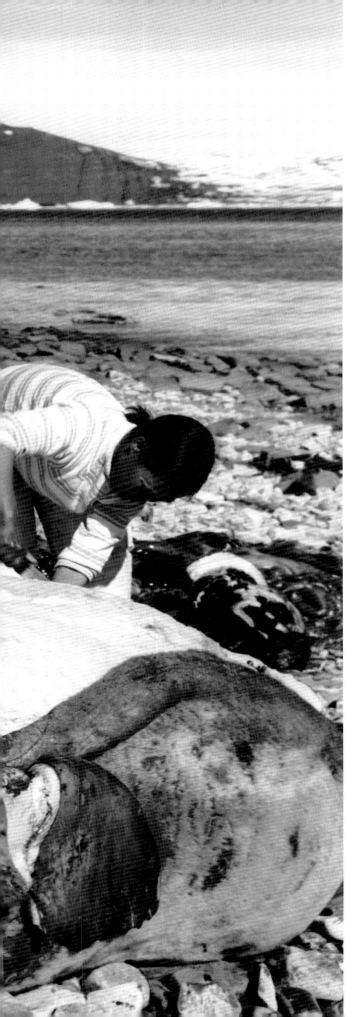

An entire Polar Inuit family helps to skin a 1-tonne walrus bull. The carcass was cut up and meat and fat were cached, future food for humans and sled dogs. From the ivory tusks, harpoon points were carved as well as various tools and toys for the children. The 2 centimetre-thick hide was sold to the South where it was used to make the tips of billiard cues.

The Inuit kayak hunter hurtles his harpoon with a spear-thrower, one of humankind's most ancient inventions, to strike a surfacing narwhal. Using the principle of the lever, the spear-thrower more than doubles the thrust of the throw.

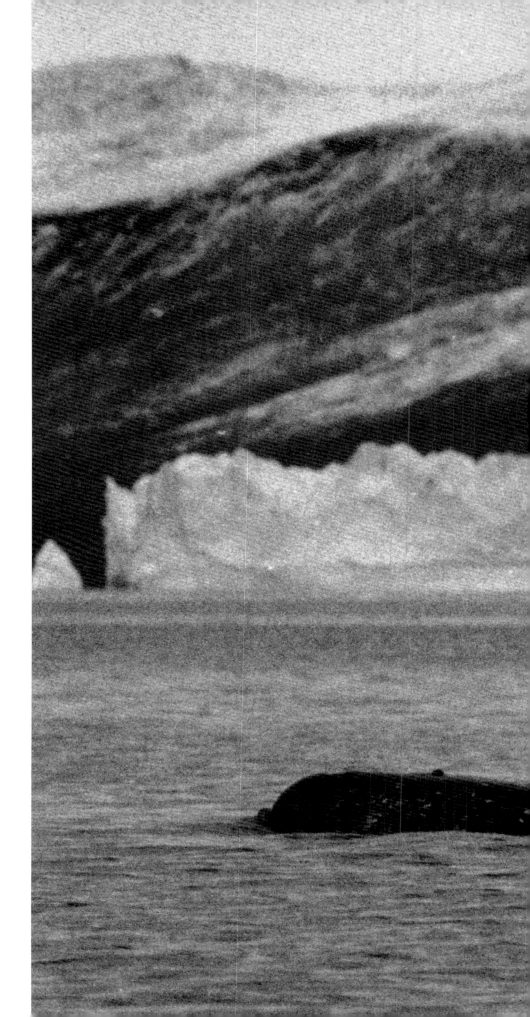

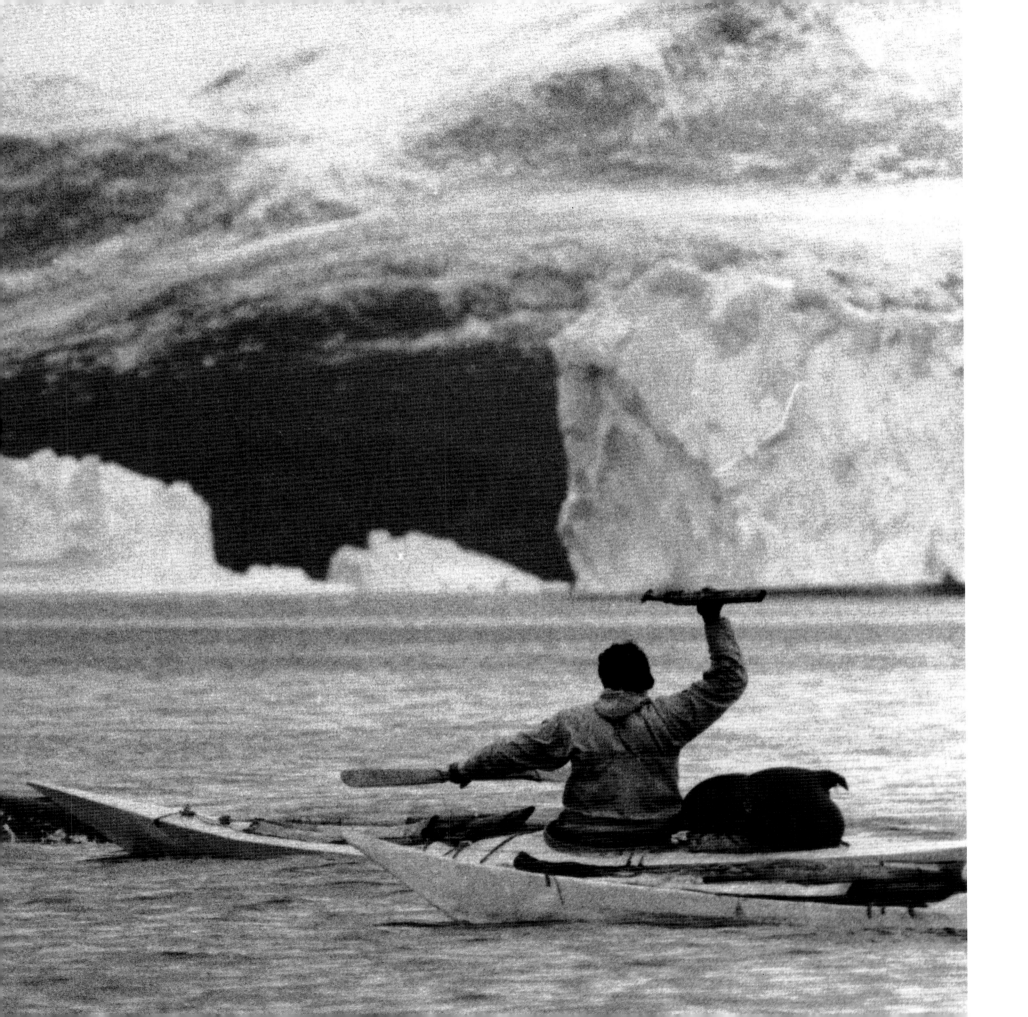

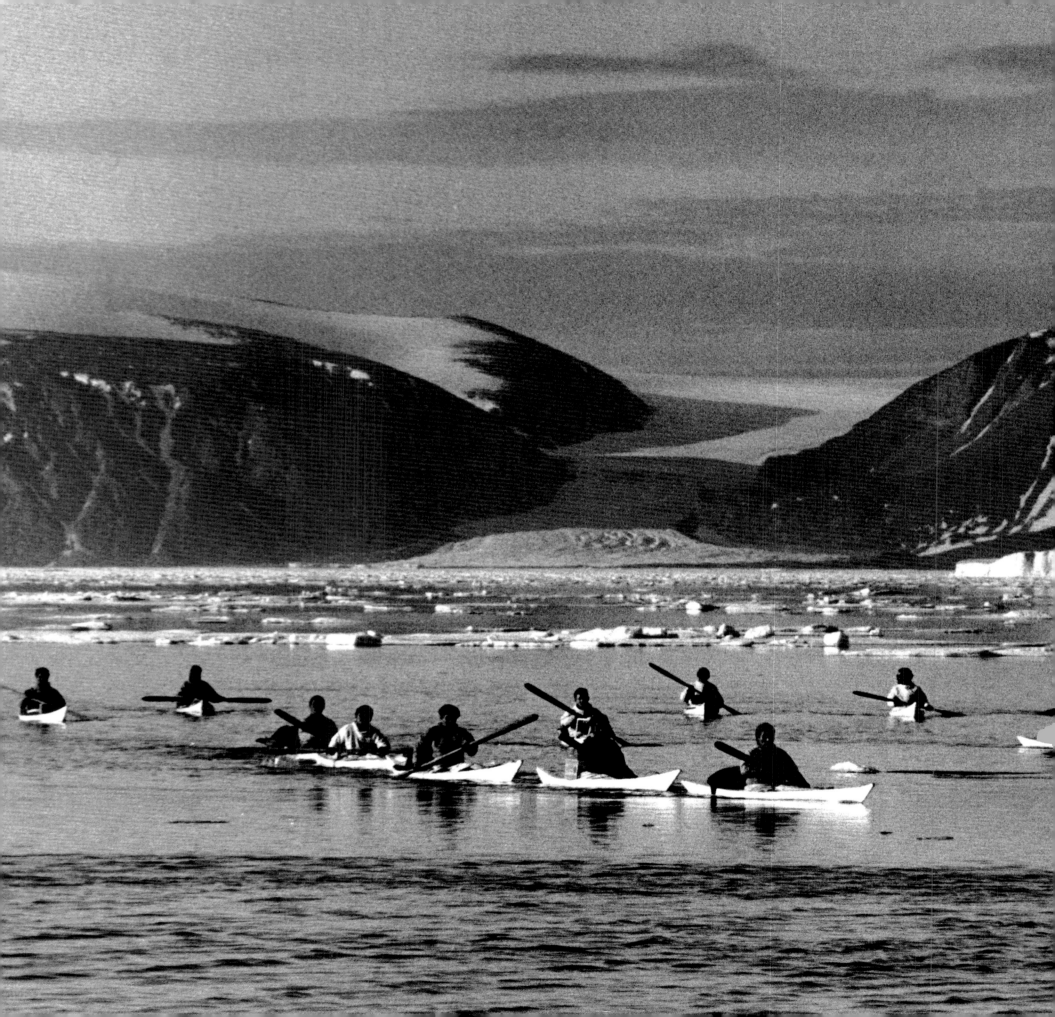

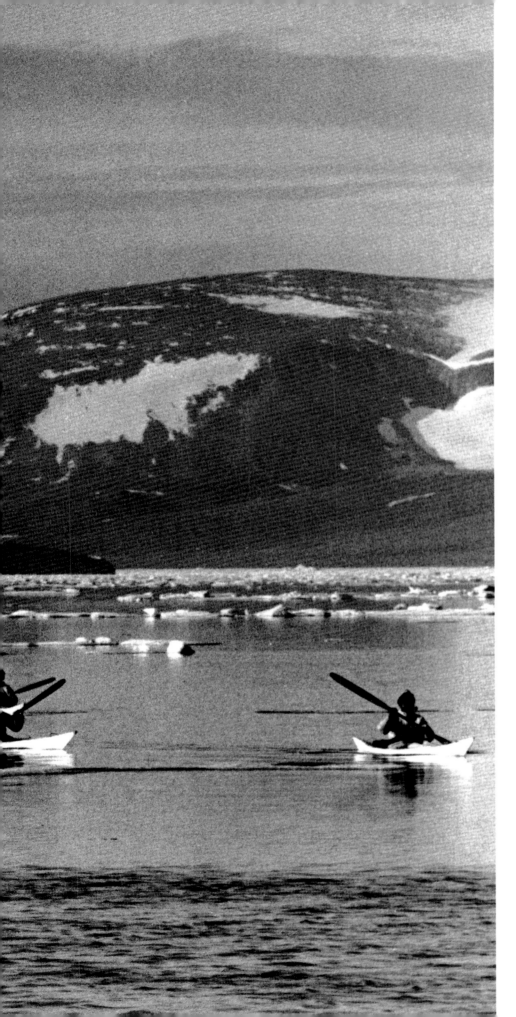

A triumphant flotilla of kayaks returns from a successful narwhal hunt in northwest Greenland. By tradition, all who take part in the hunt are entitled to a share of the meat, fat, and skin. In the past, noted the explorer Elisha Kent Kane, the Polar Inuit existed "in community of resources as a single family."

93

TRAVEL

The Inuit hunter Masautsiaq Eipe, his wife Sofie Arnapalâk, and I left Qaanaaq, the main settlement of the Polar Inuit of northwest Greenland, the northernmost people in the world, at nine o'clock in the morning of a clear, cold day in early May. His nine huskies, well fed, well rested, and eager to run, took off in an exuberant gallop and our long sled caromed through the piled-up, tide-broken ice near shore.

After the initial spurt the dogs settled down to a steady 8-kilometre-per-hour trot across the vast plain of sea ice that seemed totally devoid of life. In 14 hours, travelling about 100 kilometres with only a few brief stops to make tea and rest the dogs, we reached our goal, *imaqssuaq*, the "great water," the Arctic sea that never freezes.

Named the "North Water" by nineteenth-century whalers, it is the largest of the Arctic polynyas, those mysterious but to the Inuit vital oases of life in the Far North.

Here was the floe edge, the limit of land-fast ice, where Masautsiaq and many other Polar Inuit hunted seals and sometimes narwhals, the ivory-tusked whales of the Arctic, in late winter and during the long days and luminous nights of the High Arctic spring.

I loved to travel with Masautsiaq and Sofie. He was a small man, but very strong and agile, gentle, polite, and good-natured. Sofie, several times a grandmother, had raven-black hair, smooth skin, and liked to dress in beautiful furs. She took very good care of herself and used an unguent made with subcutaneous ptarmigan fat to protect her skin from spring's searing solar radiation.

For both Masautsiaq and Sofie the coasts we passed were alive with memories of former trips and former hunts, and while our sled slid across the hard, wavy snow with a swooshing sound, they told me tales of long ago. They simplified their language to make it easier for me to understand them. The Polar Inuit, wrote the explorer-writer Peter Freuchen, who lived among them for many years and married one of them, Navarana, "are the most tactful people in the world."

Masautsiaq was the son of Odaq, once considered the best hunter in the Thule district and one of the four Polar Inuit who had accompanied Admiral Peary to the North Pole in 1909, to *Kalalerssuq*, "the big navel," as the Polar Inuit call it. In pragmatic Inuit fashion, Masautsiaq considered that famous feat as an exceptionally stupid and useless trip.

"There's nothing there," he said. "Just ice. We also call it *kingmersoriartorfigssuak*," the place where one only eats dogs.

His travels had been extensive but practical: far south to the village of Savissivik, whose name means "the place where one gets iron," for nearby lay several large metallic meteorites that were, through the ages, the Polar Inuit's unique source of iron until Peary took them away and sold them to the American Museum of Natural History in New York for $40,000.

Each summer, Masautsiaq travelled west to hunt narwhals and white whales in Inglefield Bay. Far to the north, on the steep scree slopes near Siorapaluk, he captured each May and early June low-flying dovekies with his *ipu*, a long-handled net, and even further north he often collected thousands of eider duck eggs on islets in Smith Sound. The American explorer Elisha Kent Kane noted already in 1856 that along the 1,000-kilometre coastline forming the Polar Inuit's land, the people knew every foot of ground, and "every rock had its name, every hill its significance."

Our travels were sometimes difficult, occasionally dangerous, but never boring. On one of the trips to the floe edge with Masautsiaq and Sofie we came upon a lead filled with dead Greenland halibut, Arctic deep-sea, flounder-like flatfish, clay-grey, half a metre long, and delicious when fresh. Some unknown cause had killed them in the deep and they had floated to the surface. We gaffed an entire sled-load of fish out of that lead: the fresh ones for us, the putrid ones for our huskies. Sled dogs are not fussy.

There were six hunters, some with their families, camping near the floe edge in late spring when the storm broke. They knew it was coming. They seemed to sense changes in the weather. Clouds warned them, the shifting wind, the altered cries of seabirds that responded perhaps to changes in barometric pressure. Nearly simultaneously they all broke camp and headed for a sheltered valley on the mainland.

Outside the storm shrieked in primal fury. Inside our tents, well anchored to heavy stones arranged ages ago by earlier travellers, it was comfortable and cozy. The Primus hissed. Sofie boiled lots of seal meat. We drank mugs of tea and Masautsiaq told stories from long ago, of travels and famines and feasts. One spring when he was a boy, the hunting was bad, the caches were empty, the people starved, and for weeks, he said, "I ate only rabbit droppings dipped in old, rancid walrus oil."

Another time, he recalled, his people had managed to kill a bowhead whale, a very rare occurrence. Forty tonnes of meat and fat! "I ate and ate until my belly was soooo big," Masautsiaq said and mimicked an immense bulging belly and we laughed and chatted, ate the steaming seal meat, and drank more tea. An Inuk,

said the Canadian-born explorer Vilhjalmur Stefansson, "laughs as much in a month as the average White man does in a year."

When the storm ended we looked toward where we had camped on the ice and all was open water. The storm had broken the ice, and wind and currents had dispersed it. We now had two choices: to return home across a portion of Greenland's mighty ice cap, which was safe but long and arduous, or follow the coast on the ice-foot, which was much easier but potentially deadly.

They chose the ice-foot, a belt of shore-fast ice created by tides and frozen spray. At first it was broad and the sledging was easy, but we had to round the great cape near Natsilivik. On one side were sheer cliffs, below open water, and, glued to the cliff, high above the water, the ice-foot, a narrow, sloping ledge of ice of unknown strength.

By common, tacit agreement Inuteq took the lead. Inuteq was then 75, still a great traveller with a splendid dog team. But his eyesight was failing and at the floe edge his wife, Aleqasinguaq, a crack shot, killed the seals and he retrieved them with his kayak. This shamed him deeply and at the floe edge he and his wife always camped faraway from everyone else so none should see his weakness and dependence.

Now Inuteq went first, taking small shuffling steps with his smooth-soled sealskin boots on the narrow, sloping ice ledge frozen to the rock above the dark, icy, deadly water. He tapped the ice with his harpoon shaft, he looked, he listened, and then he returned and nodded.

He and Aleqasinguaq led the badly scared dogs, scrabbling and pressing against the rock wall. The two strongest, most agile hunters held the rear of the heavy sled to prevent it from sliding

off the ice ledge. Then, on foot, helped by the men, came the women, the children, and I, and finally the other five sleds were taken around the cape. The rest was easy. The ice-foot broadened again, we reached sea ice, and sledged home to Qaanaaq.

Two weeks later I was less lucky, but learned with what speed and assurance Inuit could deal with a potentially fatal emergency.

It was the time of the early summer walrus hunt far to the west and Utoniarssuaq, one of the great old hunters, took me along. We travelled by dog team past Herbert Island to Northumberland Island. There Utoniarssuaq and other hunters left their sleds and families and continued the hunting trip in boats. Walruses were migrating northward into Smith Sound, between Greenland and Ellesmere Island, in large, madder-brown clusters upon dung-smeared ice floes.

It was a good year for the hunters. They killed many walruses, abundant food for themselves and, above all, for their huskies, for the region's approximately 1,200 sled dogs devoured about 180,000 kilograms of meat and 45,000 kilograms of fat annually.

When they killed walruses on ice floes, Utoniarssuaq inflated each animal, blowing air into the body cavity through a thin metal tube (formerly the sharpened, hollow wing-bone of a goose). Now buoyant, the walruses were hauled by boat to traditional caching places on shore.

When the walrus was killed in water, the two- or three-man hunting crew was faced with the seemingly insuperable task of heaving a 1-tonne walrus onto the ice. They solved the problem in an ancient and most ingenious way. They chipped out several ice bollards, cut parallel lines into the thick neck hide of the walrus, and then reeved a rope or bearded seal thong back and forth through the bollards and skin loops as a simple yet highly efficient block and tackle with which two men could haul the largest walrus out of the water and onto the ice.

On shore, men, women, and children were busy for many days and nights, cutting up the huge animals and filling the ancient stone caches with meat and fat, to be picked up next winter, as needed, by dog teams.

We travelled home in tandem across the already water-flooded ice of early summer, Utoniarssuaq and two other hunters and their families, their sleds piled high with meat and fat and walrus hides.

A broad rift in the ice stopped us, a soot-black lead of open water. The Inuit sledged to a spot where the lead was fairly narrow and made, with small ice floes in the water, a sort of fragile floating bridge.

Urging on the frightened dogs, they raced across. The small floes, held up for a moment by inertia, began to sink, and the sled had to be yanked onto firm ice on the other side of the lead.

I stood at the side of the lead and photographed this amazing crossing of open water with heavily laden sleds and with women and children perched on top of the loads. When all were across, I was still on the wrong side of the lead. The ice floe bridge had been smashed by the sleds into tiny pieces.

"Jump," they called. "Run and jump."

I had no choice. I backed up, ran flat out, and jumped. I made it across, but the far ice edge was underwashed and broke and I sank into the water over my head, holding the Nikon high, for salt water kills cameras. I must have looked like the sinking Statue of Liberty.

My bulky winter clothes were full of air and buoyant. I surged

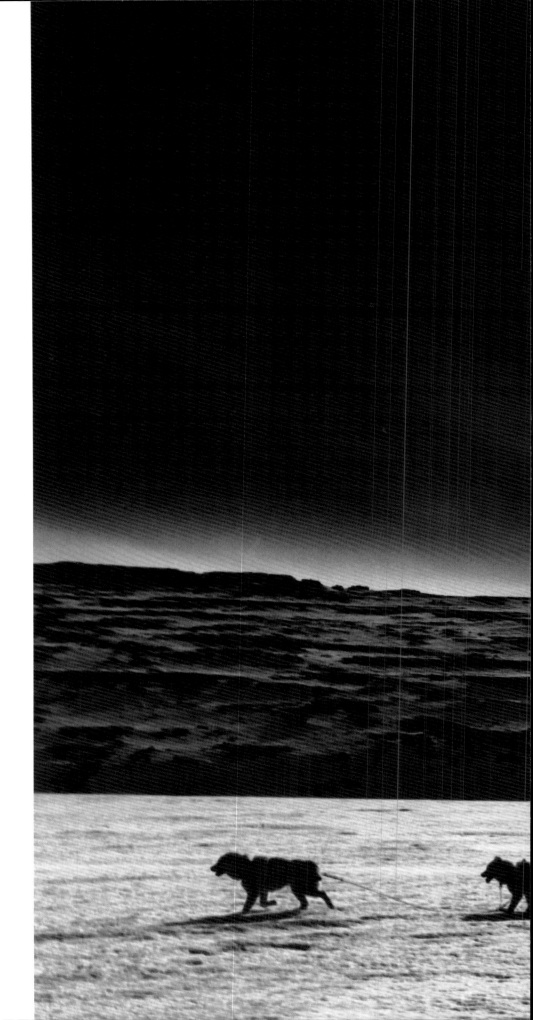

Swirling clouds presage a storm as we travel
beneath the midnight sun from our Bathurst
Inlet camp to a remote camp of other Inuit. To
visit and be visited was one of the great joys of
Inuit life, for they were essentially a sociable
and immensely hospitable people. The terrible
storm that hit us about an hour after this
picture was taken was considered only a slight
inconvenience. We camped, slept, talked,
played with the children, drank lots of tea, and,
once the storm had ended, continued our trip.

up, the Inuit grabbed me, hauled me onto the ice, then stood
around me in a worried silent group while I examined the Nikon.
Losing the camera, they knew, would be a catastrophe for me.
The few drops of water that had touched the icy metal had frozen
instantly. The camera was safe.

"OK?" they asked anxiously.

"Yes," I said. "The camera is fine."

And then they laughed. They screamed with laughter. That
White man vanishing into the sea holding his camera aloft was
the funniest thing they'd seen in years.

They also acted with the coordinated speed of experts who
knew exactly what to do in an emergency. In less than a minute
they had set up one tent. Inside three Primus stoves roared full
blast, turning the place nearly instantly into a hothouse.

They helped me pull off my wet clothing, shoved me into a
sleeping bag, and rolled and pushed and pummelled me. They
made me drink mug after mug of scalding hot tea.

I stopped shaking. Blood vessels dilated and I began to glow.
I felt sort of woozy and wonderful and suddenly very tired. They
knew the signs, the after-effect of shock. As I drifted off to sleep,
I heard them talk and laugh.

They were traditional Arctic hunters with great experience.
They loved to travel and they were good at it because they had
an immense store of knowledge, some acquired from past
generations, much of it learned in a lifetime of travelling and
hunting.

"Now," said James Ungalak, a young Canadian Inuk living in
Igloolik, in a recent interview, "I think we have lost the skills so
much. I mean, what would not have been dangerous for a man 50
years ago is now dangerous ... because we have lost so many skills."

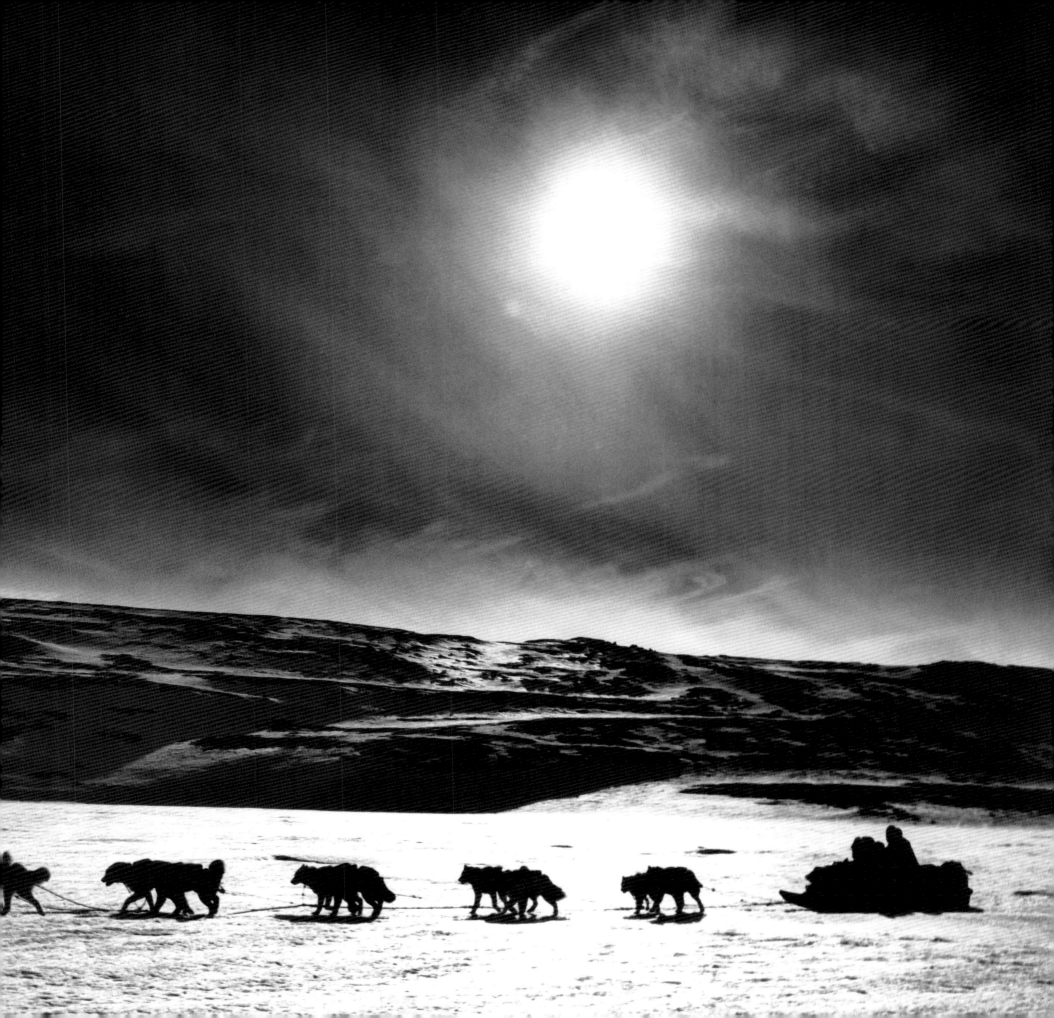

Only Inuit who hunted big sea mammals, walruses, narwhals, belugas, or the giant bowhead whales had enough meat and fat to feed large dog teams. Inuit who hunted primarily caribou and seals travelled more modestly, as in this carving made by Ekalun of Bathurst Inlet. It shows Ekalun and his wife Rosie in the 1930s hauling a heavy sled, helped by a single husky.

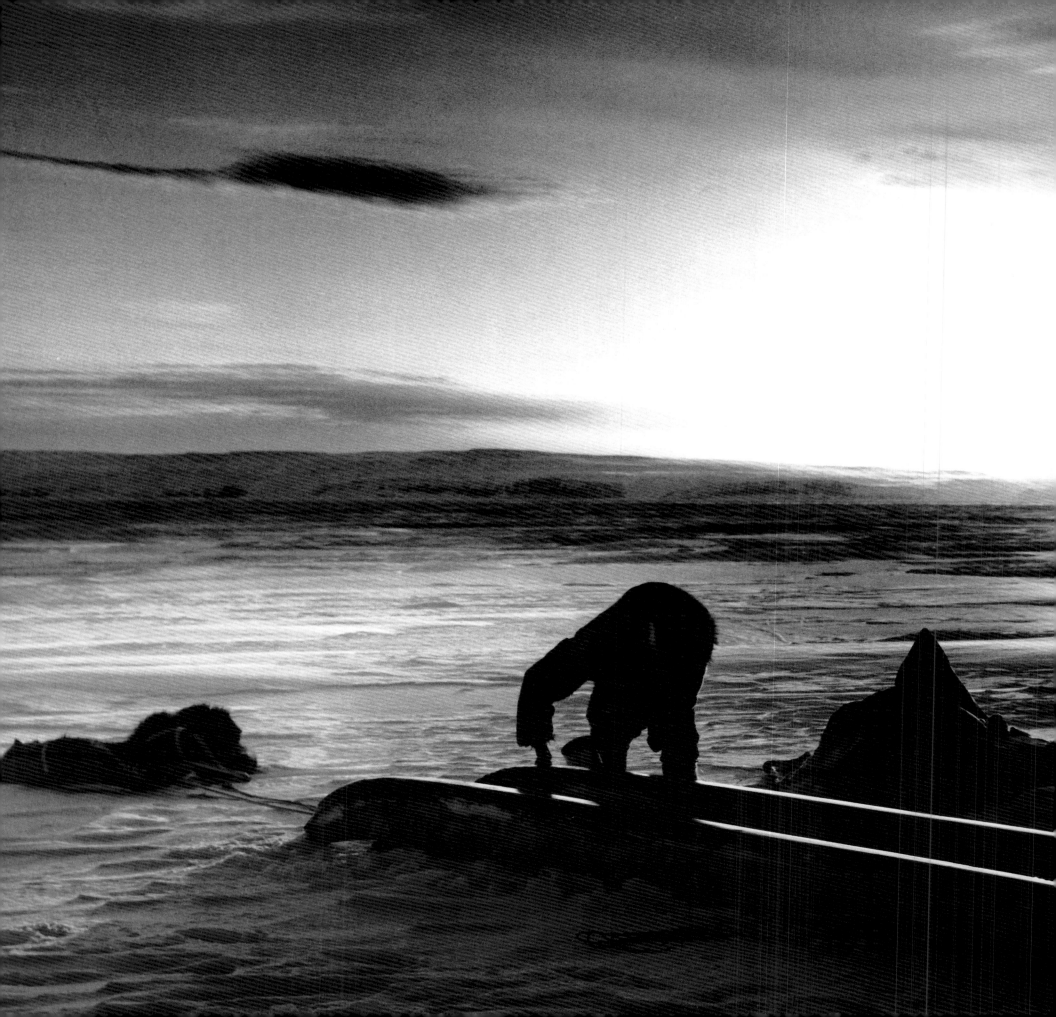

Every morning before starting a trip, the long sled runners were iced. Snow was melted, and the icy mush was spread on the runners and planed smooth with a snow knife. A piece of polar bear skin was dipped into lukewarm water and wiped quickly over the iced runners to give them a smooth, even glaze. This minimized friction and made it much easier for the dogs to pull the heavy sled.

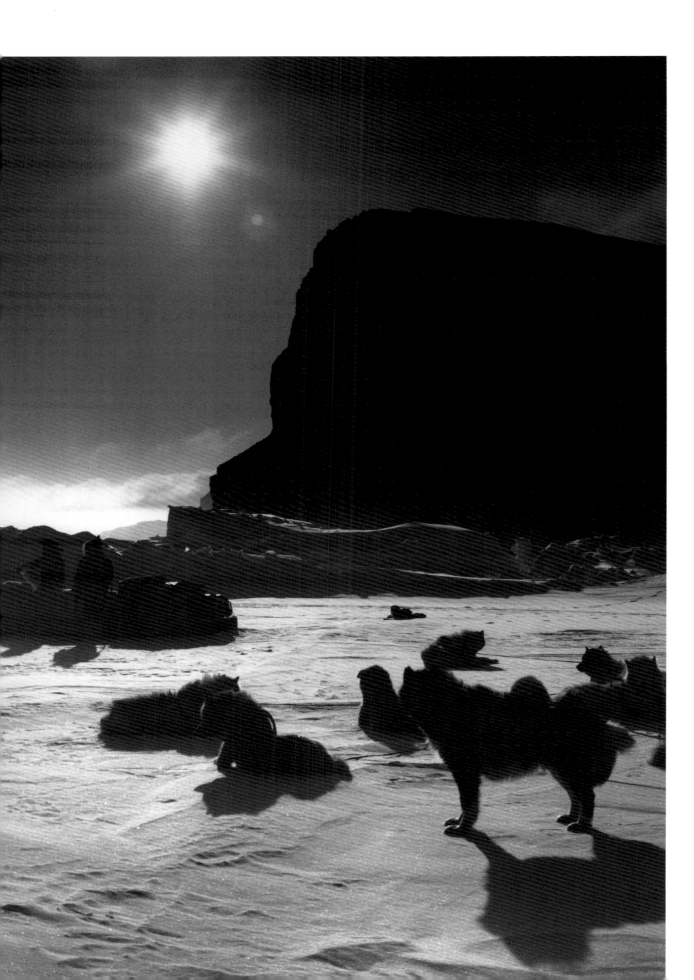

Left: Breaking camp beneath the soaring cliffs of southern Ellesmere Island. The routine rarely varied, even during a two-month dog team trip. First, a layer of large, very strong bearded seal skins was placed upon the sled to protect the load. Then came the boxes with ammunition, bags with spare clothing, our tent, our caribou sleeping robes, and, on top, polar bear skins, which were marvellously warm and soft to sit on. The entire load was lashed firmly to the sled with sealskin thong.

Right: Only in the central Arctic was the igloo, emblem of the Inuit, used as a winter home. In Siberia, Alaska, much of the Canadian Arctic, and Greenland, Inuit built their winter houses of stones, sod, bones, or driftwood, often roofed with snow blocks. Small igloos, such as this one being built by Peter Agliogoitok, watched by his little daughter Annie, were used while travelling as shelter for the night.

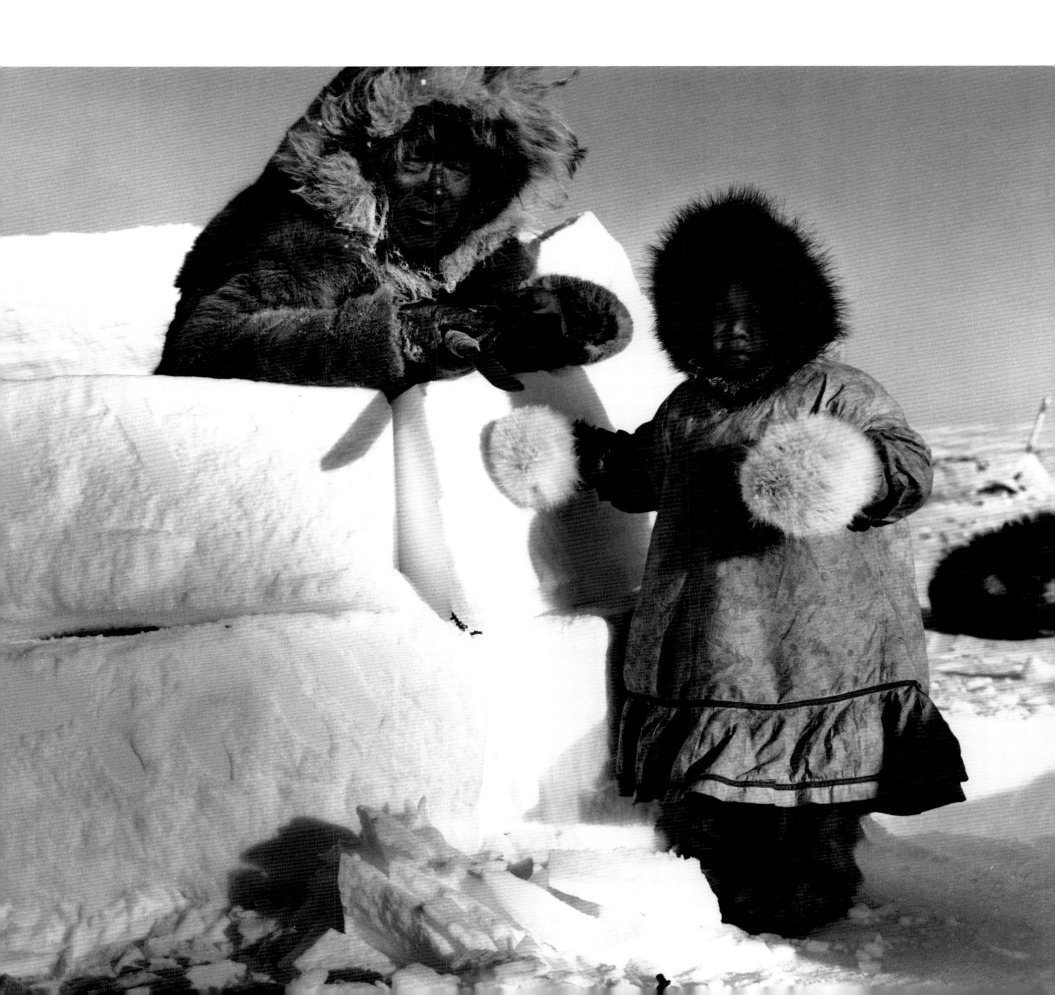

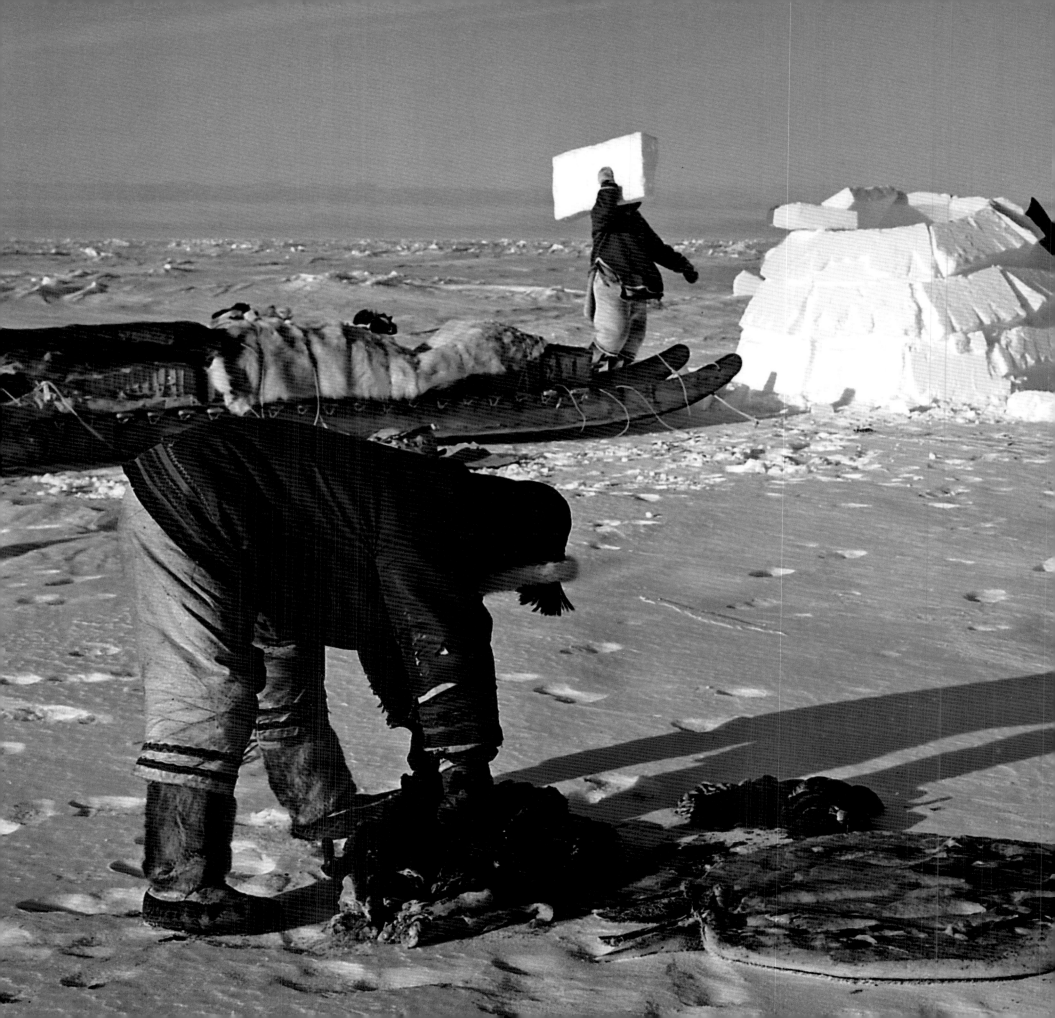

While Akeeagok cuts up a seal, our daily meal and that of our sled dogs, his brother, Akpaleeapik, helped by their sons, builds our igloo for the night. The igloo, windproof and much warmer than a tent, was built only on very cold days. While he circled the snow blocks upwards into a perfect dome, the boys and I chinked the gaps with snow. It took about an hour to build an igloo roomy enough for five people. The next day we left it. It was the perfect disposable dwelling.

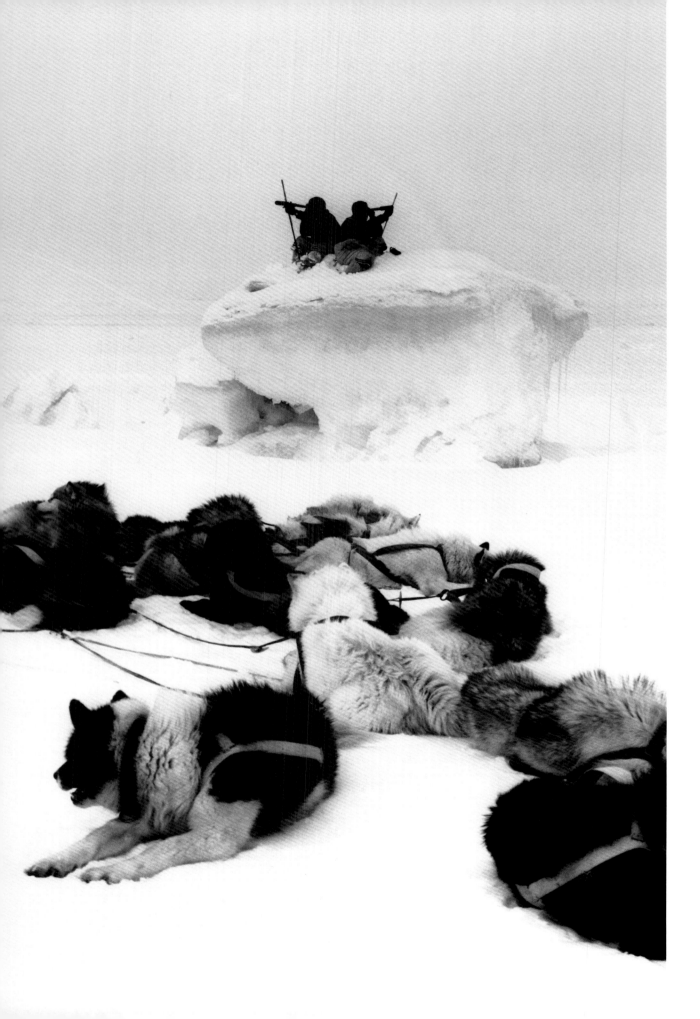

Left: Steadying their telescopes with harpoon shafts, the brothers Akpaleeapik and Akeeagok of Grise Fiord scan the ice for seals and polar bears while their sled dogs rest. Survival in the Arctic depended upon the hunter's ability to find game animals and then to stalk them successfully with the experience and skill acquired in a lifetime of hunting to live.

Right: An igloo, lit by a kerosene lamp, glows in the night. Inuktitut, the language of the Inuit, has more than 100 terms for different types of snow. *Oqaalugait*, hard-packed, unlayered snow, is perfect for cutting the igloo snow blocks. Such snow is found and tested with a *subgut*, a special slender probe made of bone, wood, or ivory.

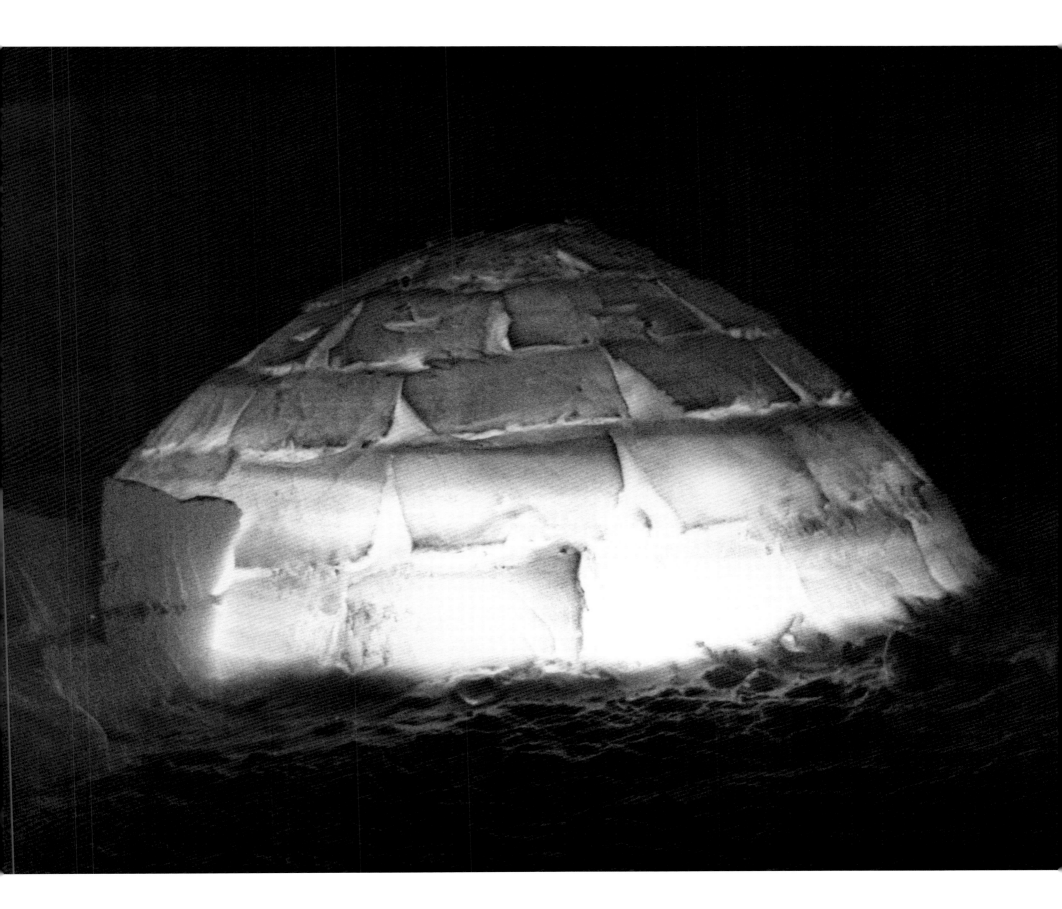

The pleasant beginning of a nightmarish trip:
the crossing of Devon Island by Inuit hunters
from Ellesmere Island. We sledged up from
Jones Sound on this frozen river. It ended in
a narrow valley filled with hip-deep soft snow
and flanked by sheer rock walls. We struggled
upwards for four days and four nights to reach
the island plateau and we had little food and
the sled dogs got no food at all. No one else
had ever tried this island crossing before.

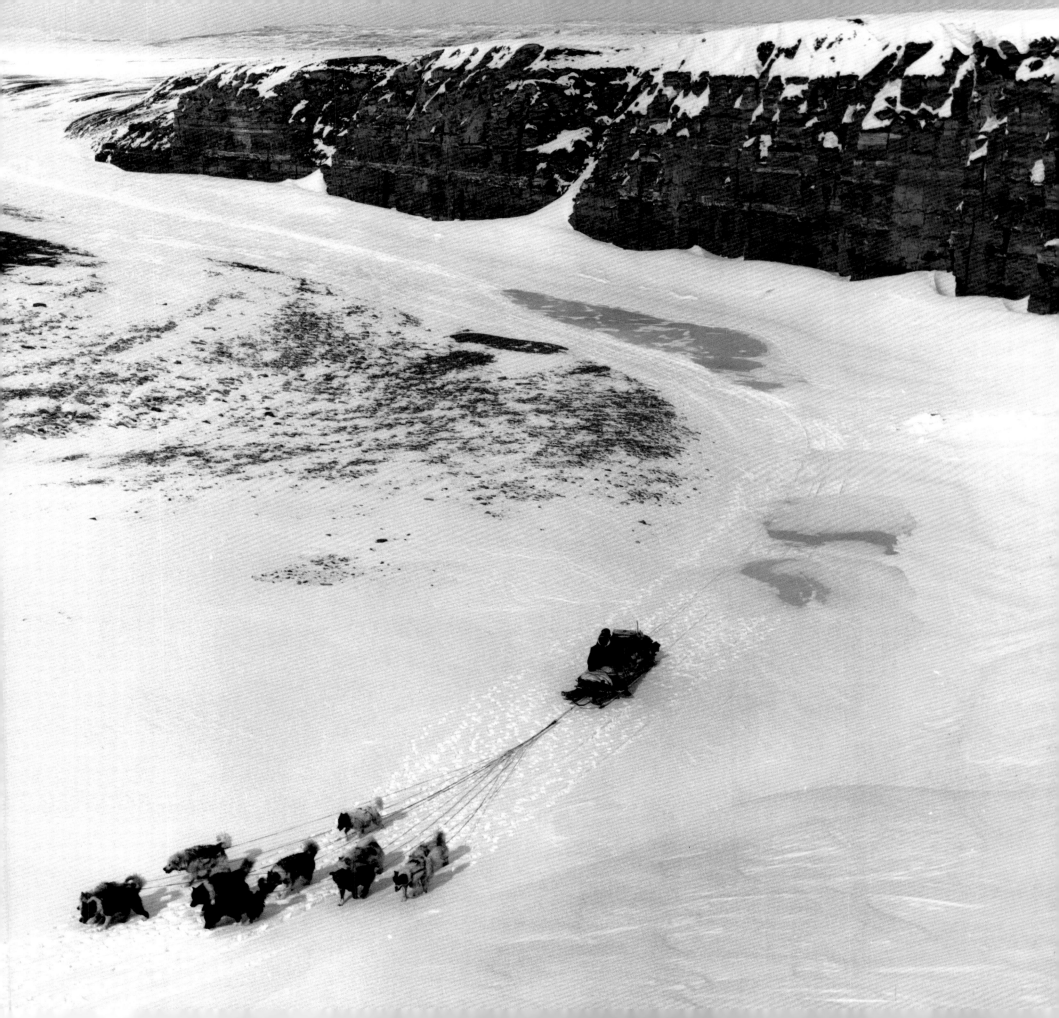

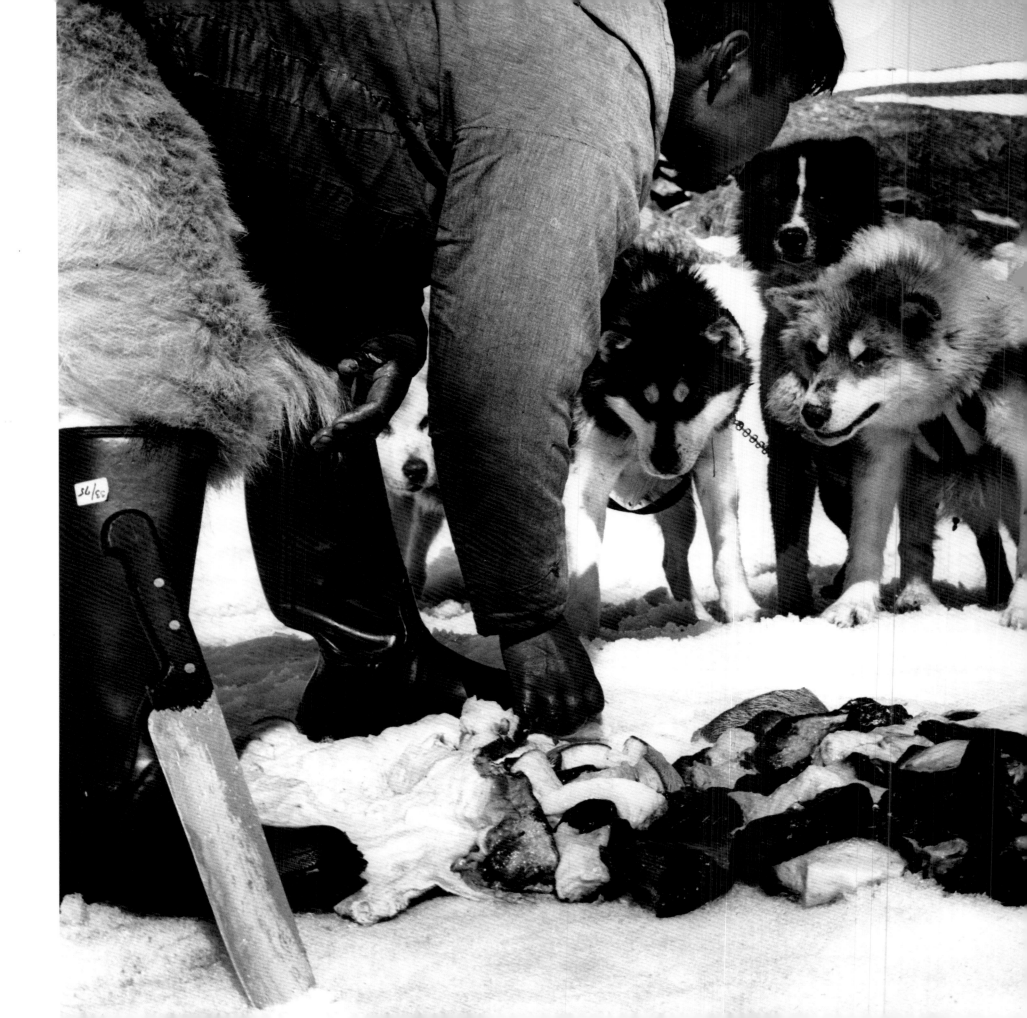

When travelling, usually 30-60 kilometres in 10-12 hours, the hard-working huskies were fed once a day and were invariably famished. They received about half a kilogram of meat and some high-energy blubber each day and gulped down their ration in seconds. They were incredibly tough. When hunting was poor, they continued to haul the heavy sled even when they were not fed for many days.

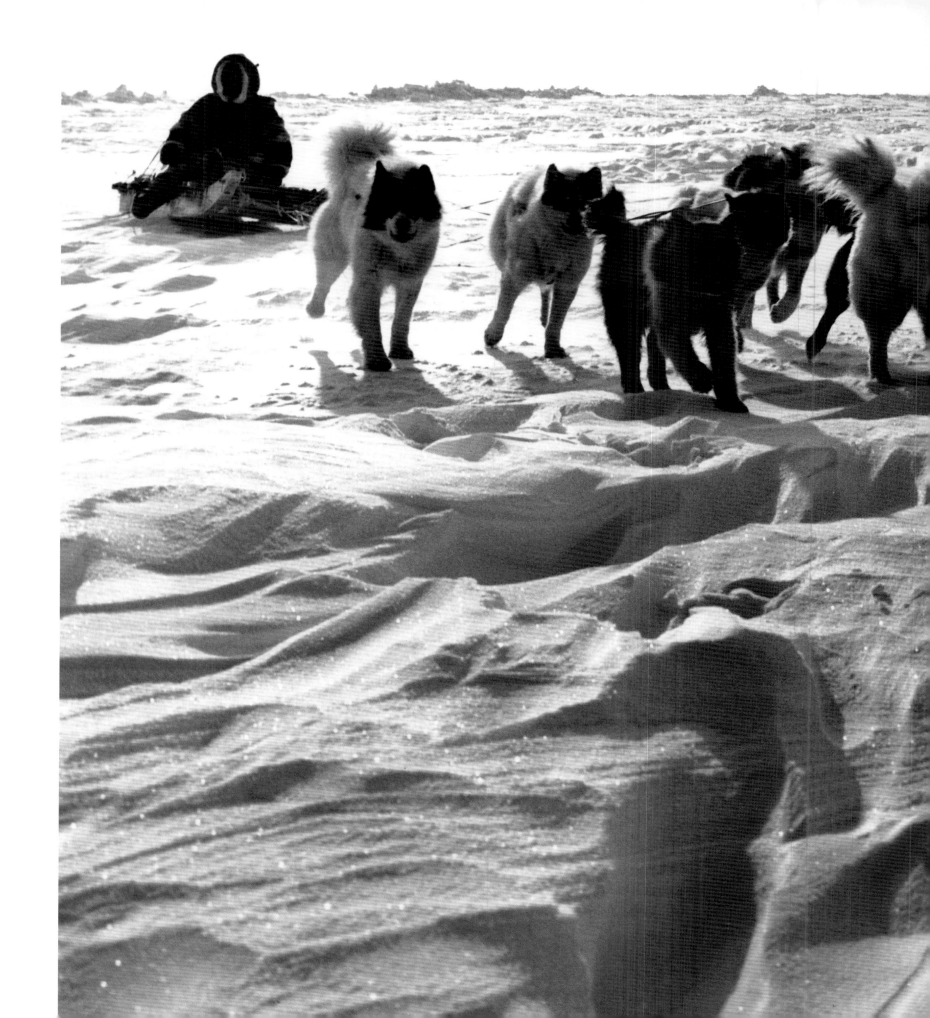

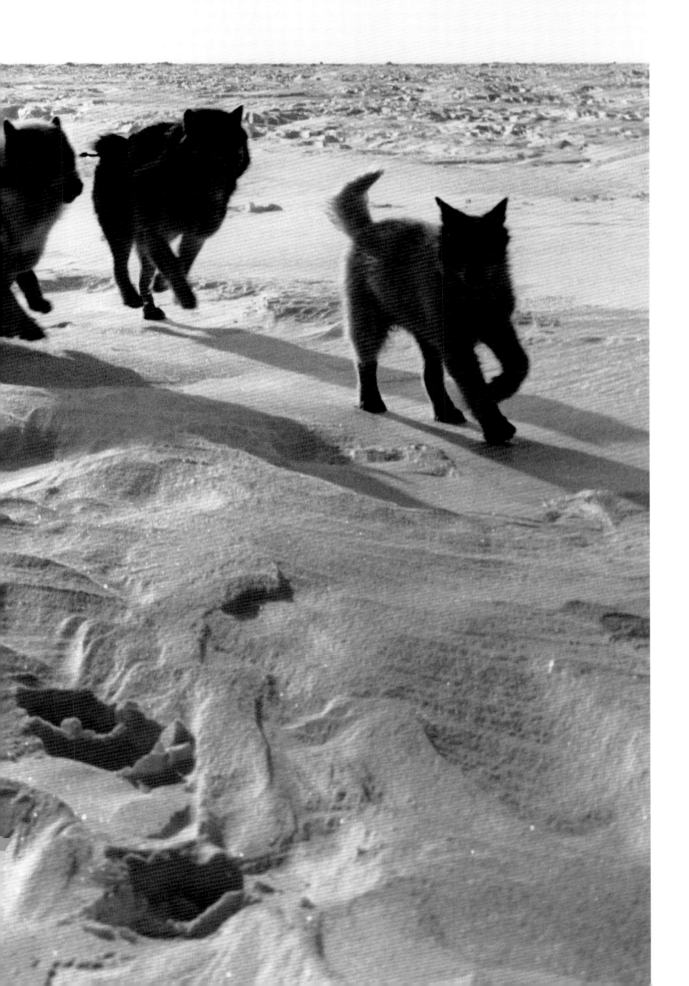

Happy huskies hurry home. The snow is fairly smooth, the going easy, and the load, alas, is light, for the hunter returns without a seal. Pewatook had spent 14 hours at the floe edge at -30° C, waiting, hoping for seal. None came close enough. "We go again tomorrow," he said.

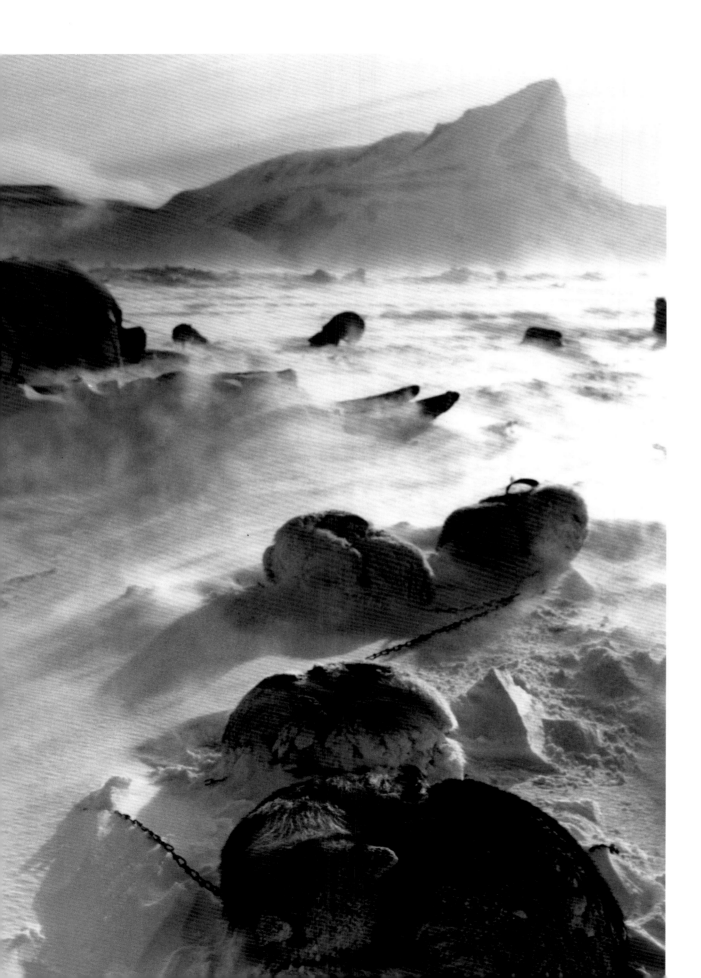

Left: We camped below Cornwallis Island's Cape Hotham. That night the storm struck and collapsed our tent. The Inuit hunters set it up again, tied the guy ropes to our heavy sleds, and built a protective wall of snow blocks around the tent. The storm lasted two days and two nights and slowly buried our sleds, our tent, and the curled-up sleeping sled dogs. So began for us the month of June in 1967.

Right: Tea break during a 15-hour, 100-kilometre early March trip from Igloolik to Jens Munk Island in a blinding blizzard at -20° C, with Pewatook and his family, including three small children, one of them a baby. The fur-clad children endured the hardships of the trip without complaining. They were as tough and patient as the adults.

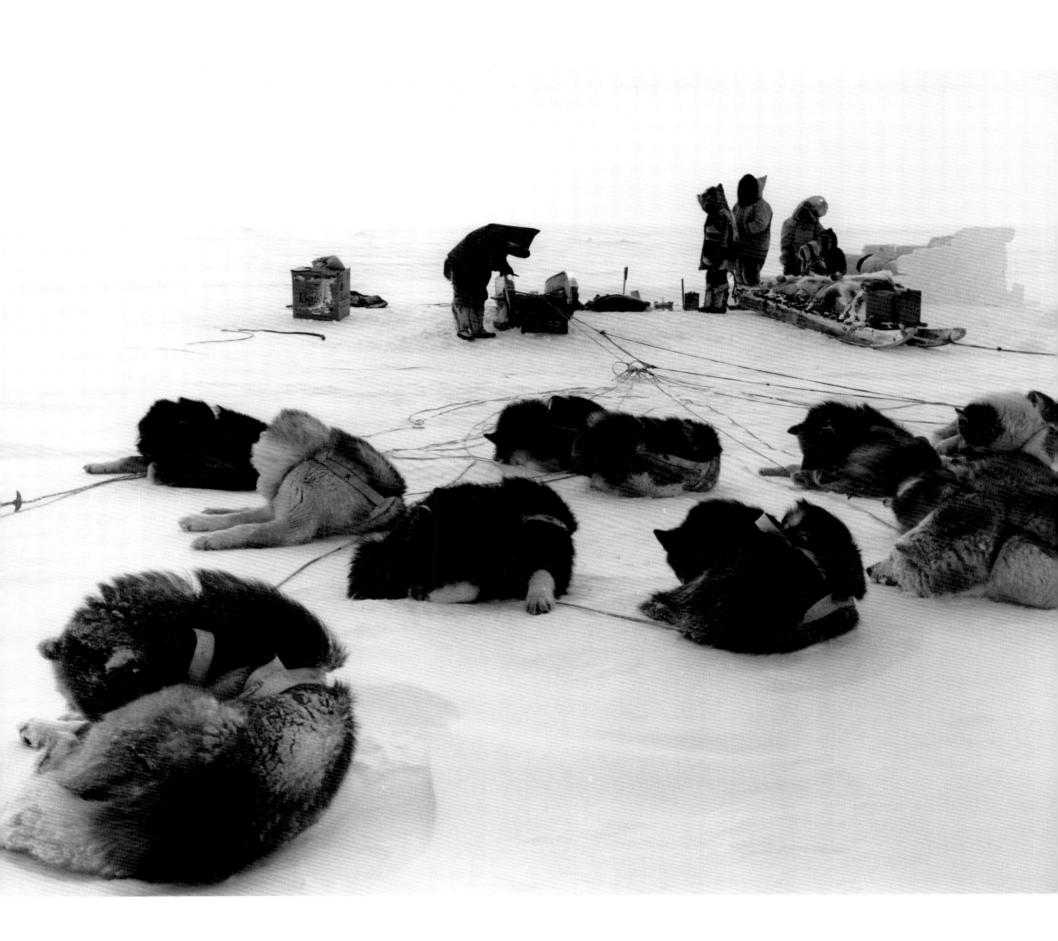

Below: Using a broad-bladed snow knife, Peter Agliogoitoq builds our igloo for the night. Each snow block is about a metre long and weighs 18-23 kilograms. The spiralling rows of snow blocks, each one canted slightly inwards, are finally capped by a keystone, a large, precisely cut snow block fitted into the top of the dome from the outside. It is a perfect shelter much stronger and warmer than a tent.

Right: In 1969, the 89 Inuit of the Bathurst Inlet area lived in 11 widely scattered camps in a region larger than Belgium. If provisions allowed, spring was their favourite time to visit friends and relatives in other camps, travelling usually during the cold, luminous night, when frost hardens the snow. In the central and western Arctic, Inuit harnessed their sled dogs in pairs to a centre trace and at its head ran the lead dog.

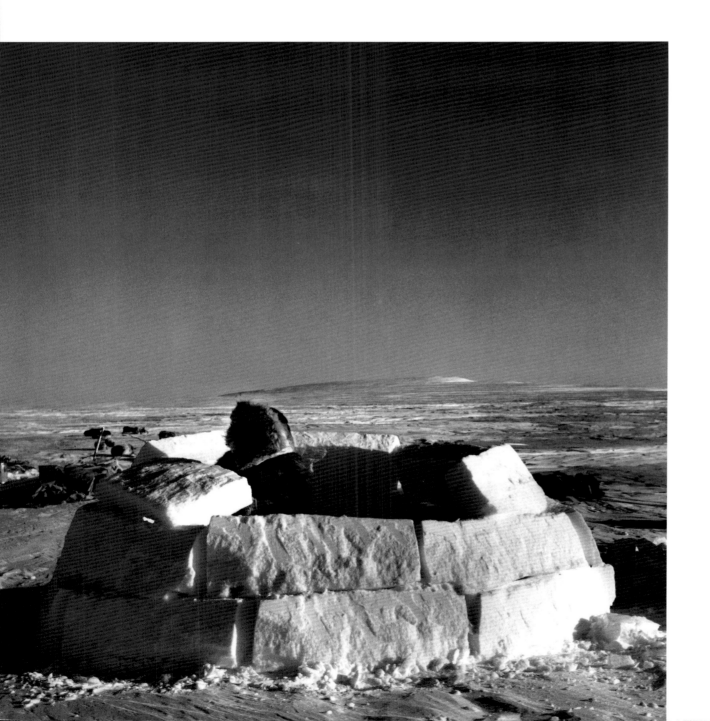

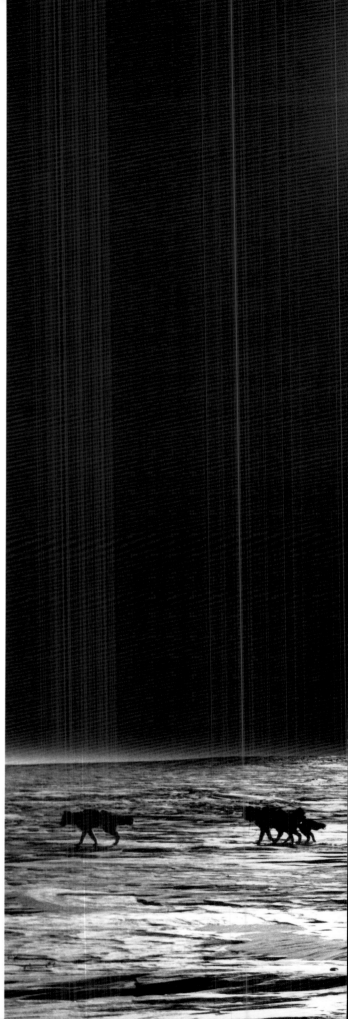

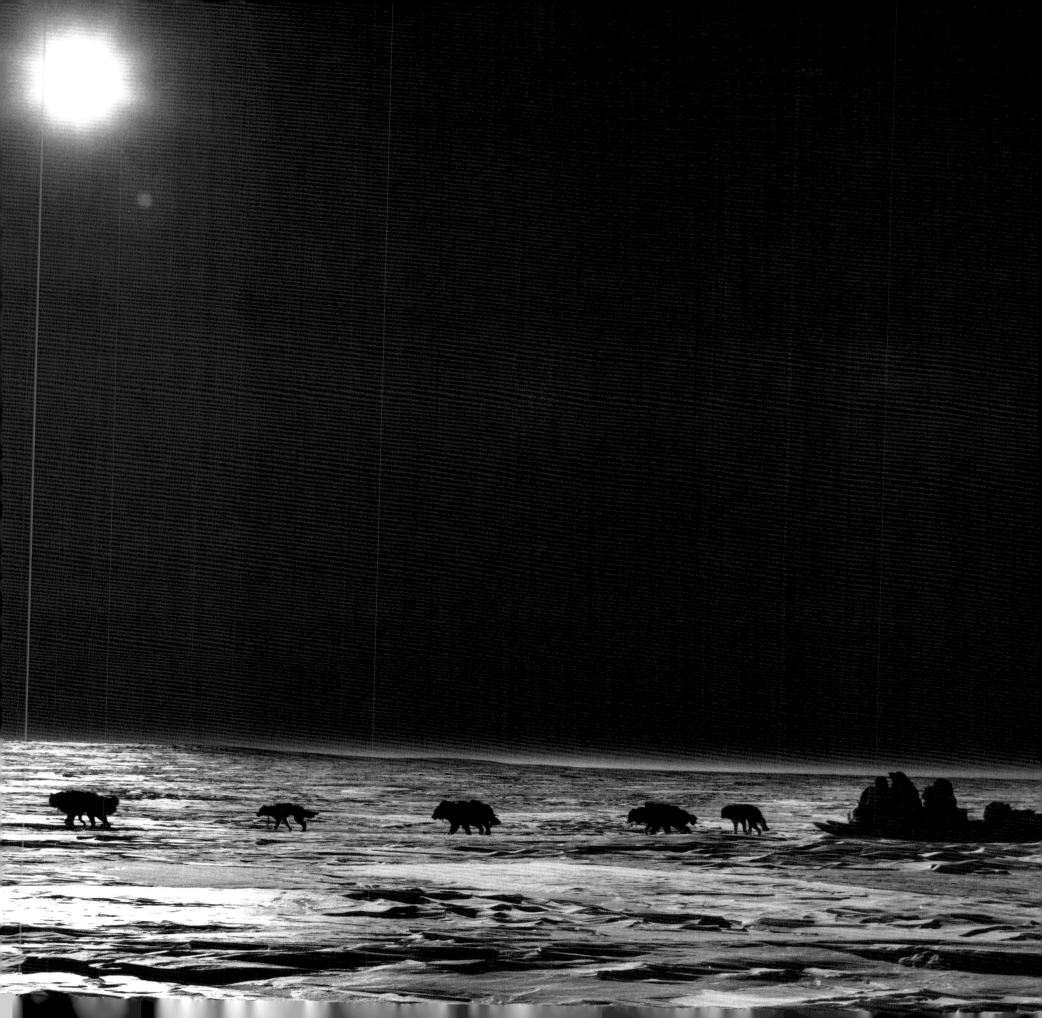

Below: Early summer travel across the water-flooded ice of Bathurst Inlet. The meltwater softens the dogs' paws and the water-eroded, needle-sharp ice cuts their soft pads. The Inuit then make sealskin booties for their dogs. The huskies hate the bag-like boots and try to flick them off. Collecting and retying cast-off boots takes a lot of time, so dogs are whipped when they shed their boots.

Right: To prevent moist spring snow from balling up between his dogs' pads, Akeeagok trimmed the long hairs on the paws with scissors. A few dogs, like this one, endured the procedure with resigned patience. Others accompanied the whole perfectly painless operation with ear-splitting screams and screeches.

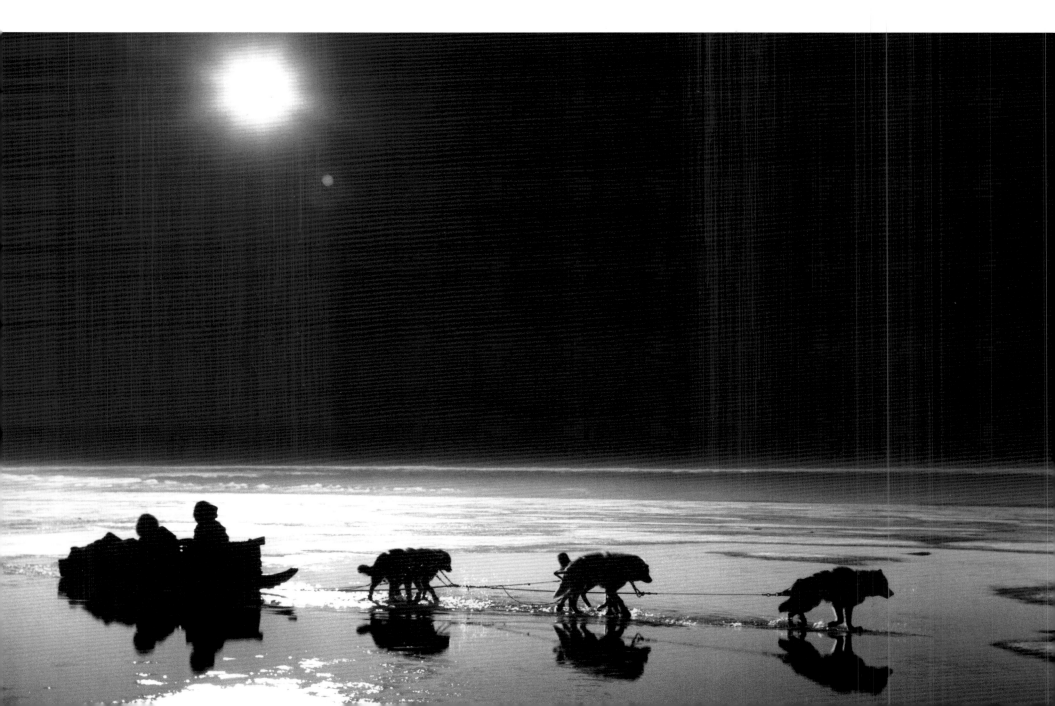

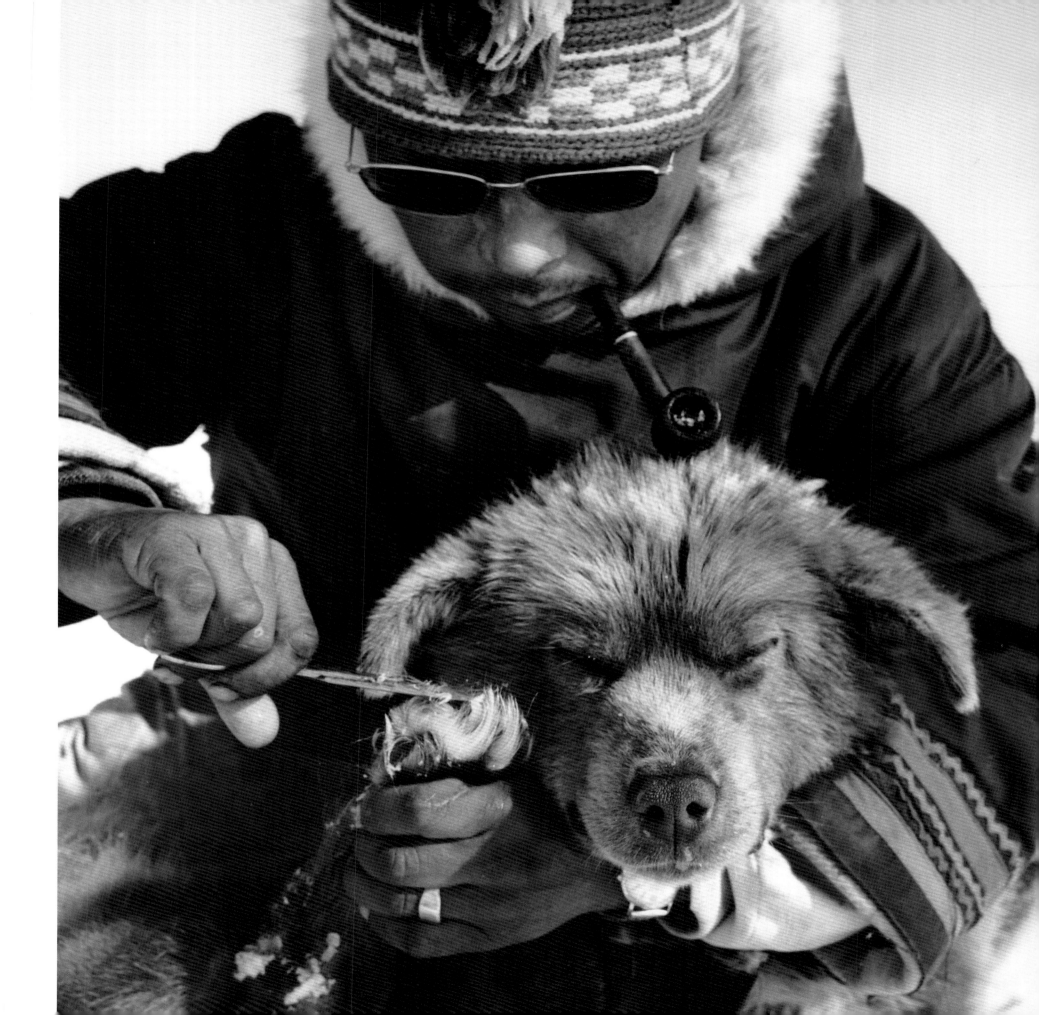

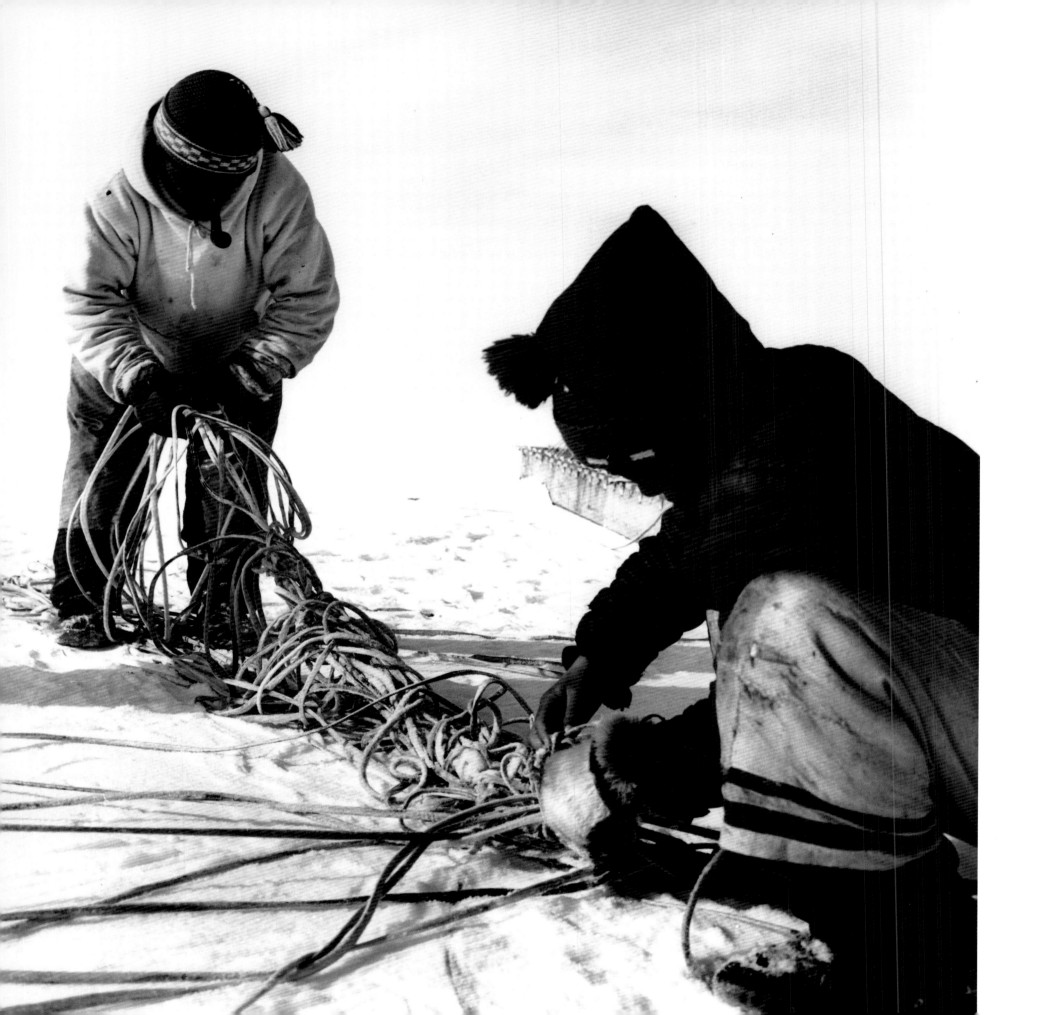

Left: Untangling the interwoven dog team traces at the end of the day. In the fan hitch used in the eastern Arctic, each dog pulls the sled by its individual trace, a strong thong made of bearded seal leather. In the course of a long day's trip, the dogs, shuttling back and forth, braid their traces into one thick plait. Unravelling the stiff, hard, frozen traces is a frigid misery.

Below: The shopping trip. About once every three months the Inuit from our camp went shopping at the lonely Hudson's Bay Company store on the northeast coast of Bathurst Inlet, a day's trip away by dog team. They sold furs, sealskins, and some carvings, and bought ammunition, fishing nets, tea, sugar, and matches. For the rest, the people were largely self-sufficient.

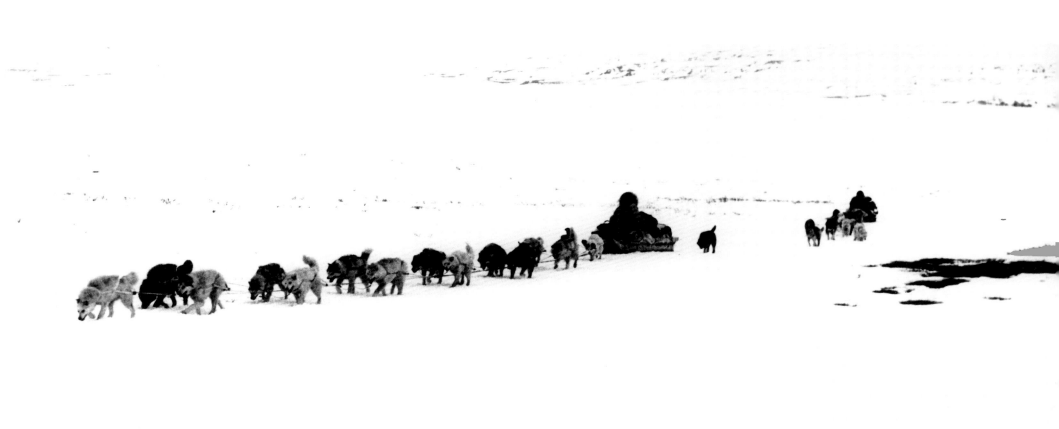

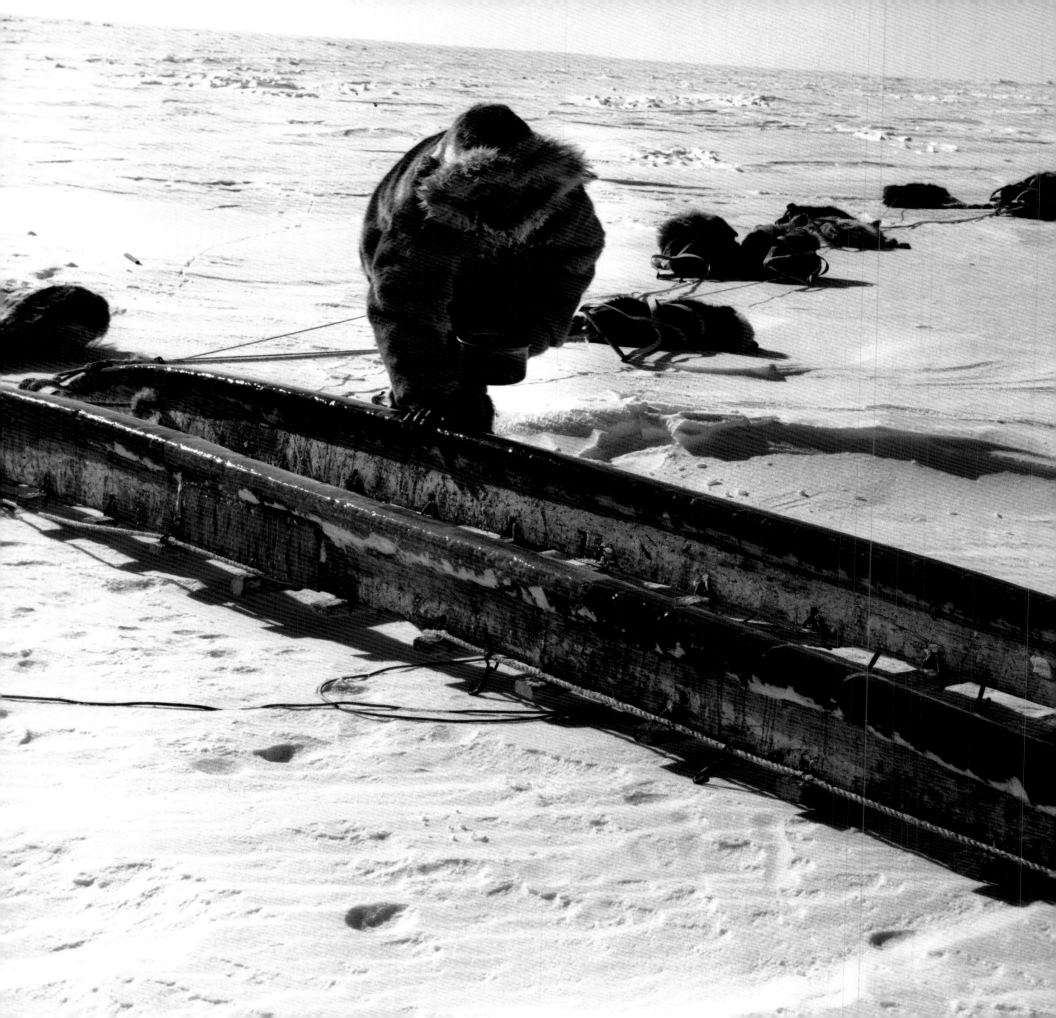

Peter Agliogoitok ices the traditional mud-covered runners of his sled. Peaty earth is dug up in fall with a hoe made of caribou antler. In early winter, the mud is boiled, kneaded into a thick, hot paste, and spread evenly onto the runners where it freezes and becomes stone-hard. This coating lasts all winter and holds the ice glaze well, which reduces friction, making it easier for the dogs to pull the heavy sled.

Endless white! We travelled like this for an entire day and part of a night and all our world was white and void. Yet during all this time, the Polar Inuk Apalinguaq knew exactly where we were and where we were going. He was guided by *sastrugi*, snow ripples created by prevailing winds, by the direction of the wind itself, and by the nearly intuitive knowledge of time and space acquired during a lifetime of Arctic travel.

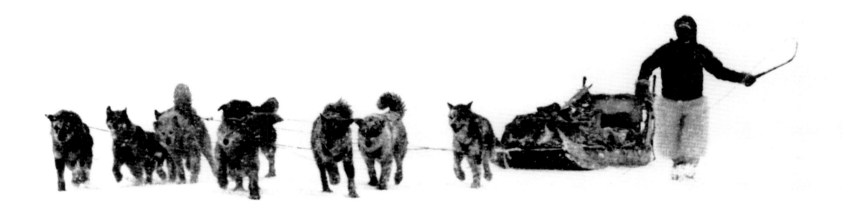

While Akeeagok builds our igloo for the night, the boys fetch freshwater ice from a nearby iceberg. This was our daily routine: one man tethered and fed the sled dogs; one man built the igloo, and, if available, the boys and I fetched ice because, for the heat expended, ice produces much more water than snow. When the dogs were fed and the igloo was finished, we chinked all cracks with snow and moved into our snow home.

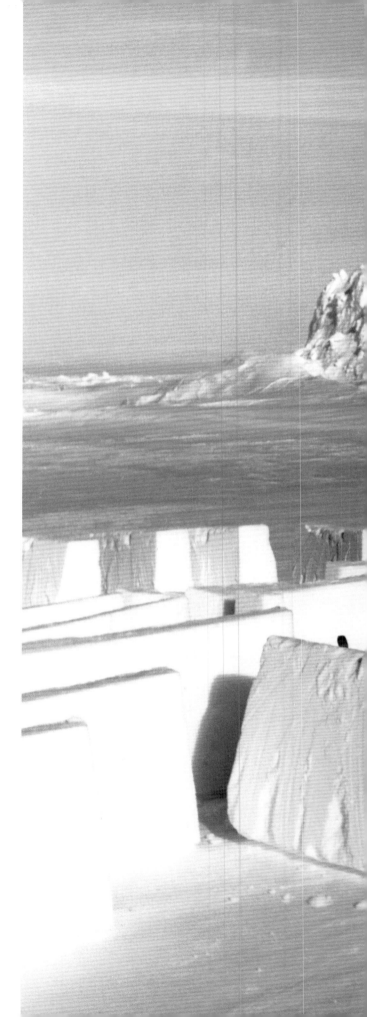

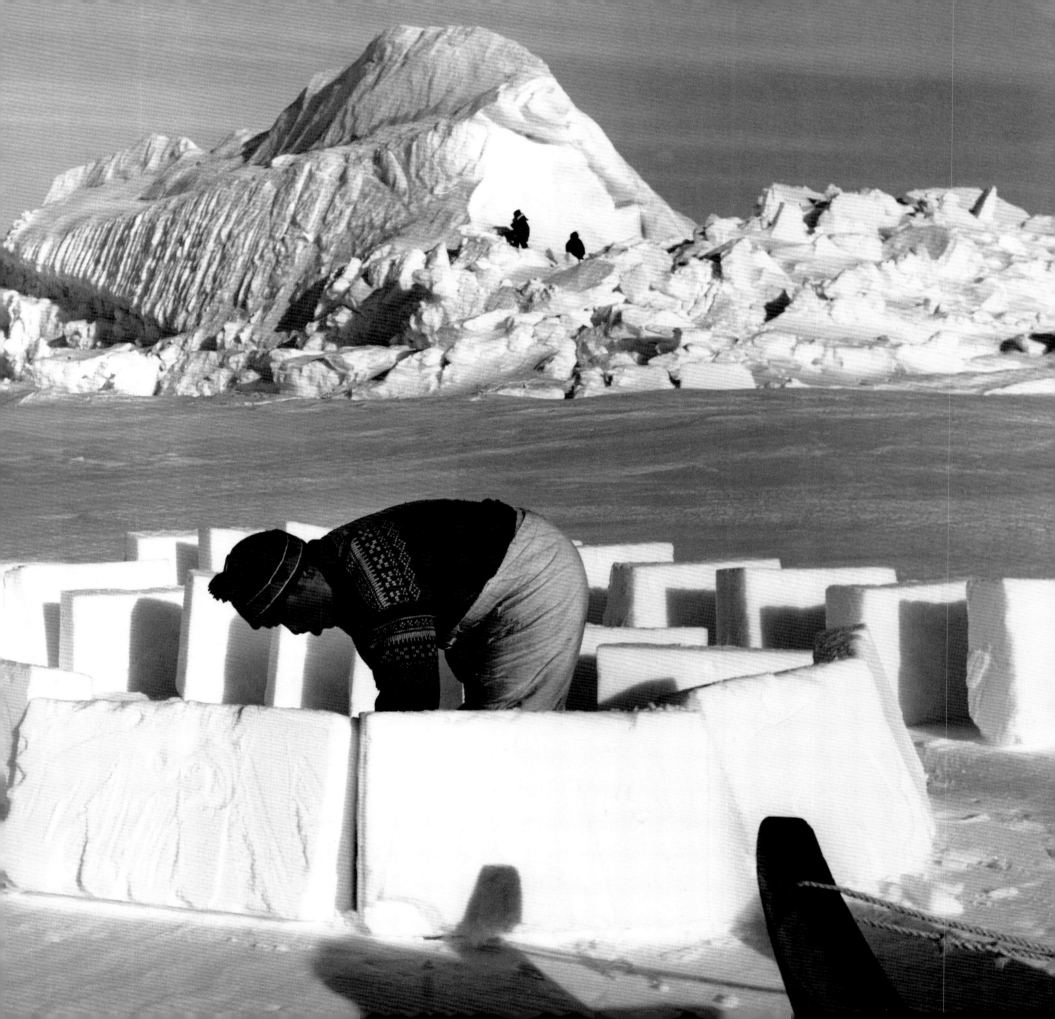

Camp on Rae Isthmus at the edge of a frozen
lake, a day's trip from the village of Repulse
Bay, northern Hudson Bay. A group of Inuit
went fishing in spring to a faraway lake,
travelling together on snowmobiles that had
replaced nearly all dog teams by the mid-
1970s. But while Inuit hunters had travelled
routinely alone with their dog teams, they
were advised by village councils and even by
manufacturers to travel in pairs or groups in a
region where a machine breakdown, far from
home, could result in death.

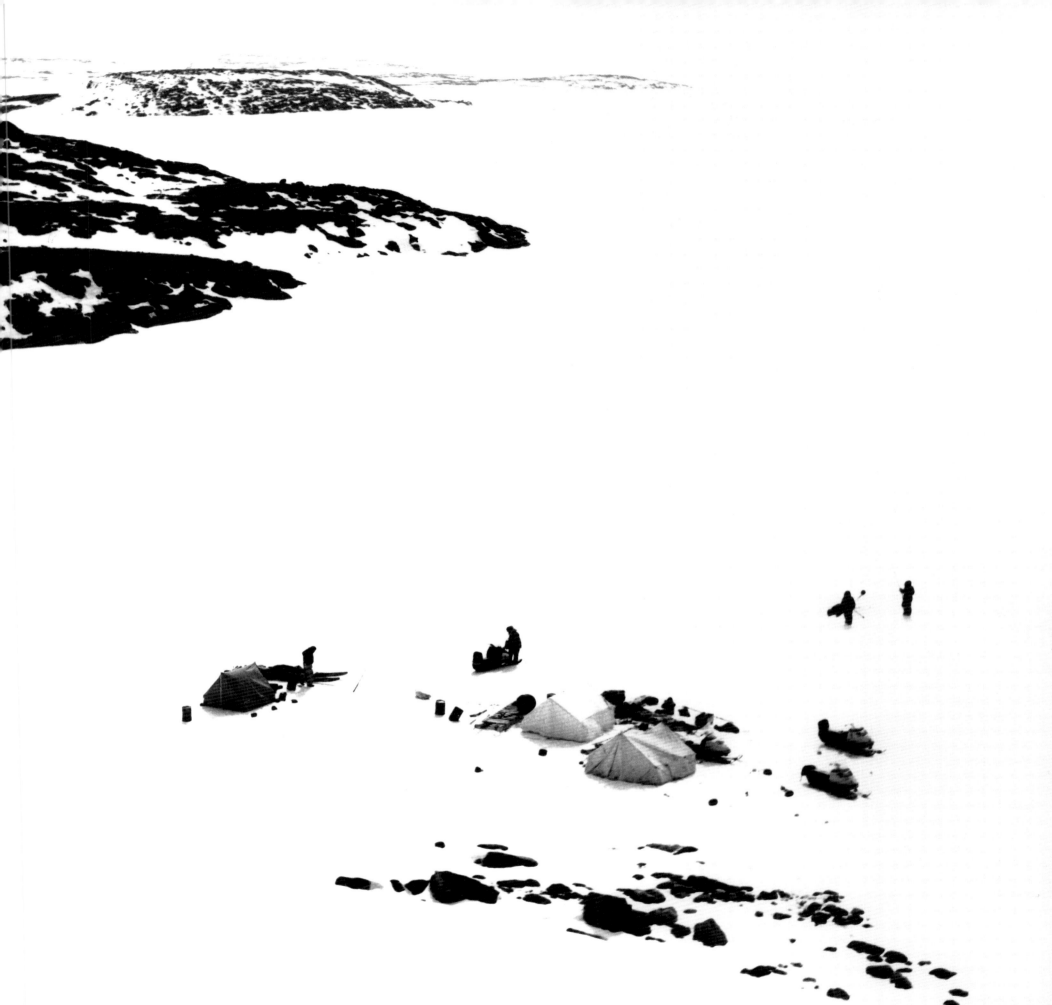

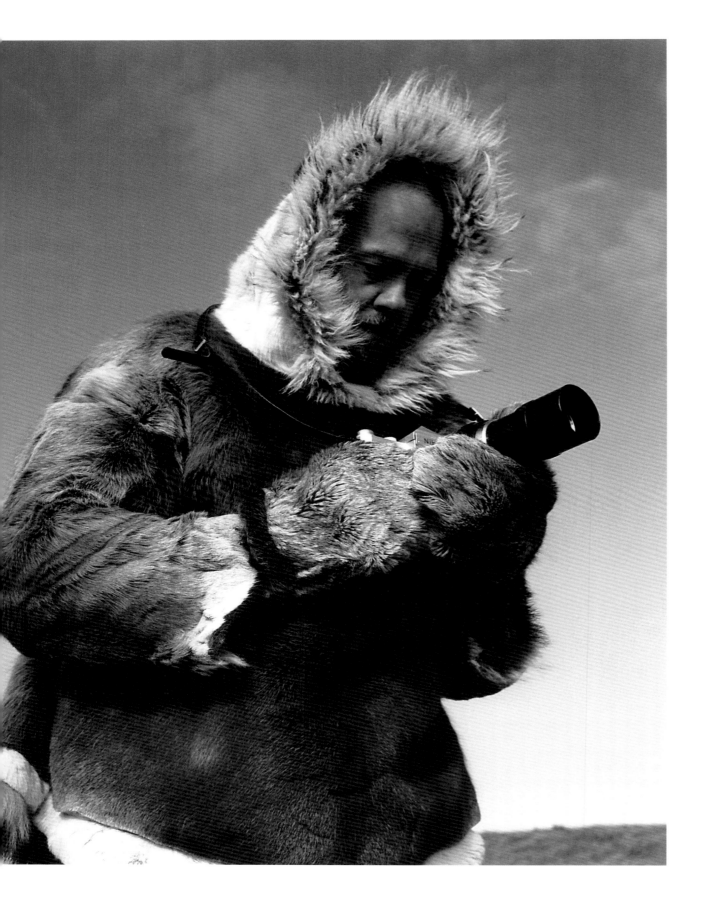

Left: The fur clothing that made Arctic cold endurable and Arctic photography possible. When I arrived in March at the Bathurst Inlet camp, Rosie Kongyona looked with disdain upon my army surplus "Arctic outfit" and made for me, in a few days, a complete set of Inuit caribou fur clothing, light, strong, and marvellously warm.

Right: On long hunting trips, Polar Inuit men often took their families along to have a home away from home while they hunted. Thus very small children became already experienced Arctic travellers. This little boy is warm thanks to his superb fur clothing: a parka of caribou fur, pants of polar bear fur, and sealskin boots with "socks" made of down-soft Arctic hare fur.

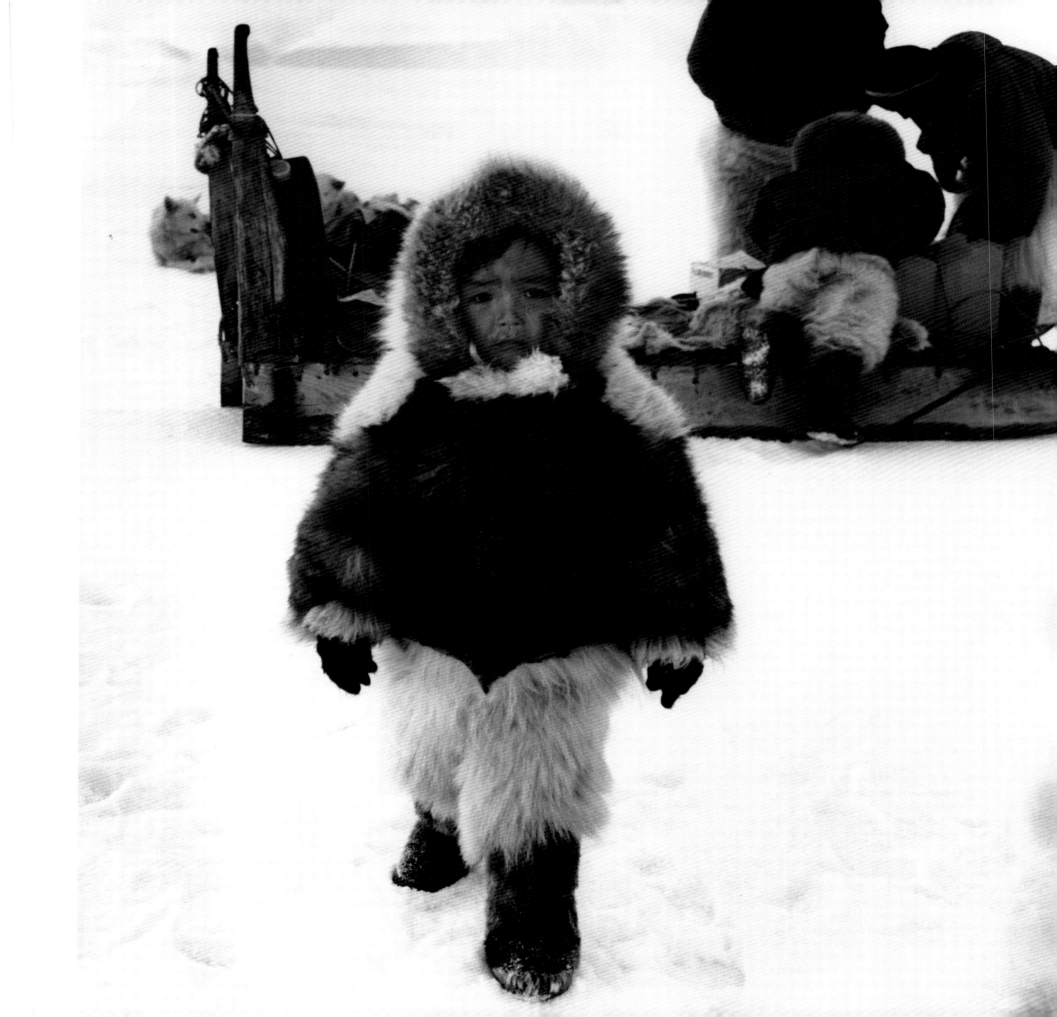

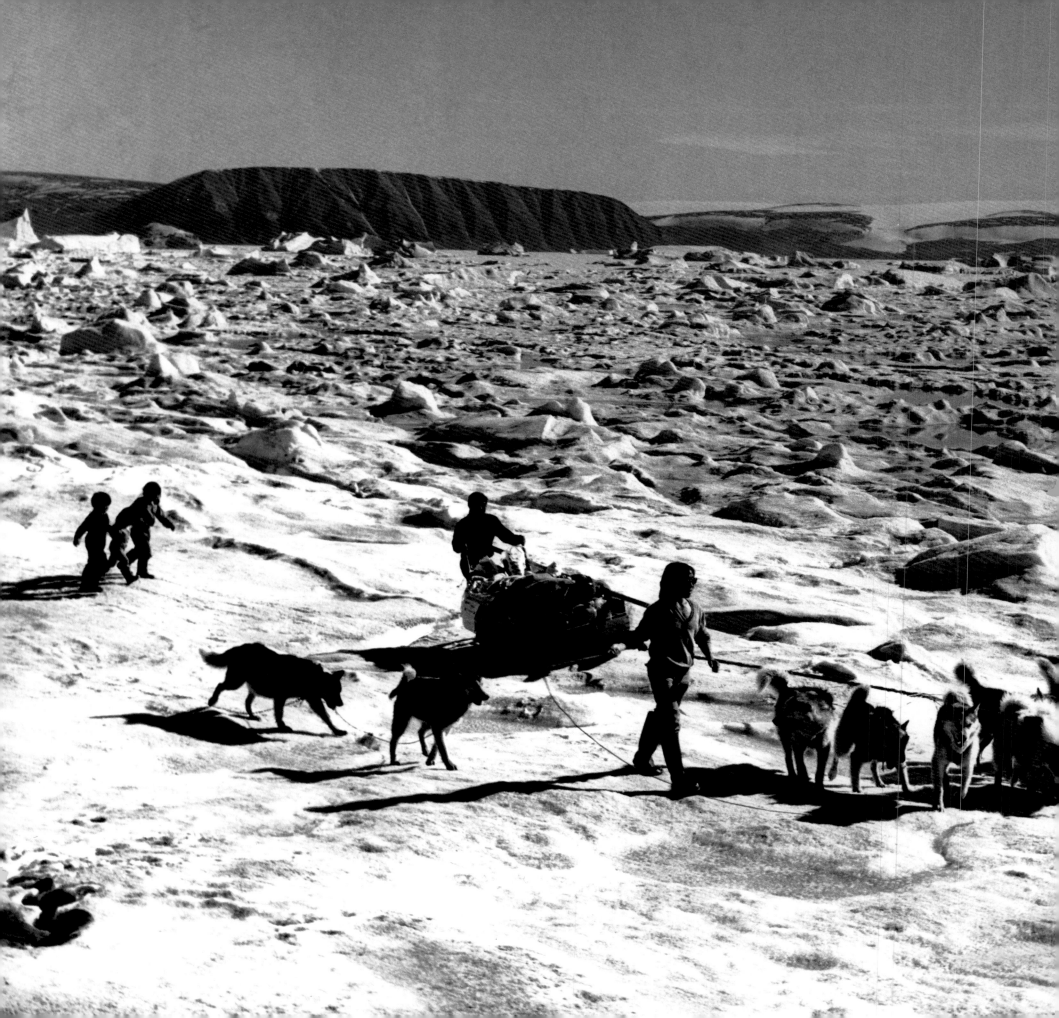

Early summer travel in northwest Greenland. It is the nicest time of the year to travel: it is warm and sunny and the children run behind the sled. It is also the worst time of the year to travel: the melting sea ice is a jumble of moving floes, and much of the land is bare and cannot be traversed by dog team. That leaves the ice-foot, the belt of shore-fast ice created by tides and spray, which is fine here where we are travelling, but often is only a narrow, dangerous ice ledge around capes with open water beneath.

Summer migration. George Hakungak carries the skin tent and his son Karetak. His wife, Jessie, carries the baby and a heavy pack. The sled dogs of winter become the pack dogs of summer. Each dog carries about 18 kilograms in sausage-shaped pouches hanging down on either side. The dogs are held on a long leash for they get very hot and, if free, head for the nearest pond or brook and soak themselves and their load.

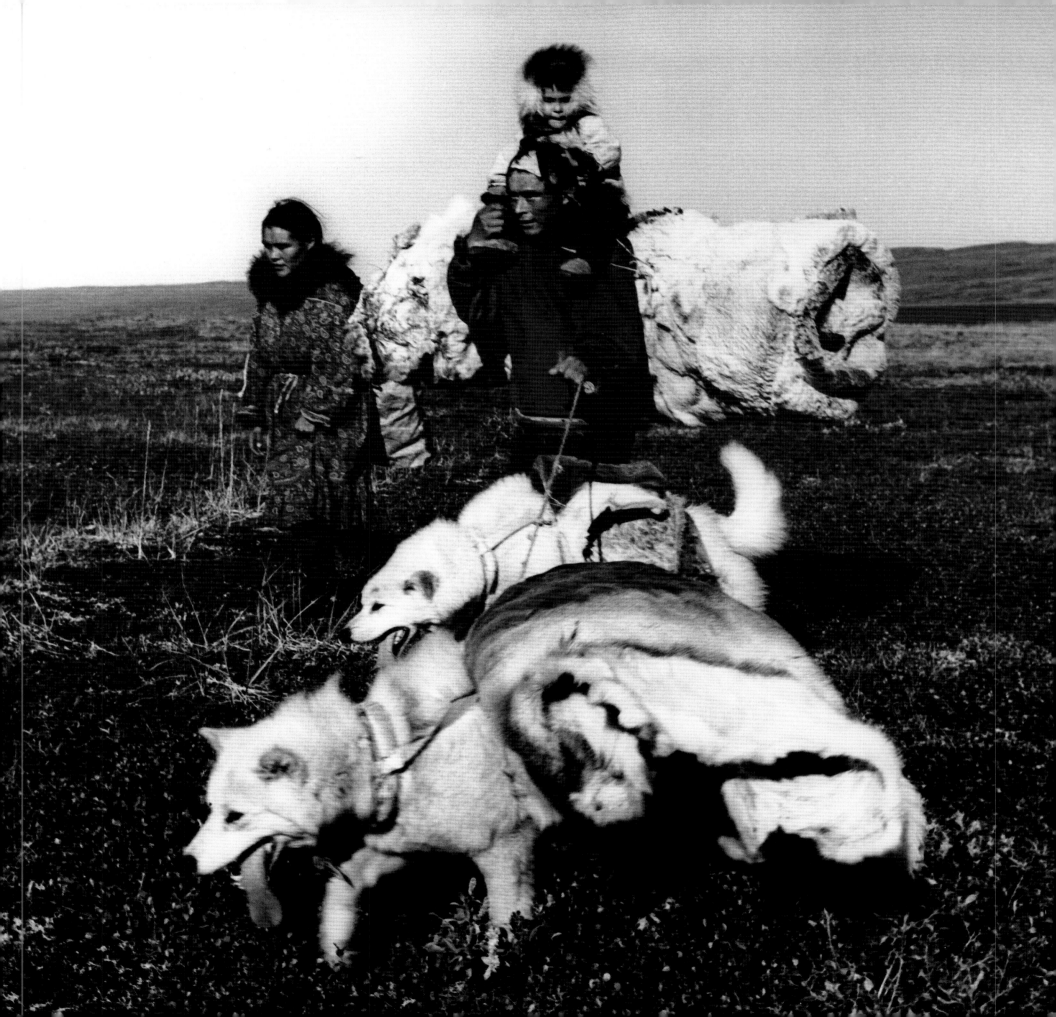

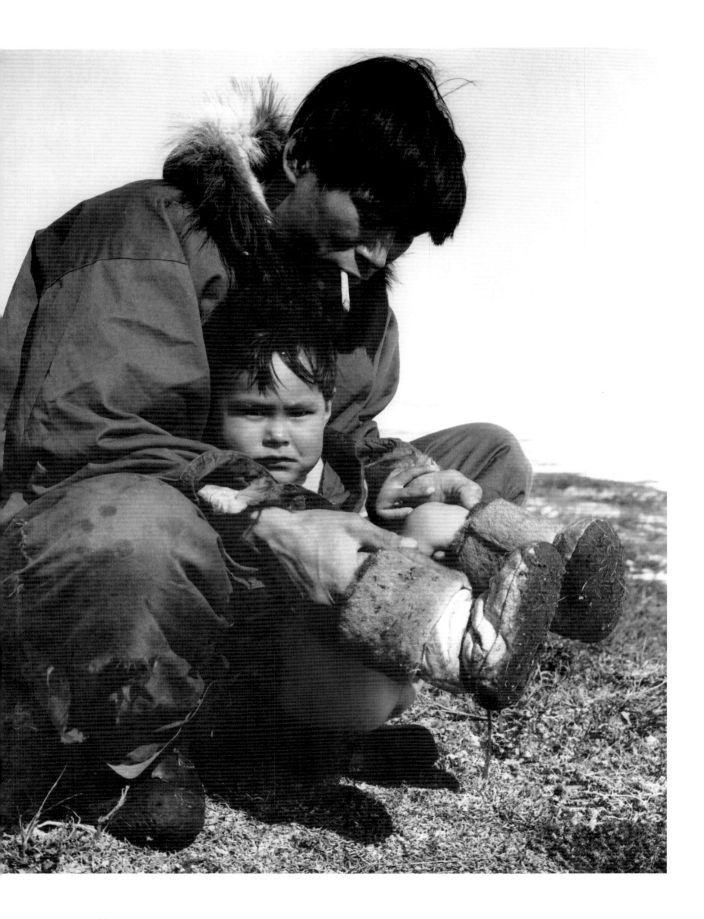

Left: While both Inuit parents love and teach their children, boys, in the past, were especially close to their fathers. The father helped the three-year-old with a call of nature so he would not soil his clothing; he told him stories about the land, about the lakes and rivers, about the many places where Inuit once lived and hunted, and slowly, over the years, the boy absorbed his father's knowledge and learned his many hunting skills.

Right: In spring we travelled by dog team on the dangerous, rotting ice of a great tundra river. To keep us safe, George Hakungak lashed a canoe onto the long sled. For a while little Karetak found the trip on the cracking river ice wonderfully exciting. Then he became tired and dozed off and Jessie held her sleeping child.

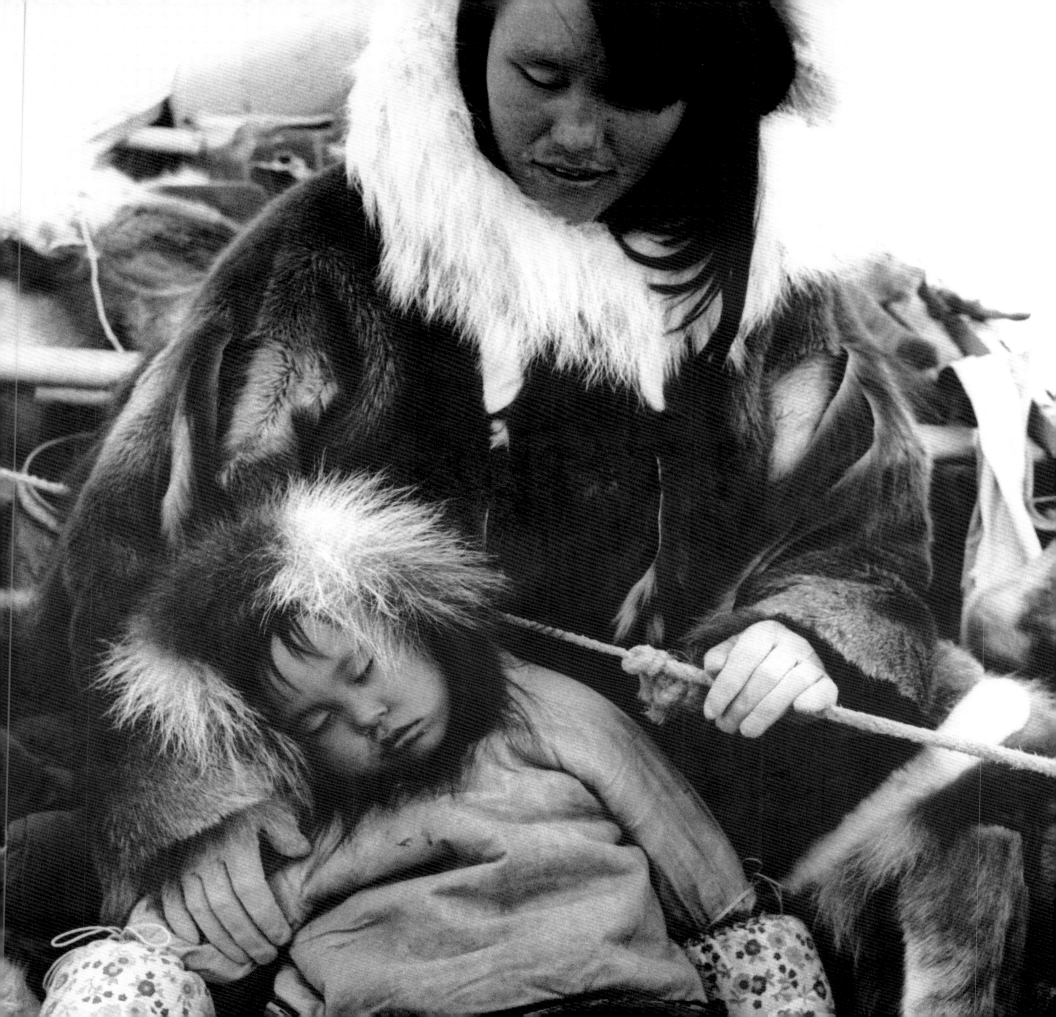

CAMP LIFE

In 1969, the Bathhurst Inlet area of the central Canadian Arctic mainland had a population of 89 Inuit, living in 11 widely scattered camps in a region considerably larger than Belgium. I arrived at the largest of these camps, population 21, by dog team in March, uninvited, unannounced, and unexpected, asked whether I could stay, and lived there for the next six months.

It is cold! If it's -30° C outside, it's probably -20° C inside our unheated tent. Last night after I arrived, they looked at my sleeping bag, made politely disapproving noises, produced several caribou furs, and now I lie cozily cocooned in furs on the fur-covered snow sleeping platform of Ekalun's tent and listen lazily, gratefully to the sounds of the waking camp. This is now my home.

Rosie gets up and lights the stove. They used to heat their tent with seal-oil lamps. Now they made 38-litre drums into surprisingly efficient stoves and burn dwarf willow and resin-rich heather. Pots clatter. I know the noise. Rosie's going to make tea. I wonder what she is thinking. It must be odd to wake up in the morning and find a complete stranger on your bed.

The tent warms quickly. I get dressed. If Rosie is amazed or curious, she does not show it. It would be impolite. She goes outside and returns moments later with a huge, oval wooden platter piled high with seal meat and puts it on the snow floor of our tent. The tea is boiling. "Tee-toi-té," tea's up, Rosie calls loudly, and gradually all 21 people of the camp crowd into our tent for breakfast. All are dressed in voluminous caribou fur clothing. They squat or sit on the low snow benches on both sides of the tent.

They are fascinated by this alien in their midst, but are far too polite to show it. Their first worry is "Will he eat our food?"

They know I have come without any shelter, without any food. I am totally dependent on them, but I have already lived for several years at other Inuit camps and happily and gratefully eat any food. Raw blubber, white, greasy, and slippery, was a challenge at first. Now I love it—crave it, in fact. It's high-energy food, bursting with calories. It heats me from inside.

Each one of us gets a big mug of tea, very dark and with lots of sugar, takes a chunk of meat, bites into it, and slices off a piece with a large, razor-sharp knife, fast and very close to lips and nose. The children do it, but I can't. I cut my meat very carefully, with cross-eyed concentration. The adults, really immensely observant, pretend not to see it. The kids stare and giggle at my gauche way of eating, but only a bit. They, too, are marvellously polite.

We rub our greasy hands with snow, then wipe them clean and dry on the feathers of ptarmigan skin. The women leave. The men smoke. I try to talk, but it sounds strange to them. "You speak like an Iglulingmiut," says Ekalun, meaning like a person from Igloolik. It's true. I spent a preceding year living with an Igloolik area family on remote Jens Munk Island and that's the Inuktitut dialect I now speak. To the Bathurst Inlet people it sounds as funny as Bavarian German spoken by a Japanese.

Mary Arnnaoyok calls "Tea's ready," and we all troop over to her tent for a second breakfast, then to Jessie Kungaglak's for a third, and to Ella Tonakahok's for a fourth. It is the pride of every woman in camp to serve us the best food and lots of it. It shows that she is a good and generous person and that her husband is an excellent hunter, a good provider.

All food is shared. We eat from tent to tent: four breakfasts, four lunches (if the men are home), and four suppers. Even

tobacco is shared. We're in Mary's tent. I've forgotten my pipe and tobacco. Ekalun pushes over her husband's tobacco can. "Smoke," he says. Then, with a grin, he adds, "We are not like people in the South who, as they tell me, like to keep things for themselves. What we have, we share."

Ours is a four-family camp: Ekalun and his wife Rosie, and their children and grandchildren. All are equals, for theirs is essentially an egalitarian society, yet Ekalun is very clearly the *primus inter pares*. He is respected. When he talks all listen. He is an impressive man, with a powerful body, a lean, strong face, aquiline nose, and shaven head except for a tuft of hair on his forehead.

Ekalun is about 55 years old. He does not know his exact age and he does not care. He finds my White man's preoccupation with figures and time ludicrous and tiresome. When he was young, his people counted only to five. Beyond that it was "many."

They did not count the years, but I can sort of figure out his approximate age because I know he was a 10-year-old boy when he and his people were "discovered" by the 1913-1918 Stefansson-Anderson Canadian Arctic Expedition. Once, in a reminiscent mood, he tells me about that amazing day. "They were so rich," he recalls, still with awe in his voice. "They had so much wood, and pots and guns, and steel needles, and so many things made of metal." He and his people had only poor pieces of driftwood and native copper found occasionally on the beaches of faraway islands.

Ekalun was about 20 when he married 16-year-old Kongyona, her beauty enhanced with extensive tattoo lines on face, hands, and upper arms. About that time, in addition to hunting, he began to trap, sold furs, and bought his first gun. Until then he

had hunted caribou with bow and arrow or from ambush with a spear, and he had captured and killed seals with his harpoon. At that time, too, missionaries came to his land and Ekalun, until then a "pagan," became a Christian and was baptized Patrick and his wife Rosie.

Our camp consists of four large white canvas tents, each one about 3.5 metres long and 2.5 metres wide. The tents are encircled by high snow-block walls to protect them from the wind. Two are covered with caribou skins for additional insulation. I live with Ekalun and Rosie.

The entrance to our tent is sheltered by an extensive snow-block porch. The tent door has a seal-thong hinge that pulls it shut after you enter or leave. That's important. The camp has 10 children. Two are babies and live warmly and usually peacefully in their mothers' *amauts*, the fur-lined back pouches of their voluminous coats. The rest of the kids, aged two to 15, are highly mobile. They play outside or emulate the adults and help with work. They're in and out of the tents all day and whenever they are hungry, they eat meat and drink tea in whatever tent they happen to be in. It's really one big family that slowly also manages to absorb an alien entity like me.

At the far end of the tent as you enter is our sleeping platform, made of snow, about a metre high, the width of the tent, and 2 metres deep. It is covered first with dense mats made of willow twigs tied with seal thong. Upon this insulating layer lie sealskins, an old moose hide, and a bear skin, and upon them a top layer of well-scraped, chamois-soft, deep-pile caribou skins. In daytime, our sleeping robes of caribou fur are piled against the rear end of the tent.

The sleeping platform is the centre of our home. That's where we sleep. And that's where, on days when Ekalun is not away hunting, he and Rosie sit, right-angled, and work. She is usually sewing or repairing fur clothes, especially those of the grandchildren. Ekalun carves, with great skill and infinite patience, an ensemble of soapstone figures: a man, a woman, and one dog hauling a heavy sled. "That's how we travelled long ago," he says.

Rosie's realm is on the left, with a rack near the stove for drying clothes, especially the outer sealskin boots and the inner boots made of caribou fur. Upon a counter made of snow and covered with wood are the tea mugs, the huge teapot, her *ulus*, the crescent-shaped women's knives, and a few long, deep-brown bone skewers to fish chunks of seal or caribou meat out of the boiling broth. Near her on the fur-covered platform are bags with spare clothing, her extensive sewing kit in a loon-skin bag, and another bag with dried caribou sinews, the traditional thread used to sew fur clothing.

Ekalun sleeps and works next to her. At the back are bags with his extra clothing and a box with tools, some new and store-bought, and some hand-made and very old, of bone and antler and native copper.

I sleep on the right side of the platform. Next to me is my bag with spare clothing and a pouch with my diaries, pens, and pencils (pens freeze when it's cold) and an old reliable Leica, kept at tent temperature for inside use. Outside the tent in a box covered with sealskin, are the film and my "outside" cameras, a Rolleiflex and a Nikon. I've tried to explain that I've come to photograph. At first they're partly curious and amused, and partly annoyed for it is intrusive. After a while, they cease to notice it. It's just another one of my peculiarities.

They tolerate odd behaviour as long as it does not make special demands that in any way curb their freedom. They are very sociable, but at the same time highly independent-minded individualists. They do what has to be done when they feel like doing it. They take orders from no one and give orders to no one. Life in camp runs to an ancient order, an immutable rhythm of need and mood in harmony with the primal rhythm of the seasons.

In camp measured time means nothing. At first I kept asking, "When will this happen?" and "When will that happen?" and the invariable answer was "Nauna," I don't know. It will happen when the time is right, when the need is there, when they're in the mood. In the meantime, they're not going to be pinned down to any schedule by this inquisitive, time-ruled guy from the South.

The children in camp are charming and amazingly well behaved. They are rarely scolded and never beaten. Their behaviour is modified by example, with teasing and with ridicule. After a while I notice with amusement that Ekalun is slowly educating and moulding me as he would an Inuit child. By prod and praise and subtle sanctions and rewards, he is altering my behaviour to conform to the rhythm and temper of camp life, with its social cohesion and individual freedom.

In late May a plane arrives and lands on the sea ice near camp. The doctor from the settlement of Cambridge Bay on faraway Victoria Island has come for a medical inspection. He finds us all in the best of health, but leaves us germs and soon after we all come down with colds. In our isolation, we have little resistance to outside illnesses.

Five-year-old Attaguatiak comes home. At
Pewatook's camp on Jens Munk Island, a
few snow steps, screened by a porch of snow
blocks, led to a first door. This opened into
a large, ice-roofed anteroom igloo. From it
a narrow passage, a cold-trap, led slightly
upwards to the living quarters of the family.

The plane brings me a long letter from Maud, my wife, and takes out my letter to her. It will be her only news from me from March, when I left, until October when I return.

Ekalun sits on the sleeping platform and works on a soapstone carving. He glances at me as I read the letter again and again. Finally, in a very oblique way, he sort of inquires whether the letter "is good." I've lived in camp now for two months, but so far no one has asked me a single personal question, like "Who are you?" "Are you married?" "Why did you come?" "How long will you stay?"

Yes, I tell Ekalun. All is well. It is a letter from my wife. I show him a picture of Maud. "Is she Inuk?" he asks, surprised. She's Dutch-Indonesian; their common Asian ancestry accounts for the resemblance.

Rosie comes into the tent, listens, and for the first time asks questions: "Do you have children?" I show her pictures of Aurel, then six years old, and René, just 14 months. They're fascinated and now that I have volunteered information, they are finally free to ask questions. I had taken their lack of questions for indifference. Now I realize that in their cultural view it would have been impolite prying, an invasion of my privacy.

Later, at supper, the others come into our tent. The tea is ready. Piles of seal meat and fat steam on the great platter. Now all want to see the pictures. They love babies and ooh and aah over the picture of René. They carefully wipe their hands on ptarmigan feathers and pass on the pictures. We eat and talk and laugh. I finally feel I'm part of the camp. I belong.

In the evening I lie among the furs and re-read Maud's letter. Rosie is finishing a beautiful, ankle-length caribou-fur coat for Jessie, her daughter-in-law. She has been working on it, off and on, for weeks, ornamenting it with dyed tassels of wolverine skin and with intricate, inlaid patterns of variegated furs. Ekalun repairs his harpoon. And while they work, both sing long, chant-like ballads of former days.

Maud's letter tells of the children, of friends who visited, of pictures sold to an American magazine, of a good film she saw, of working in the garden. It is a letter from another world.

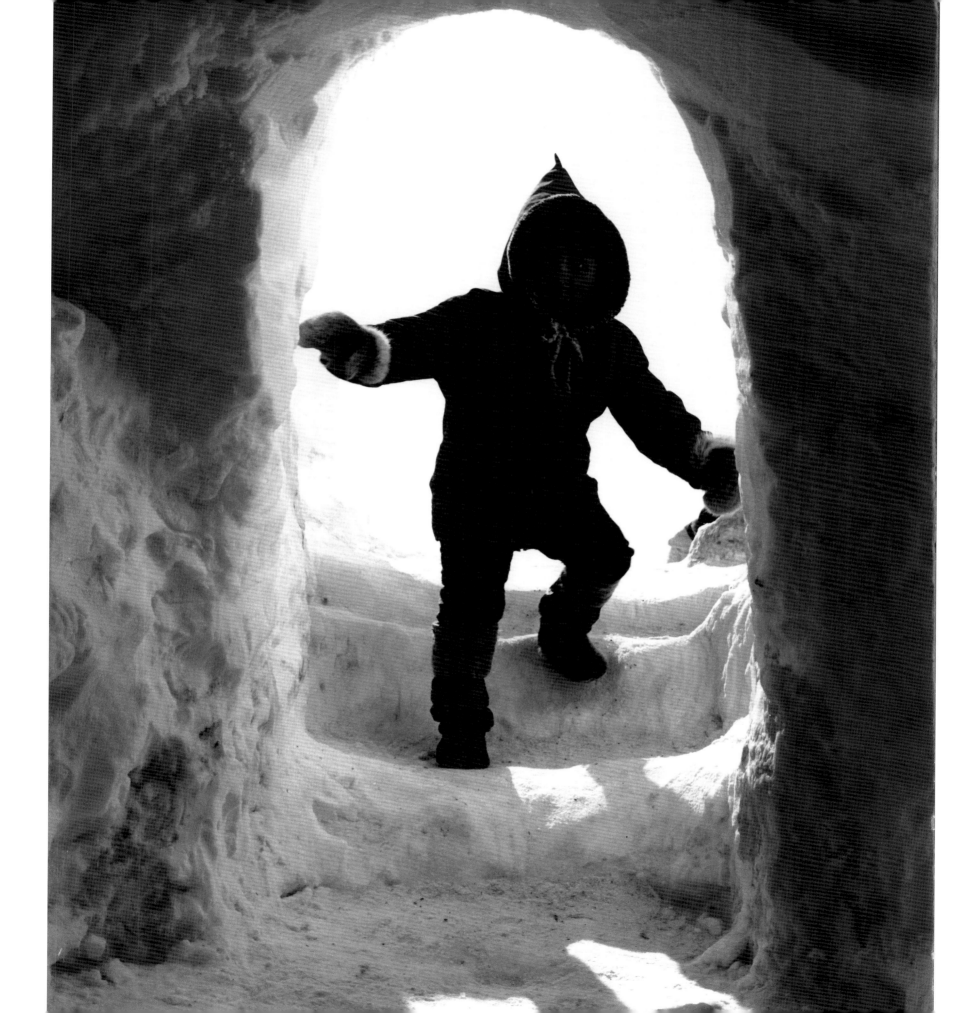

My home at Bathurst Inlet. I arrived by dog
team in early March 1969, unexpected and
uninvited, and asked Ekalun whether I might
live at his camp. He waved his hand over the
fur-covered snow sleeping platform in his
tent and said, "This is your home," and my
home it was for the next six months.

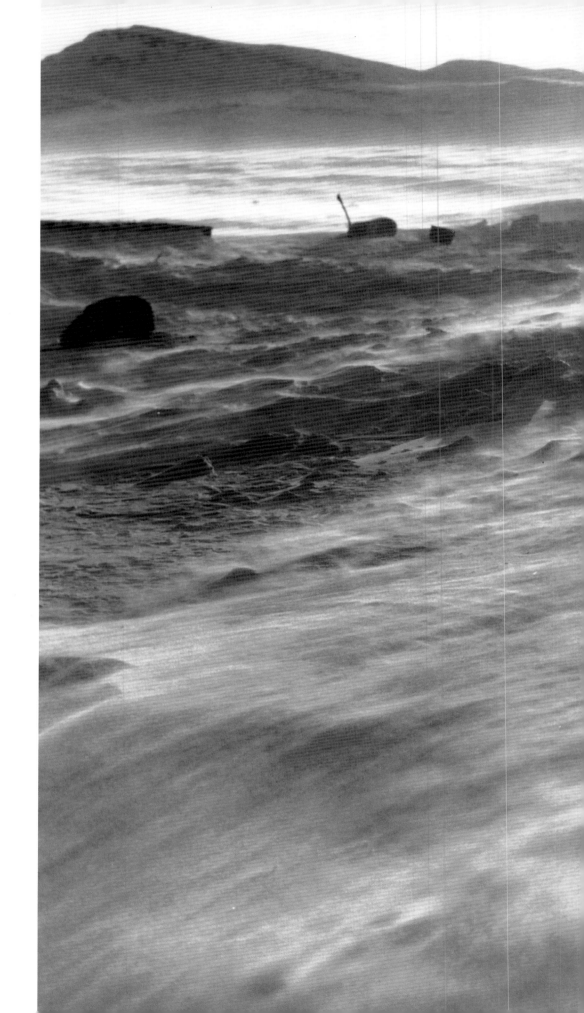

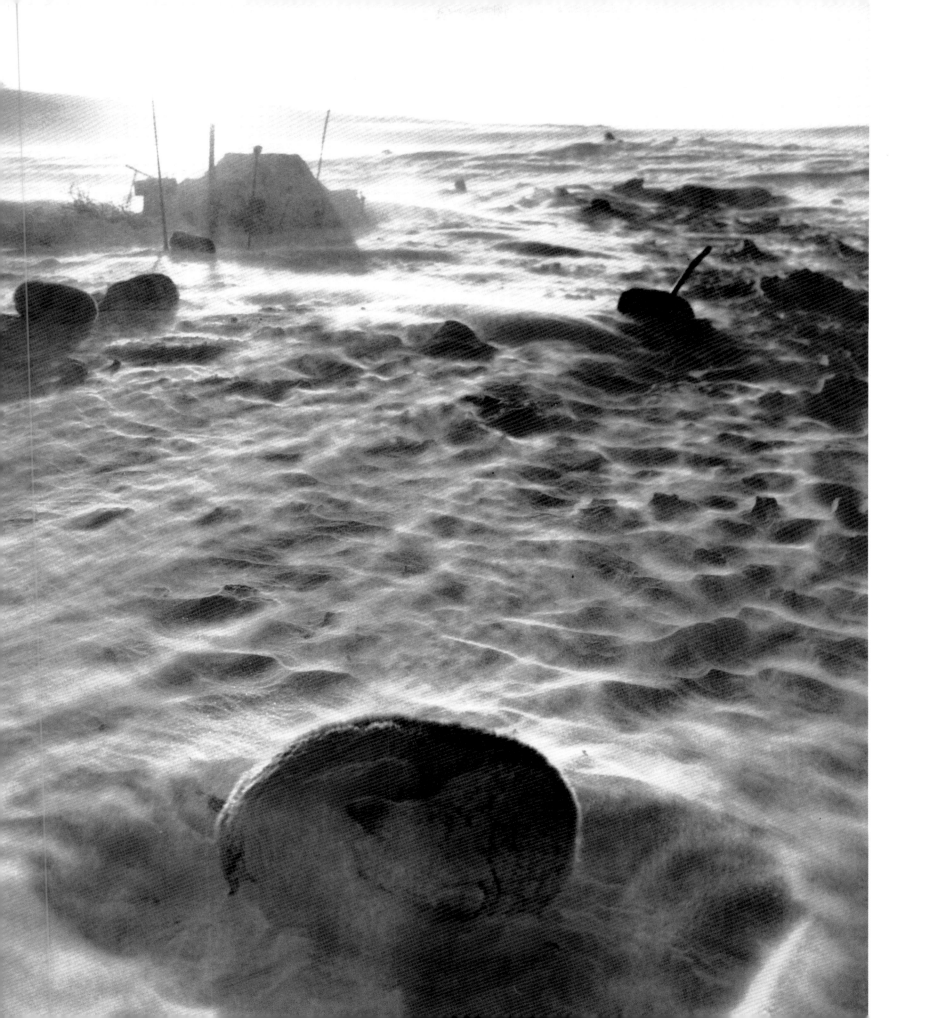

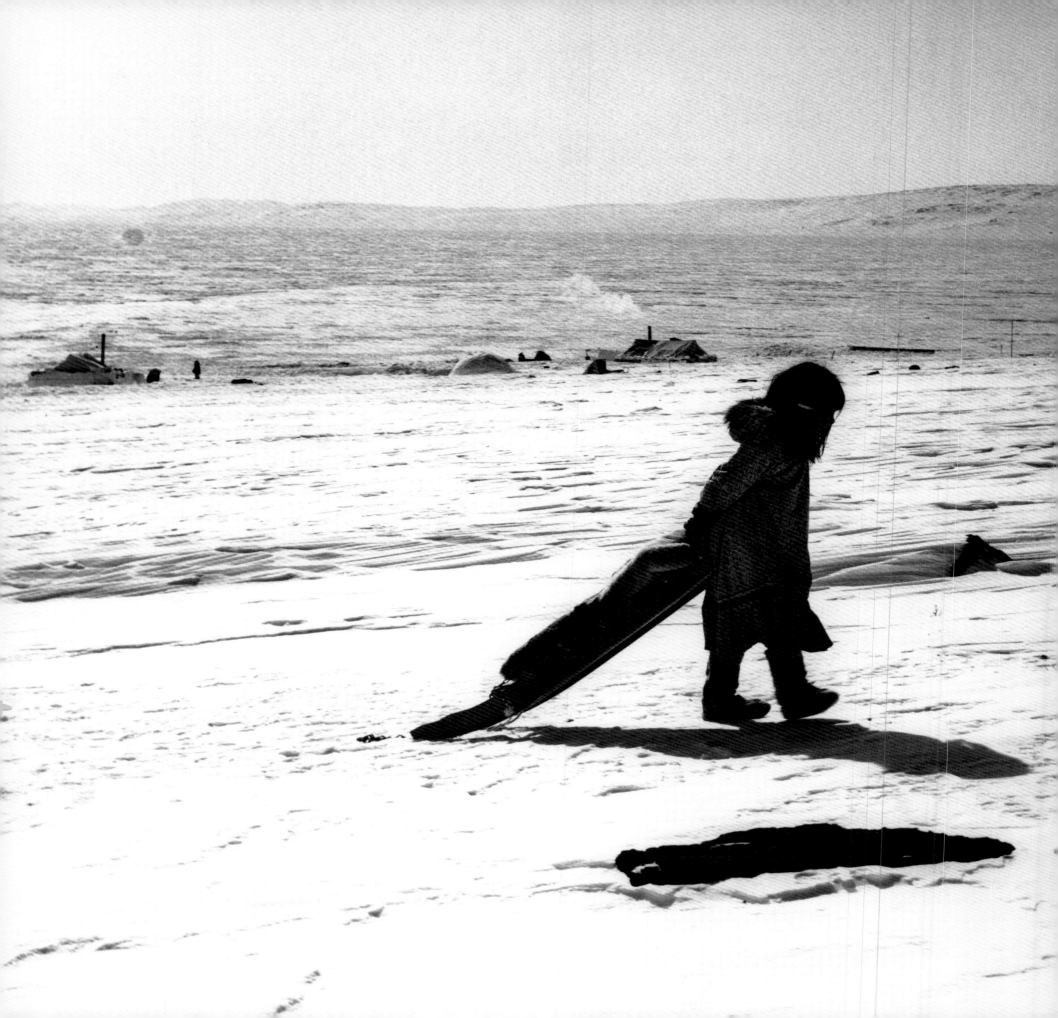

A young girl and her world: four canvas tents protected by snow block walls, 21 people, all closely related, and about 40 sled dogs. This was the camp at Bathurst Inlet where I lived for six months, a self-contained and nearly self-sufficient Inuit community, living off the land and sea, hunting seals in winter, fishing char in summer, and hunting caribou in spring and fall.

It's spring and an igloo, built in winter to shelter visitors, begins to melt and becomes a playhouse for the camp children. They dragged in some old caribou skins, made a sleeping platform, and had marvellous games in their own house, or played tag, racing in and out of the crumbling igloo.

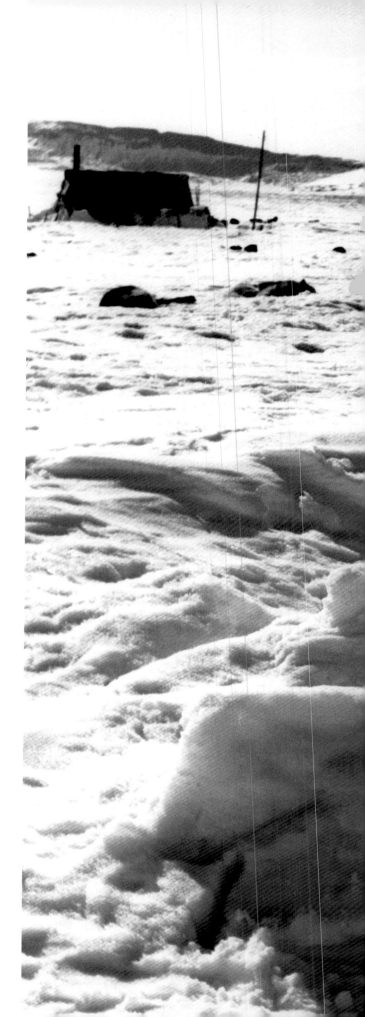

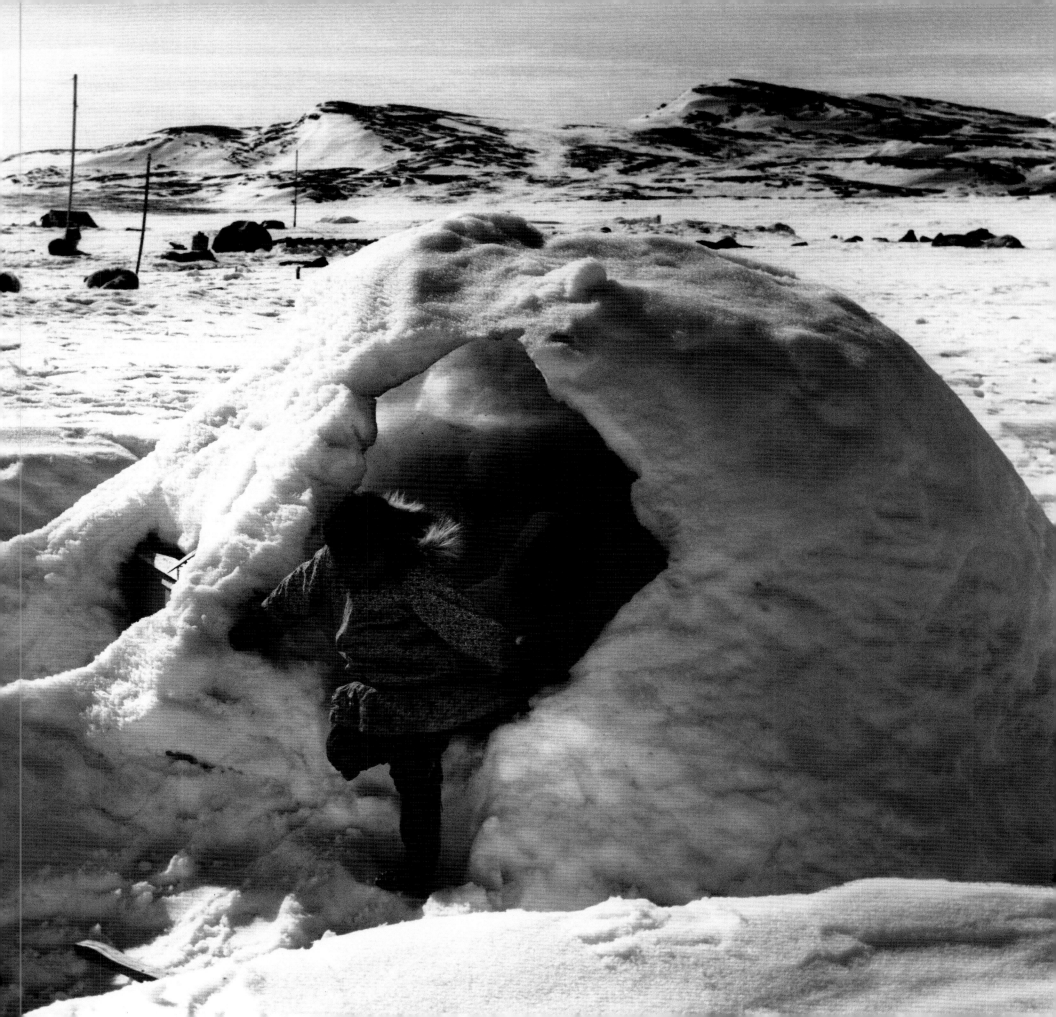

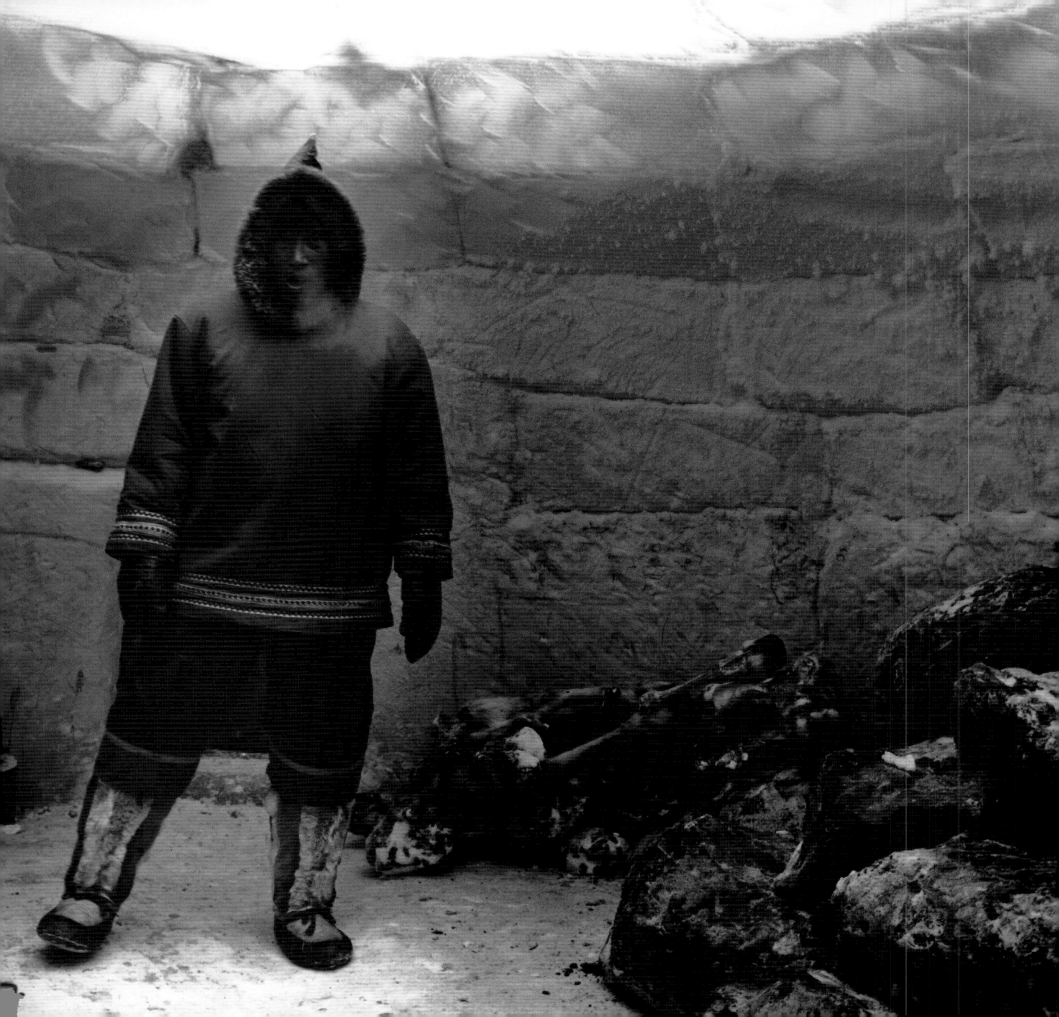

Left: Malliki in the anteroom igloo of Pewatook's camp on Jens Munk Island. Here, cold and dry, was stored the bulky outer fur clothing, the blubber for our seal-oil lamps, and piles of cut-up carcasses of caribou, seal, and walrus. This was a most unusual igloo, for it was roofed with blocks of freshwater ice and on bright days was suffused by a beautiful blue-green light.

Below: A traditional Inuit tent made of many caribou skins, with gable windows, front and back, made of scraped, translucent seal gut membrane, near a Bathurst Inlet bay. The tent was warm and comfortable, but dark inside and when moving camp was the bulkiest item that had to be carried. By the early 1960s nearly all such traditional tents had been replaced by the lighter, brighter, more efficient canvas tents.

Using her *ulu*, the traditional crescent-shaped Inuit woman's knife, Rosie Kongyona cuts up a seal carcass outside our home at Bathurst Inlet. The meat and blubber we ate, raw or cooked. From the collected seal blood, together with blubber and bits of meat, Rosie made a high-energy soup. The seal's skin, carefully cleaned and dried, was used to make light and durable sealskin boots.

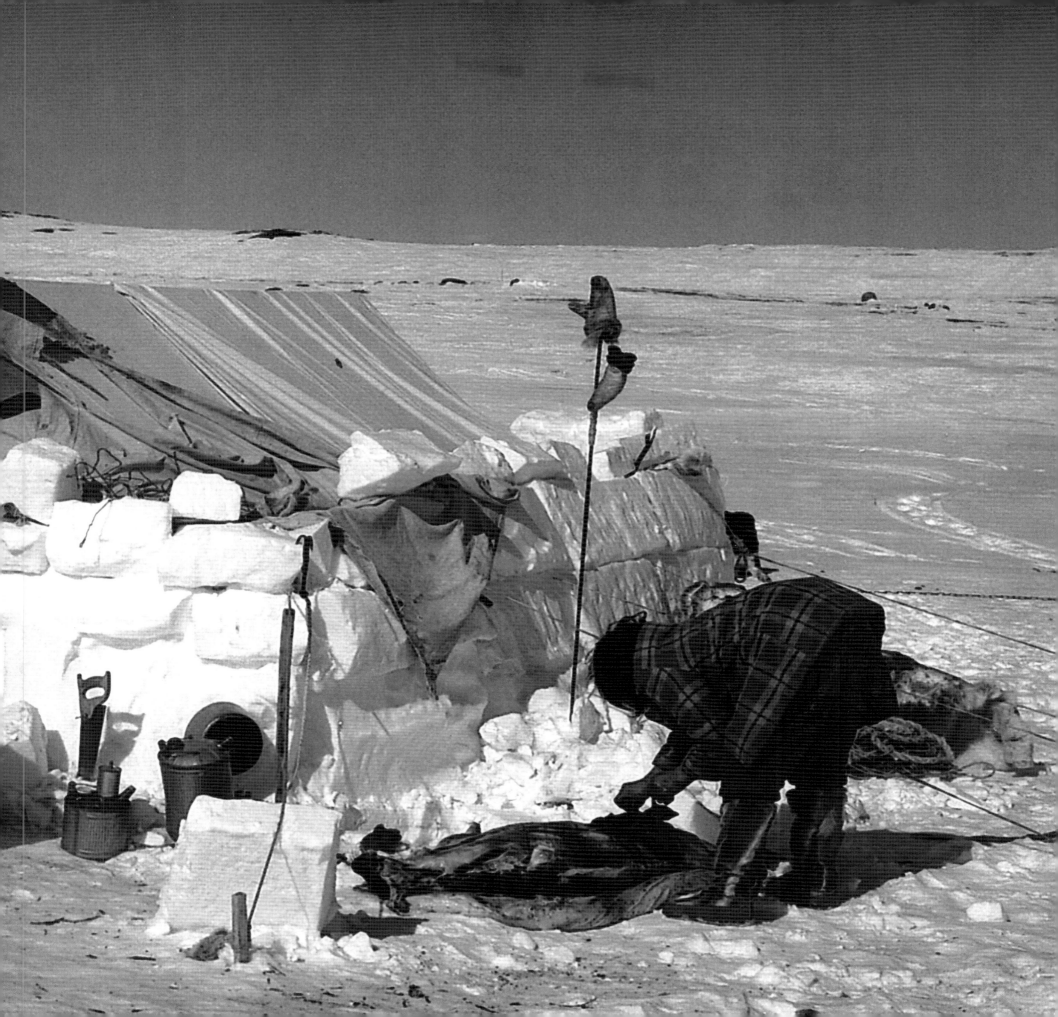

The camp at Kater Point, Bathurst Inlet, was home to only three people: George Kuptana, his wife Alice Anaoyok, and their son Noah. Alice had carefully cleaned two sealskins and pegged them out to dry. I visited them from Ekalun's camp, a 50-kilometre walk, and arrived at a bad time. The family was very short of food and was embarrassed, for they took pride in feeding guests. What little they had they shared with me.

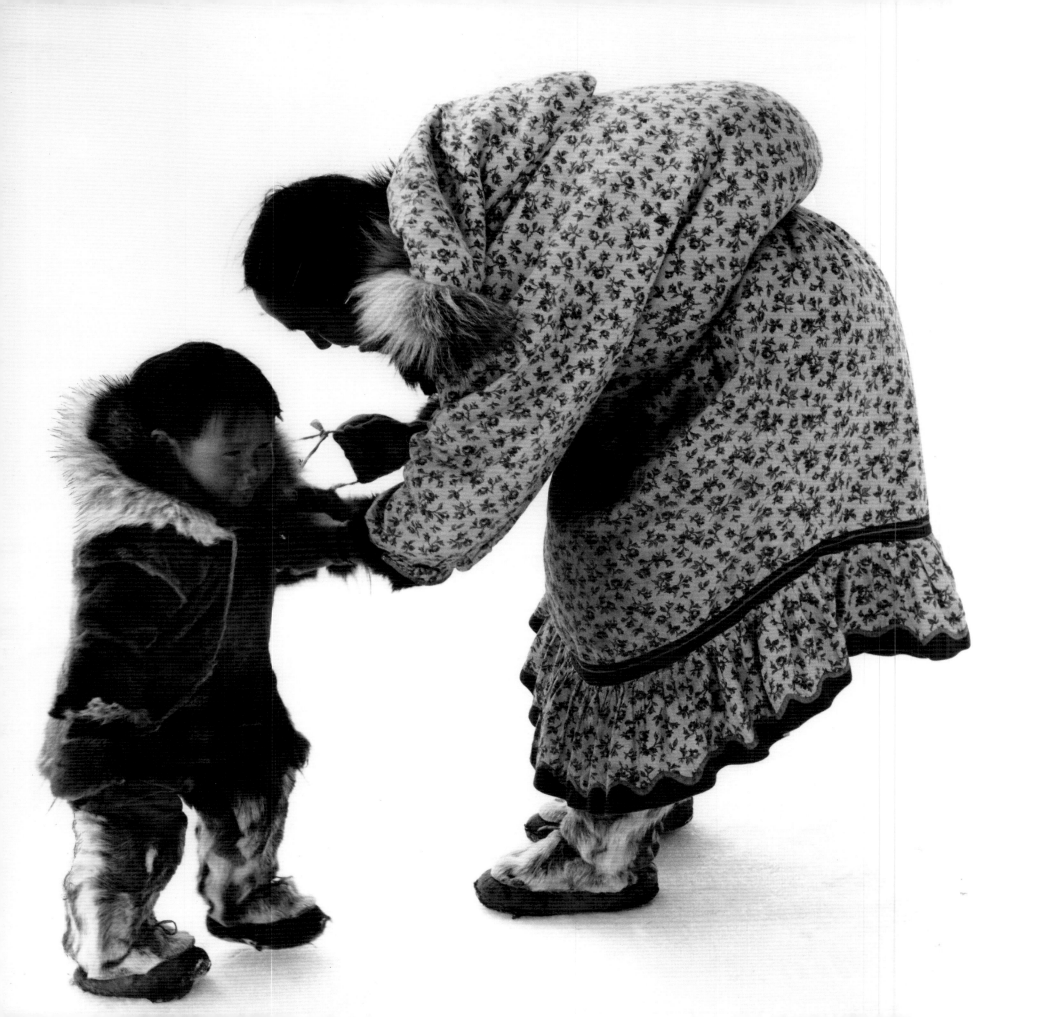

Left: Three-year-old Oched is raring to go and play, while his mother, Ella Tonakahok, makes sure the seal-thong harness that holds his caribou-fur mitts is well adjusted. To the children at our camp all the world was their playground and, warmly dressed in fur clothing, they romped outside all day, even when it was extremely cold.

Below: Girl cousins at our Bathurst Inlet camp push a battered, homemade sled up a hill and then come racing downwards. They had infinite space and endless energy. And when they were hungry, they rushed into any one of the camp's four tents, ate lots of meat and fat, drank mugs of tea, and rushed out to play again. In play they acquired the hardihood and many of the skills they would later need in adult life.

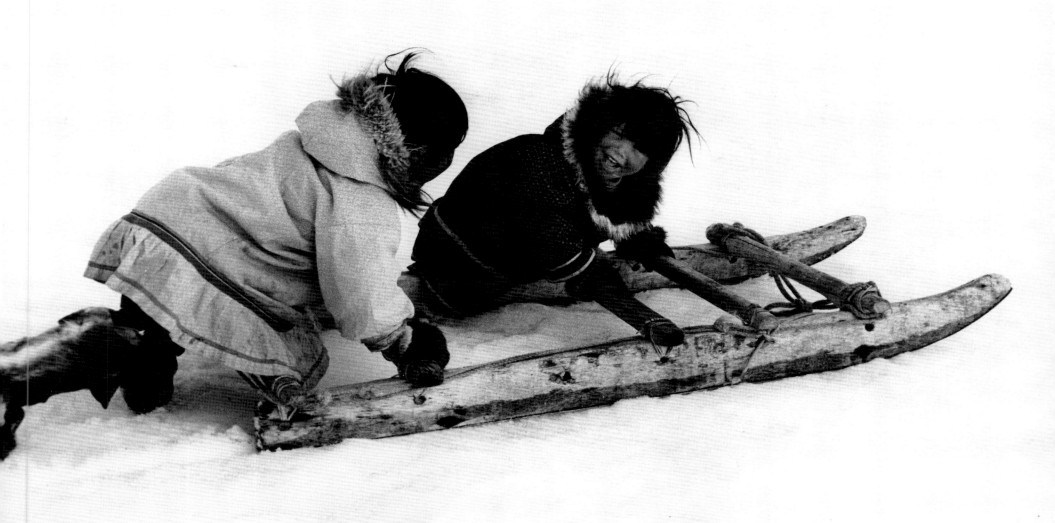

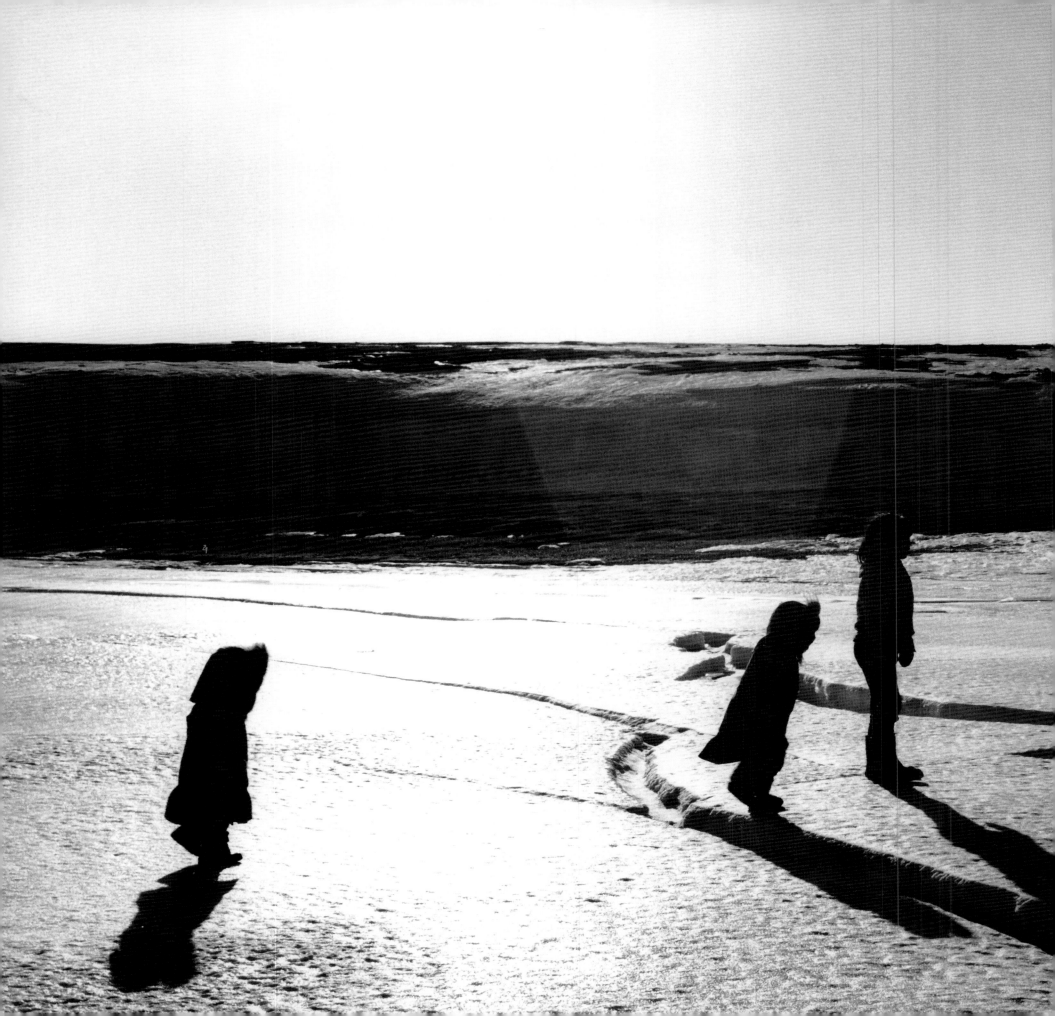

Children play on the sea ice near our Bathurst Inlet camp in the soft, luminous light of the Arctic spring night. The easy rhythm of camp life was vastly different from the clock-regulated lives of people in the South. Children slept as long as they liked, helped adults with small chores, and often played together much of the night.

Below: Exhausted after hours of play, three-year-old Karetak sleeps on the fur-covered platform of our tent at Bathurst Inlet. Children were loved by everyone in camp, were watched that they did not get into serious trouble, and were usually marvellously free.

Right: Sweating profusely, Atooat of Arctic Bay, northern Baffin Island, cleans sealskins she had soaked in hot water. Her face was tattooed when she was about 12 years old, she told me. A needle was pushed through the skin, pulling a sinew thread covered with soot for black lines or with gunpowder for blue lines. "It hurt badly, but it made me very beautiful," Atooat said with a big smile. She was about 80 years old when I took this picture of her in 1966.

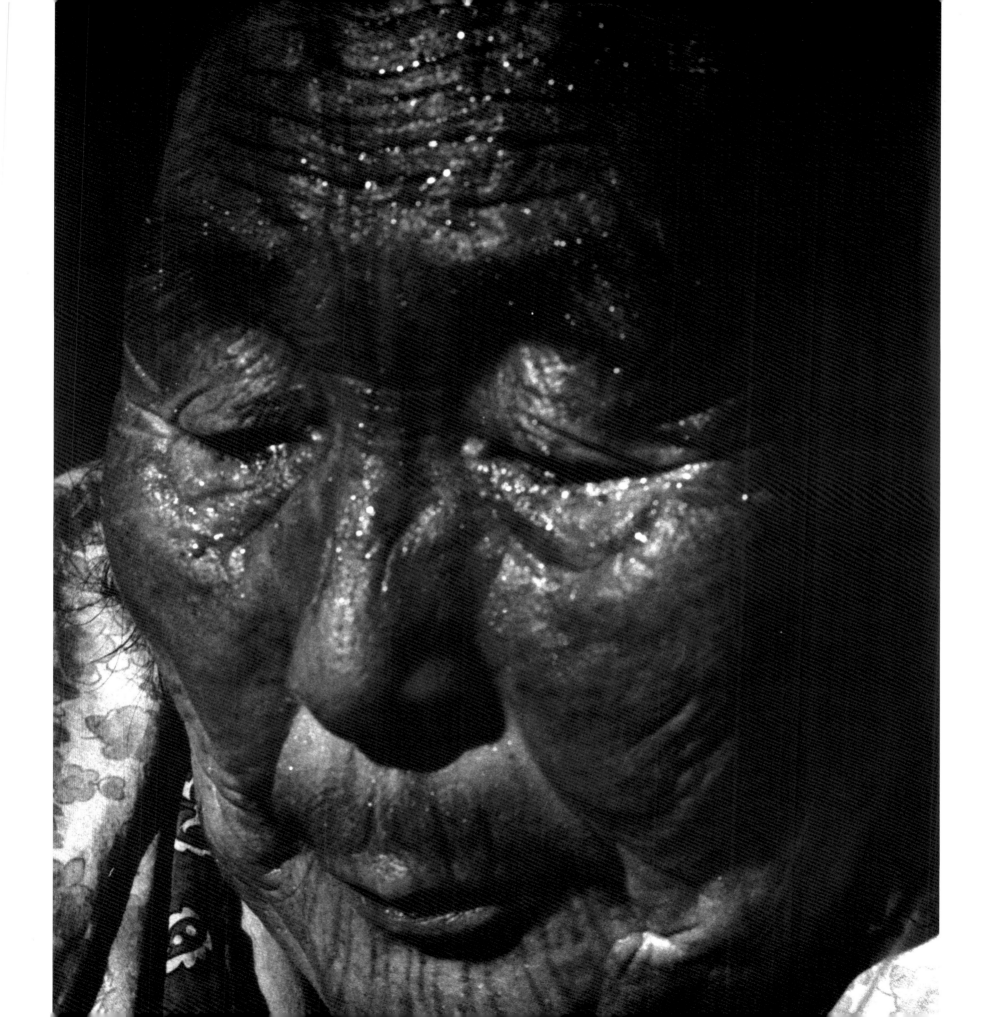

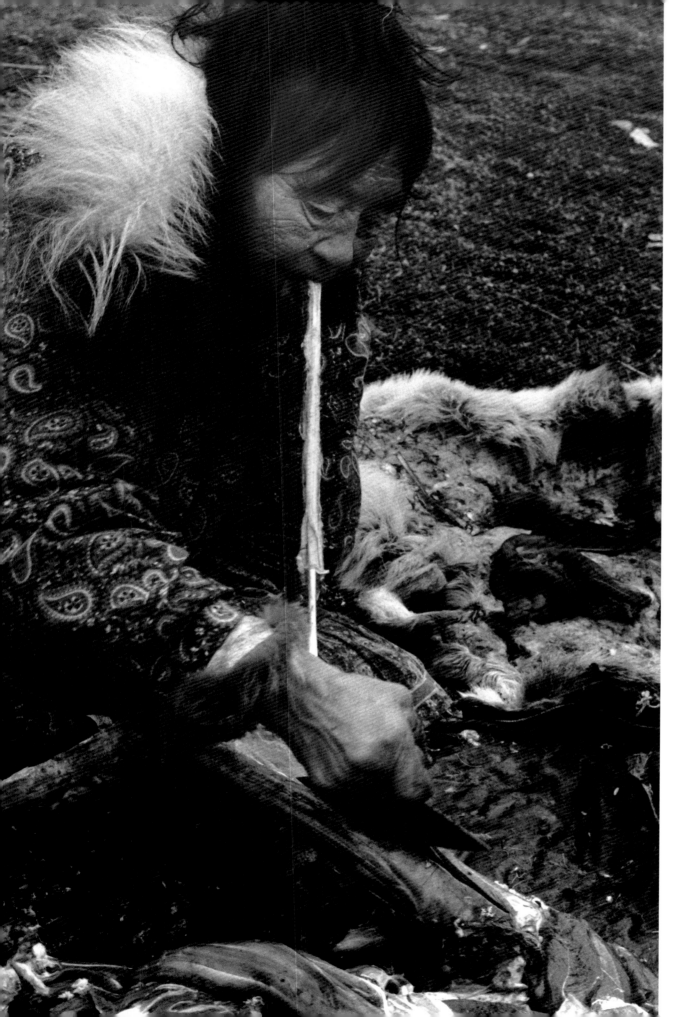

Left: Rosie Kongyona cuts up a caribou carcass, removing a tendon from the leg to be made into sinew thread. Every part of the killed caribou was used: meat, fat, and intestines as food for humans and sled dogs; antlers and bones for tools and toys; and the dense fall fur of the caribou for the best Arctic clothing, sewn with sinew thread, which moulds itself to the leather but does not tear it.

Right: Inuterssuaq of Siorapaluk, Greenland, the world's northernmost settlement, uses a traditional Inuit bow drill to cut a hole into a walrus ivory harpoon head. The bow was made of walrus bone and seal thong with a wooden drill and a steel bit, which cut fast and, when used by an expert, with great accuracy. Similar drills were used by Inuit in the past to make fire by friction.

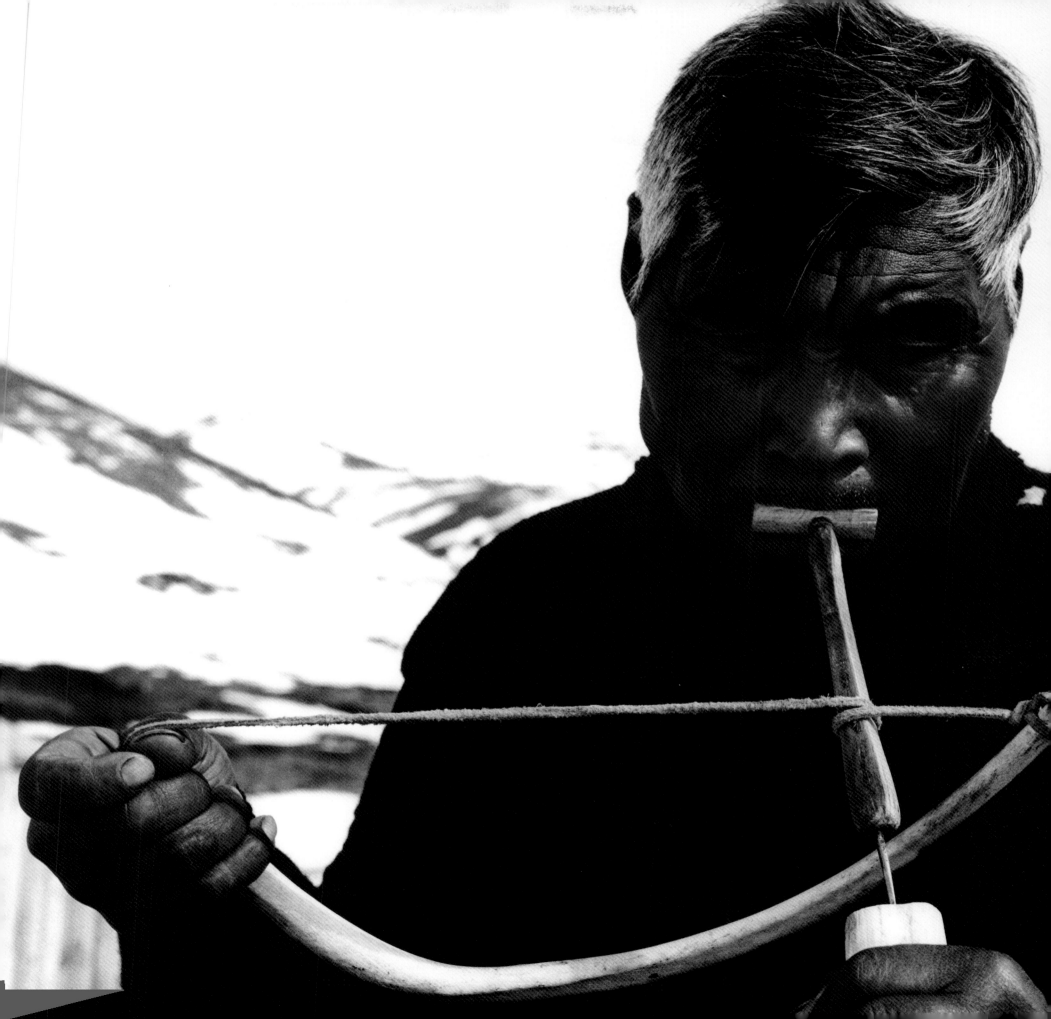

It is June of 1966 and Inuit string out across snow-covered Baker Lake for a tug-of-war at their annual spring festival. Both the festival and the game were ancient Inuit traditions. Spring, before the snow melted, was the best time to travel with dog teams and Inuit from many camps visited each other, held spring festivals, exchanged goods, and played games, including tug-of-war, using a very long thong made of bearded seal leather.

The Polar Inuk Ululik Duneq checks the ivory
foreshaft of his intricate toggle harpoon,
which he has just carved from a walrus tusk.
The toggle harpoon, possibly invented by the
Inuit's forebears, was the most important
weapon of sea mammal hunters, making it
possible to hold and retrieve struck game
animals, from seals to whales.

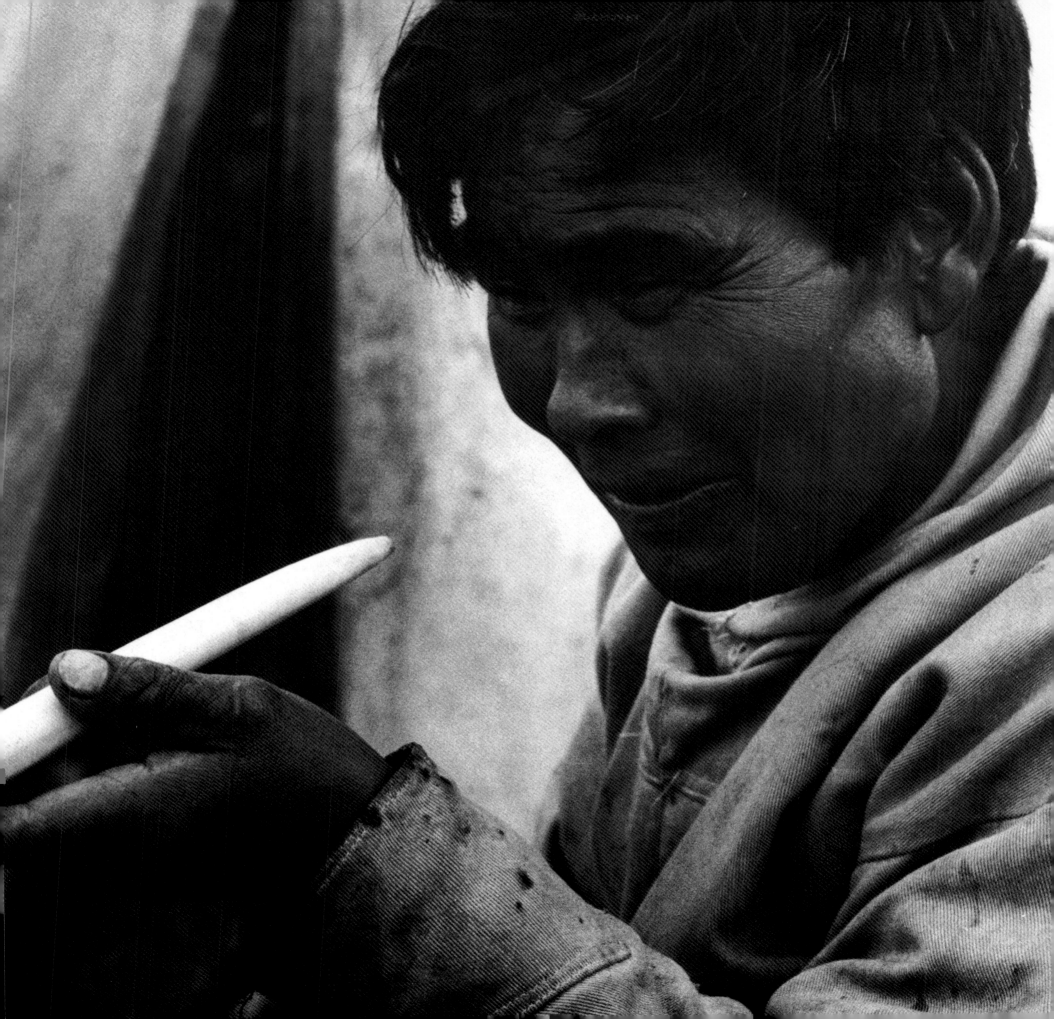

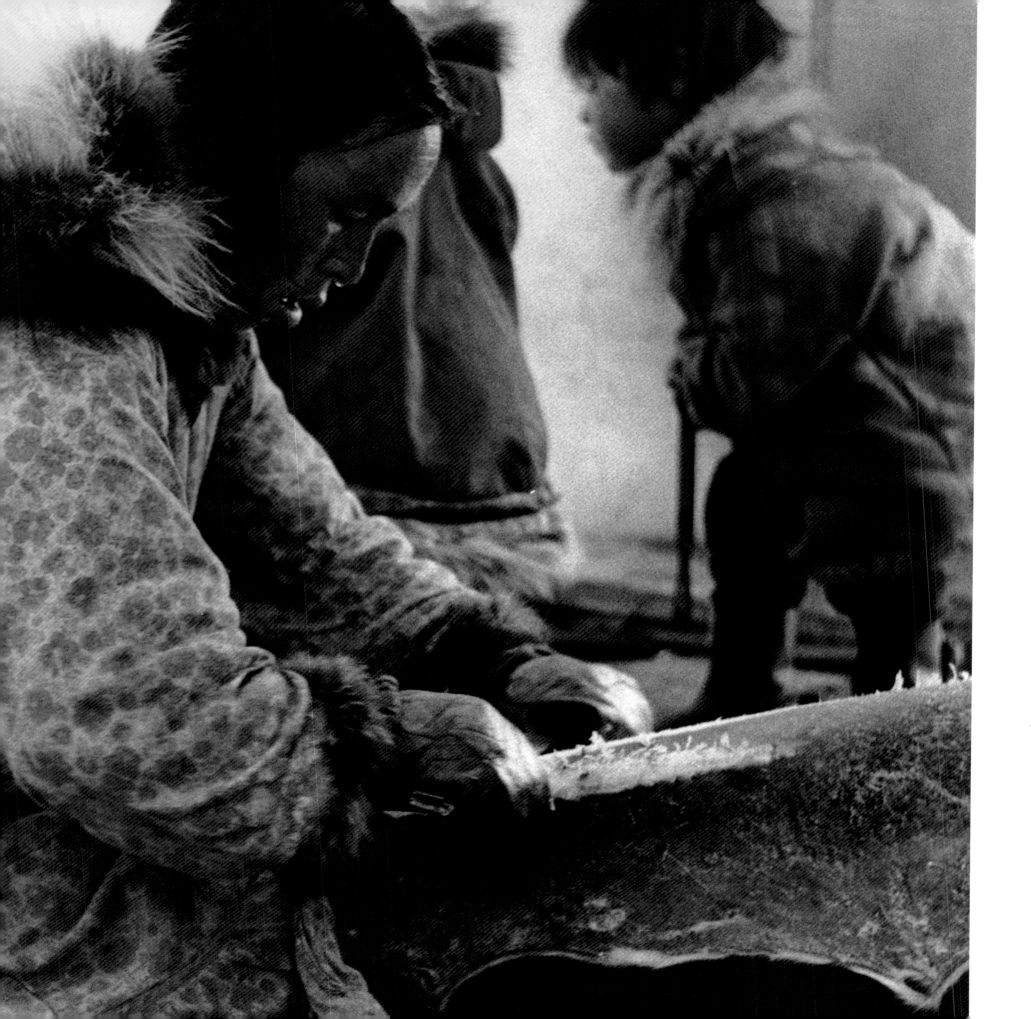

Left: Preparing a sealskin for clothing was very hard work. First, the blubber had to be carefully removed. Then the cleaned skin was pegged out on gravelly ground to dry. Finally, the inner membrane of the stiff, hard skin had to be scraped off. Sweat dripping from her nose, Ella Tonakahok uses a metal scraper. In the past scrapers were made of bone or stone. An expertly scraped sealskin was as supple and soft as chamois leather.

Below: Watched by her dog, Aleqasinguaq of Qaanaaq, northern Greenland, methodically chews a cut-out bearded seal *kamik* sole to make the stiff leather smoothly pliant prior to sewing it onto a new sealskin boot. Ringed seal skins, soft and with beautiful silvery fur, were used for the elegant upper section of the *kamik*. Bearded seal leather, extremely tough and durable, was used to make long-lasting *kamik* soles.

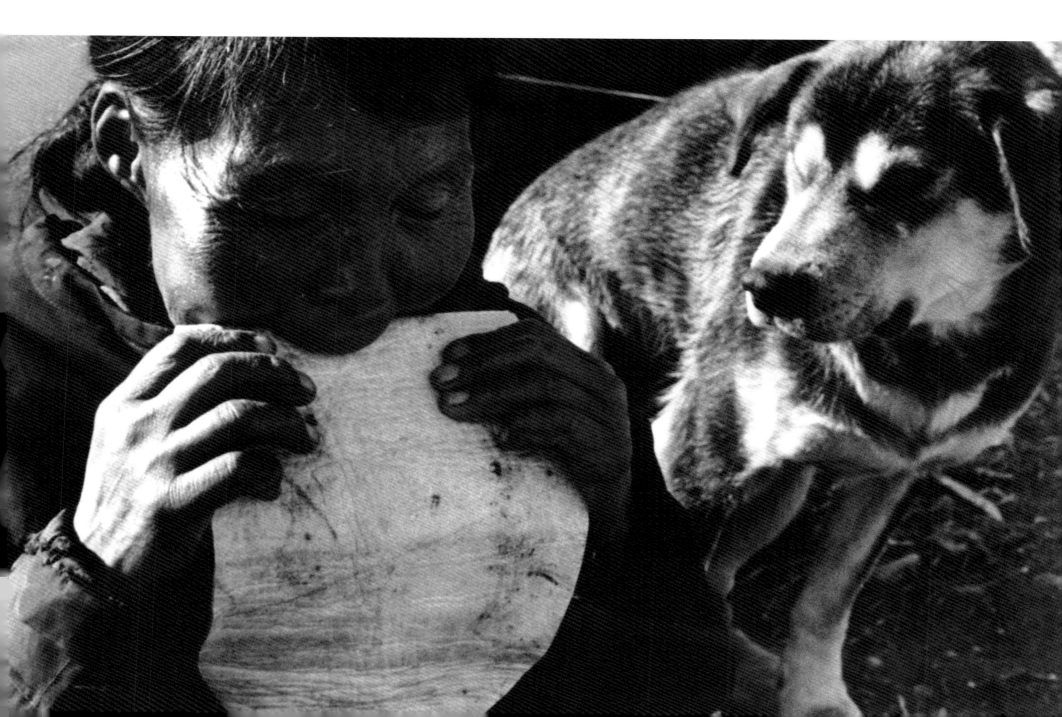

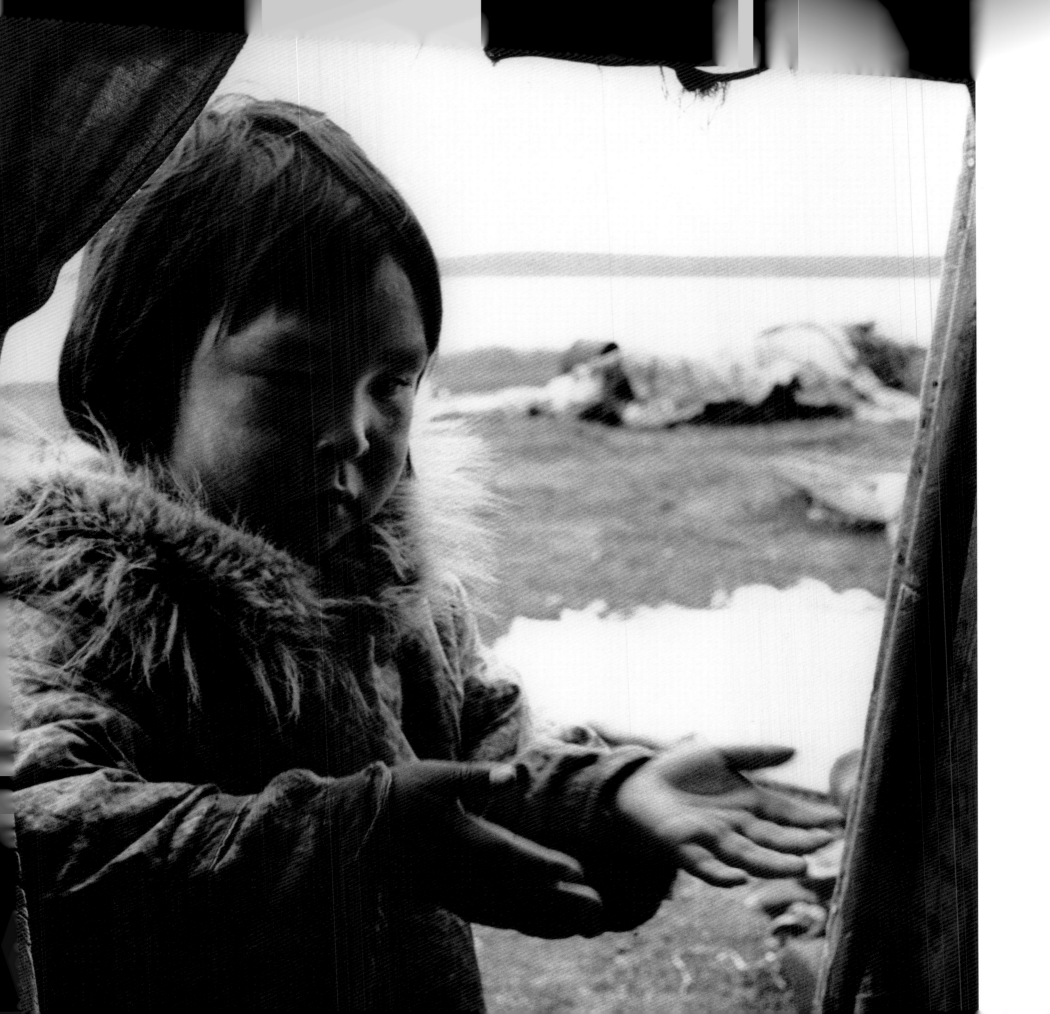

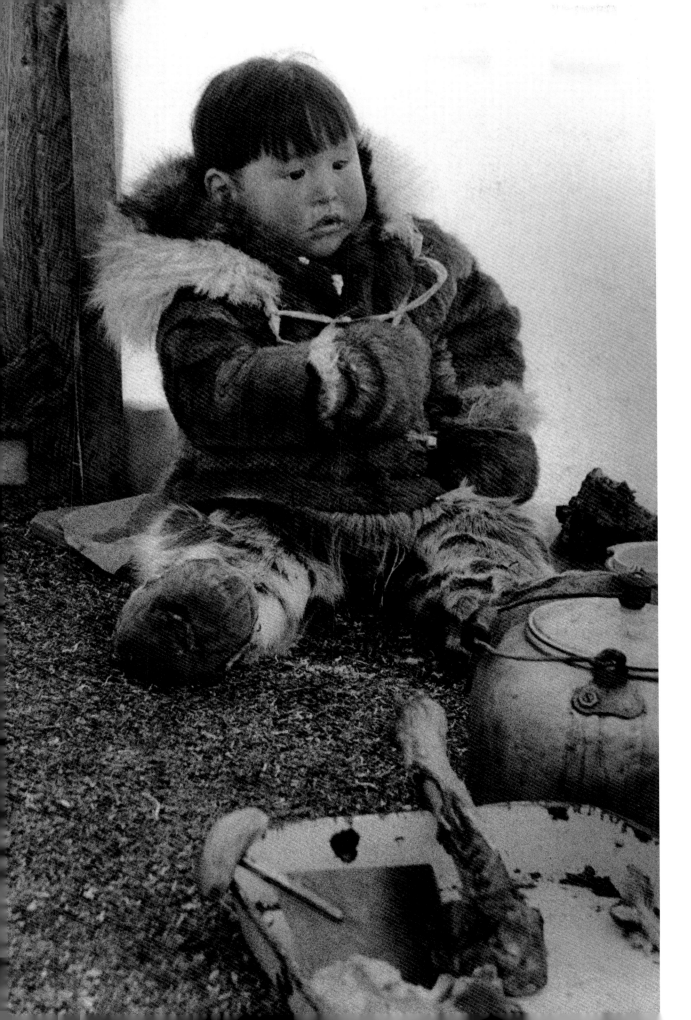

Far left: "Come and play," seven-year-old Puglik, standing in the entrance to our tent at Bathurst Inlet, tells her three-year-old brother Oched. Looking after her little brother was one of her many duties and she took it very seriously. The children at our camp were a busy, active, inventive, happy little tribe, with the older children being very protective of the younger ones.

Near left: Little Oched loved to eat and was, on the whole, a plump and pleasant child. He regularly visited all the tents of our four-tent camp to check who had the best food and there he would remain for a while. Here he is in the tent I shared with his grandparents, waiting to be fed by his grandmother.

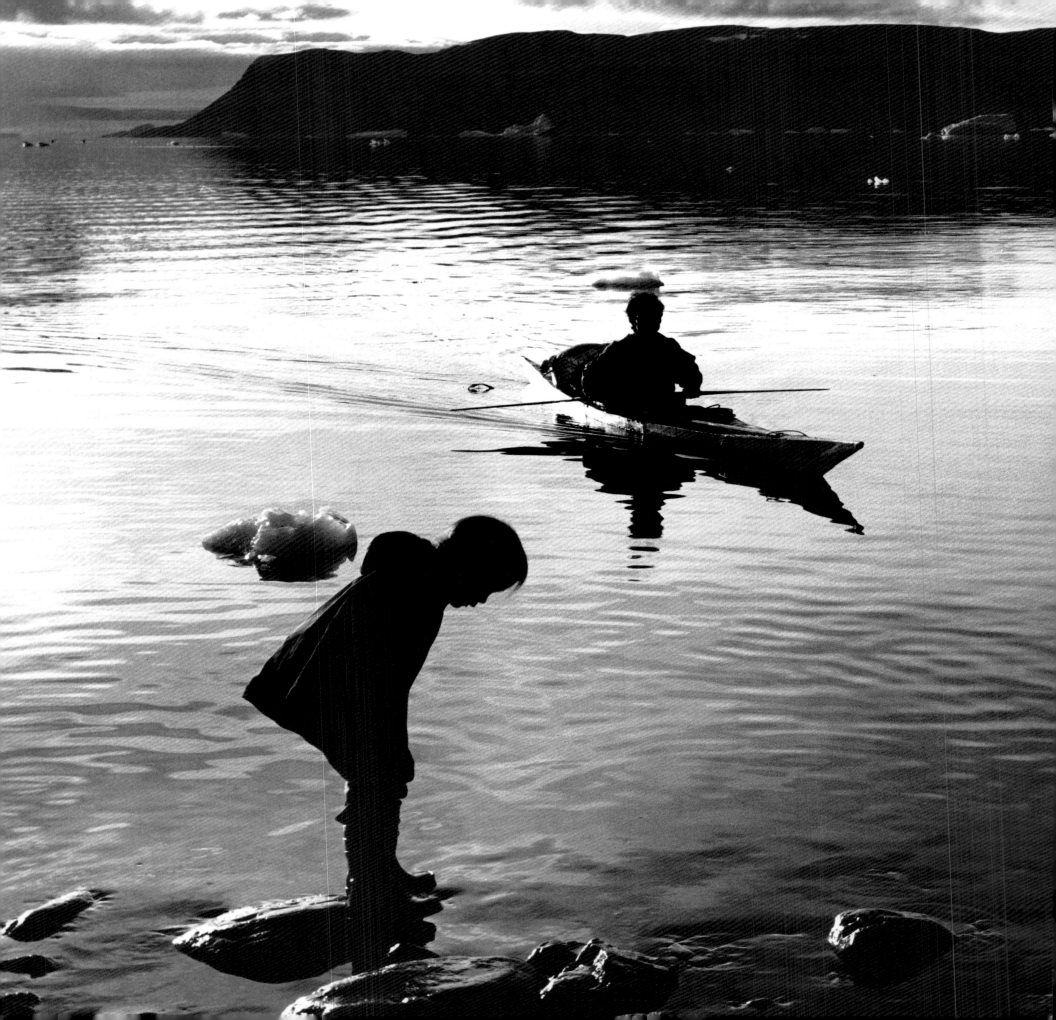

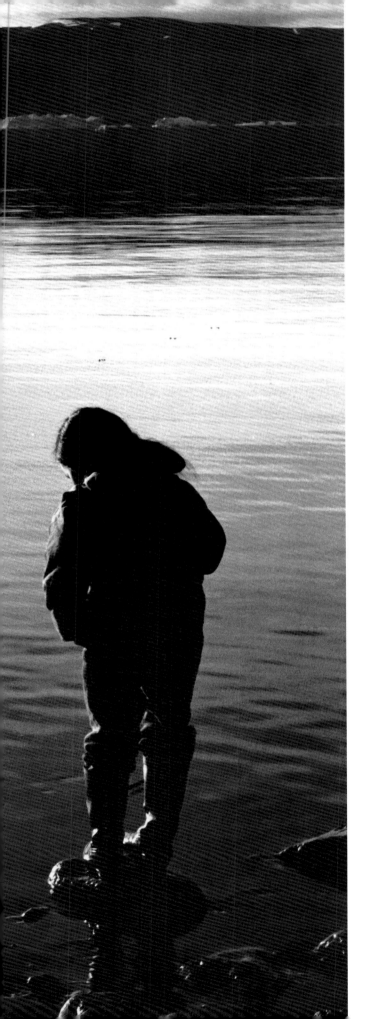

Children await their father as he returns from the hunt, Inglefield Bay, northwestern Greenland. During the brief, High Arctic summer, the men hunted seals, white whales, and narwhals with their sleek, fast kayaks, perhaps the most perfect hunting craft ever designed by man. The hunters built their own kayak skeletons. The women cleaned many sealskins and, using narwhal sinew as thread, sewed them into tight-fitting, long-lasting kayak covers.

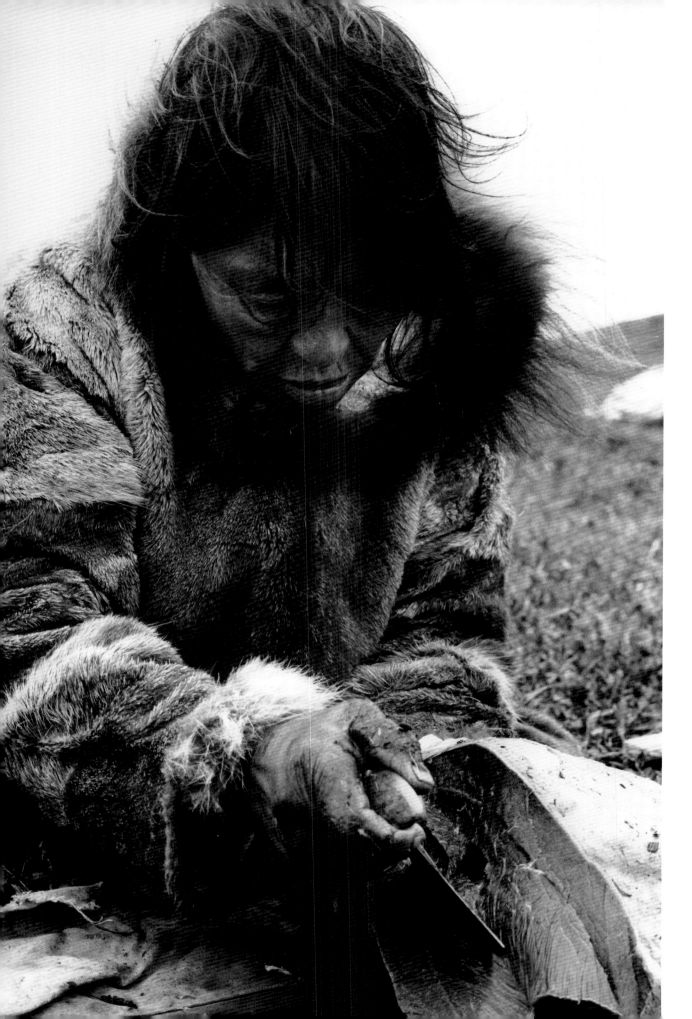

Left: Making *mipku*, caribou jerky. Using her *ulu*, the woman's knife, Rosie Kongyona cuts caribou meat into thin slices to be air-dried on rocks and racks. Our spring was warm and moist, so the meat was slow to dry, and became fly-blown and full of life. At mealtime, we held our chunks of jerky for an instant in the fire to kill the mass of larvae and then ate the raw meat together with the sautéed maggots.

Right: Puglik carries a load of squirming husky pups in summer to a brook near camp to give them water. Men looked after the adult dogs. The camp children took care of the pups. They gave them water, cleaned them, fed them, and played with them. Pleasure and duty were nicely mixed and children acquired early a perfect understanding of sled dogs.

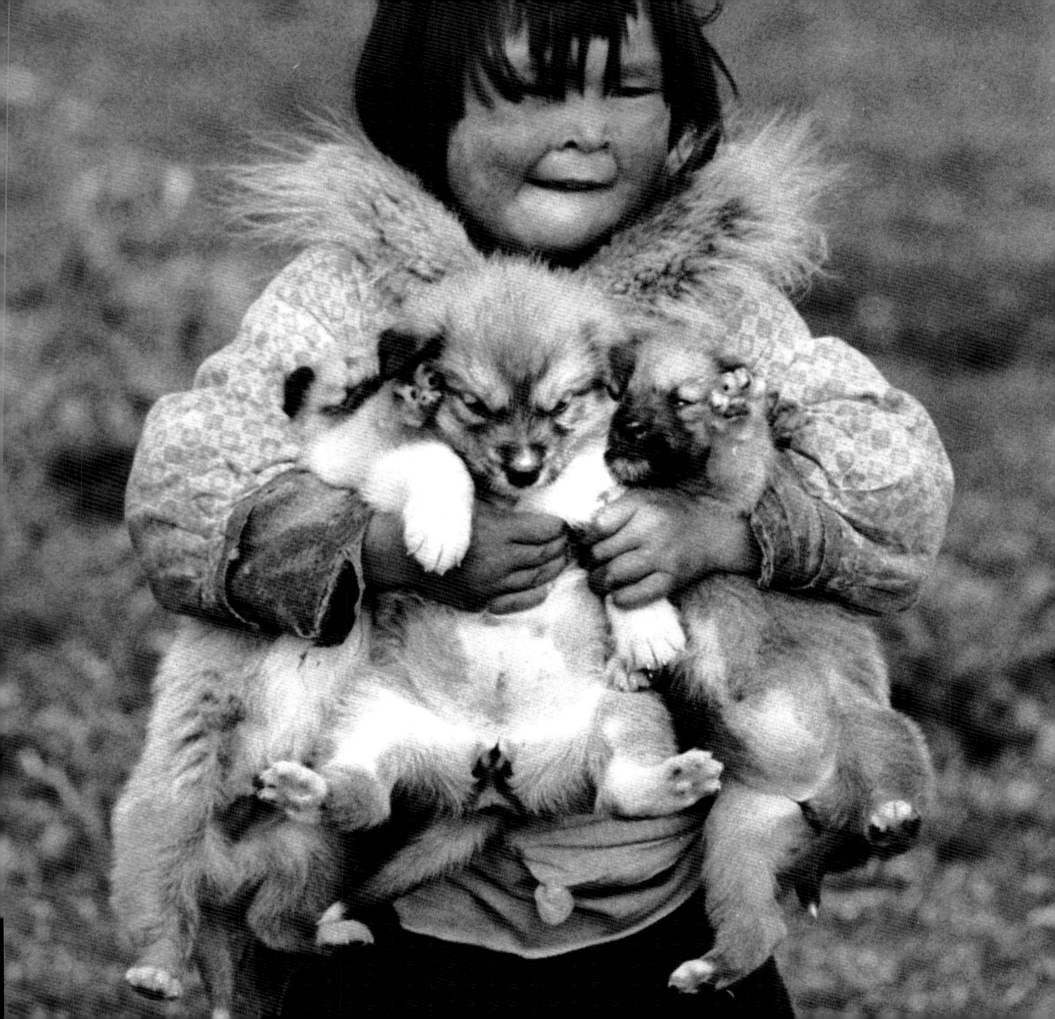

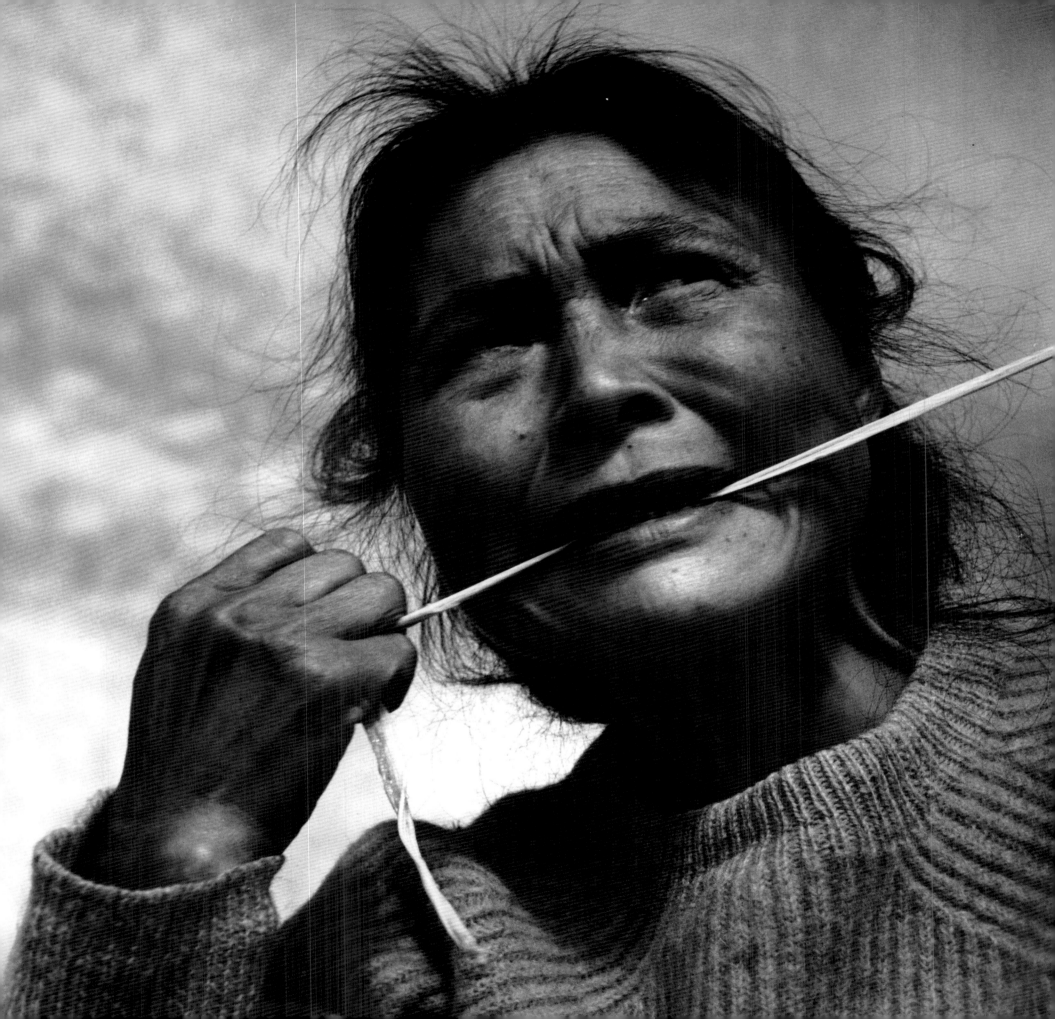

Preparing the best thread of the Arctic, sinews from metre-long narwhal tendons. Isigaitsoq of the Polar Inuit, at whose camp I lived for many weeks, cut out the spaghetti-like sinews, and chewed and cleaned them, removing with her teeth all traces of meat and fat. Finally, the sinews were washed, dried on rocks and boards, tied into neat bundles, and kept in a loon-skin bag. Sinew of caribou or whale was the nearly universal thread of Arctic women who sewed with it the fur clothing that made survival in the Arctic possible.

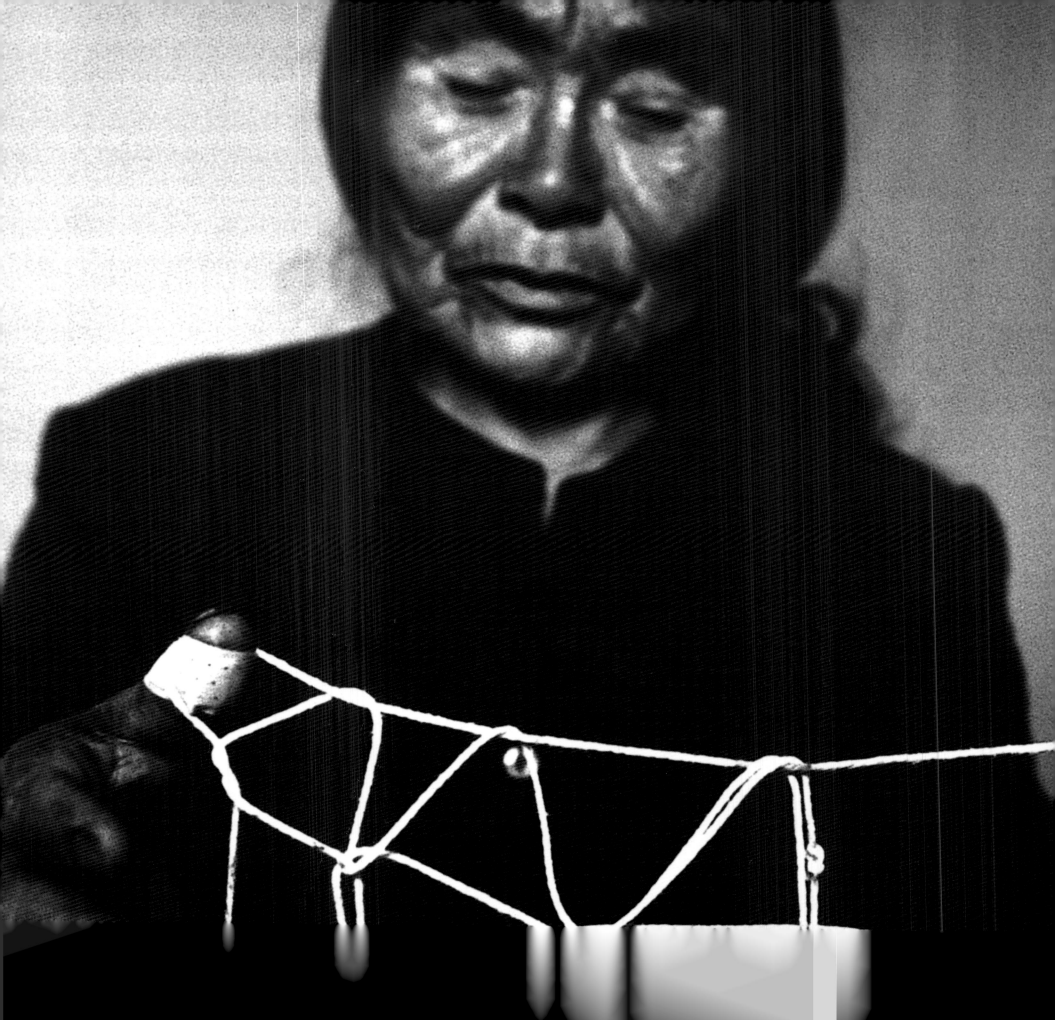

Among the Polar Inuit of northwestern Greenland, Naduq was famous, for she knew how to make more than 100 traditional cat's cradle figures, such as this one of the "running caribou." One of the figures she created was of the *kilifagssuk*, the long-extinct mammoth, whose memory lived on in this extremely ancient Inuit game.

Three-year-old Oched goes on a fantasy trip with an old toboggan and some of the husky pups of our camp. Since I lived for six months at the Bathurst Inlet Inuit camp, the children, initially politely curious, had long ago ceased to notice me and I spent delightful hours watching them and photographing their busy little lives.

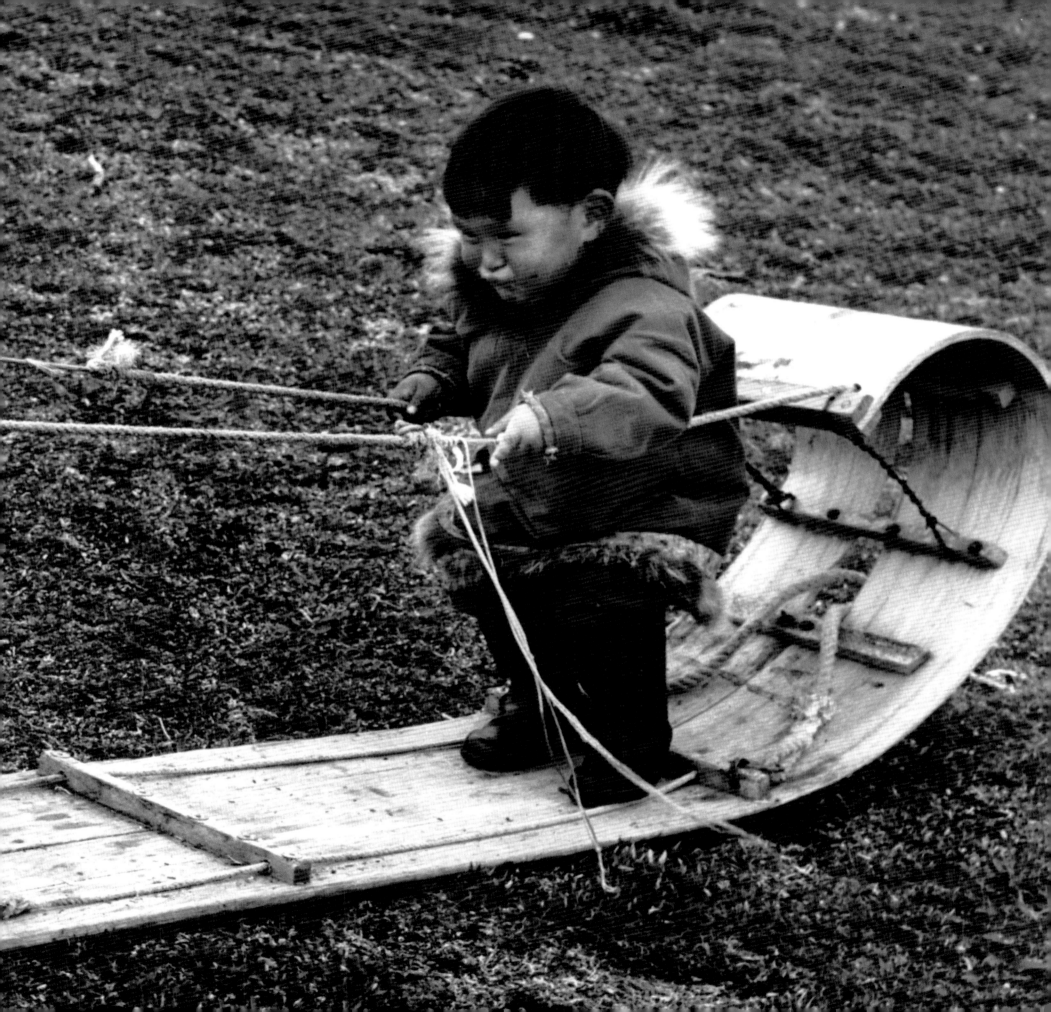

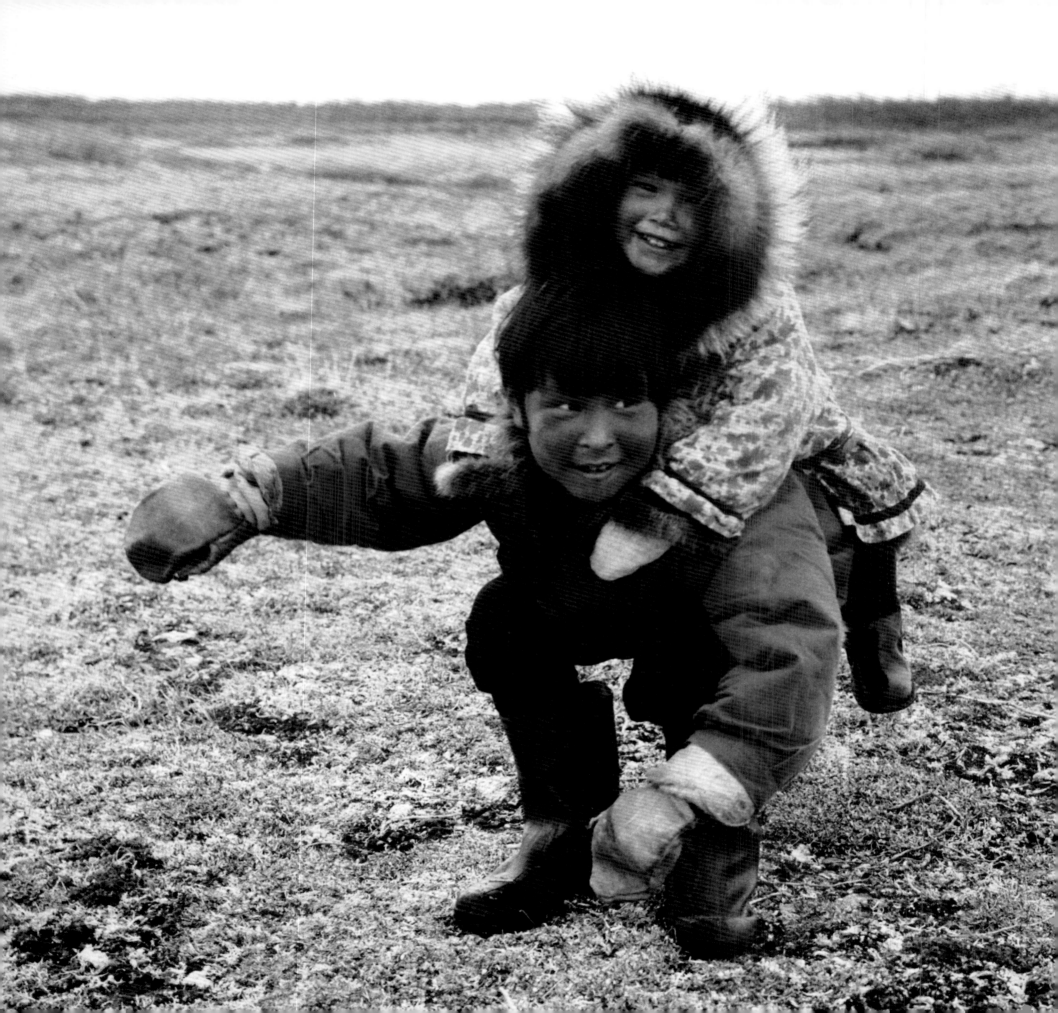

Left: Visitors were wonderful. In the isolated Inuit camps of former days, the arrival of visitors was always a joy. Adults spent hours exchanging news and practical hunting information. Camp children played with new friends. Three-year-old Linda Kayoina, who came with her parents to our Bathurst Inlet camp, gets a piggyback ride from David Papak.

Right: A swinging mom dances to radio music at the north Labrador char fishing camp of Tom Okuatsiak on the coast of Saglek Fiord. The permanent camps north of Nain had long ago been abandoned, but every summer families from Nain travelled north to ancestral camping places to net the abundant and delicious char.

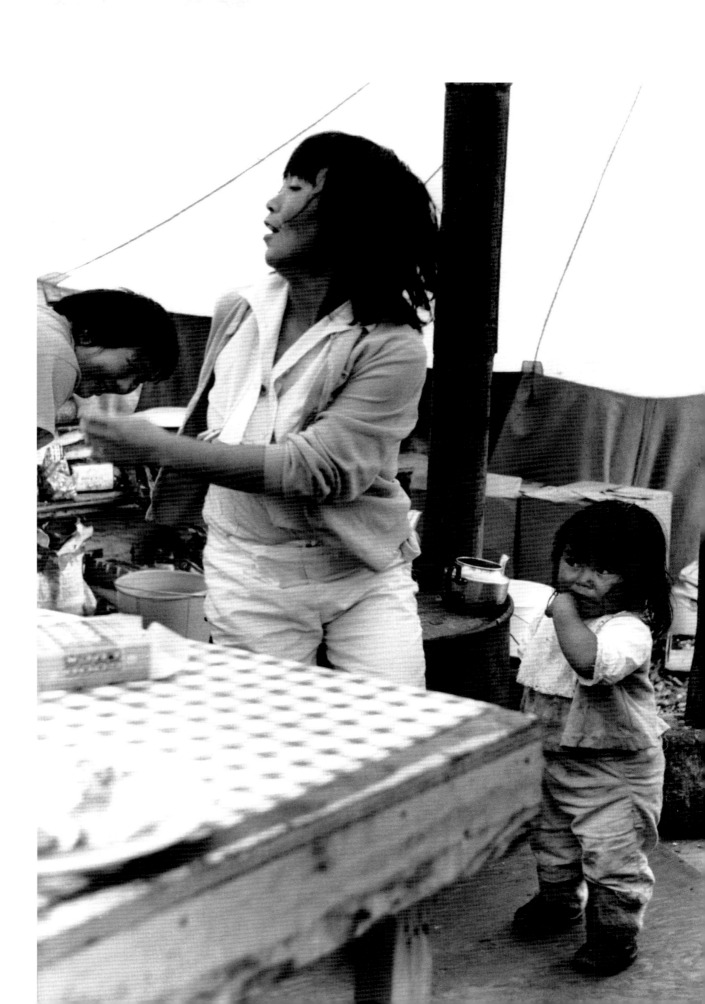

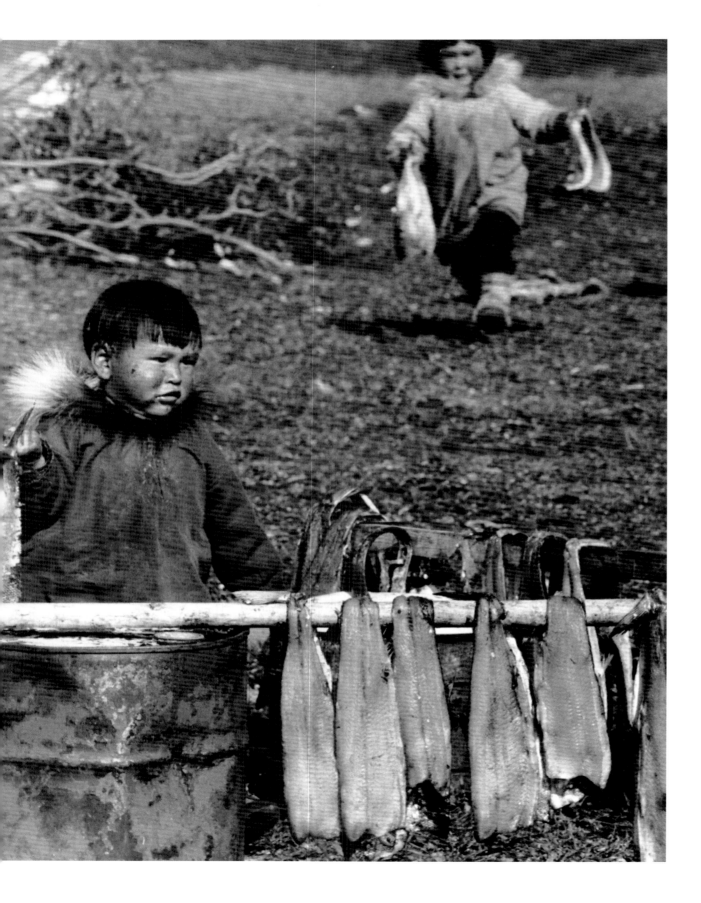

Left: In early summer lean caribou arrived near our camp on the Arctic coast and fat char ascended the rivers. The men hunted and fished. The women cut up meat and char and air-dried both on rocks and racks, food for the coming winter. The children helped. Three-year-old Oched and his sister Puglik hang split char onto poles.

Right: Five-year-old Sophia Ittulak conscientiously washes everyone's socks at a char fishing camp in northern Labrador. Camp children played a lot. They were marvellously free and their whole wide world was a playground, but they were also encouraged to help with the work, thus sharing adult life and duties. They were praised and it made them feel big and important.

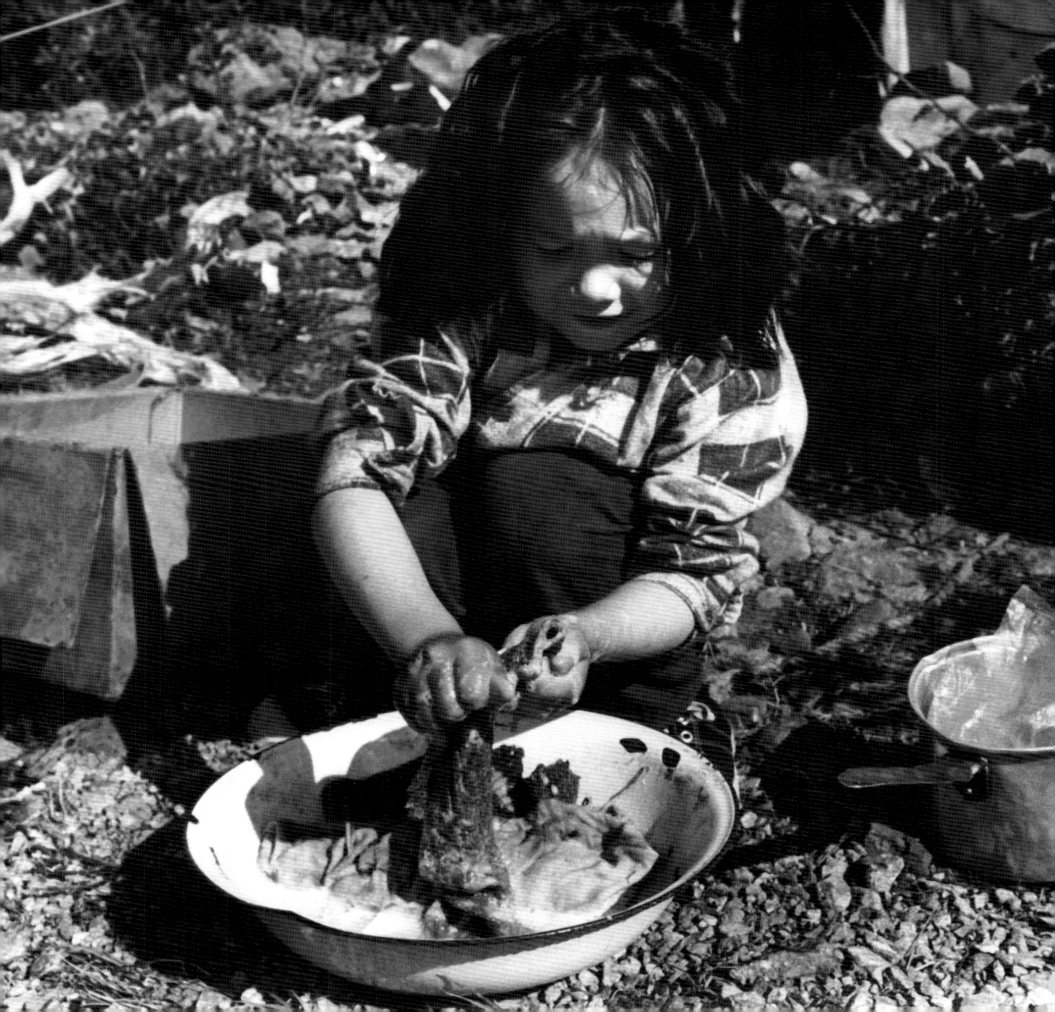

Below: While the older children brought the needed firewood to camp, the younger ones collected large bags of Arctic white heather that grew in extensive hummocks on slopes near our camp. It is the ideal Arctic fuel to start fires, for the heather is so rich in resin that it burns with a hissing, sputtering flame even when wet.

Right: In July our summer at Bathurst Inlet really began. All cooking was now done outdoors over open fires. Stunted Arctic willow was the main fuel. Getting the wood was one of Papak's chores. He walked to a sheltered valley a few miles from camp and returned after some hours with a large load of dry willow branches.

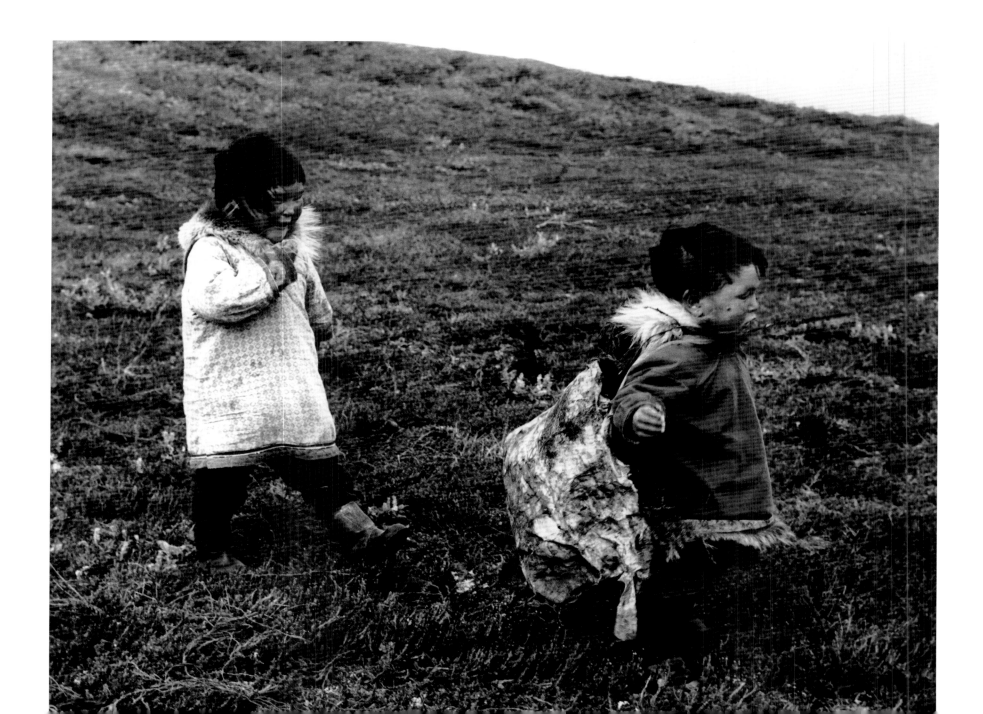

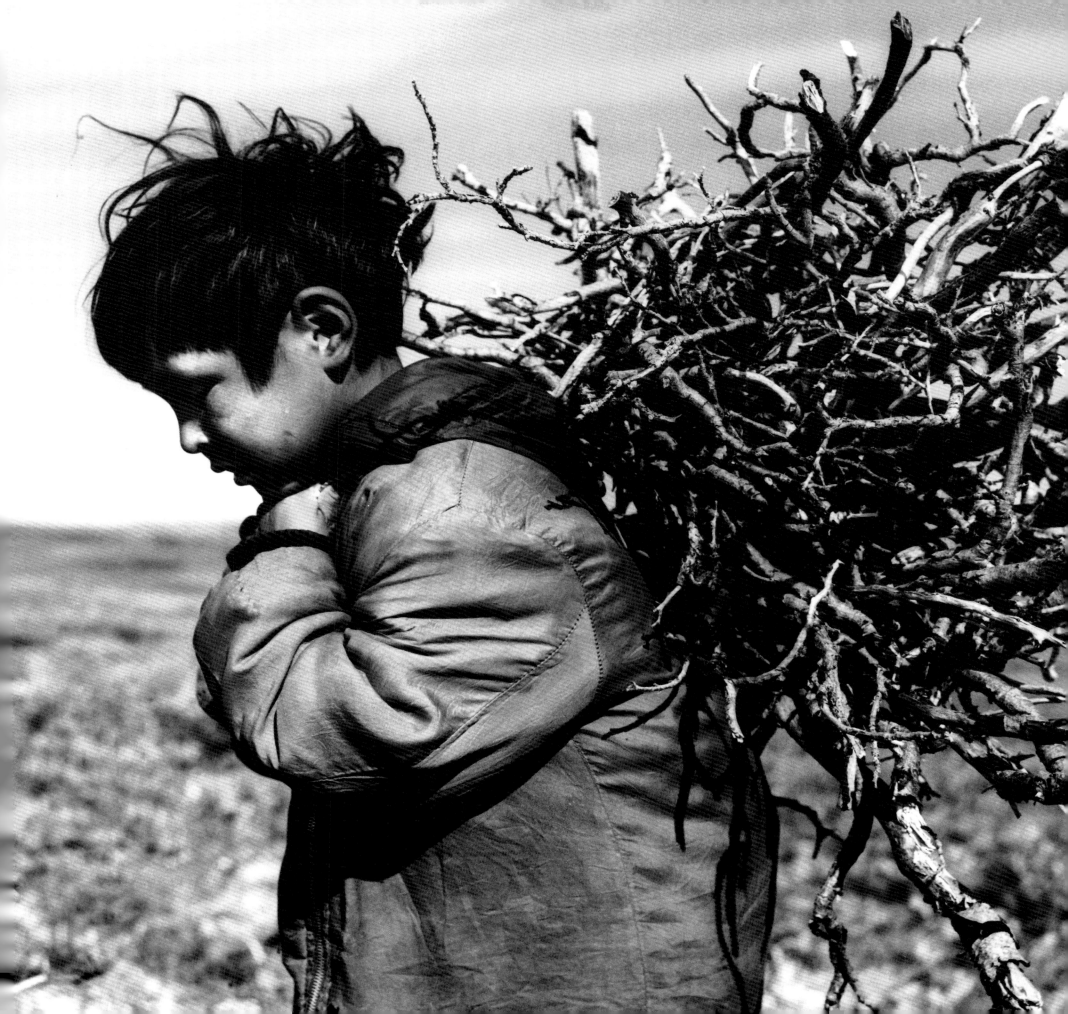

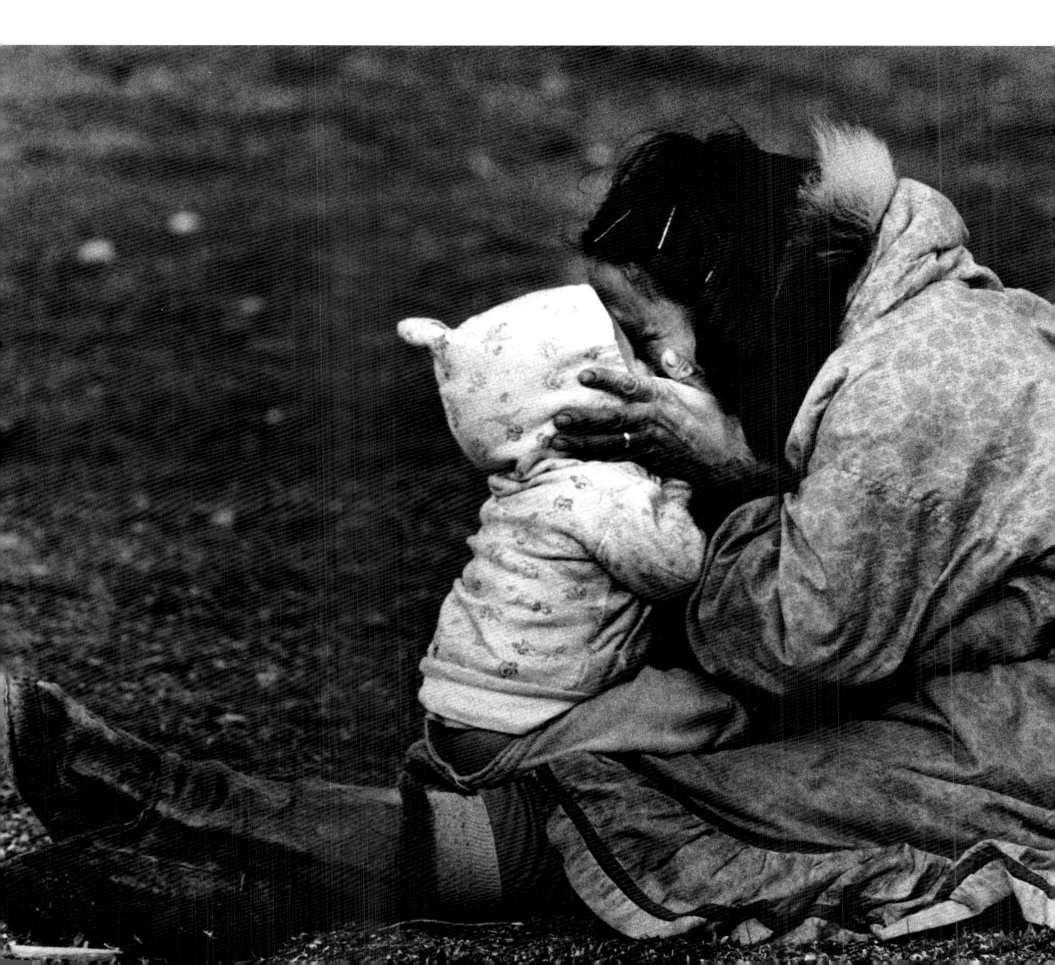

Left: Ella Tonakahok loves and nuzzles her baby Ooloosie. All in camp were loved, but the newest baby was a mother's special joy and the darling pet of everyone in camp. Ella wears her *amautik*, the mother's parka, with an ample hood and a spacious dorsal pouch, the *amaut*, the baby's cozy nest close to its mother's body.

Right: The best Arctic clothing was made from the fall fur of caribou. At that time caribou have moulted into winter fur, which is extremely dense and very warm, yet the skins are strong and light. Preparing the fur for winter clothing required much work and great care. The skins were thoroughly scraped; a mere smidgen of remaining fat could spoil a hide. Before pegging out a cleaned skin to dry, Lucy Ananglak, at that time the oldest woman in the Bathurst Inlet region, chews off the remaining bits of fat from the edges of the caribou skin.

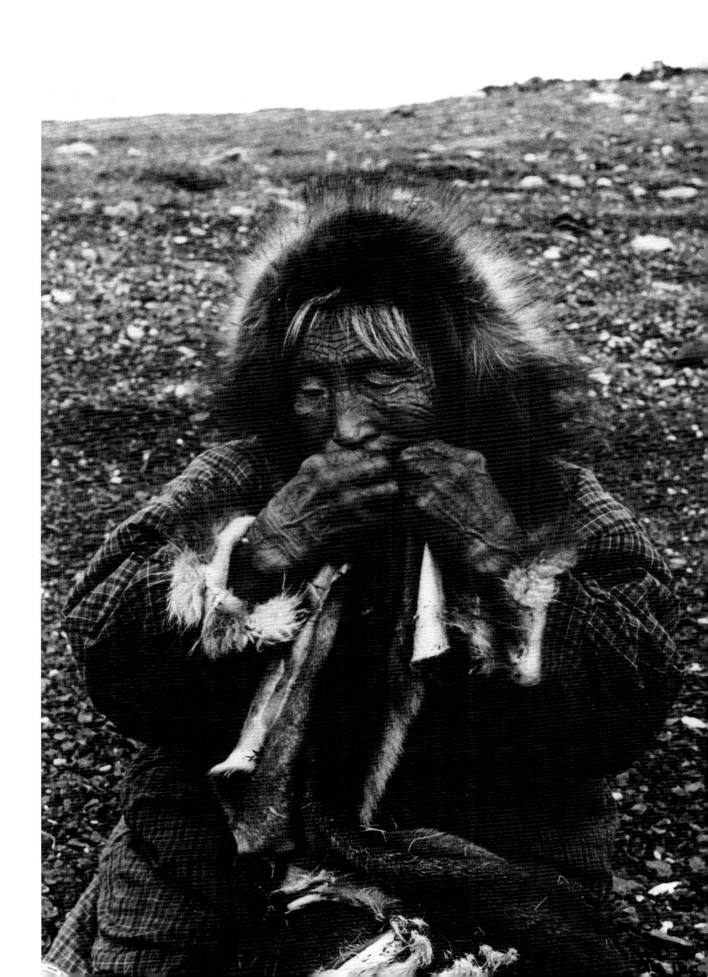

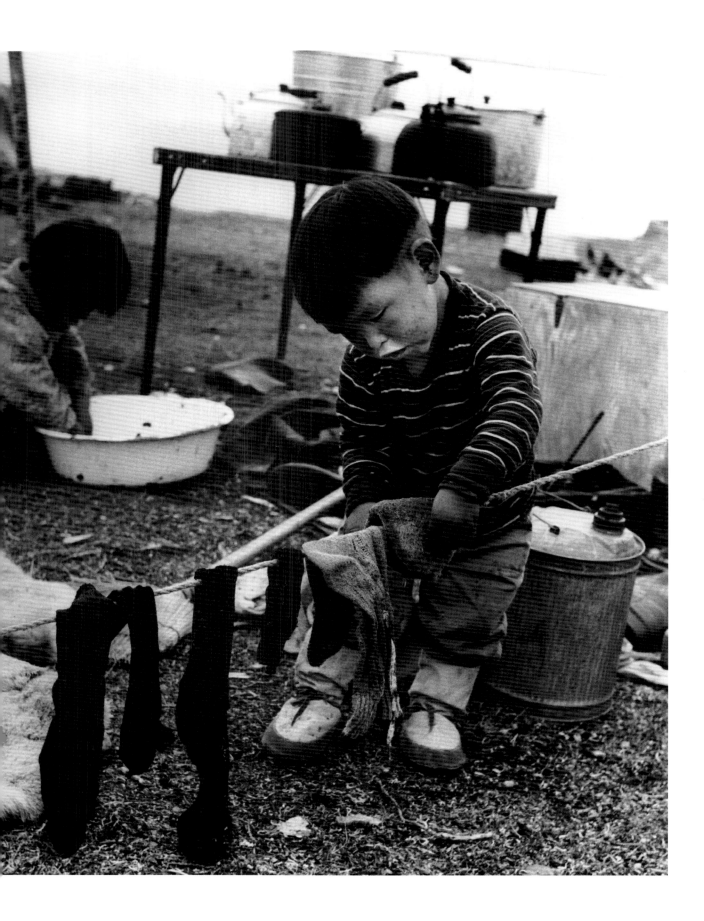

Left: Mother's little helpers, three-year-old Oched and his sister Puglik do the washing in summer. Our camp children were a happy, busy little tribe. They played a lot; their freedom was nearly unbounded. They also worked, not because they had to but because they wanted to and they were rewarded with praise. By imitating adults, the children acquired skills they would later need to survive in the Arctic.

Right: Wielding a heavy axe, seven-year-old Puglik hacks open a caribou leg bone to extract the raw marrow, a favourite Inuit delicacy. All children were allowed to use axes and the large, sharp knives used to skin and cut up caribou and seals, so they learned early, and sometimes painfully, to be skilful and careful. Caribou marrow, eaten raw or taken from cracked boiled bones, is particularly rich and fatty in the fall and, recent studies have shown, contains iron, thiamin, niacin, and vitamin A.

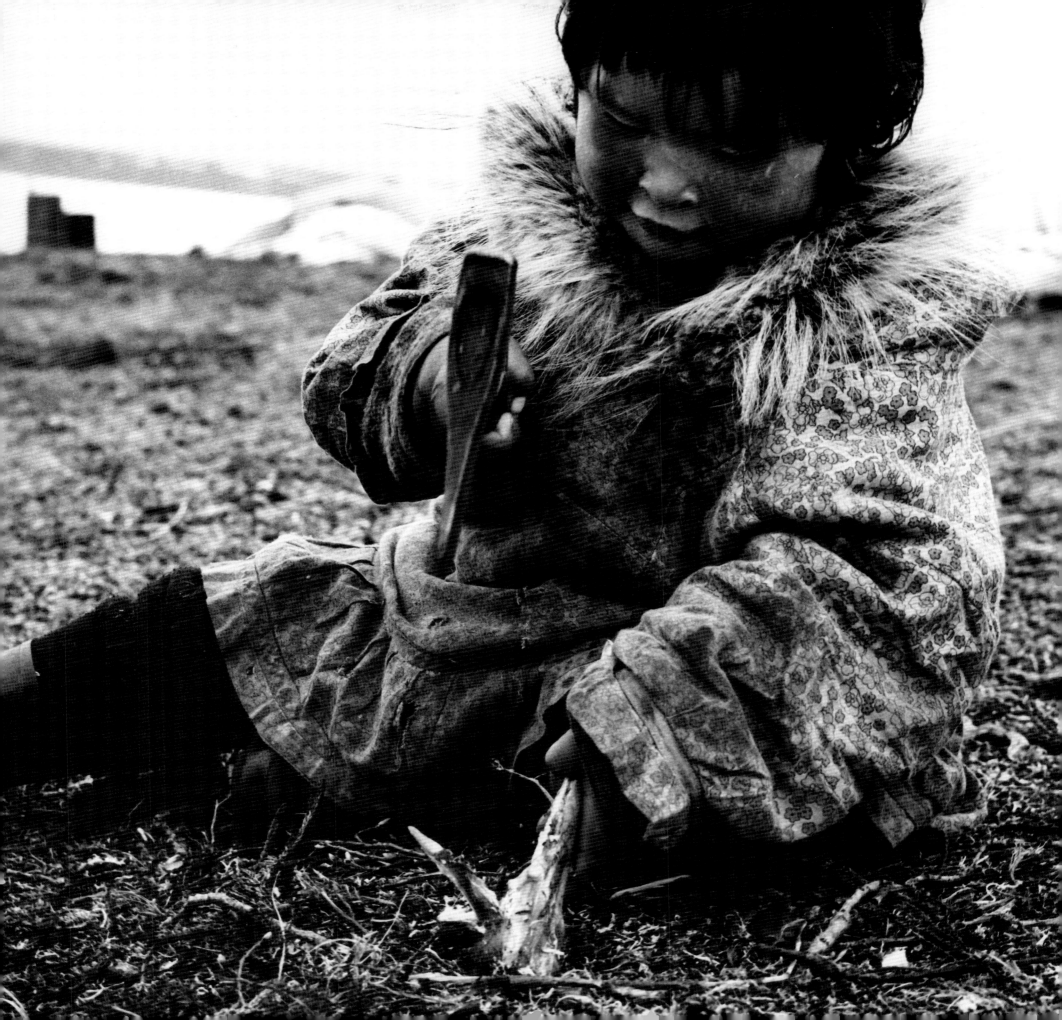

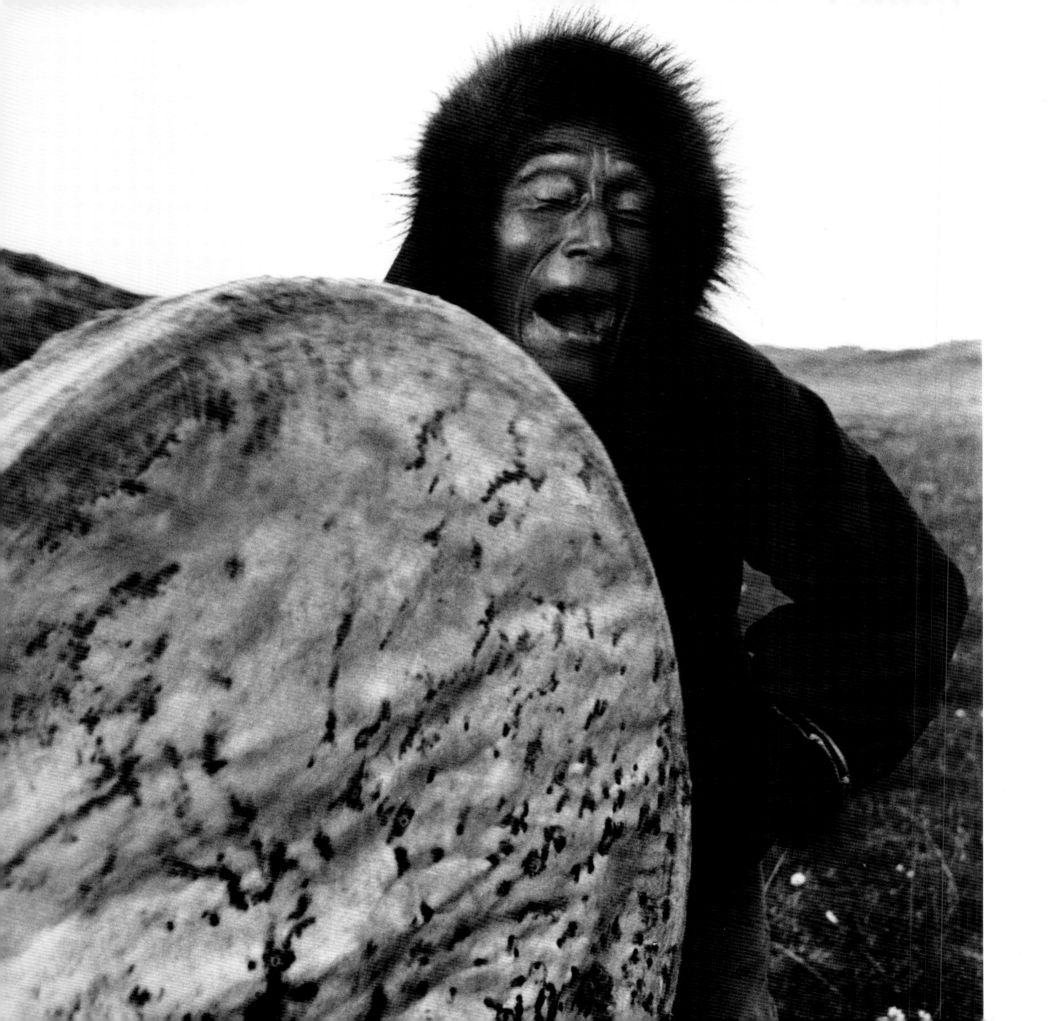

Left: At a neighbouring camp, Ekalun discovered an old drum and, beating its rim, began to play and sing Inuit songs of long ago. The large drum, scraped caribou skin stretched tautly over a wooden frame, had suffered from moisture and age, but for Ekalun it brought back memories of his youth, when drums were played at meetings and dances and at shamanistic séances.

Right: When I spent the summer of 1966 with him, Samson Koeenagnak and his family were the last Inuit to live on the land of the central Barren Grounds, a region nearly as large as France. His wife, Elizabeth Arnajarnerk, dressed in an ample summer caribou-skin parka, the fur side inside, plays with her eight-month-old baby, Eeootchuk.

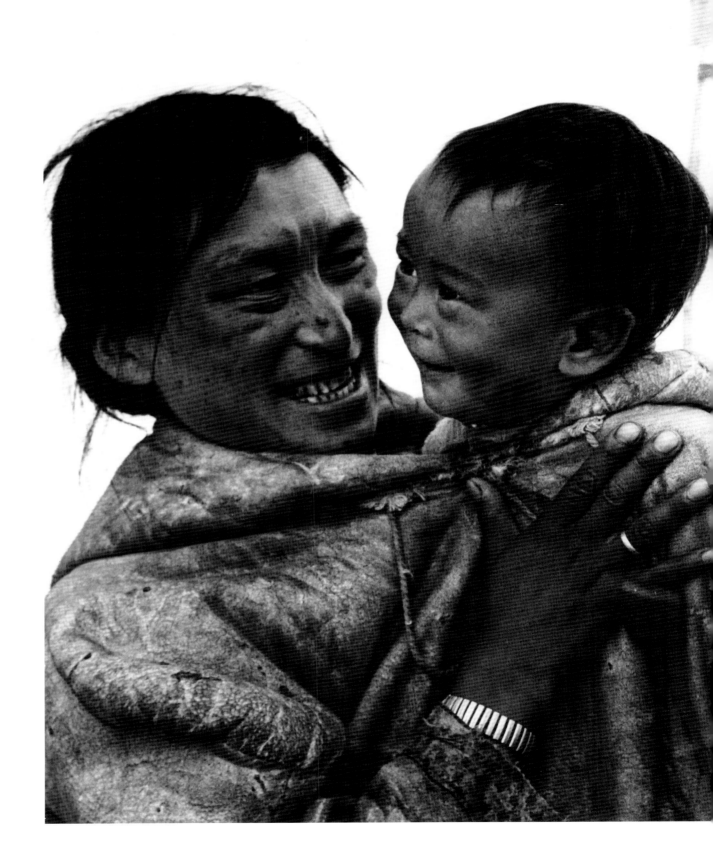

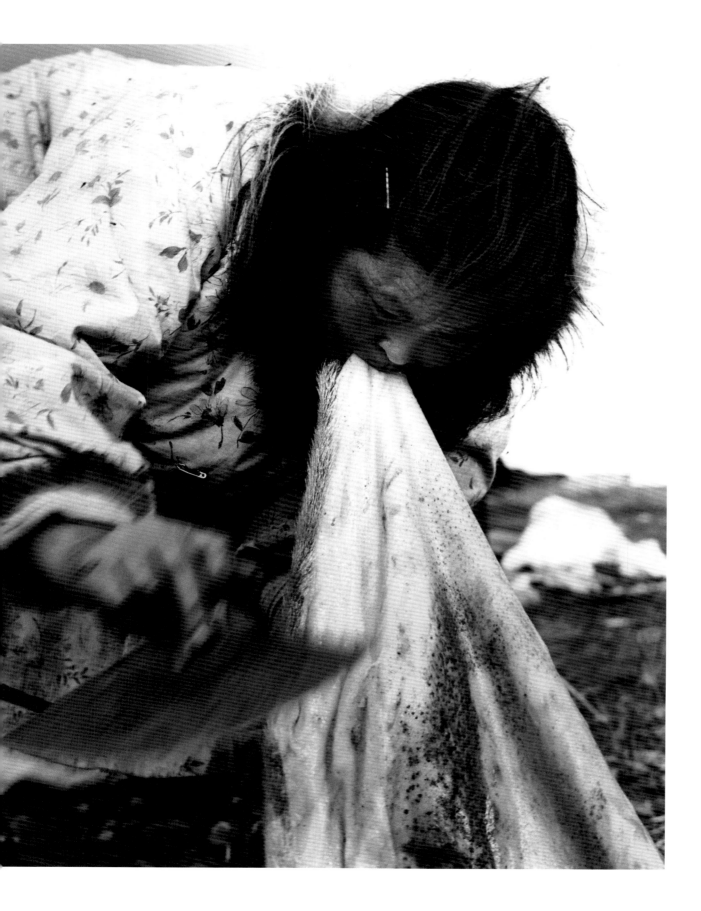

Left: Holding a sealskin with her teeth, Alice Anaoyok uses her *ulu*, the crescent-shaped woman's knife, to remove all blubber. It required great skill and experience to do this smoothly and not nick the skin. The blubber was eaten or preserved as fuel for the seal-oil lamps in winter. The cleaned skin was pegged out to dry and was later made into sealskin boots.

Right: In early summer, Papak, using the traditional composite bow of the Inuit, stalked sandpipers and snow buntings near our camp at Bathurst Inlet with great determination but little success. As a young man, his grandfather Ekalun had hunted caribou with a similar bow, made of antlers and driftwood pieces and backed with plaited sinew cord to give it spring. Lacking good wood, such a bow was a masterpiece of ingenuity, but its lethal range was only about 20 metres.

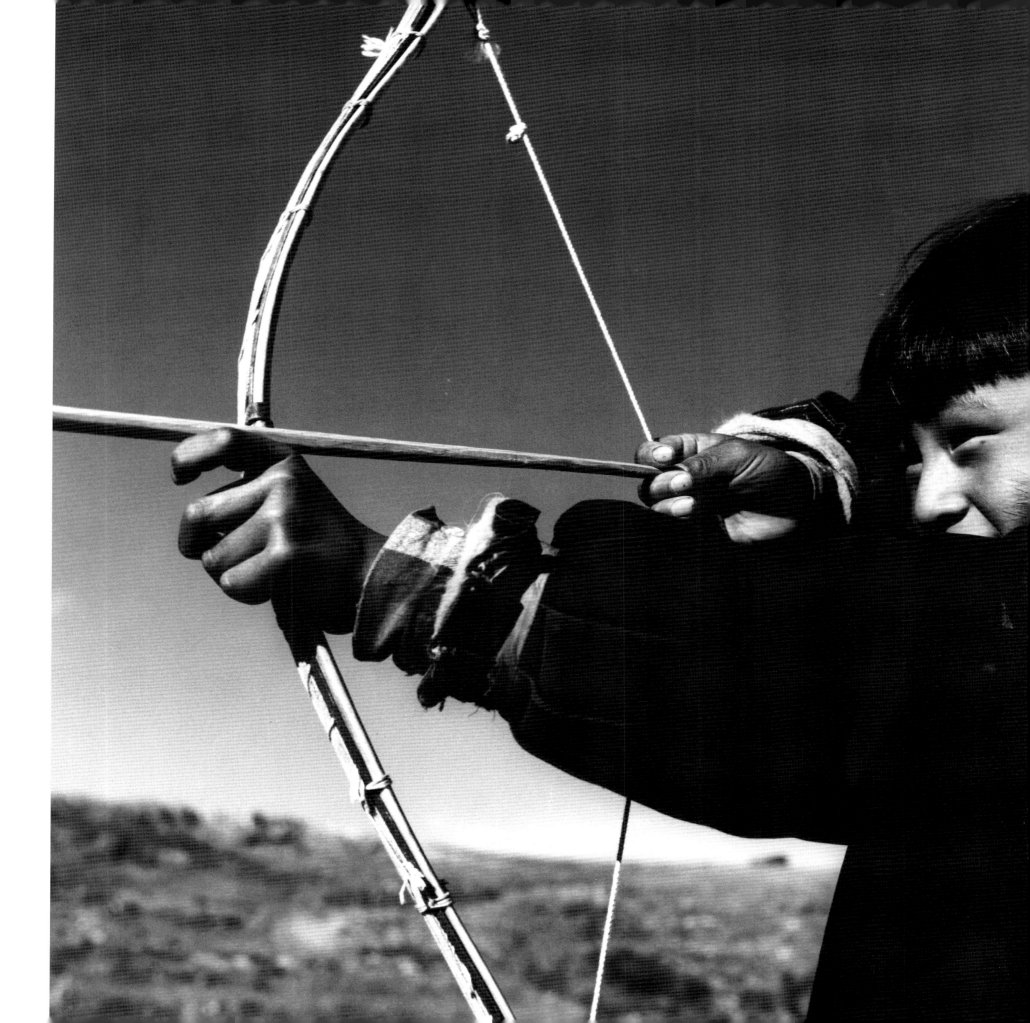

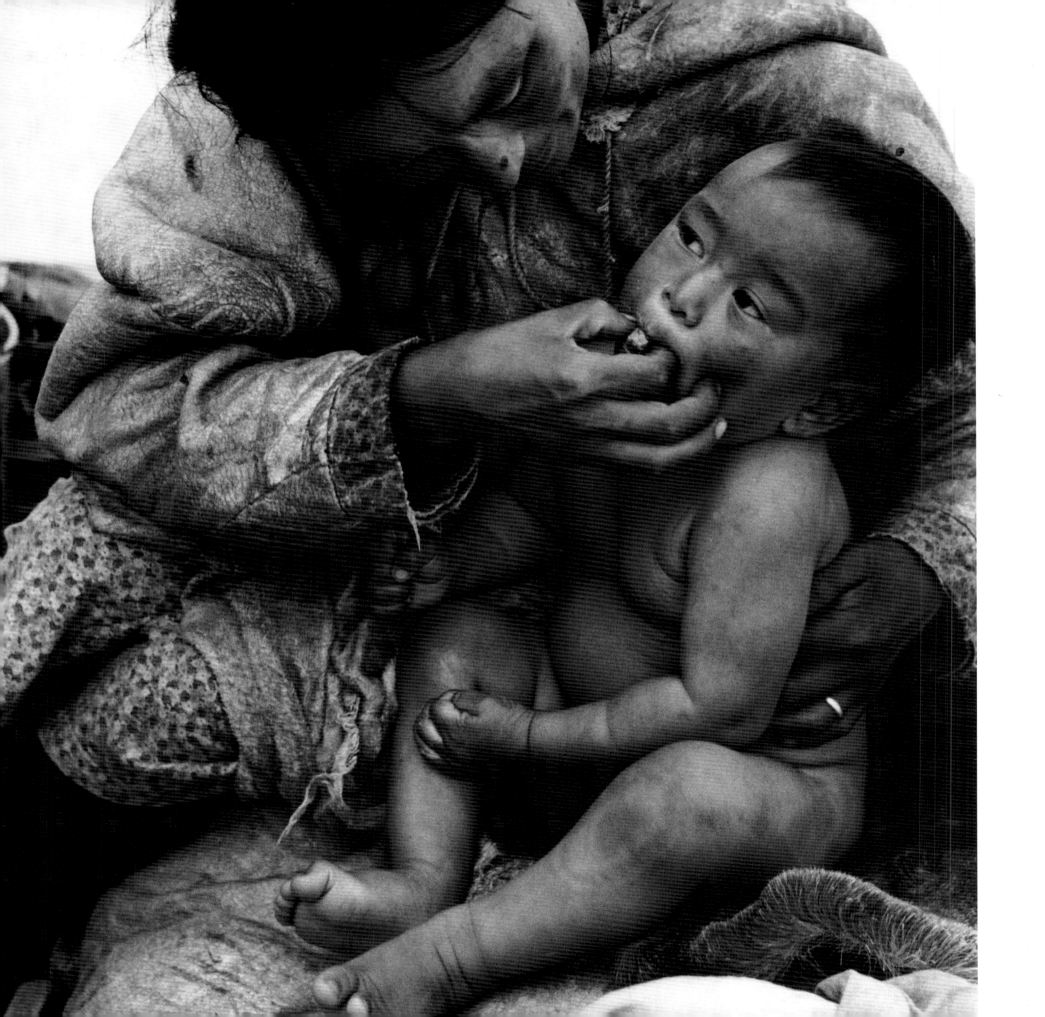

Left: Too far from the coast to hunt seals, Samson Koeenagnak, like all the other inland Inuit of former days, lived nearly exclusively on caribou meat and fat and upon fish, usually eaten, when supplies were good, at two great meals a day. Special delicacies were caribou tongue, marrow, and a sort of sausage made by boiling the mesentery fat in a piece of intestine. Elizabeth Arnajarnek feeds small pieces of pre-chewed caribou meat to her eight-month-old baby.

Right: Sharing was an essential part of Inuit society. Successful hunting is a mixture of experience, skill, perseverance, and luck, and lucky hunters shared food with those less fortunate. When there was plenty, all members of a camp ate well. When there was little food, all shared it and endured hunger together. When I brought cookies for the children in 1966 at their camp at Maneetok, north of Igloolik near Fury and Hecla Strait, two-year-old Angele promptly gave part of her cookie, then a rare delicacy, to her father Isidore Iyitok.

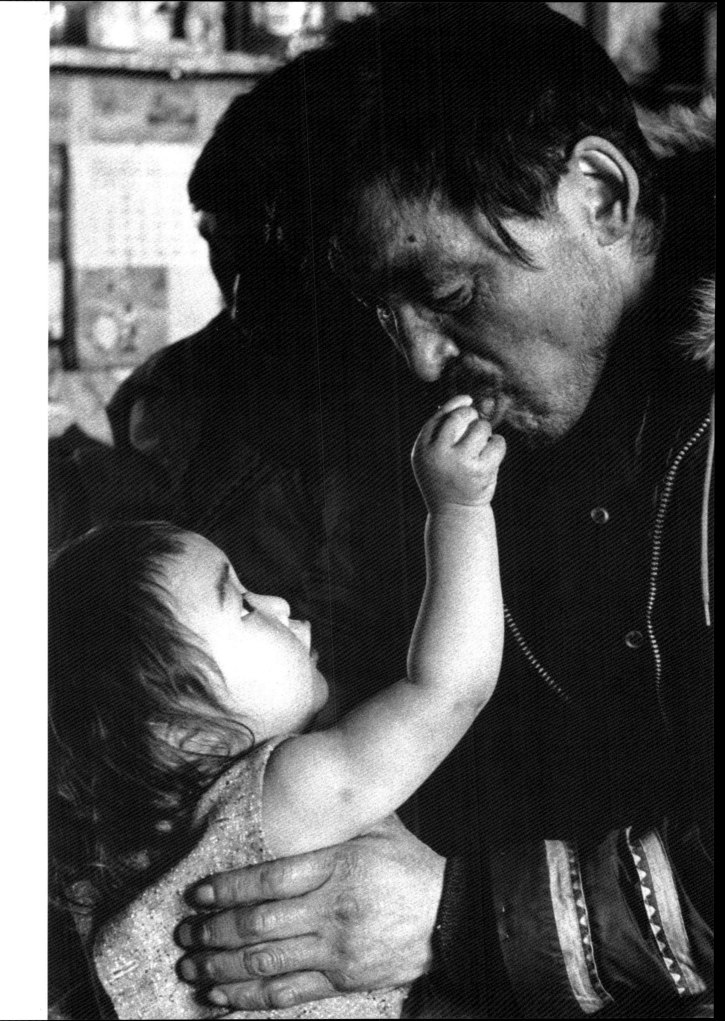

ARCTIC PORTRAITS

They were the people of the caribou and they once lived in that vast region of the Canadian North that awed Europeans called the "Barren Grounds." Until the late nineteenth century outsiders knew virtually nothing about the Caribou Inuit and their land.

When J.W. Tyrrell of the Canadian Geological Survey made, in 1893, "an exploratory survey through the great mysterious region of terra incognita known as the Barren Lands ... of almost this entire territory less was known than of the remotest districts of 'Darkest Africa'."

Tyrrell saw the marvel of migrating caribou crossing the Barrens in herds that then numbered hundreds of thousands of animals. In the area of the upper Dubawnt River: "The valleys and hillsides for miles appeared to be moving masses of caribou. To estimate their numbers would be impossible. They could only be reckoned in acres or square miles." When he walked into the path of the herd, he caused "little more alarm than one would by walking through a herd of cattle in the field." The vast throng parted and flowed past him, as a river streams past a boulder.

Caribou then numbered about 5 million in North America: 1 million in Alaska, 1 million in Labrador and far-northern Quebec, and 3 million on the central Canadian Arctic mainland. The latter were the basis of life of the Caribou Inuit of the Barrens.

The coastal Inuit, from far-eastern Siberia to East Greenland, were primarily sea mammal hunters. Their staff of life was comprised of seals, walruses, and whales. Most also travelled inland to hunt caribou to obtain the furs for winter clothing essential for their survival.

The inland Inuit depended nearly entirely on caribou. A man had to kill about 150 caribou annually to keep himself, his family, and his sled dogs alive.

They hunted caribou with bow and arrow, but, lacking good wood, their bows were weak and killed from no farther than 30 paces. Using very light kayaks, they speared swimming caribou at traditional river crossings, or at narrows between tundra lakes. They steered migrating caribou toward hidden hunters with alignments of inukshukit, human-shaped stone cairns. And they captured and killed caribou in winter in pitfalls, deep, V-shaped trenches cut into snowdrifts, covered with sheets of snow, and baited with urine that caribou crave because of its salt content.

Caribou provided the people with nearly all their needs. Caribou meat and fat was the main food of the people and their dogs. The warmest, lightest Arctic winter clothing ever created was made of caribou fur. Seven skins were required to dress a man, a woman required six, and a child four. Tools, toys, and hunting weapons were made of caribou antler. Caribou sinew was the essential and perfect thread to sew fur clothing and thimbles were carved from caribou bone. Had the world been created with but one animal, the caribou, the inland Inuit would have been content.

Humans and caribou, predators and prey, had existed for centuries, perhaps millennia, in balance upon the Barrens. Less than 1,000 inland Inuit, living in two- to five-family camps scattered across a region twice the size of France, were hunting a portion of the 3 million caribou that migrated annually across the Barrens.

That ancient balance was broken when White men and their efficient weapons came to the North. Starting probably in the

1930s, the caribou began to decline. Overhunting and forest fires that destroyed "caribou moss," the slow-growing lichen that is the caribou's vital winter food, were the main causes of the decline.

In the late 1940s and early 1950s disaster struck. A 1950 Canadian Wildlife Service census showed that of the 3 million caribou a century before, only 670,000 were left. A 1955 recount was worse. Now only 278,000 caribou remained. By 1960, the herds had dwindled to 200,000. Less than 10 percent of the caribou, once in herds so vast they could only be "reckoned in acres or square miles," survived.

The great tide of animals that gave life to humans on the Barrens ceased and the Inuit waited in vain. "Widespread famine came around 1950," noted the scientist Eugene Y. Arima in his 1984 Smithsonian Institution monograph on the "Caribou Eskimo." Many starved. The survivors fled to Baker Lake, the only settlement in the Barrens, or to coastal villages on Hudson Bay. In 1966, when I went to live on the Barrens, it was a land nearly entirely without people.

1966 was my caribou year. In spring I flew together with scientists of the Canadian Wildlife Service and their Inuit assistants to the caribou calving grounds in the Kaminuriak Lake region, south of Baker Lake and west of Hudson Bay. Hidden behind boulders on tundra hills, we watched the widely dispersed females about to give birth. We counted caribou. And we captured and marked calves, one of the more humiliating endeavours of my life, for a three-day-old, gangly-legged little caribou calf could outrun me with apparent ease.

There is nothing in the world as marvellously triumphant as an Arctic spring that breaks winter's deathlike dormancy. The tundra was full of life. Lemmings, busy, mouse-like creatures with rampant libidos, scurried, squeaked, and mated. Ptarmigans courted. Elegant horned larks spiralled toward the sky, then drifted gently downwards with a joyous, lilting song. The caribou herds, widely scattered at birthing time, began to coalesce again, the females now followed by their long-legged, reddish-brown or fawn-coloured calves.

After a month our plane returned and we followed the animals northward, their ancient migration routes marked by dark earthy trails worn deep into the tundra soil by endless caribou herds of ages past.

Everywhere beneath us on the vast tundra, especially near lakes and rivers, we spotted signs of past human habitation: stone circles used as ambushes by hunters; stone rings that had held down their tents; stone cairns to scare caribou toward hidden hunters; and stone pillars that once kept skin-covered kayaks beyond the reach of hungry huskies.

Their signs were there, but there were no more humans on the Barrens. In that immense region west of Baker Lake there stood only a single tent on the shore of Aberdeen Lake, the home of Samson Koeenagnak and his family.

Our float plane landed and taxied to shore. Peryoua, one of the Inuit assistants now living in Baker Lake, translated, for this was for me a strange and very different Inuktitut dialect from others I had previously learned. Yes, Koeenagnak agreed, I could stay and live with them. And yes, in late fall he planned to travel to Baker Lake by boat. I would get home to my family before winter.

The plane took off. The Inuit made room for me on the fur-

covered sleeping platform at the rear of the tent and I became acquainted with my new family: Samson Koeenagnak, then 46, a powerful, broad-shouldered man, with dark hair, and a strongly chiselled, deeply lined face that often smiled; his much-younger wife, Elizabeth Arnajarnerk, kind and very gentle; and their three children, the boys, Kaloo, eight years old, and Kingnuktuk, four, and the one-year-old baby Eeootchuk.

The baby, plump and placid, lived most of the time in cozy comfort, naked in his furry nest, the mother's *amaut*, the spacious back pouch of her dress. The boys, I thought, were too rambunctious, their parents too tolerant and overindulgent. I had lived in Inuit camps on Baffin Island and the children there, though deeply loved and joyful, were, on the whole, very well behaved, excessive wildness being curbed by reproof or ridicule.

In time, told very simply so I could understand, the story of a terrible tragedy unfolded, and then I understood the passionate, protective love the parents had for their children.

Koeenagnak was born on the northern fringe of the Barrens, near the coast of the Arctic sea, in the Chantrey Inlet area. Later he, his young wife, and their four small children moved southward along the Back River. Their camp was near Garry Lake in the path of the caribou migration, and every fall Koeenagnak killed enough animals to survive the winter. And then, in the famine years of the 1950s, one fall the caribou did not come. "We waited and waited. I walked very far and there were no caribou," he recalled with a sad smile.

They fled the empty land. They ate the last of their stored food, they ate pieces of leather, they killed and ate the sled dogs, and he and his wife hauled the sled into the icy emptiness of winter. Weeks passed and their four children died of starvation. They buried them beneath small mounds of stones upon the Barrens.

They struggled on all winter, starving, weak, and getting weaker every day until, emaciated and near death, they reached the safety and supplies of Baker Lake in late winter. There, a year later, Kaloo was born.

But settlement life did not suit Koeenagnak and in 1958 he and Elizabeth moved back to the Barrens, where the two other children were born in 1962 and 1965. The three children were their joy, their love, their everything.

We lived quietly at Aberdeen Lake. The spring caribou migration had passed. Elizabeth sewed clothes, played with the children, cooked, and, after a bad storm, repaired our torn tent.

Twice a day, Koeenagnak walked up a hill a mile from camp. Prone on the ground, his telescope steadied on a rock, he systematically scanned the infinite tundra. Most caribou had migrated north. A few stragglers remained and Koeenagnak stalked his prey with great caution and skill, keeping in its lee and using every unevenness of ground as cover.

He deftly skinned the shot animal, trussed up the carcass, heaved the 45-kilogram load—or 90 kilograms if it was a great caribou bull—onto his shoulders using a long rope as a sort of tumpline, one sling across his massive chest, the other over his brow, and walked back to camp, often many kilometres.

Elizabeth cut up the meat. Some we ate raw. Most she boiled in a huge pot over a dwarf willow and heather fire. And then we ate masses of meat. Koeenagnak alone consumed daily over 3 kilograms of caribou meat and fat. The best meat and the special

Pewatook lived at Kapuyivik , a camp on Jens Munk Island. He visited Igloolik in the late winter of 1966 to shop and when he and his family returned to their remote camp, he took me along. I sledged with him every morning to the floe edge, the limit of land-fast ice, a two-hour dog team trip across storm-piled ice. There he waited in the moist, cutting cold, often at -40° C, for 10-12 hours with the infinite patience of the true hunter for a seal to come within shooting range.

delicacies—the tongue, the marrow, and a sort of sausage made by boiling the mesentery fat in a piece of intestine—were for the children. "Nirguin," she urged them, eat more.

Our talk was mostly of *tuktu*, the caribou. Often, after patient hours at his lookout, Koeenagnak would return to camp. "Tuktu nauk," he said. No caribou. But soon they would come and then he talked about good times, long ago on the Barrens, when caribou had streamed up their valley far in the north, and there had been plenty of food. And he talked of other years when caribou were scarce and the people suffered. *Tuktu*, always *tuktu*, the all-important, vital caribou.

The herds arrived in fall. One day there were no caribou. The next day a grey-brown stream of animals trotted across the tundra, sleek and fat after grazing all summer on the verdant, Far North "Arctic prairies." Koeenagnak hunted day and night and carried carcass after carcass back to camp. Elizabeth cut up the meat, preserved the rich slabs of back fat, stored meat in shade-cooled caches, and air-dried slices of caribou meat. Both worked with little rest day and night, on and on while the caribou passed.

His family was safe. There was now plenty of food for all, even for the sled dogs, to last until next spring when the caribou would migrate north again across the Barrens. He could make the long trip to Baker Lake in his 6.5-metre freighter canoe to buy ammunition, tea, and sugar before the onset of winter.

We crossed Aberdeen Lake and Schultz Lake, shot the long, foaming rapids of the Thelon River, which had frightened even Tyrrell's famous Iroquois Indian canoemen from Caughnawaga, and then cruised down the great river.

On either side of the river the tundra rolled away toward the horizon, vast and empty, green and brown in sunlight, grey and sombre in shade. From its nest on a cliff high above the river rose a rough-legged hawk and circled above us, its wild and mournful cry echoing the mood of the Barren Grounds.

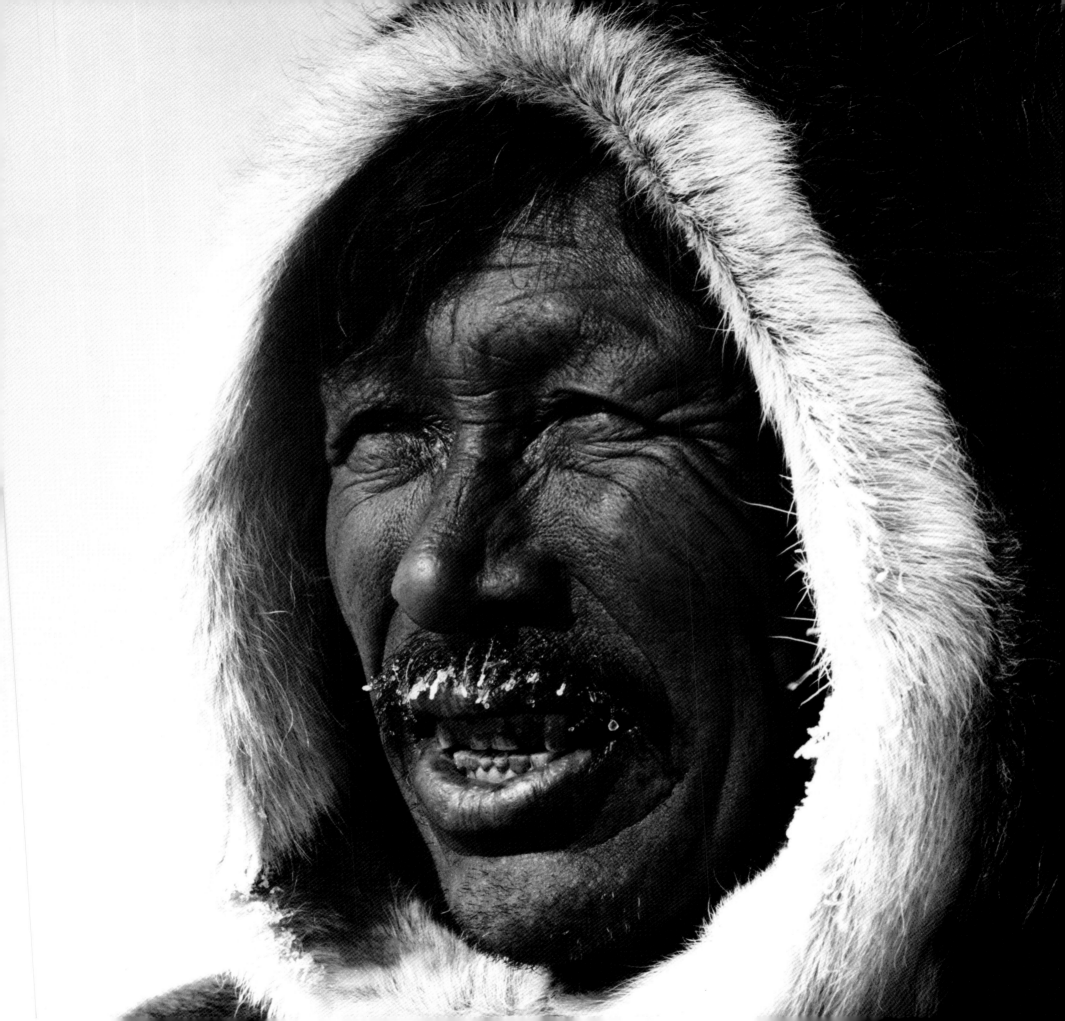

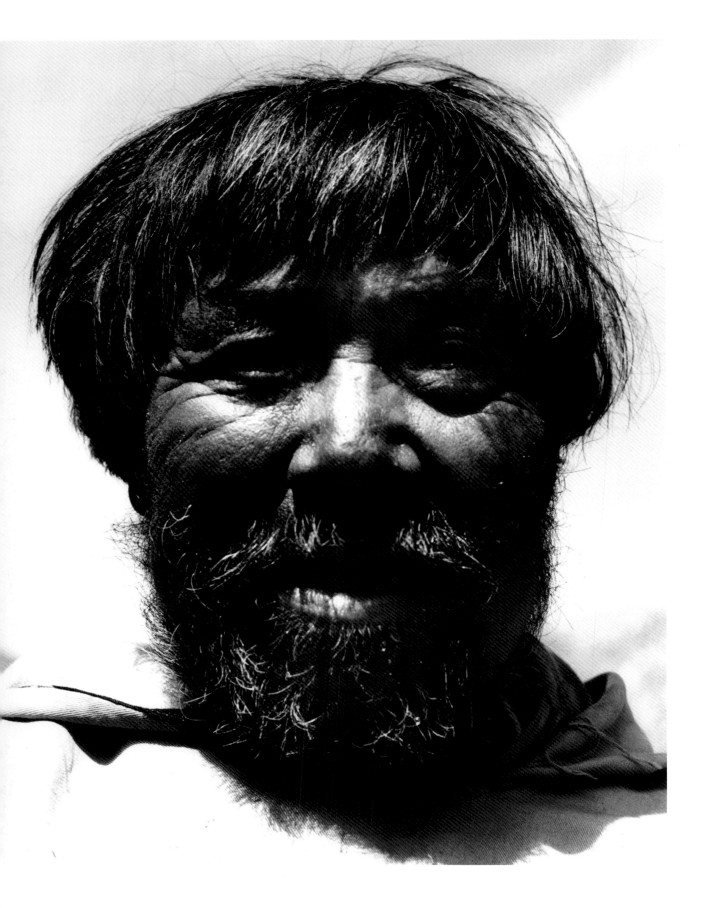

Left: The many ancient Inuit camps of the north Labrador coast have long been abandoned. In 1918 the Spanish flu epidemic reached this coast and within three months more than a third of all Labrador Inuit were dead. The survivors moved into settlements. In summer some returned to their ancestral char fishing camps in the magnificent fiords of northern Labrador and there, at Bears Gut in 1968, I met the Labrador Inuit fisherman and hunter Jefta Jararuse.

Right: Etuguloopia's summer camp was at Ward Inlet off Frobisher Bay on southern Baffin Island. I was in the town of Frobisher Bay (now Iqaluit) in the summer of 1965 photographing the painter A.Y. Jackson, when I met Etuguloopia at the Hudson's Bay Company store. Could I come and live at his camp, I asked. "Yes," he said with a smile, "if you like to eat seal." The next day we left by canoe and I spent many weeks and ate many seals at the camp of this kind and charming man.

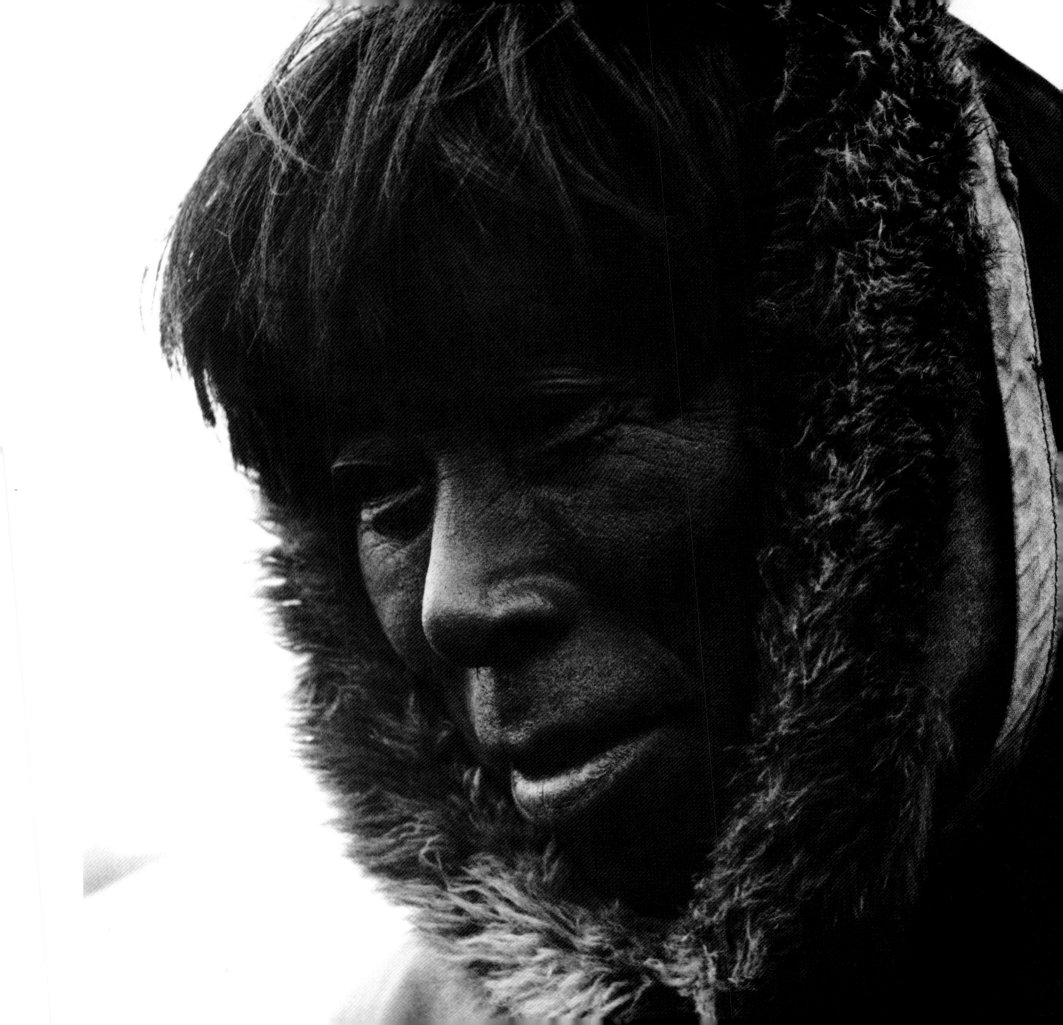

Simon Kadlun and his family travelled nearly
300 kilometres by dog team from their inland
camp at Contwoyto Lake to visit us at Bathurst
Inlet where his daughter was married to one
of the best hunters. I liked him. He was a
strong and confident man with an easy laugh.
He had heard through the very efficient Inuit
grapevine the odd news that a White man
was now a part of Ekalun's camp and he was
politely amused when he met me.

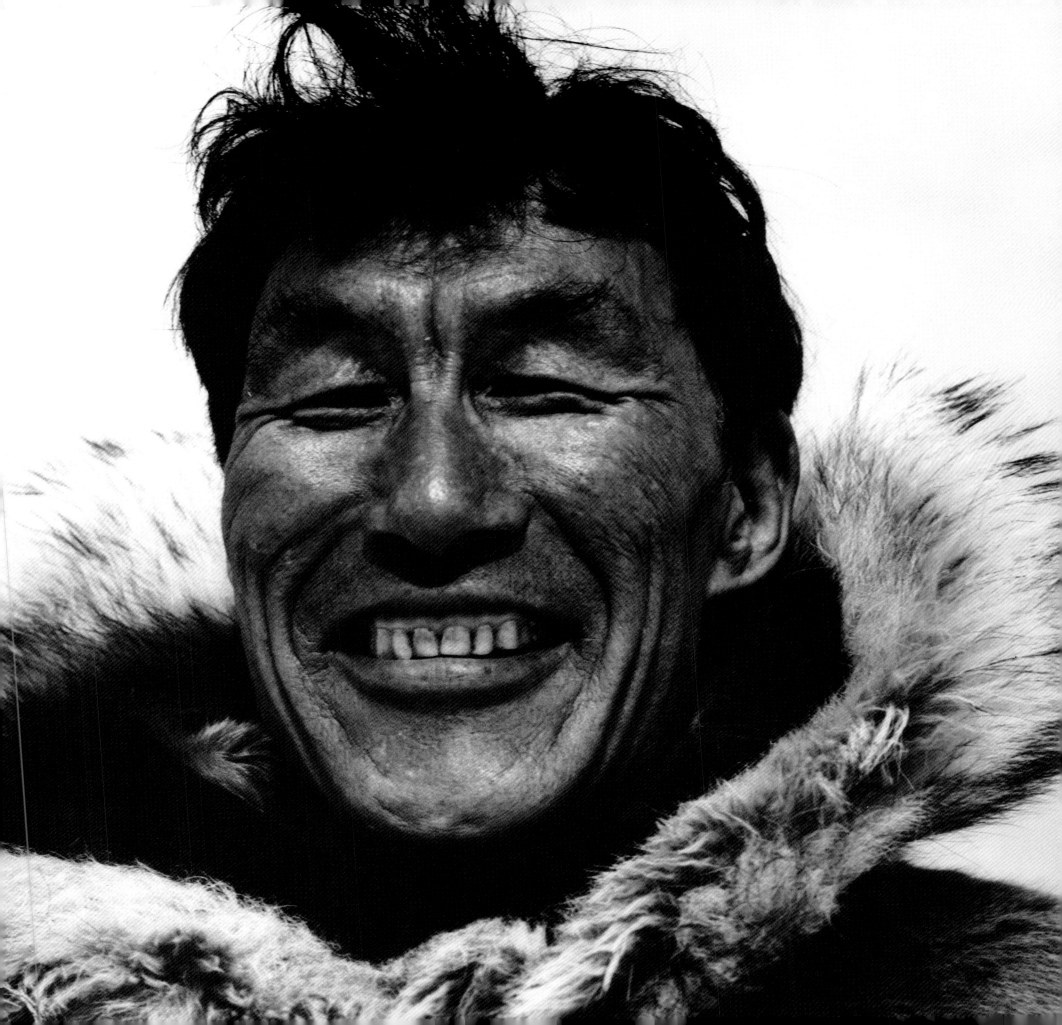

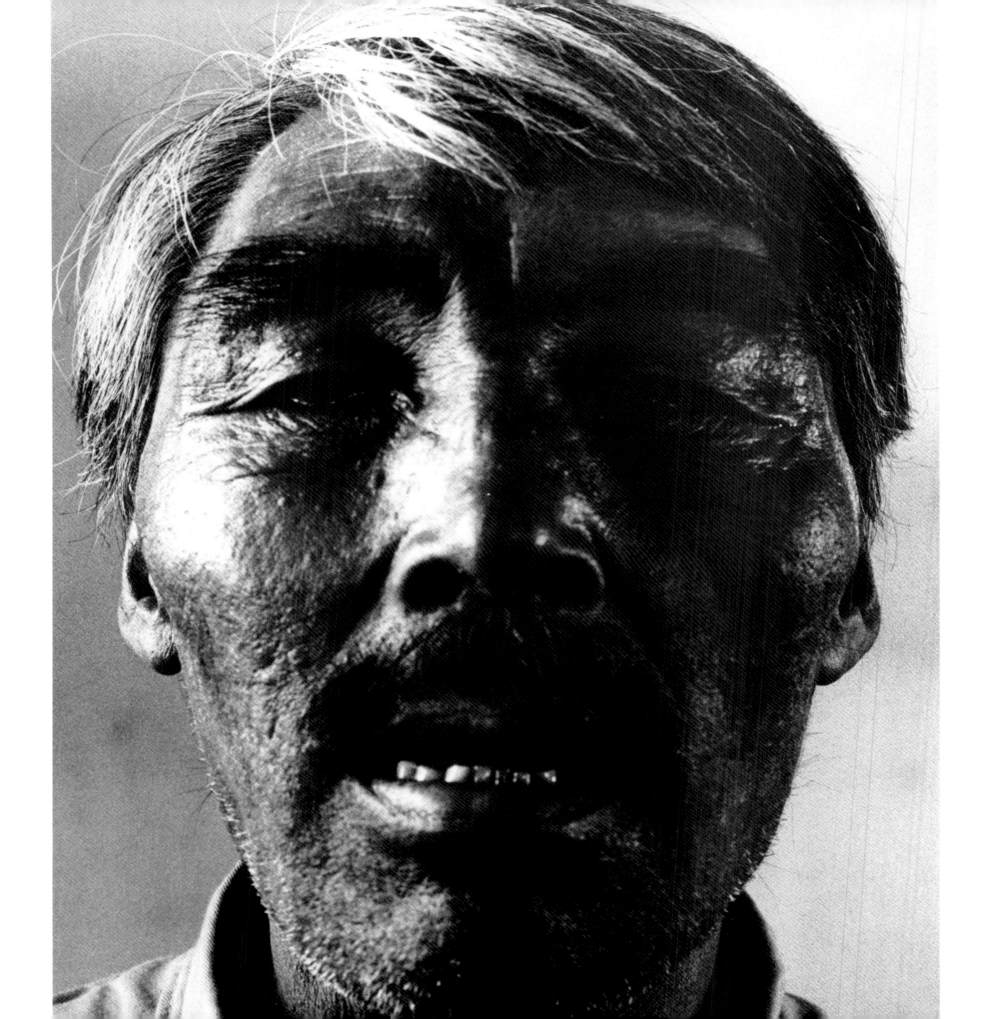

Left: During the 10-day dog team trip in March of 1969 from Cambridge Bay on Victoria Island to Ekalun's camp at Bathurst Inlet where I hoped to live for six months, we stopped briefly at Baychimo and I visited John Okhena and his wife Lucy Ananglak. They received me kindly, made tea, and gave me meat, but they were very quiet and reserved. When I asked to take their picture, they agreed immediately, but sat totally still and stared at me, their faces like graven masks.

Right: Rosie Kongyona and her husband Ekalun, both great-grandparents in 1969, were very fussy about their appearance. Pure Inuit, perhaps because of their long-ago Asian origin, remain dark-haired even when they are very old. Consequently Ekalun and Rosie regarded white hair as unseemly and carefully removed them from each other's heads with tweezers. Long ago, he told me, they used tweezers made of clam shells to remove unwanted hairs.

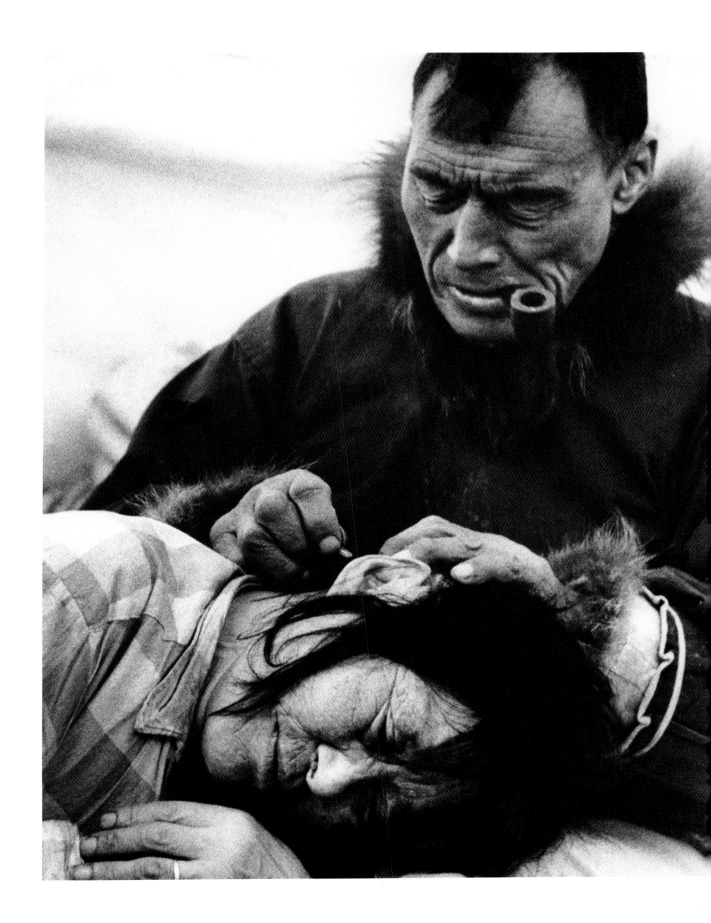

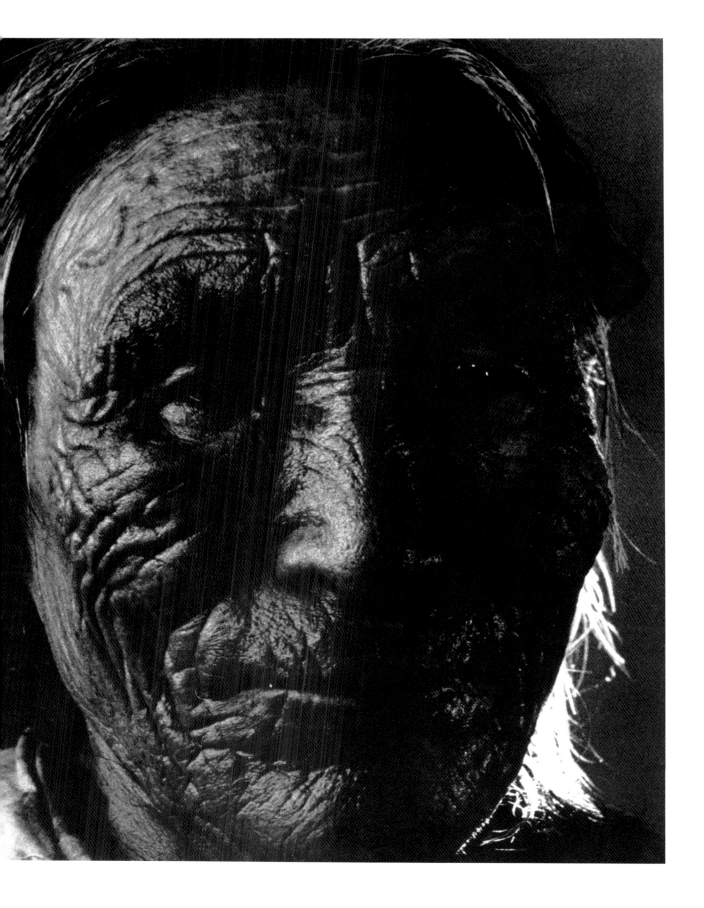

Left: The face of time. Born probably in the 1880s, Lucy Ananglak was by far the oldest person in the Bathurst Inlet region when I lived there in 1969. When she was young, Inuit measured time in moons and seasons, but not in years, and Lucy did not know her age nor did she care. She was forever busy, cooking, sewing superb fur clothing, catching fish, and cutting up the seals and caribou brought home from his hunts by her much younger husband.

Right: The Polar Inuk who picked me up with his dog team near the Thule Air Force base in northwest Greenland in 1971 was very dark. He was Anaqaq Henson, the son of Matthew Henson, Admiral Peary's Black servant. On a dresser in his spacious, self-built house in the village of Moriussaq, Anaqaq had placed a picture taken by Peary of Matthew Henson at the North Pole holding the U.S. flag. "My father at Kalalerssuaq [the big navel]," he said proudly. A joyful man of 65 who liked to laugh, he was one of the best hunters in the Thule district.

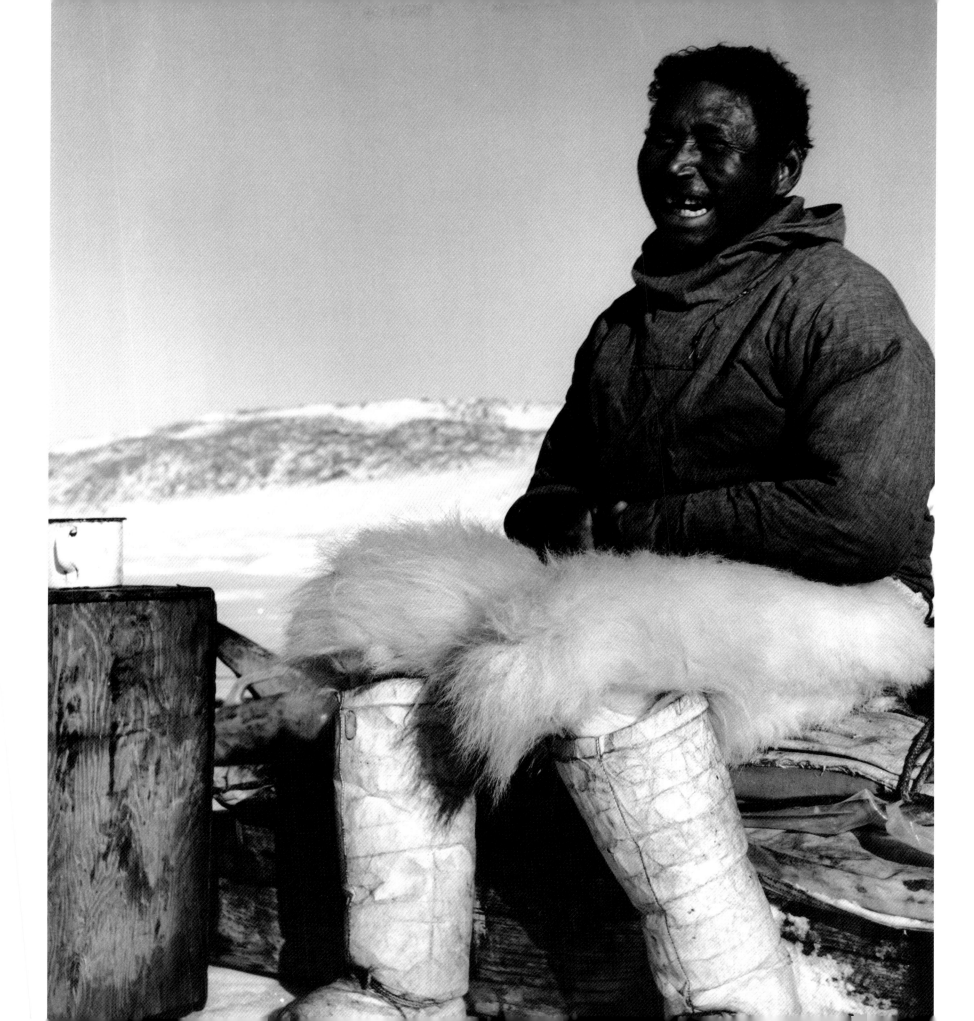

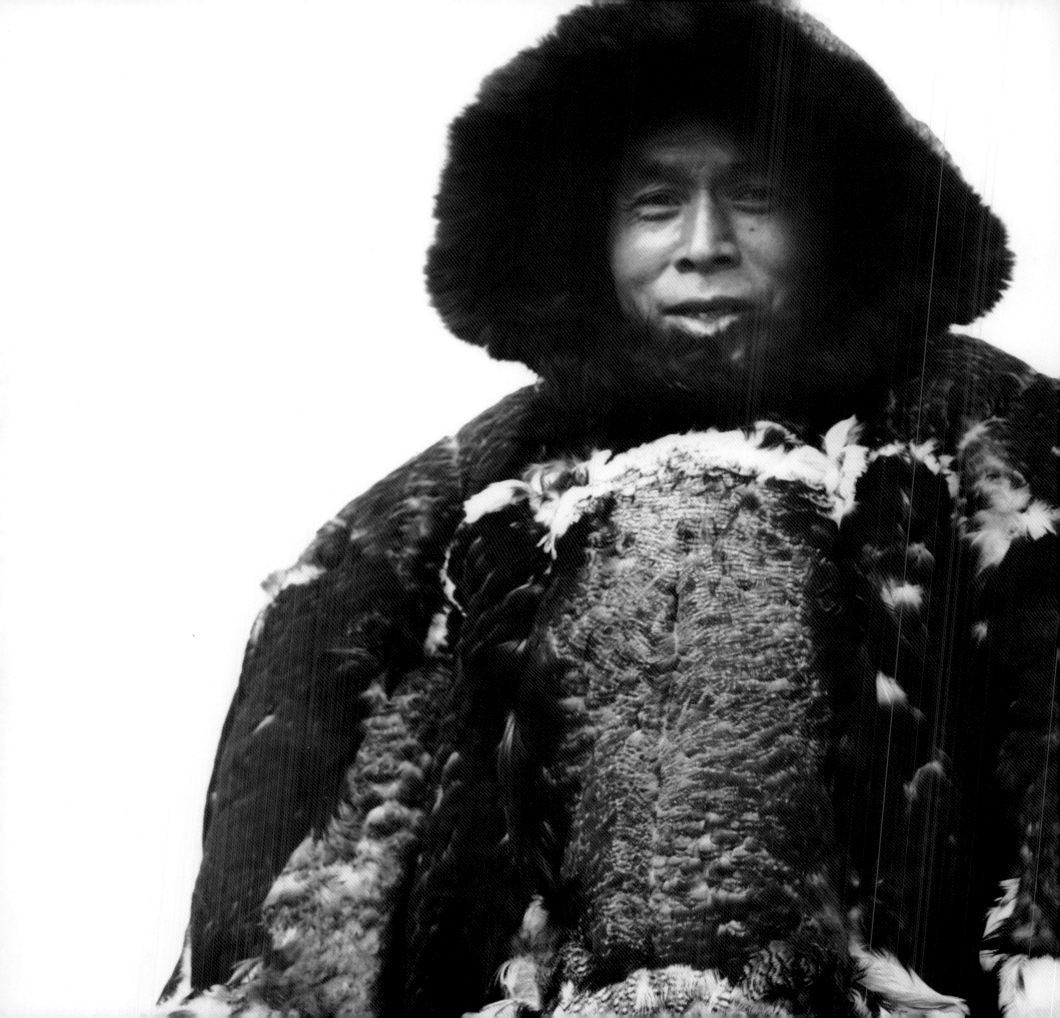

In the late 1880s a terrible winter struck the remote Belcher Islands, about 160 kilometres off the east coast of Hudson Bay. The snow was deep. In March it rained heavily. That turned the snow to mush. Then came severe cold, the mush became ice that covered all the islands and all the caribou, source of the essential fur for winter clothing, died out. The ingenious island Inuit solved the problem. Their women made *mitvin*, parkas of about 24 sewn-together eider duck skins, such as this one worn by Moses Meeko. Such a duck-skin parka was as warm as one made out of caribou fur, he told me, but not as lasting.

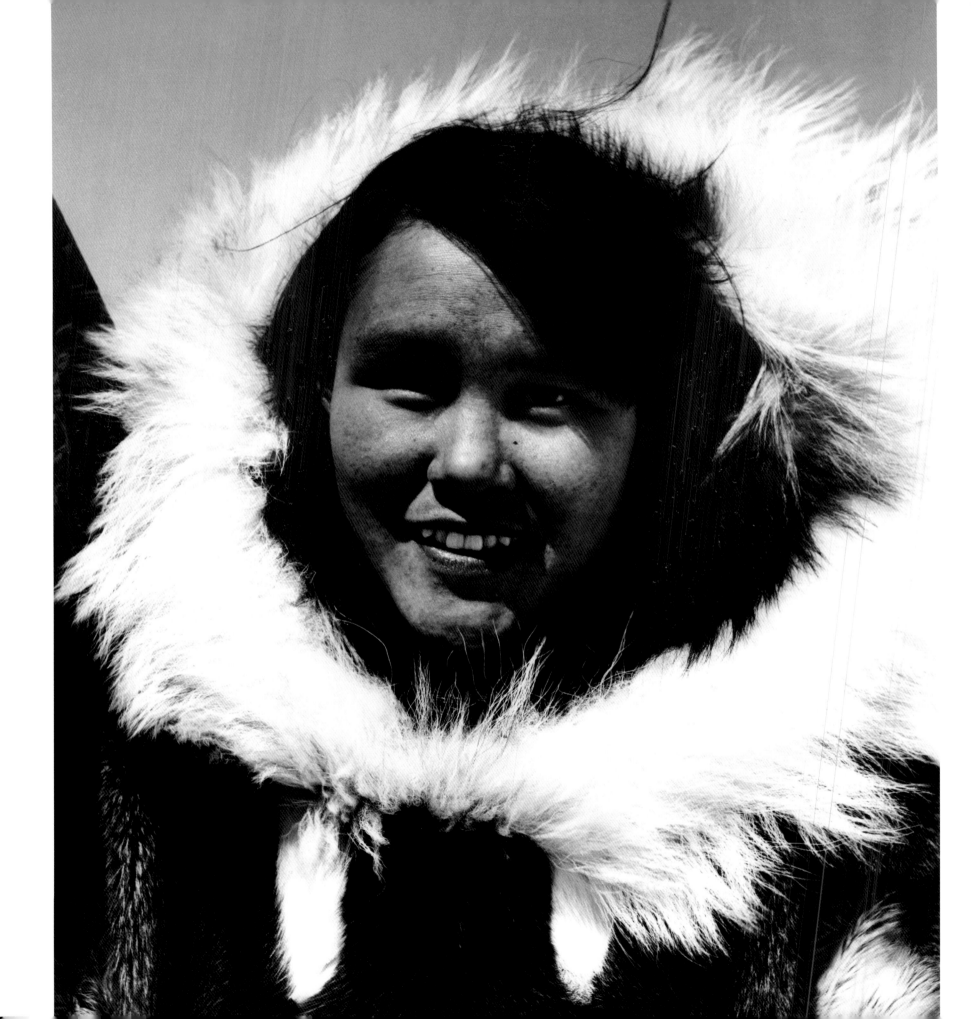

Left: Jessie Kungaglak, the beautiful wife of George Hakungak, in her magnificent winter caribou-fur parka with a wolf-fur ruff. She was the mother of two small children, three-year-old Karetak and just-born Niirk. Despite that, she and her husband made very long and arduous hunting trips by dog team and sometimes, since they knew I loved such trips, they took me with them. Gentle and kind, Jessie fed us well and, when necessary, repaired my fur clothing. On a few occasions when, after taking pictures, my hands were badly frozen, she helped me to put on the large fur gloves she had made for me. "It's like having a third child along," she once remarked with a smile.

Right: Sofie Eipe, of northernmost Greenland, liked to dress in the height of Polar Inuit fashion. It showed that her husband, Masautsiaq, was a superb hunter who could cover her in the best of furs. She wore a parka made of the winter fur of blue foxes, warm and elegant, with a large helmet-like hood of ringed seal skin with a fox-fur ruff, pert little fox-fur pants, hip-high pure white sealskin boots fringed at the top with the long, silver-glistening mane fur of a polar bear, and inner boots made of down-soft Arctic hare fur.

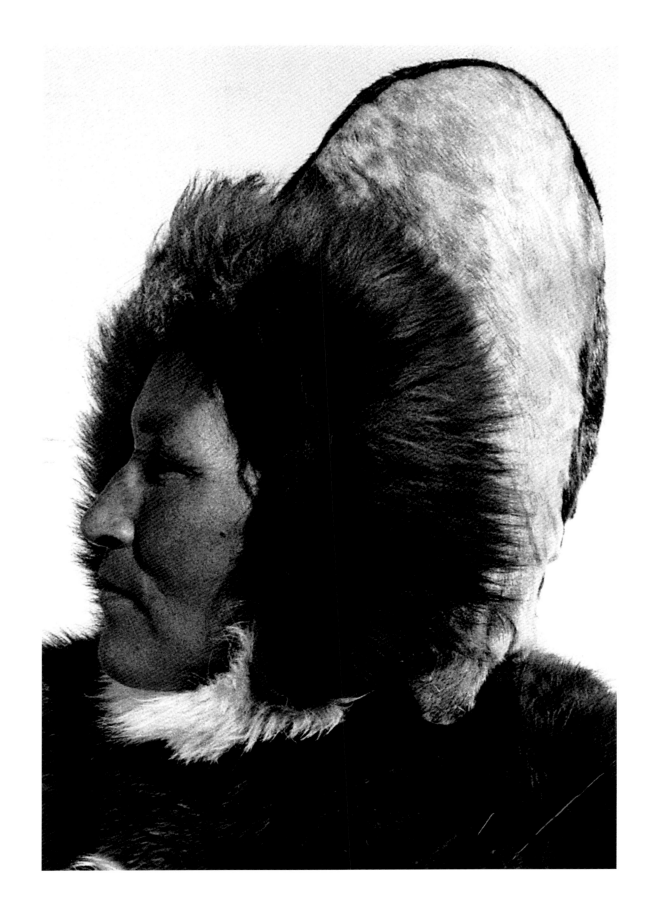

THE CHILDREN

We left the village of Igloolik on the coast of northwestern Foxe Basin in a blinding blizzard, Pewatook, an Inuk hunter, his wife Tatigat, and I, to travel by dog team to his camp at Kapuyivik on remote Jens Munk Island, 100 kilometres to the north. After shopping in Igloolik, Pewatook and Tatigat were going home. For me, in 1966, it was my first winter trip to an Inuit camp.

Tatigat, roundish in her voluminous furs, sat on the sled. I sat behind her. Pewatook called to the dogs. The heavy sled lurched forward and gained momentum.

I looked back. Igloolik had vanished. Eight dogs, a long sled, two fur-clad Inuit, and I seemed to glide through an infinity of white, like mites in milk.

After five hours Pewatook stopped. Time for tea. With his long snow knife Pewatook cut snow blocks to build a curved windbreak and lit the Primus stove.

The tea was nearly boiling when out of that white nothingness a second sled appeared. It was Malliki, Pewatook's son, his wife Erkarasa, and their three children: seven-year-old Kattanak, her five-year-old brother Attaguatiak, and the baby Panipak, naked in the warm dorsal pouch of Erkarasa's *amautik*, the brilliantly designed "mother parka" of the Inuit.

Kattanak peered at me, her fur-framed face plastered with snow. She was about to brush it off. "Leave it, please!" I said and mimed picture taking. She waited, immobile, patient, and polite. The camera's metal felt like fire. I took four pictures. Then my hands went numb. The fingertips were frostbitten. Later they turned black.

We travelled like that for 15 hours, in a searing blizzard at about -20° C, with three small children, somewhere on the ice of Foxe Basin, and all was white and void and featureless until we came to a small white mound in an endless expanse of white. "Kapuyivik," said Pewatook. We had arrived at our home.

The men unharnessed and fed the sled dogs. The women and two children carried the sled load into their home. Half a dozen snow steps, screened by a porch of snow blocks, led down to a first door. This opened into a large anteroom igloo where the bulky outer fur clothes were stored, cold and dry, on one side, while the other side was piled high with the cut-up, frozen carcasses of caribou, seals, and walruses.

It was a huge circular room, about 6 metres across and 4 metres high. The bottom portion was built of snow blocks. The roof consisted of fused blocks of transparent freshwater ice. On a bright day this spacious, ice-domed igloo was suffused by a beautiful blue-green light.

From the igloo a second door led into a narrow, upward-sloping passage, a cold trap, and a third door opened into the spacious living quarters of the two families.

At the far end of the room was the sleeping platform, strewn with furs, where all slept at night. In the daytime it was the living/playing/working space for adults and children. Three large, half-moon-shaped *kudlit*, seal-oil lamps, burned day and night and kept the superbly insulated room comfortably warm.

For me Pewatook and Tatigat built a separate sleeping platform across from theirs, covered it with a thick layer of sealskins and caribou furs, and placed upon a stand of stone and wood near the head of my bed my own seal-oil lamp for extra warmth and light.

It was a large lamp, carved out of soapstone, nearly a metre

long, the basin filled with oil, the long, straight rim covered with a wick made of moss and the bolls of Arctic cotton grass. Maintained by an Inuit woman, such a lamp, adjusted from time to time with a *tarkut*, a small, hammer-shaped wick trimmer made of stone, burned with a bright, hot, even flame. It heated the room, cooked our food, melted ice or snow, and dried clothes arranged on drying racks.

I had seen women in other camps adjust their lamps. It looked easy. It wasn't. I either extinguished the flame or it flared up and spewed soot.

Kattanak watched this for a while, then came over and, with a few deft taps of the *tarkut*, adjusted my wick to perfection. From then on she became the self-appointed guardian of my lamp and of me as well. Serious and diligent, she checked my sealskin outer boots and caribou fur inner boots every day when I returned from hunting trips with her grandfather and made sure all my clothing was properly dried. She repaired my fur clothing, sitting on the sleeping platform next to her mother, sewing any gaps and gashes with sinew thread, the stitches neatly spaced, for mending, sewing, trimming lamps, and drying clothes were women's work in Inuit society.

Apart from taking care of me, Kattanak, armed with a long-handled knife, went every day to a special place to cut chunks of *aniuk*, the coarse-grained snow that, when melted, yielded the most water. She played with the baby and fed it small pieces of pre-chewed meat. When she was not busy helping her mother, she and Attaguatiak played for hours outside or, when the weather was very bad, inside with several traditional games of skill made of carved seal and caribou bones.

The children were marvellously sufficient unto themselves. They had to be. Their world consisted of their grandparents, their parents, the baby, and me. There were no other humans within 100 kilometres of us, yet the children never seemed lonely.

Kattanak was alternately a joyful, exuberant child, playing outside with her brother, or the earnest, conscientious little housewife, helping her mother, learning skills, and repairing my clothing, responding with a shy but pleased little smile when I thanked her and praised her expert sewing. Like many outsiders before me, I marvelled at the near-total independence of the adults and the charm of their children.

Inuit society, the anthropologist Diamond Jenness noted in 1914, did "dispense with all authority and grant to the individual a freedom that was well-nigh absolute. The very ideas of servitude, of master and man, of the subjugation of one man's wishes to another man's will were totally alien to the Inuit. Their language does not even have a word for 'obey'."

It was a cultural trait that White explorers found in turn admirable, baffling, and exasperating. "They cannot be controlled," complained the American explorer I.I. Hayes, annoyed that Greenland's Polar Inuit would not accept orders from him. "…the Esquimaux are each a law unto himself. They are the most self-reliant people in the world."

On Baffin Island at the same time (1860), another American explorer, Charles Francis Hall, was having problems with the free-spirited Inuit. They were, he admitted, good companions and superb hunters, but "they will do just as they please…utterly regardless of my wants and wishes. They mean no ill, but the Inuit are like eagles—untameable."

If the utter independence of the adult Inuit often annoyed White explorers, they were amazed and delighted with Inuit children. Coming from a society that believed the rule "spare the rod and spoil the child," they were puzzled that Inuit children who were never beaten could be so utterly charming. At Point Barrow in Alaska in 1881, the anthropologist John Murdoch observed that Inuit children "though indulged to an extreme extent are remarkably obedient."

Mrs. Tom Manning, who lived with her naturalist husband among the Inuit of southern Baffin Island in the 1930s, found that "children are rarely scolded or corrected for any fault. It is a mystery to me how they grow up to be, for the most part, such charming people, obedient, cheerful, courteous." And 30 years later, the Canadian author Sheila Burnford was equally charmed with the Inuit children of northern Baffin Island, who "were the most happy, self-contained and naturally courteous little people I have ever met."

That "old way of life," as the Inuit call it, died fairly abruptly when the people left the land and the ancient, ancestral camps, moved into the new settlements, and when their children attended schools dominated by an entirely different culture. "By the late 1960s," wrote the scientist Eugene Y. Arima in his Smithsonian Institution monograph on the "Caribou Eskimo," "only the aged knew the old traditions....Youth was interested in White mass culture, media and music."

In 1972, while attending a conference in Pangnirtung on Baffin Island, William Tagoona, a young "city Inuk," met some camp Inuit who had come "to town" to do some shopping. Later he wrote about the meeting in the magazine *Inuttituut*: "I was surprised to see how unspoiled and happy they were. I did not feel much of an Inuit beside these happy people and thought to myself 'so these are the real Inuit!' I felt I was an Inuit of today and did not have much in common with the old."

Camps closed. Traditions died. A millennial way of life flickered and then faded away. For 30 years I was a part of this world, the ancient world of Inuit hunters and their families, living on the land. I lived it, watched it, photographed it, and now this world has vanished.

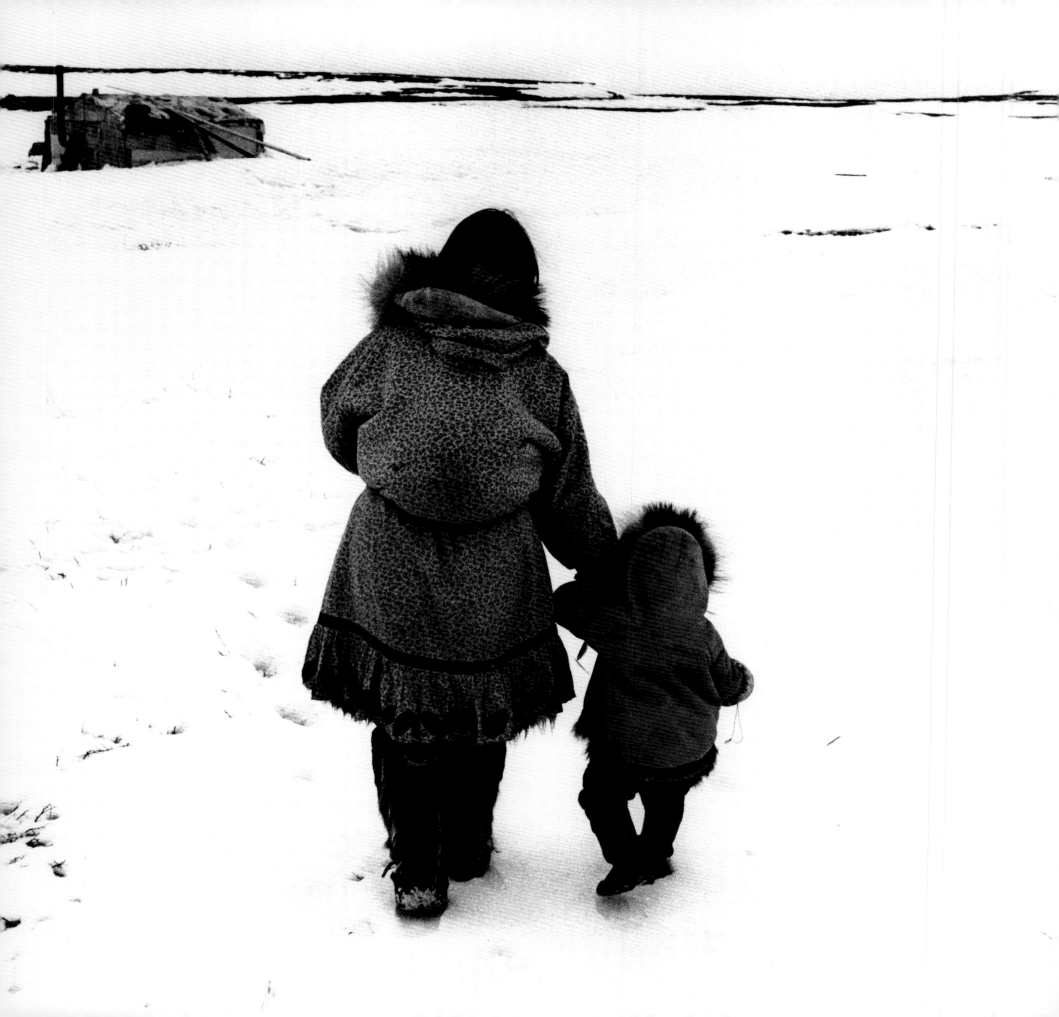

Left: Going home: George Hakungak, his wife Jessie, their two small children, and I were travelling far inland by dog team in search of caribou in the lonely region beyond the Hood River when we came upon this hut, covered with old caribou furs and used as a travel shelter by the Bathurst Inlet Inuit. We cleaned out the snow that had drifted into the hut, collected Arctic willow and heather as fuel for the simple stove, spread our sleeping furs, and for a week it was our home.

Below: Children at play in a white world. The game was "stalking." Three-year-old Oched was the "caribou" and his older brother the "hunter." Oched zigzagged across the vast white plain near our camp. Papak followed at a distance, ran suddenly, and pounced and Oched squealed in the snow. Then the roles were reversed and little Oched stalked his brother. It was one of the many hunting games of a hunting society.

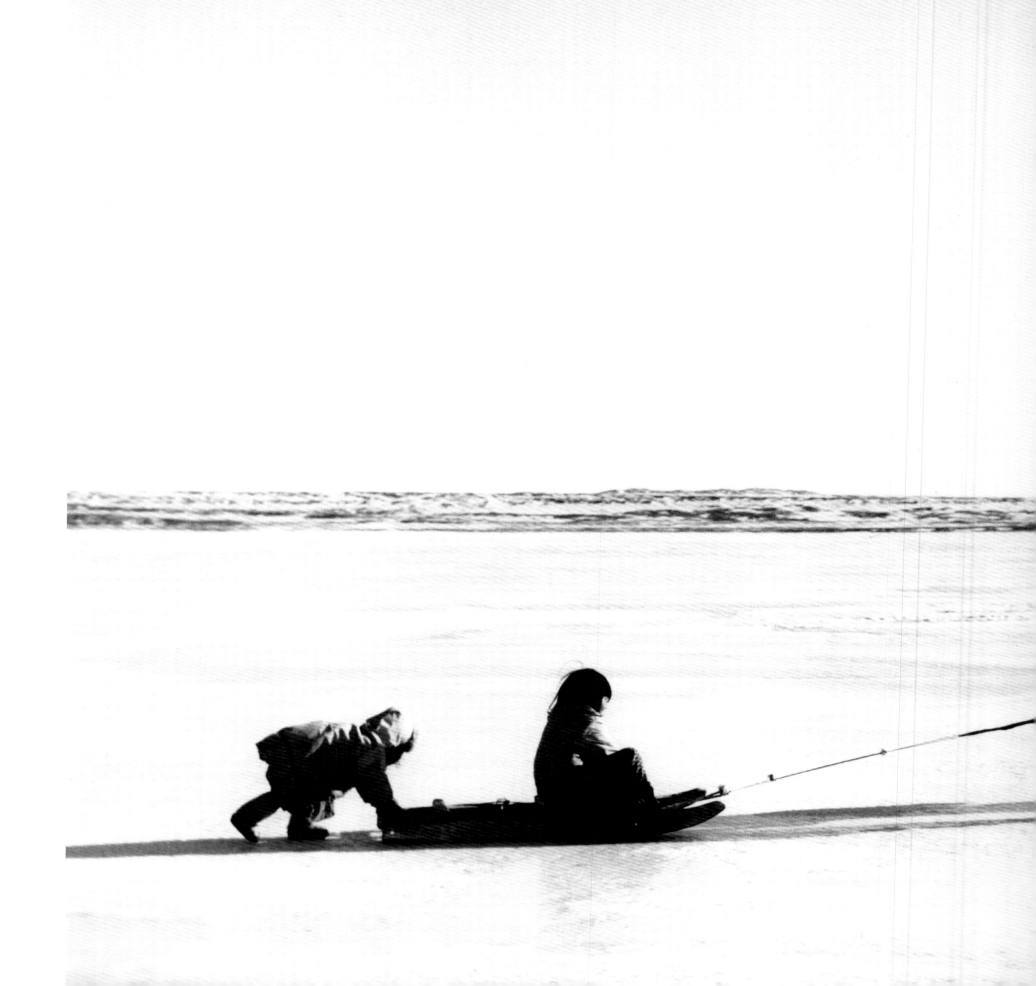

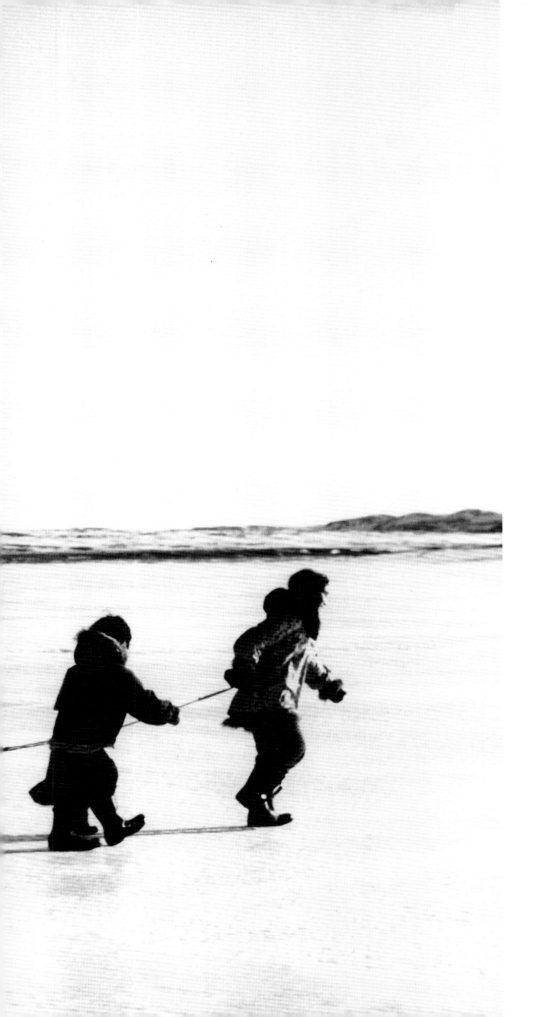

There were 11 children at our Bathurst Inlet camp and they were forever busy, doing small chores in camp, or playing together with an old battered sled on the sea ice near our camp. The men hunted, carved, or repaired hunting equipment. The women cooked, cut up game carcasses, cleaned skins, sewed clothing, repaired dog harnesses, gossiped, and played with the babies. The children did as they pleased and, as a rule, played together in happy harmony.

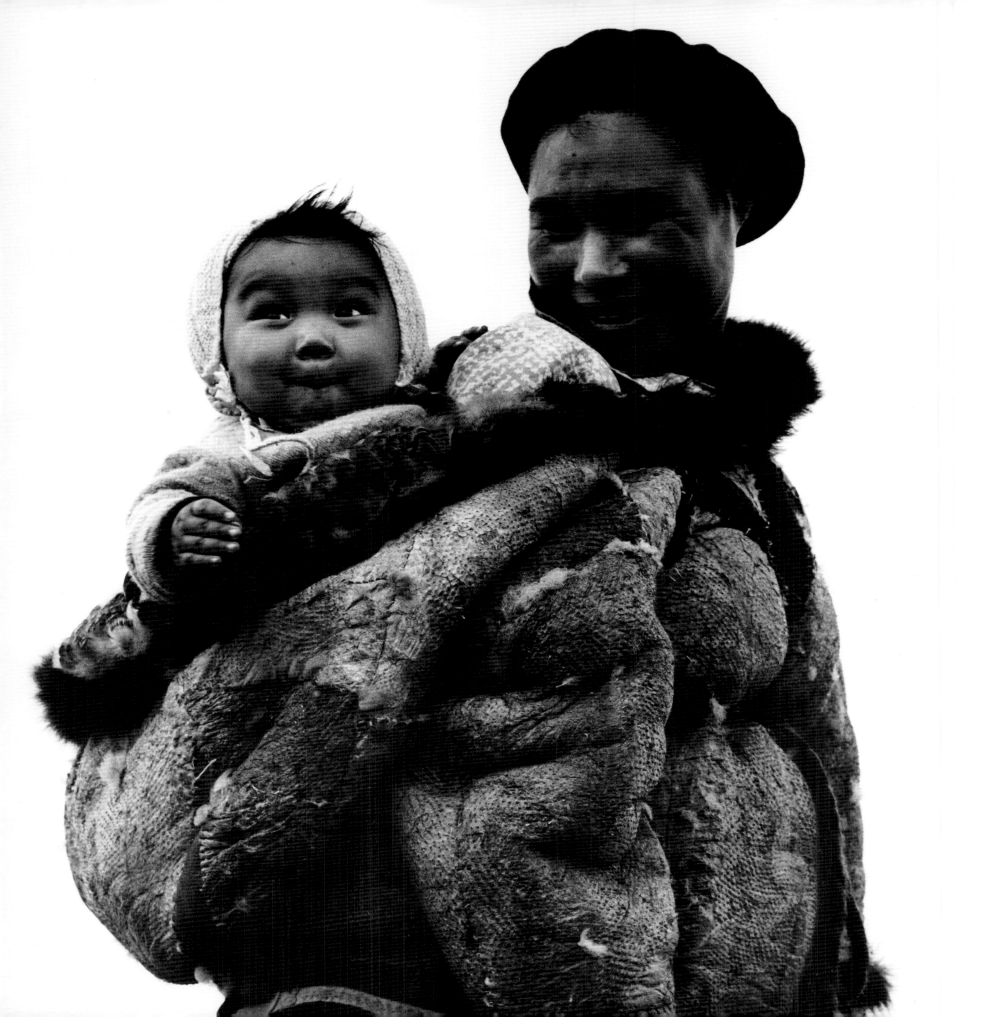

Left: Little Johnassie sits warmly in a feathered nest, the *amaut* his mother Louisa Empuk made of sewn-together eider duck skins. During a terrible winter in the 1880s, caribou died out on the remote Belcher Islands in eastern Hudson Bay. It would have doomed a less inventive people, for the Inuit needed caribou fur to make their superb winter clothing. With the caribou dead, the Belcher Island women made their clothing out of eider duck skins. These *mitvins* were warm and cozy, but as a rule lasted only about a year.

Right: At our camp near Aberdeen Lake in the eastern Barren Grounds, Elizabeth Arnajarnerk uses a file to extract marrow from the recesses of a cracked caribou leg bone. In former days, among their amazing arsenal of specialized tools and hunting weapons, the Inuit had a marrow extractor, a slender, rod-like, hand-long implement carved of bone or caribou antler, with a spatulate end perfect for removing the deliciously oily, vitamin-rich marrow from cracked bones.

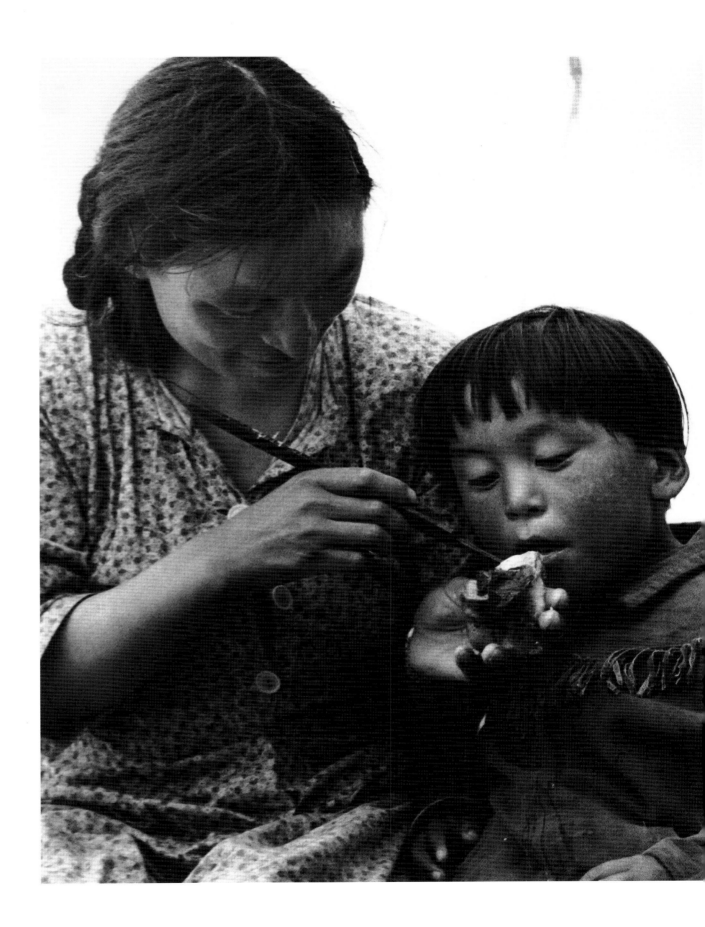

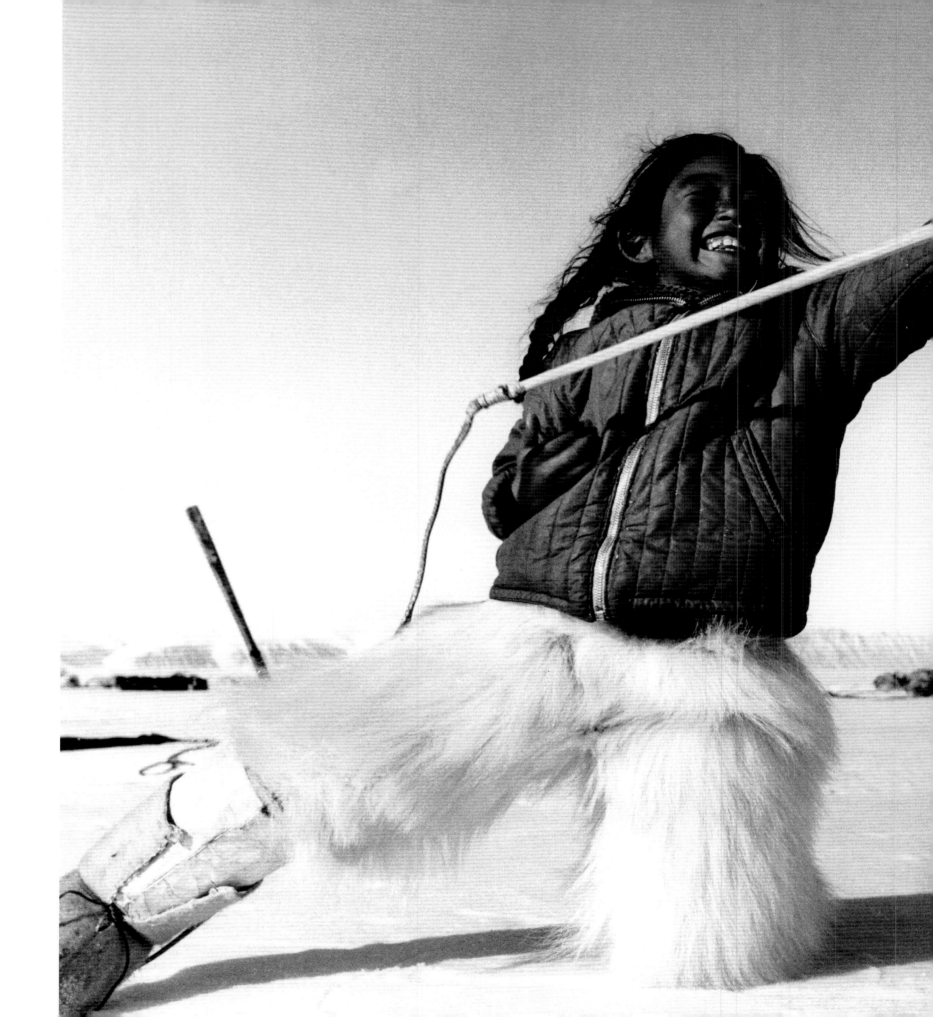

The Polar Inuit of northwest Greenland often took their families along on hunting trips to the floe edge, the limit of land-fast ice, a 100-kilometre trip by dog team from their village. The men hunted seals at the ice edge. The women set up tents and kept house. And the children played, batting snowballs with the handle of their father's sled dog whip.

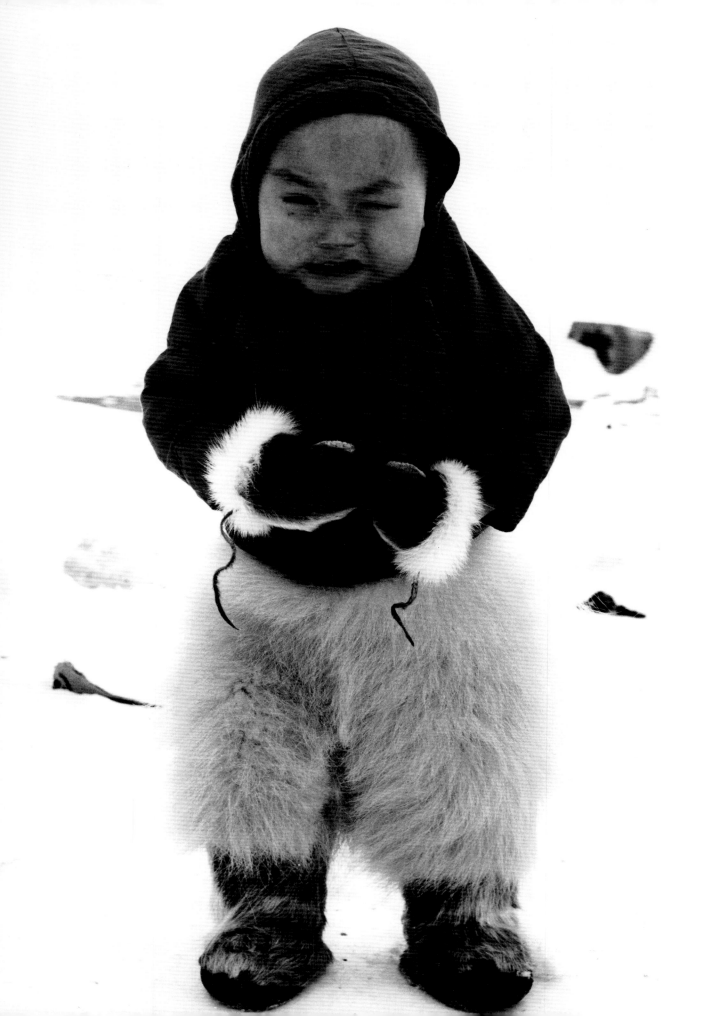

Left: I spent a lot of time on my knees while photographing the children of the Arctic in order to be on their level and not shoot down on them. The children at first found it funny to have this tall, lanky White man crawling around on his knees, but since I lived with them for months, the novelty wore off and they soon ignored me. This little boy lived in Siorapaluk, Greenland, the northernmost village on Earth. He wears a traditional anorak, fox-fur mitts, pants made of polar bear fur, and sealskin boots.

Right: Ekalun, of Bathurst Inlet, with his grandson Niirk. During the six months I lived in Ekalun's tent, he subtly, and sometimes not so subtly, set out to alter my White man's behaviour. By prod and praise, by sanctions and rewards, he educated me exactly as he would have educated an Inuit child to conform to the cultural norms and manners of his society.

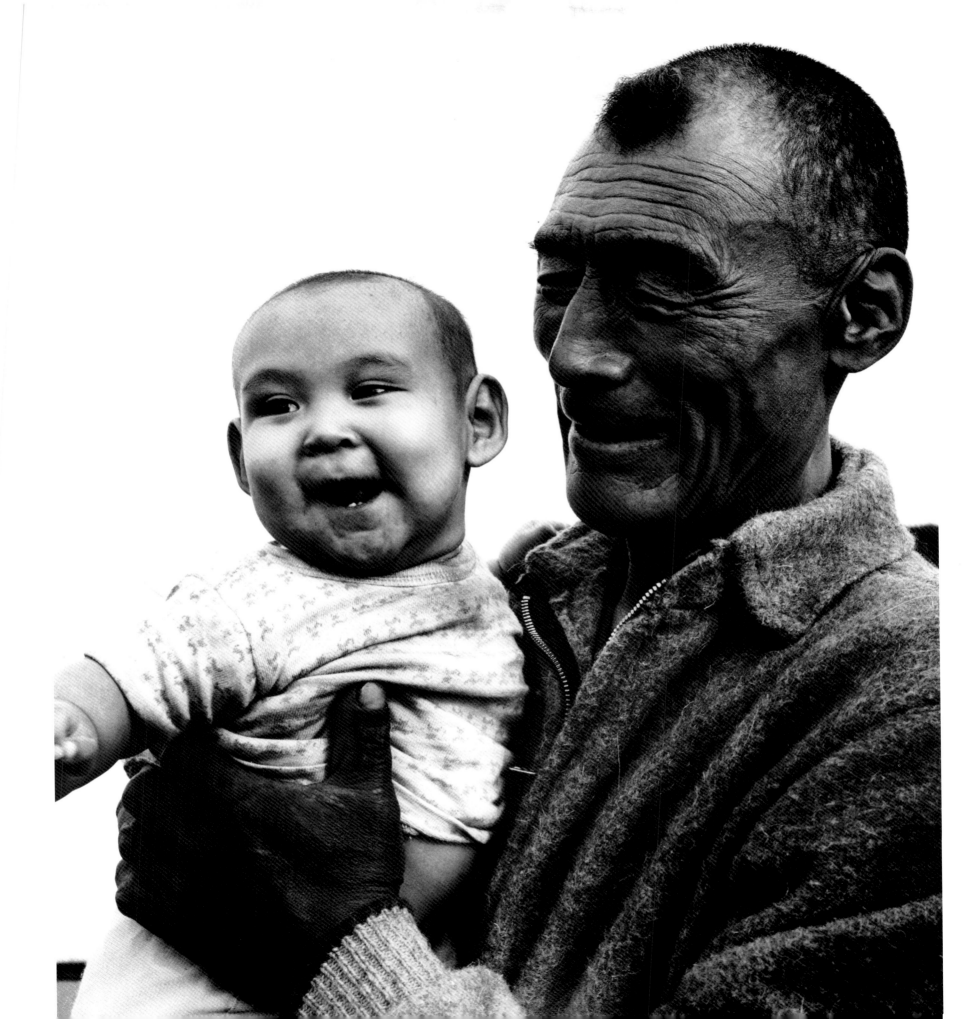

Children in endless space. For Inuit children camp life of the past was one of immense freedom. They slept when they felt like it, ate when they were hungry, helped willingly and eagerly with the work in camp, and played together for hours. Near our Bathurst Inlet camp a coastal hill sloped down to the vast expanse of snow-covered sea ice. Puglik, joyously energetic, pushes the old sled up the hill again. For little Linda Kayoina who visited us from a faraway camp where she was the only child, playing with other children was wonderful.

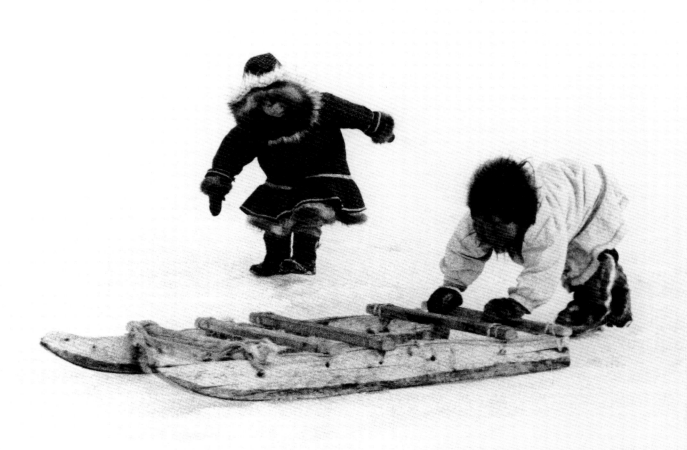

Children at the snow-block entrance to the
winter home of Pewatook on remote Jens
Munk Island in northern Foxe Basin. When I
lived at this camp in the late winter of 1966,
its total population consisted of eight people:
five adults (including me), two children, and
one baby. The nearest settlement, Igloolik,
was 100 kilometres away, a 15-hour trip by dog
team. Thus in their whole world, seven-year-
old Kattanak and her five-year-old brother
Attaguatiak had only each other to play with.

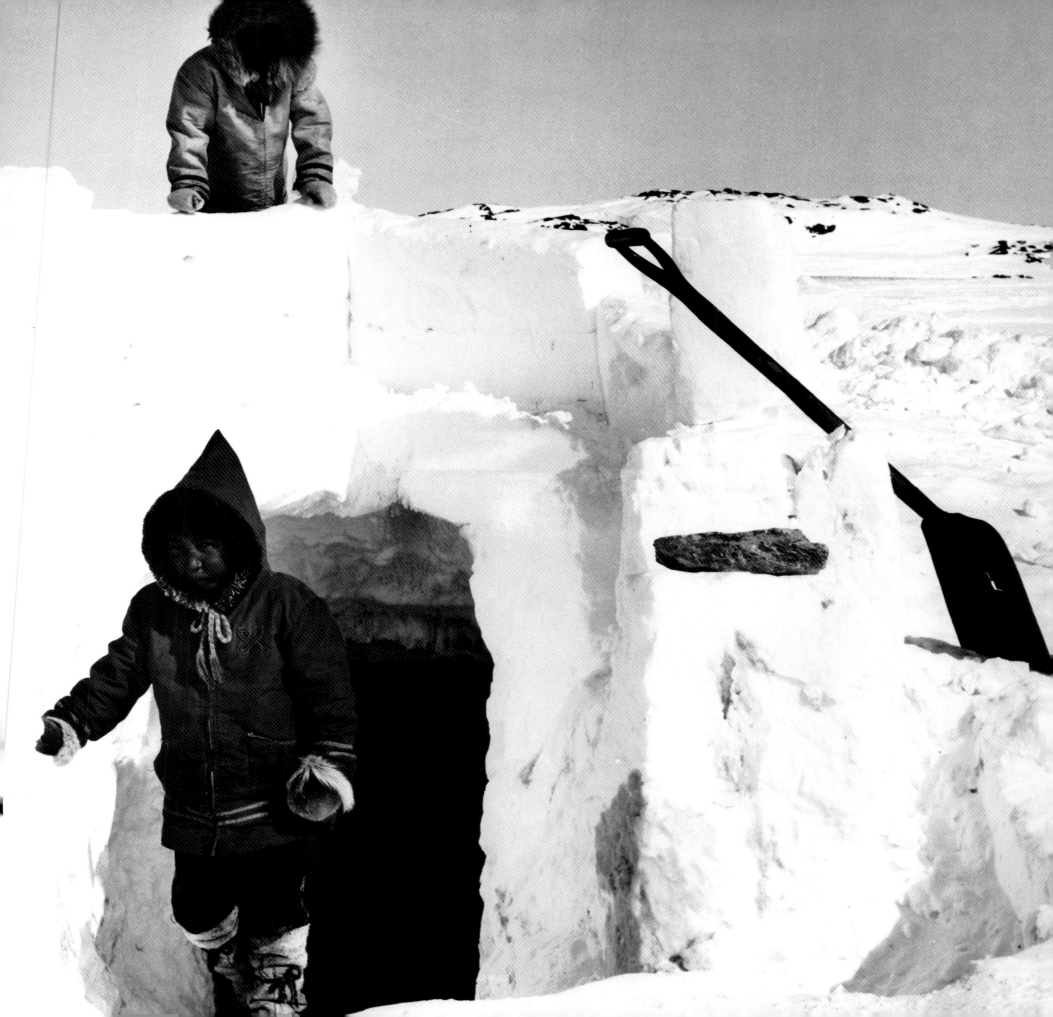

It's July and a favourite sport of the children of
Qaanaaq, the main settlement of Greenland's
Polar Inuit, was to jump flea-quick from ice
floe to ice floe on the bay in front of their
village. It was a risky game: the ice was rotten,
the floes often broke, and they shifted with
the tides and the currents. Once when I got
marooned far out on a floe, the villagers
thought it was a cute idea to send a six-year-
old boy to rescue me. He jumped to my floe
with marvellous skill, said earnestly, "Come,"
and guided me back to shore.

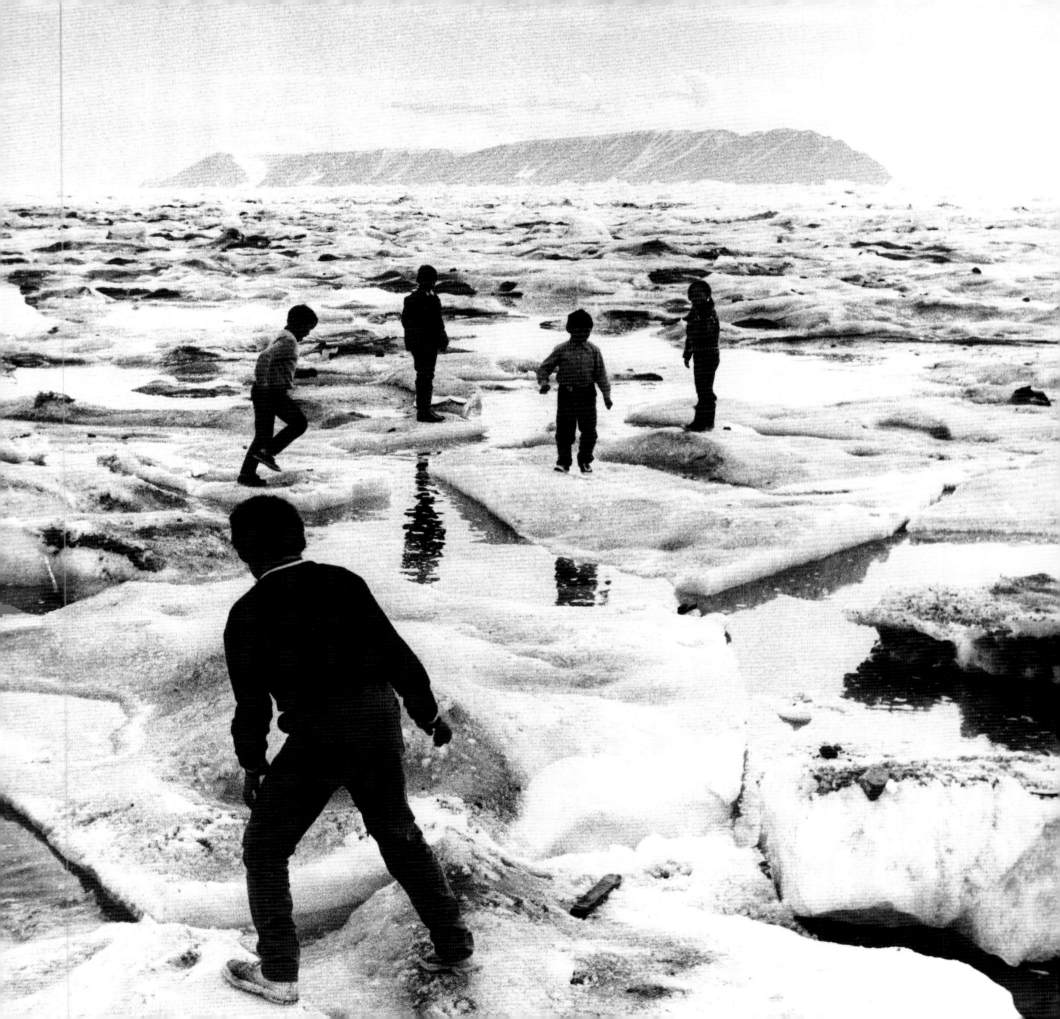

Left: A sad moment in a usually busy, happy life. Puglik had rushed into the tent at Bathurst Inlet where a huge platter had just been filled with boiled seal meat for everyone in camp. "It's hot," she was warned, but Puglik, impatient and famished, had grabbed a piece anyway, burned her hand, and cried with pain. Everyone laughed, and it was mocking laughter. It was a part of Inuit education. She had disregarded a warning and in consequence suffered pain and ridicule.

Right: This little Inuit girl is dressed in hybrid clothing: a caribou-fur snowsuit with zipper and mismatched adult woollen mitts. She had fallen asleep on a sled during the 1966 spring festival at Baker Lake. She woke up while all adults watched the dog team race, felt alone, began to cry, and held out her arms when her mother came running.

Left: Polar Inuit children on a hunting trip amuse themselves while their parents are busy. It was very cold and damp near the ice edge, the limit of land-fast ice. The children were 100 kilometres from their village. It didn't matter. Wherever their parents set up camp, the children were instantly at home, helped with some of the work, and, warm in their polar bear-fur clothing, played on the ice with joyous abandon.

Right: In Siorapaluk, northwest Greenland, the northernmost village in the world, a Polar Inuit boy tries out a bow his father has made for him. Long ago, Inuit lived as far north as there is land. In the sixteenth century the climate changed. The Little Ice Age began, it became much colder, and Inuit left the Far North or died out—all, that is, except the 200-odd Polar Inuit who remained, isolated from all humankind, for many centuries in their exceptionally game-rich region of the High Arctic.

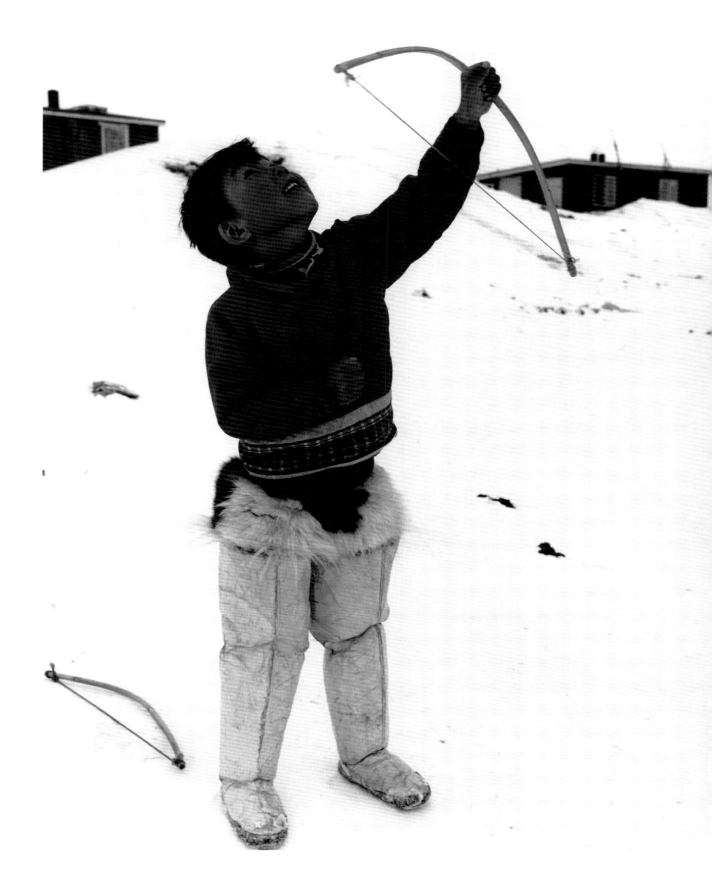

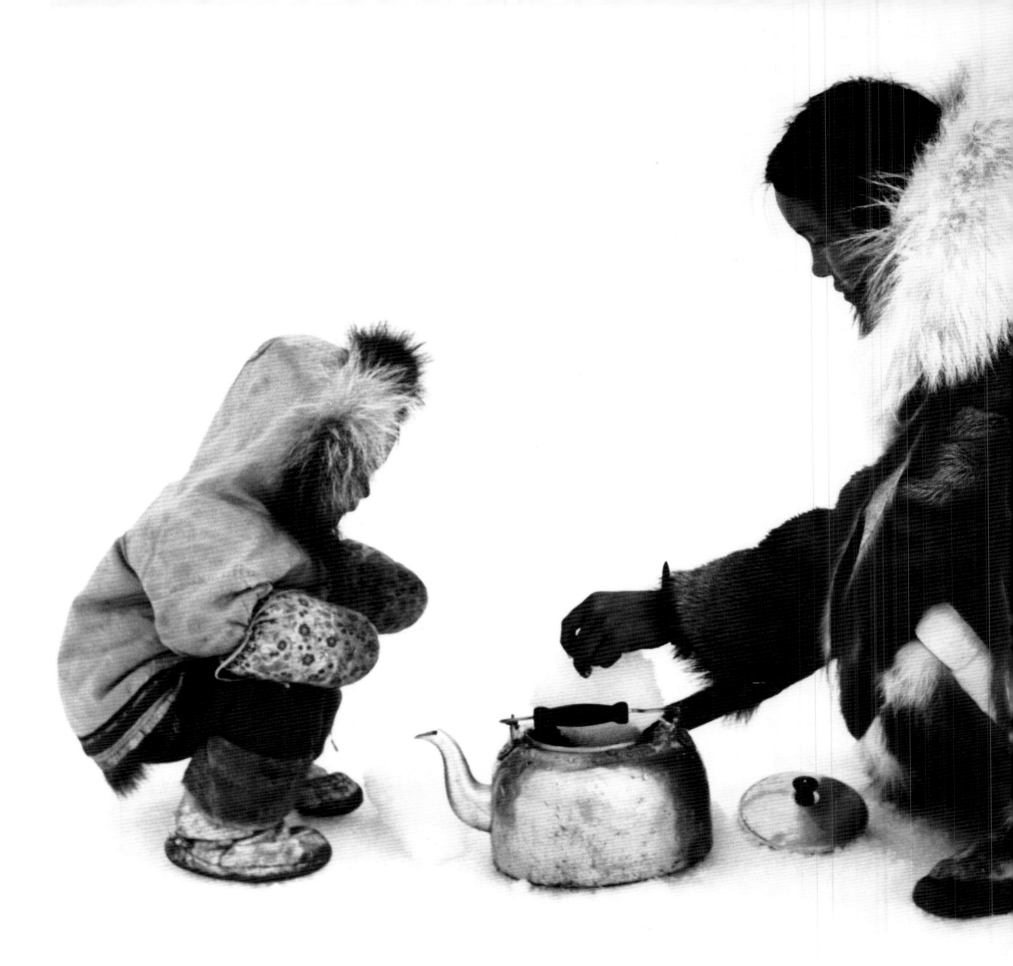

Left: There is one word for "snow" in English and more than 100 words for different types of snow in Inuktitut, the language of the Inuit. Certain types of snow produce, when melted, very little water. Other forms of snow are better suited. After searching for a while and probing with her snow knife, Jessie Kungaglak cuts chunks of pukajaq, the hard, coarse-grained snow that, for the amount of energy expended, will produce the most water for making tea, while her three-year-old son Karetak watches and learns.

Following page: In the late winter of 1967, I lived at Grise Fiord, on Ellesmere Island, Canada's northernmost settlement. Two hunters had promised to take me along on a two-month polar bear hunt, travelling by dog team. While I waited for them to get ready, some of the village children came and visited me at my cabin, watched me with polite and charming curiosity, got a cookie, mumbled "thank you," and left again. Paulasee's little daughter came to show me her husky pup.

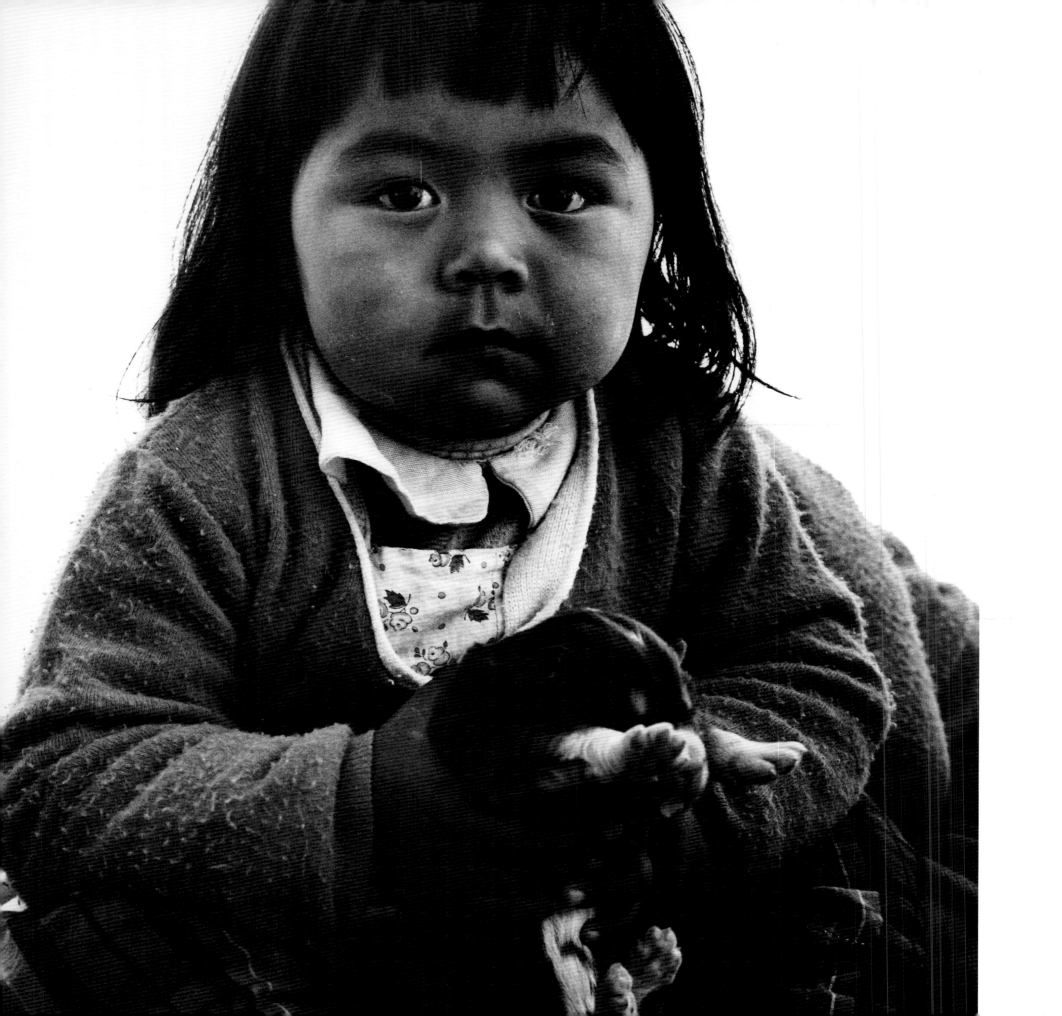

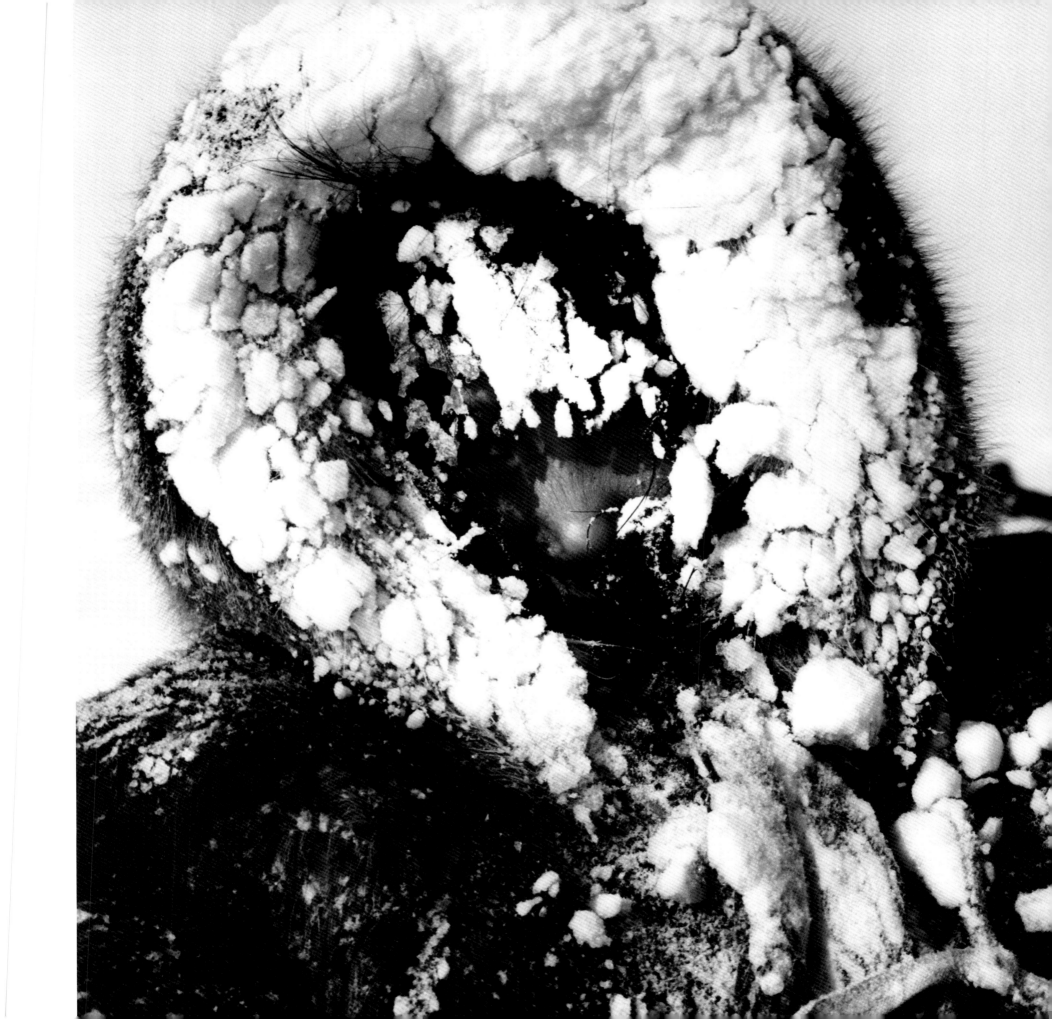

Preceding page: We travelled for 15 hours in a blinding snowstorm from the village of Igloolik to Pewatook's camp on remote Jens Munk Island, five adults and three small children. After five hours we stopped for tea. Pewatook built a snow shelter for the Primus stove and tea kettle. Seven-year-old Kattanak peered at me, her fur-framed face plastered with snow. I took four pictures. At -30° C the camera metal felt like fire. My hands went numb. The fingertips were frostbitten. Later they turned black.

Near right: In the fall of 1966 a chapter of Canada's northern history came to an end: The Hudson's Bay Company supply ship Pierre Radisson made its final voyage to the North. For nearly three centuries, ships of the venerable "Company of Adventures" had brought supplies, initially mainly from Great Britain and later from Canada, in its own ships to its many Arctic trading posts. I took part in that last voyage and photographed, at Broughton Island, Baffin Island, this little boy who watched in wonder the unloading of cargo.

Far right: Easter Festival, Igloolik, 1966. A young girl in a magnificent Inuit caribou-fur parka and a very Western shawl watches the traditional dog team race followed by the modern snowmobile race. Change came quickly to the Canadian Arctic. Until the mid-1940s nearly all Inuit lived in widely scattered camps, spoke only their own language, and their contact with the outside world was minimal. By the early 1980s, nearly all Inuit had left the land, were living in settlements, and their traditional way of life had nearly vanished.

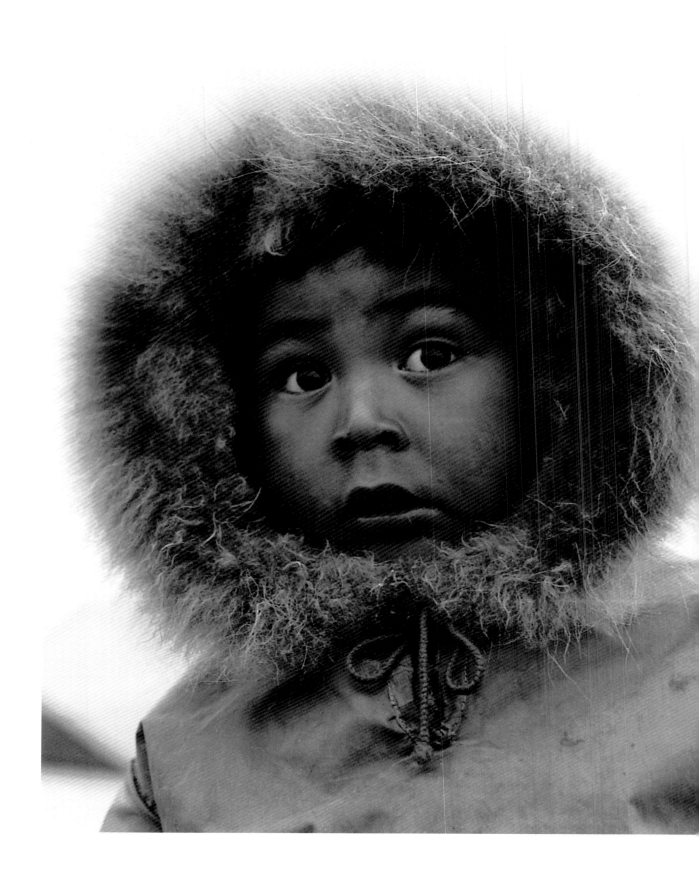

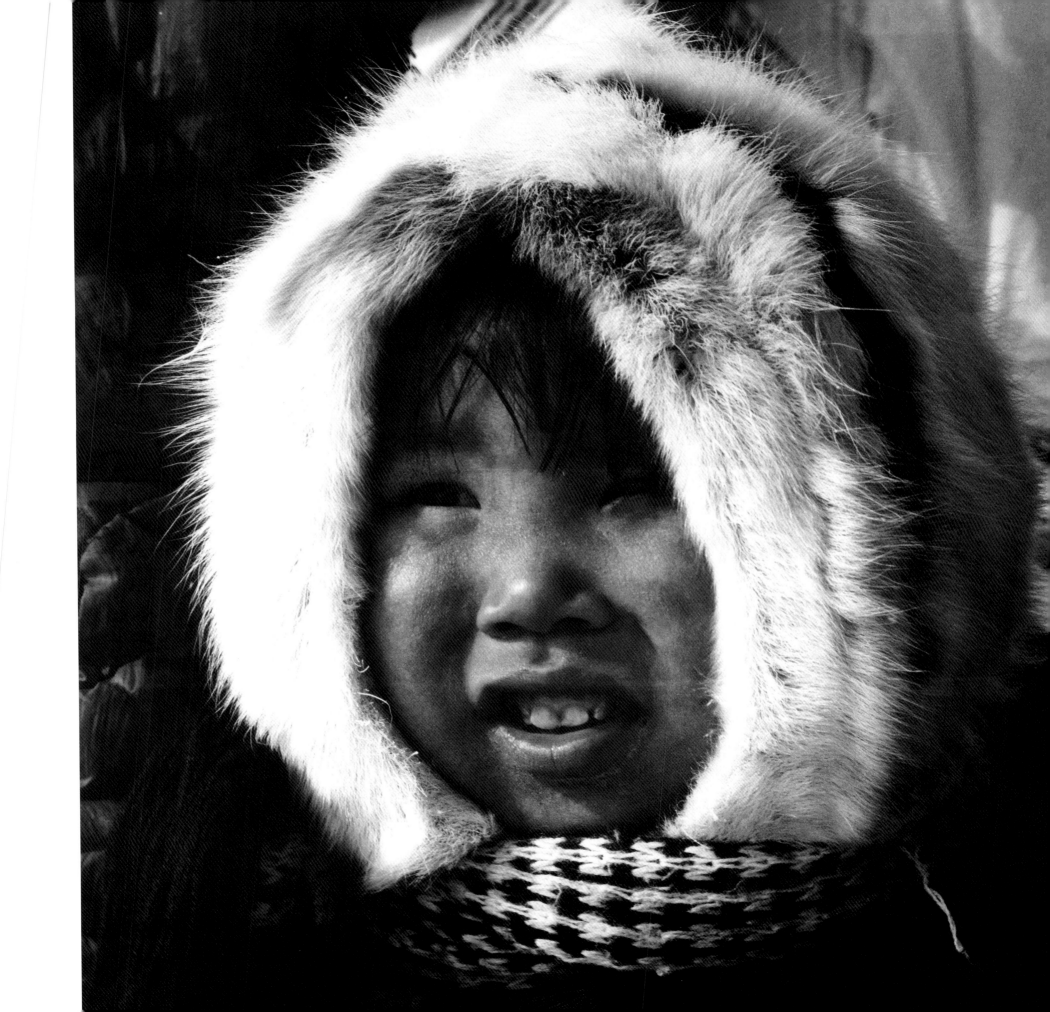

Wielding the razor-sharp butcher's knife
his elders use to cut up seals, walruses, and
whales, a Polar Inuit boy slices muktuk,
narwhal skin, into small pieces and eats
them. It is a favourite delicacy, crunchy, with
a fresh-hazelnut flavour, and is extremely
rich in vitamin C. Cutting up game carcasses,
cleaning skins, and using sharp knives were
all essential skills for a people who once
survived entirely by hunting and fishing.

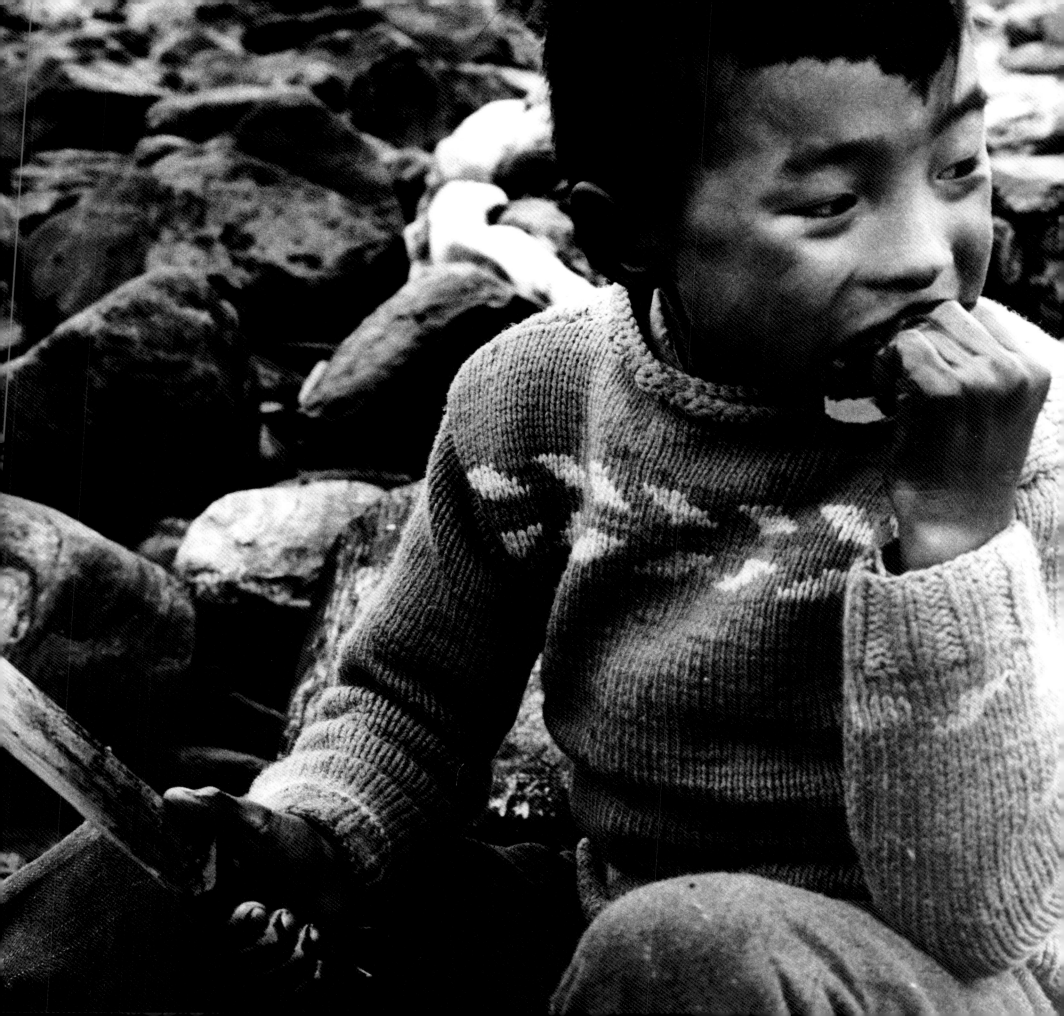

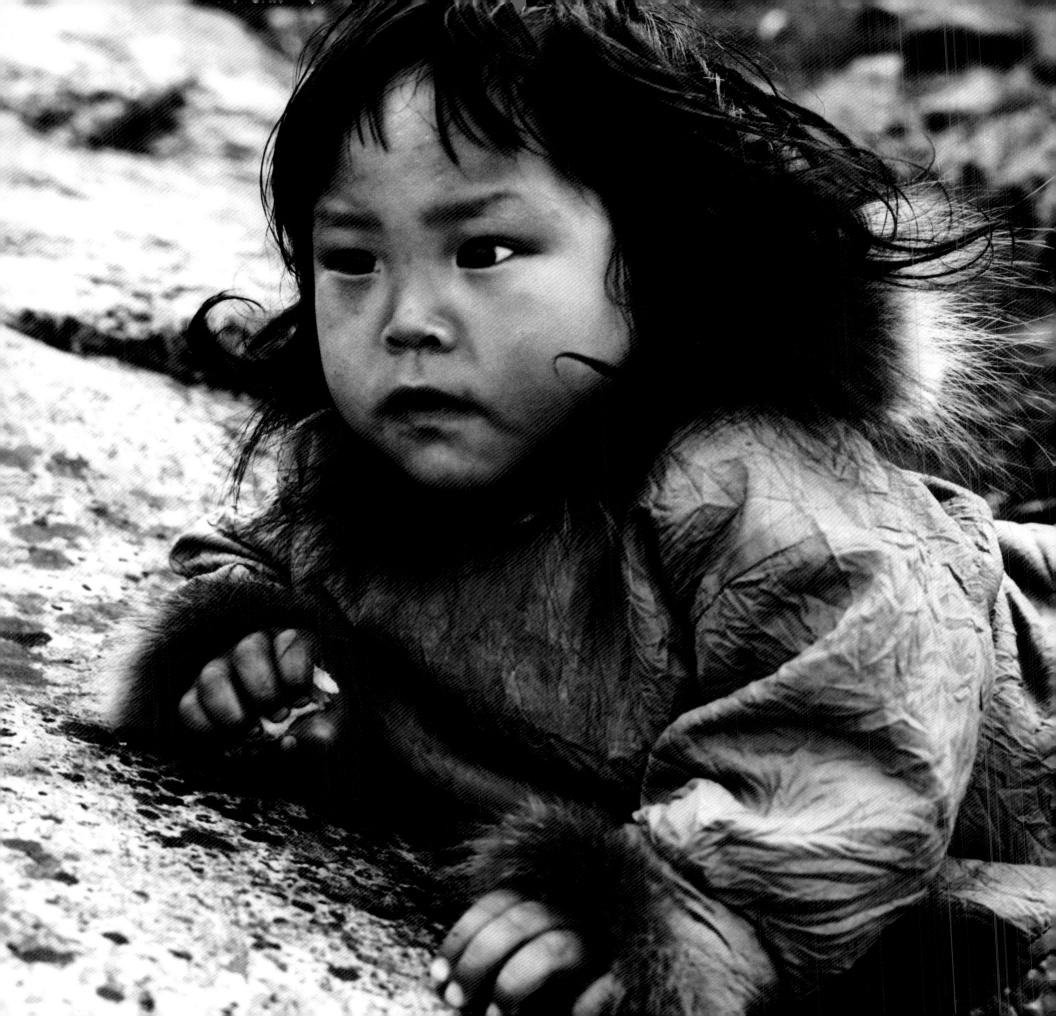

A midsummer night's crawl. Billy Kingnatak came in summer with his wife and several children to visit Ekalun's Bathurst Inlet camp where I lived. For two-year-old Kudlak, it was a new camp, a new world to explore far into the luminous Arctic night. Until then, she had seen only a few White men and only at a distance. At first she was very shy in my presence. After a while she got used to me and we would crawl together.

A vicious late-March blizzard imprisoned us
for several days in our tents at the Bathurst
Inlet camp. Outside, the storm raged, the
snow so dense and blinding it was dangerous
to go the few yards from one tent to another.
Inside the tent, shielded from the storm
by snow-block walls, life went on as usual.
The men made carvings or repaired hunting
weapons. The women sewed clothing and
cooked. I wrote my diaries and practised
my Inuktitut, the language of the Inuit. And
eight-year-old Papak played with his little
cousin Karetak.

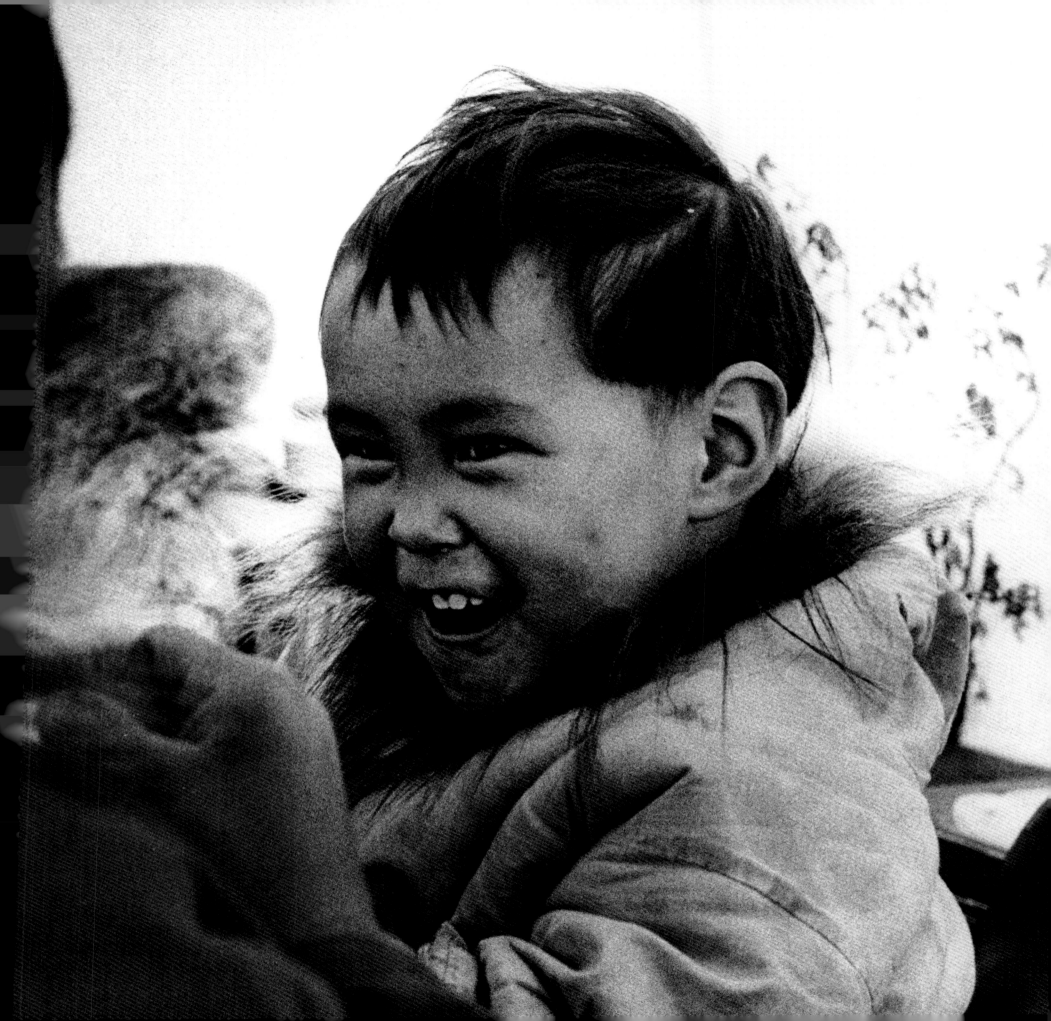

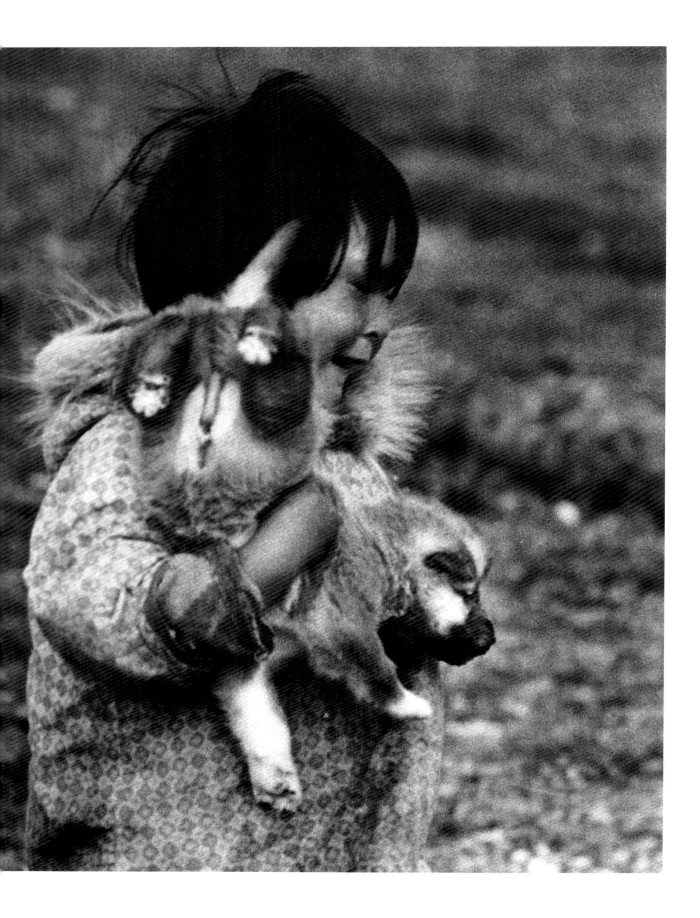

Left: Puglik with one of her husky pups. There were more than 40 sled dogs at our Bathurst Inlet camp. In summer lots of pups were born and seven-year-old Puglik looked after them. She carried them to a nearby brook to give them water and fed them bits of meat and fat and fish when the pups were older. If food was plentiful in camp, the pups had an easy life until harnessed as sled dogs when they were six or seven months old.

Right: It was moving day in 1965 at Etuguloopia's Ward Inlet camp. Frobisher Bay, Baffin Island. Adults and children packed and loaded the canoe. Eight-year old Elisapee looked after her baby sister. She carries her in a miniature *amautik*, a woman's dress with dorsal pouch for a baby. Girls in camp very early assumed their future adult roles: They helped their mothers and learned to sew and cook, they took care of smaller siblings, and mothered and pampered the latest camp baby.

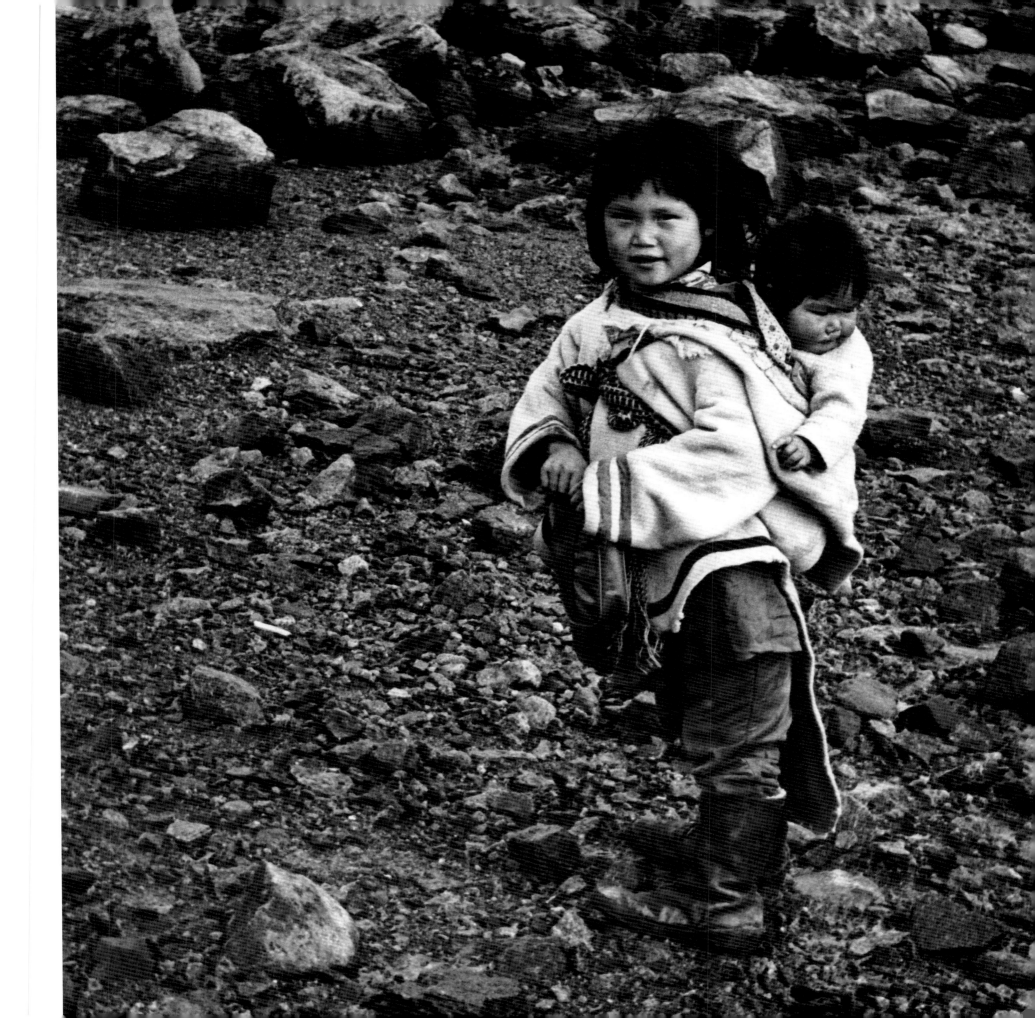

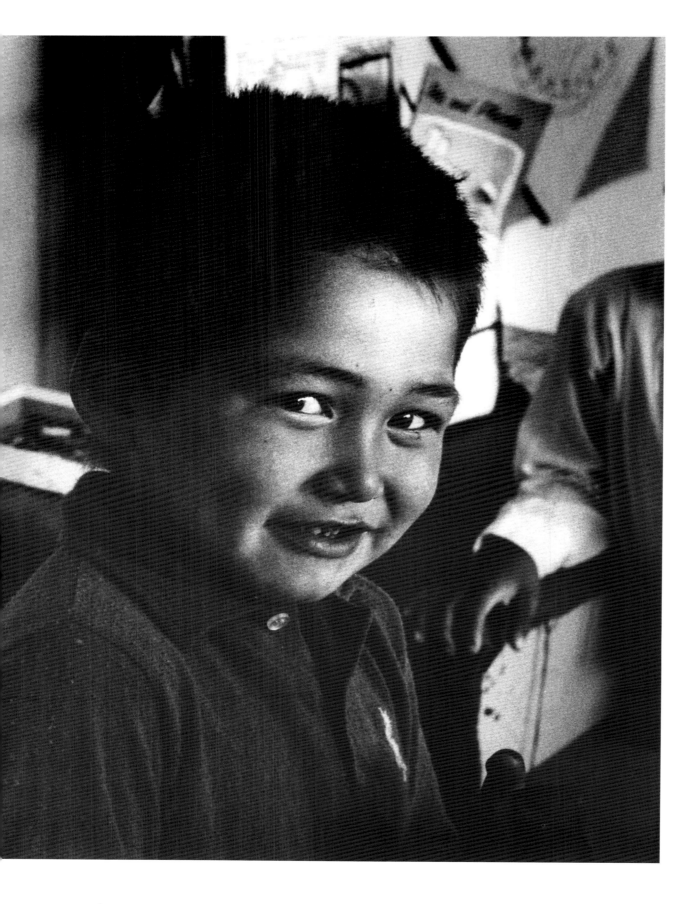

Left: A little Inuit boy at the Moravian school in Hopedale, Labrador, in 1968. In 1766, German missionaries, the Moravian Brethren, who were already established among the Greenland Inuit, began to create mission posts along the Labrador coast and gave them German or Old Testament names: Hoffenthal (now Hopedale), Zoar, Nain, Ramah, and Hebron. I spent the summer of 1968 on the Labrador coast, photographed life at Inuit fishing camps, children at the Hopedale school, and read there the ancient mission diaries written in meticulous Gothic script.

Right: Summer at Ituguloopia's camp at Cormack Bay, Baffin Island. Here the Hudson's Bay Company had had a small trading post from 1921 until 1949. That year it moved to the nascent town of Frobisher Bay (now Iqaluit). For centuries, perhaps millennia, the land near the sheltered bay had been an Inuit campsite, with a brook nearby for fresh water and a broad meadow near the sea where the children played with each other and with a young husky.

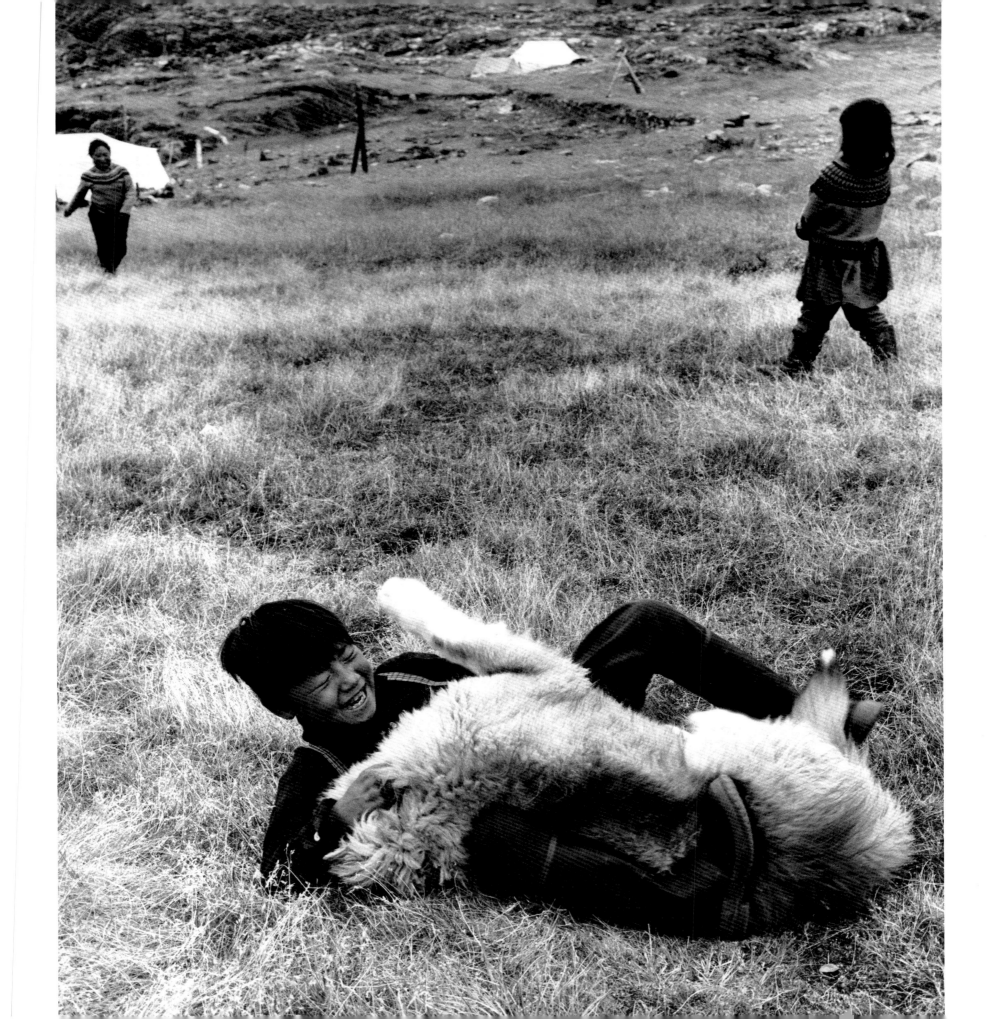

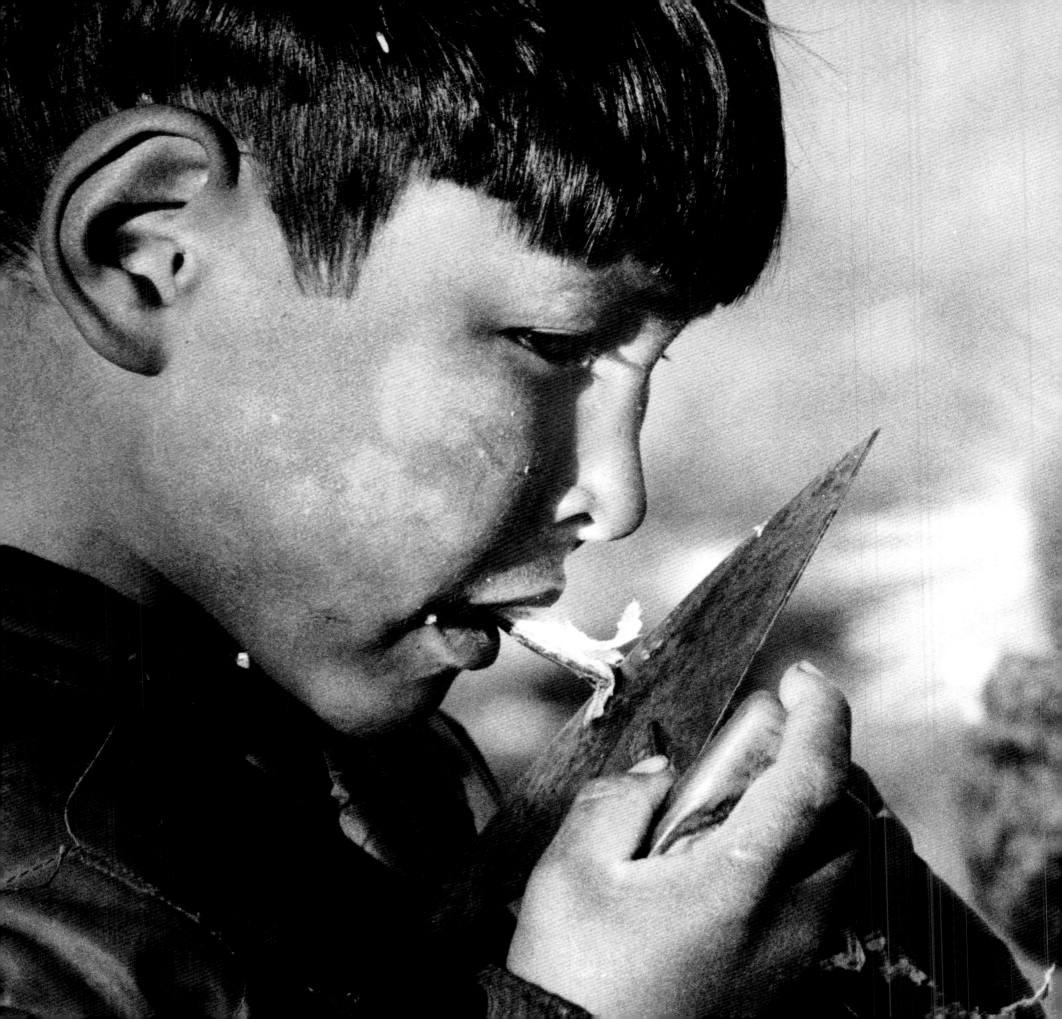

Left: Eating *mipku*, caribou jerky. The spring caribou were lean after their long migration. At our Bathurst Inlet camp we had run out of all fat and lived nearly entirely on *mipku*, air-dried caribou meat, which was leathery and lean. This exclusively protein, fat-less diet began to take its toll. We ate a lot, yet were forever hungry. We tired quickly, and after a month developed the first symptoms of protein poisoning: diarrhea and swollen feet. As soon as we could supplement our lean meat diet in summer with fat fish, we were fine again.

Right: Babies were showered with love by nearly everyone in camp, even by small children. Three-year-old Oched loved to play with his baby sister Ooloosie, but he was a tempestuous little boy who got easily carried away. He either poked the baby with a grubby finger or smothered it with so much love that the poor thing could barely breathe and their mother, Ella Tonakahok, gently intervened.

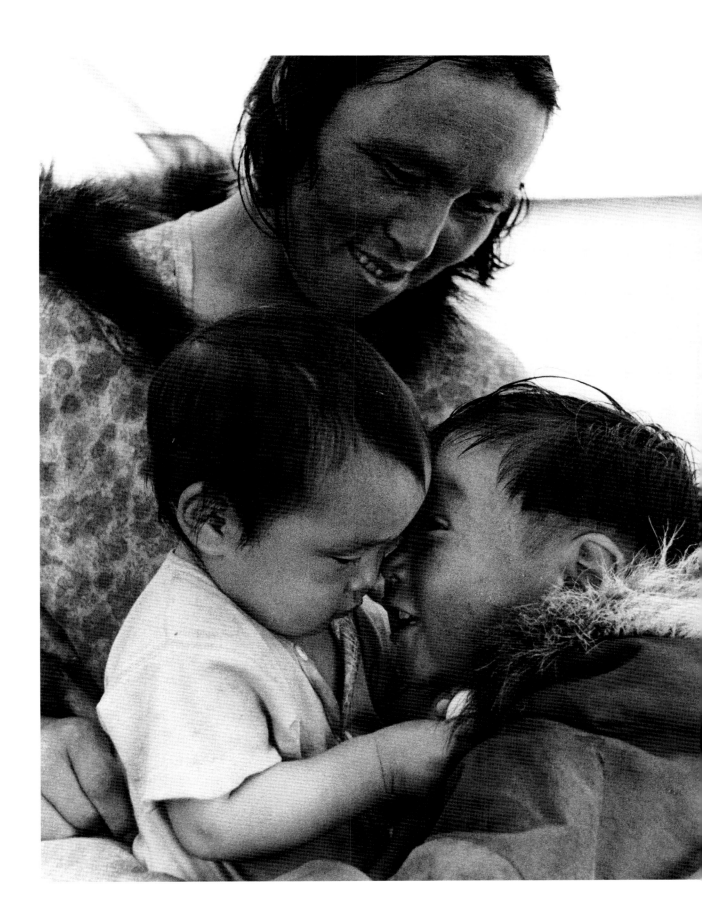

Church for many Inuit was a place to pray
and play: the adults prayed, their children
played. In the new Arctic settlements of the
early 1960s lived children who had grown up
in camps, were used to great freedom, and
being pious and still in church was not for
them. They played in the aisles, they played
on the pews, and when some got too noisy and
rambunctious, they were taken out for a while.
These little girls next to me passed the time
exchanging gum.

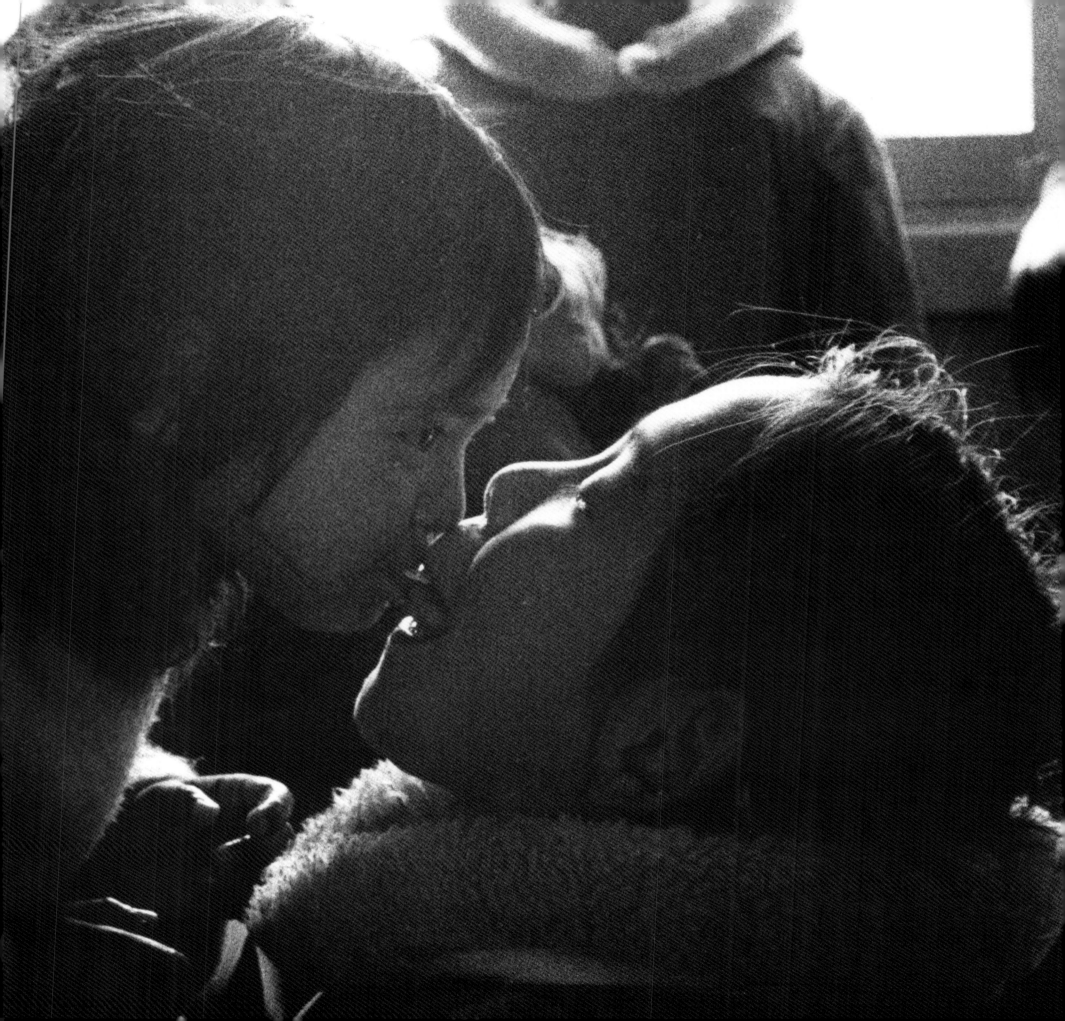

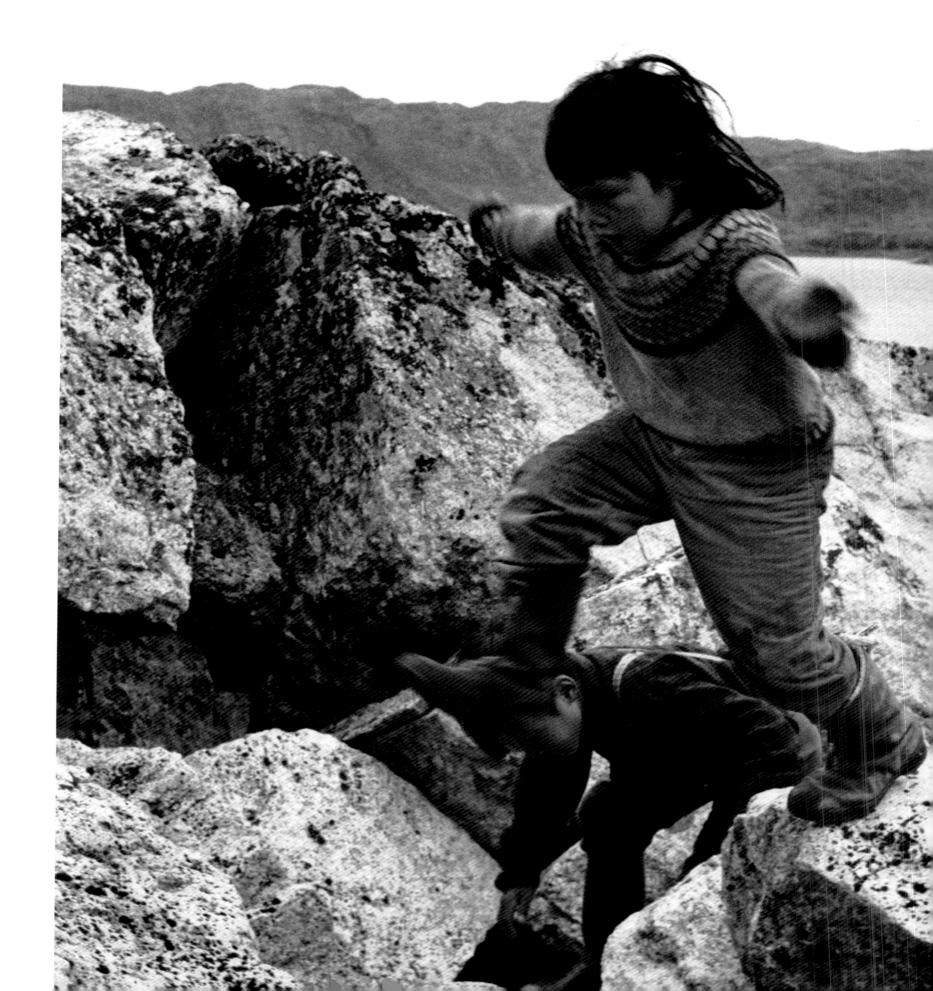

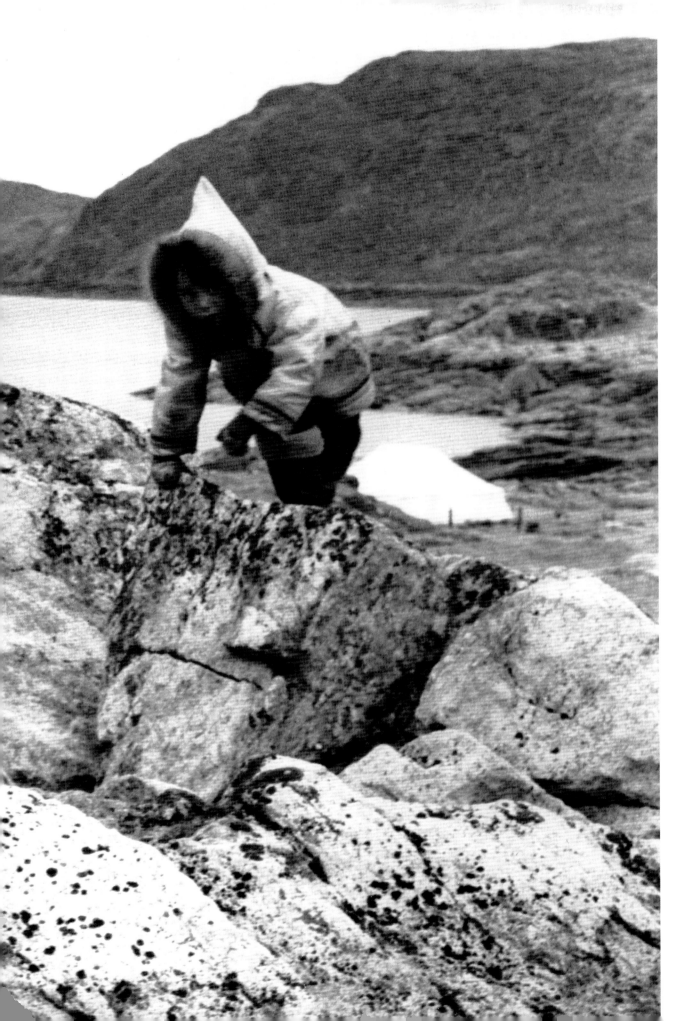

A wild game of tag across the rugged, riven rocks near camp, close to Cormack Bay, Baffin Island. Camp children, typically, were happy, hardy, and able to amuse themselves. When I first travelled by dog team with Inuit hunters, I was impressed by their skill in guiding the heavy sled across slippery ice-block pressure ridges. Later I realized they had acquired many of their skills in the games of their childhood.

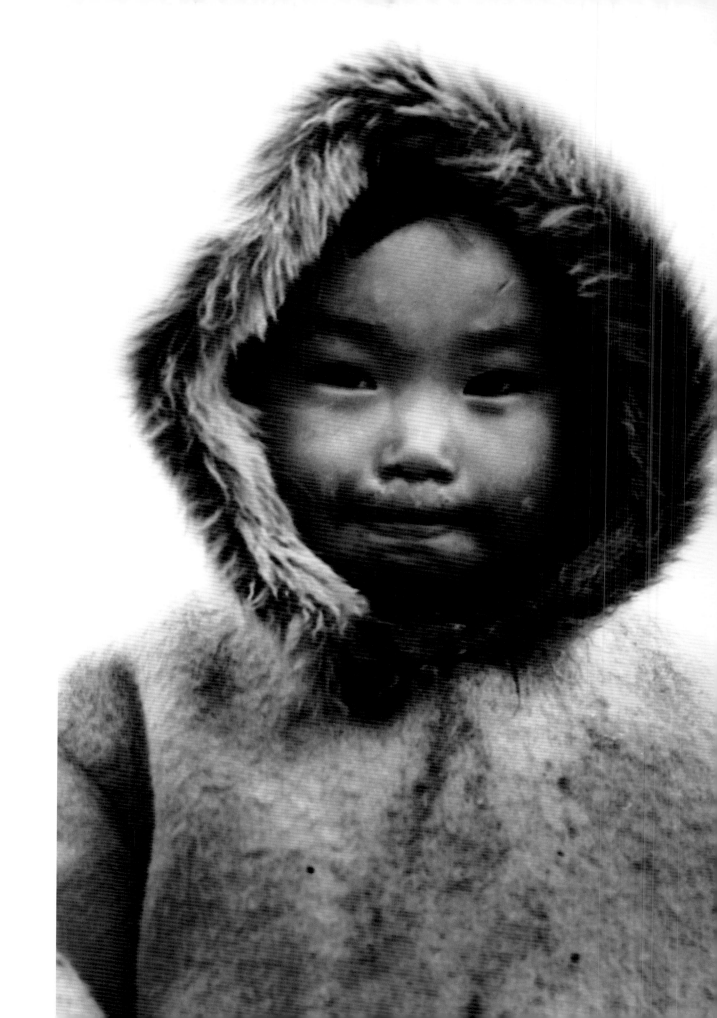

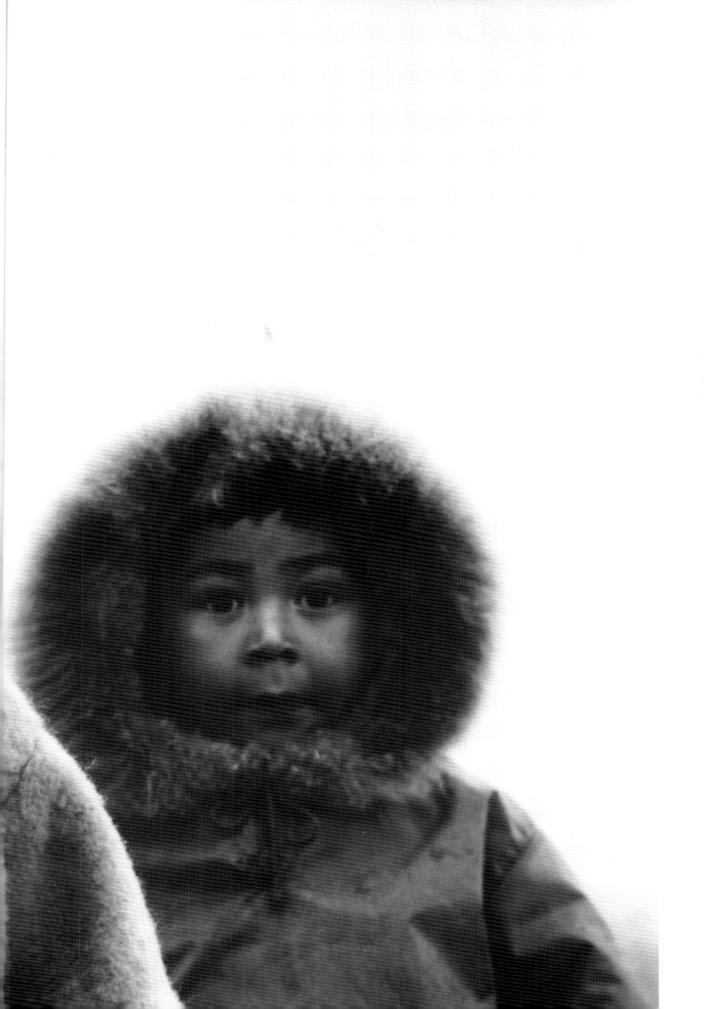

In 1966, most Arctic settlements were still very isolated. Only a few villages had airstrips. At the others, planes could land only on winter ice. Most supplies came with the yearly supply ship of the Hudson's Bay Company. In 1966, an era ended. After nearly 300 years, the last Hudson's Bay Company vessel, the *Pierre Radisson*, made its last trip to restock the company's Arctic trading posts. It stopped briefly at the village of Broughton Island, Baffin Island, and I photographed these boys who watched in fascination as people rushed back and forth, carrying cargo ashore from the great ship.

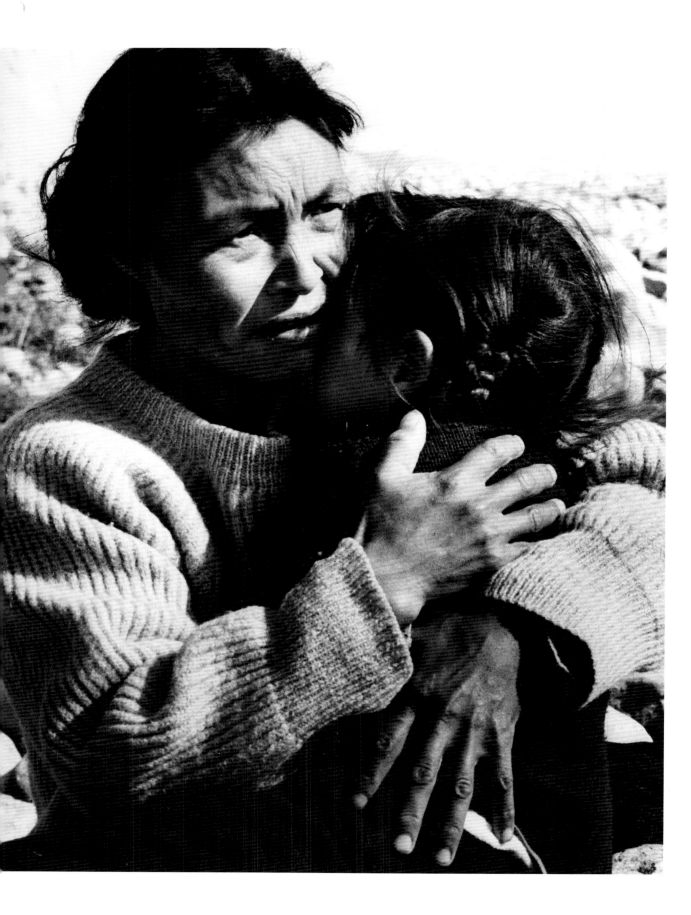

Left: A Polar Inuit mother comforts her little daughter. The mother, Isigaitsoq, had made a rag doll and the girl loved and mothered it. She and a few other children had been playing with the doll, there was a scuffle, a push-and-pull, and the doll's head tore off. Crying and clutching her headless doll, she rushed to her mother, who held her protectively, soothed her sorrow, and later repaired the doll.

Right: Karetak in the berry patch. Since we lived nearly entirely on fat and fish, eating berries in the fall was for all of us at the Bathurst Inlet camp a special treat: sweet, mealy bilberries; the delicious amber-yellow cloudberries, extremely rich in vitamin C and a great favourite of Inuit children; and the abundant, sourish, watery crowberries that Karetak is picking on a slope near our camp.

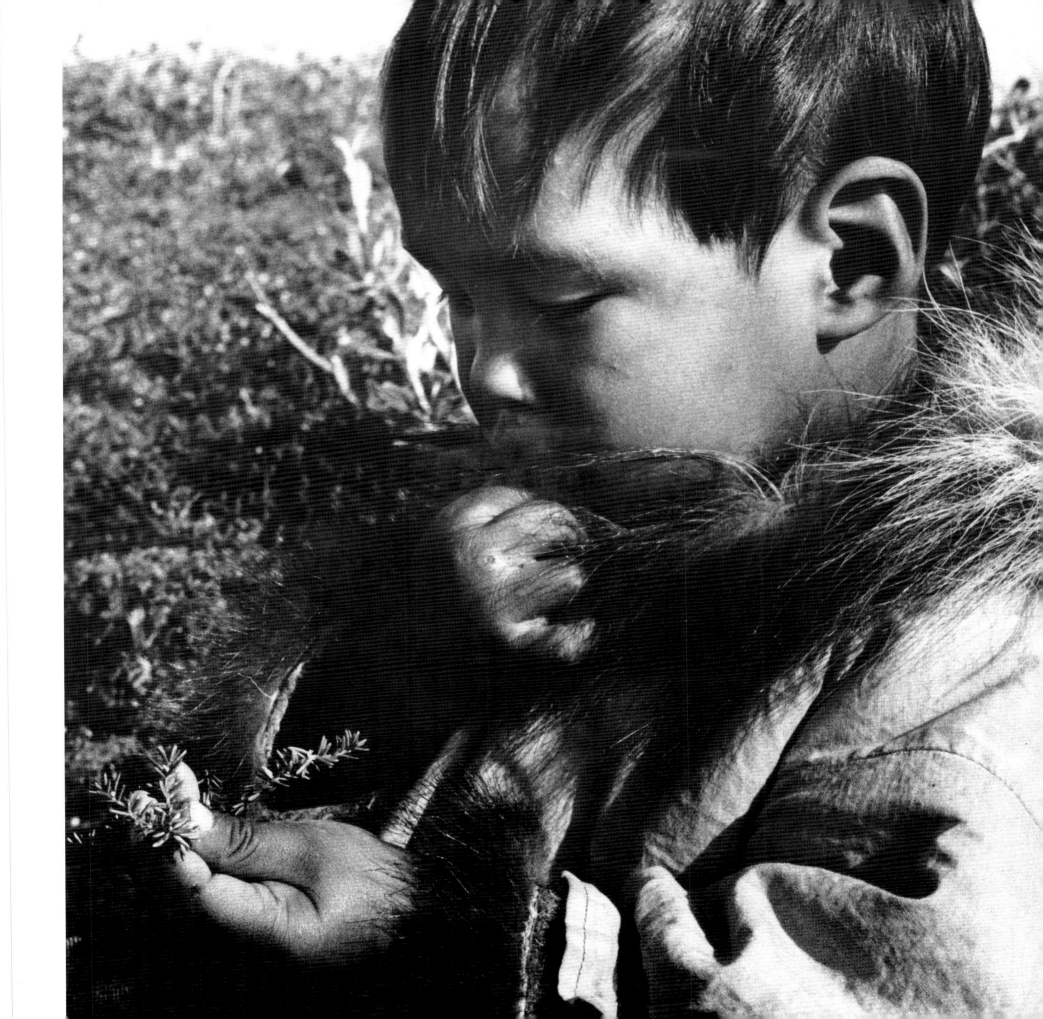

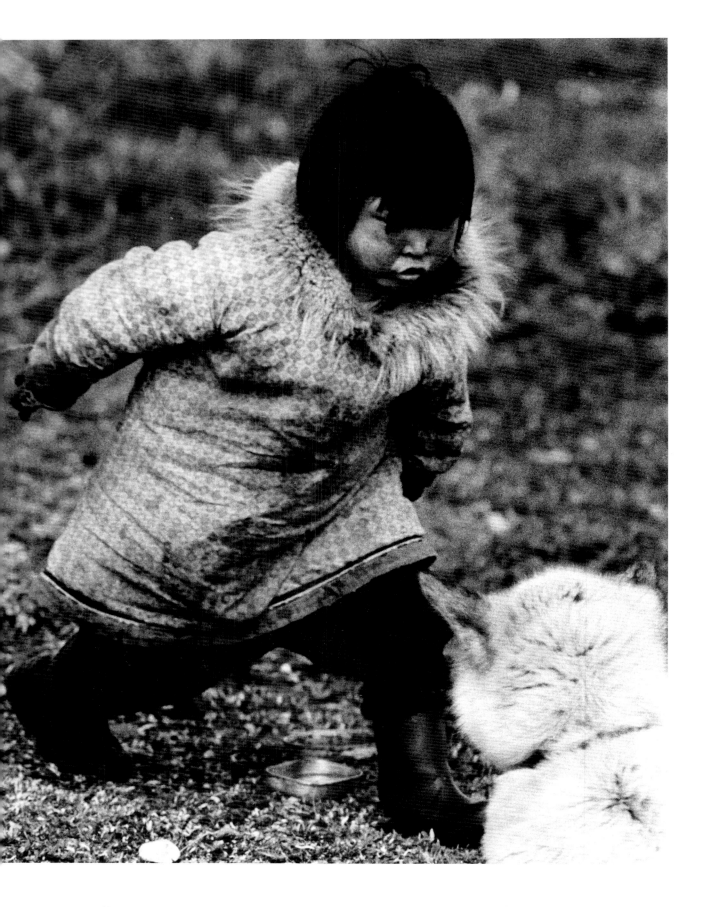

Left: Puglik telling off a bitch that had threatened her when she came to pick up one of the recently born pups. There were about 40 tethered dogs that were friendly. A few were snarly and might snap, and bitches with just-born pups were defensive and could be dangerous. Little Puglik feared none of them. Since it was her summer job to give the pups water, she confronted snarling, bare-fanged bitches, took their pups away, and was never bitten.

Right: A baby's first walk. Helped by her sister, Alice Ehonatuk Ooloosie takes a few cautious steps. Camp children were close and older girls often assumed surrogate-mother roles. As little girls they mothered dolls. When older, they looked after the younger children in camp and played with them. This gave their mothers time to cook, sew clothing, or clean animal skins.

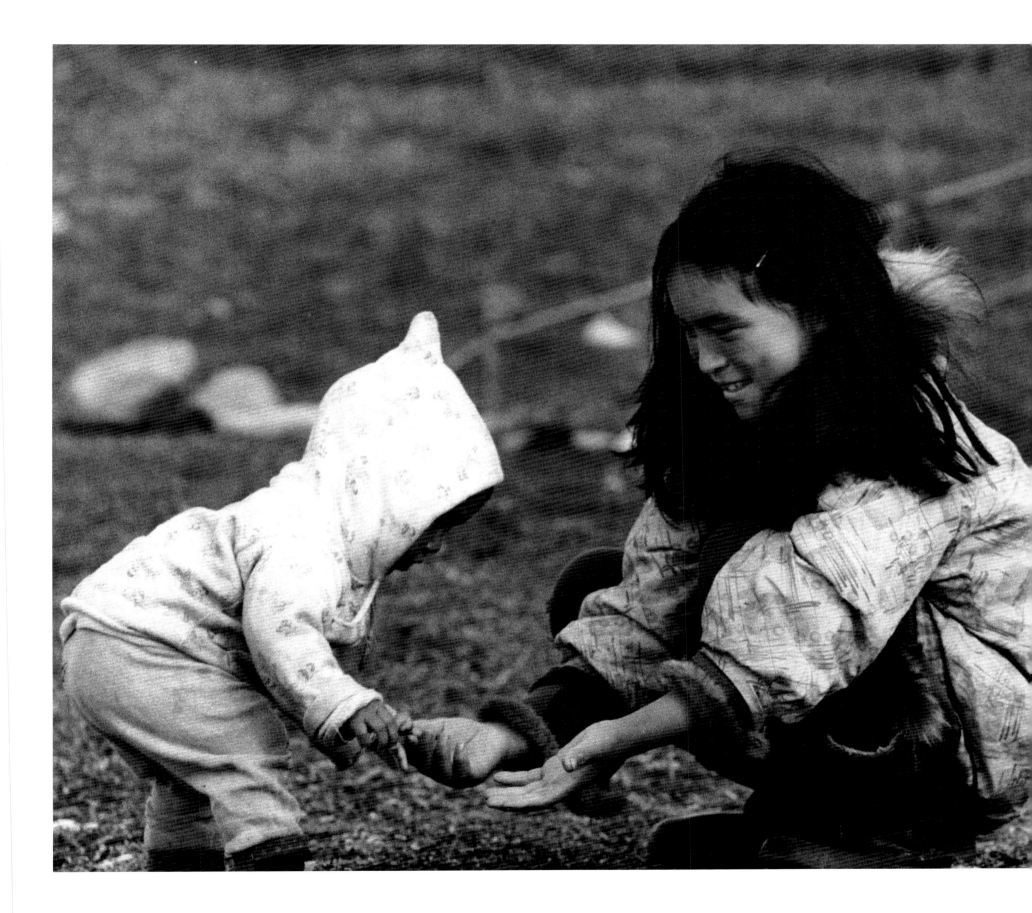

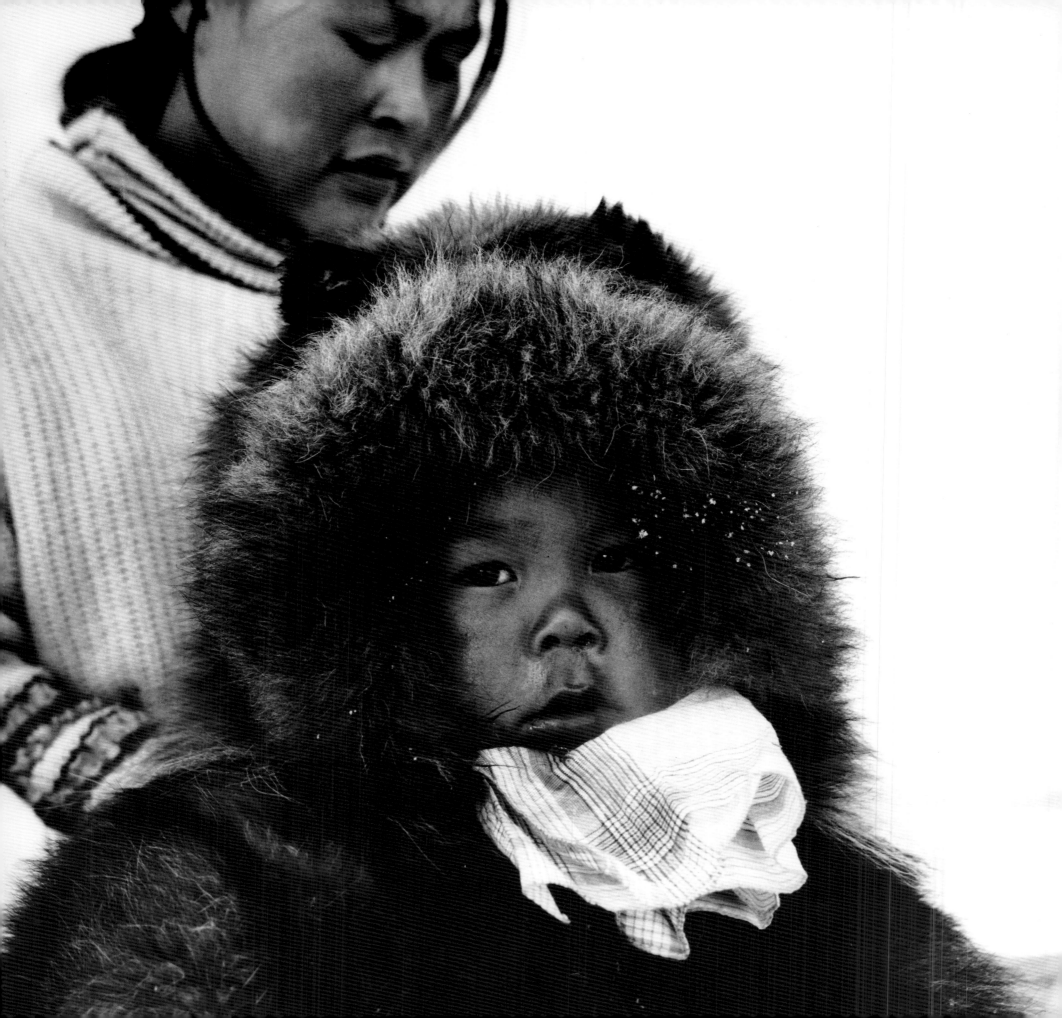

Left: While I was on a hunting trip to the floe edge, the limit of ice, with Masautsiaq and his wife Sofie Eipe, we met a Polar Inuit family returning to their village after weeks spent hunting at the ice edge, their children warmly dressed to endure the cold. The little girl wears a superb parka made of the winter fur of blue foxes. A handkerchief absorbs any drool because moisture mats the fox fur and later it freezes. In the past, Inuit used little bibs made of Arctic hare fur.

Right: The transition. This boy, who concentrates on his work in the Repulse Bay school in 1967, grew up in a remote camp on northern Baffin Island. When he was five, his family settled in the nascent town of Repulse Bay, which became a hub of Arctic aerial traffic. They moved into a house and the boy attended the recently built village school. His *kamiks*, mostly traditional, are made of sealskin with caribou-fur tops, but the sole is made of store-bought sheepskin.

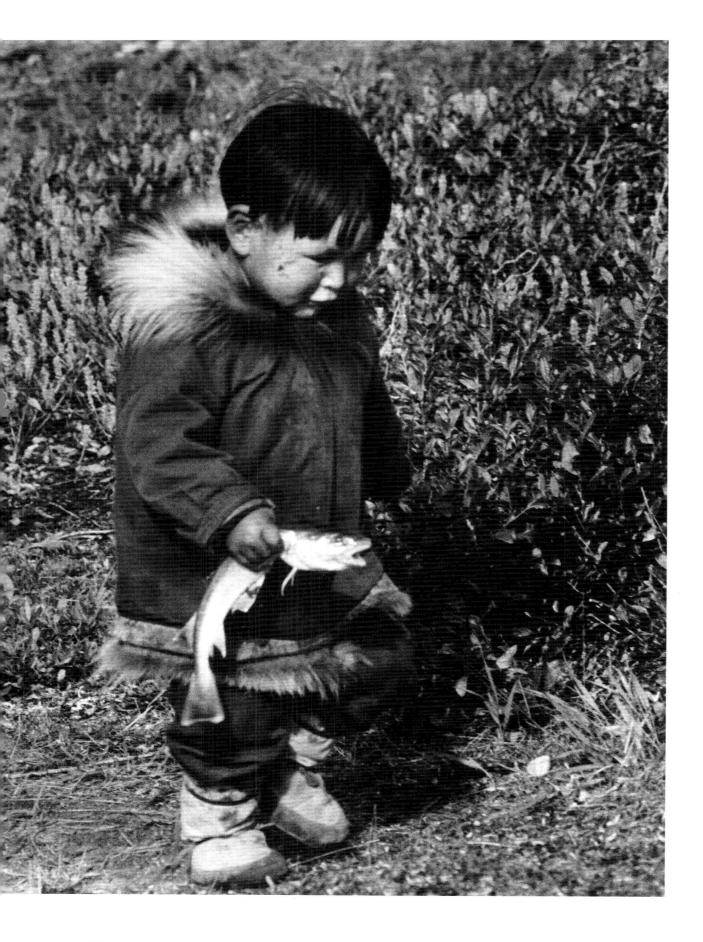

Left: Three-year-old Oched had been down at the beach helping his grandfather remove a meagre catch of Arctic cod from the net. As reward he got a fish and carried it proudly home to his mother's tent. In traditional Inuit society, children were early guided toward their future roles in adult life: man, the hunter, fisherman, and provider, and woman, the home-keeper, seamstress, wife, and mother.

Right: Oched loved to play with little beings, his baby sister Ooloosie, or with our camp's cuddly husky pups. Sled dogs were an essential part of finding *agloos*, the seals' breathing holes beneath the snow, to hold a polar bear at bay, or to carry loads in summer. By playing with pups and young dogs, Inuit boys, the future hunters, became familiar with handling working dogs.

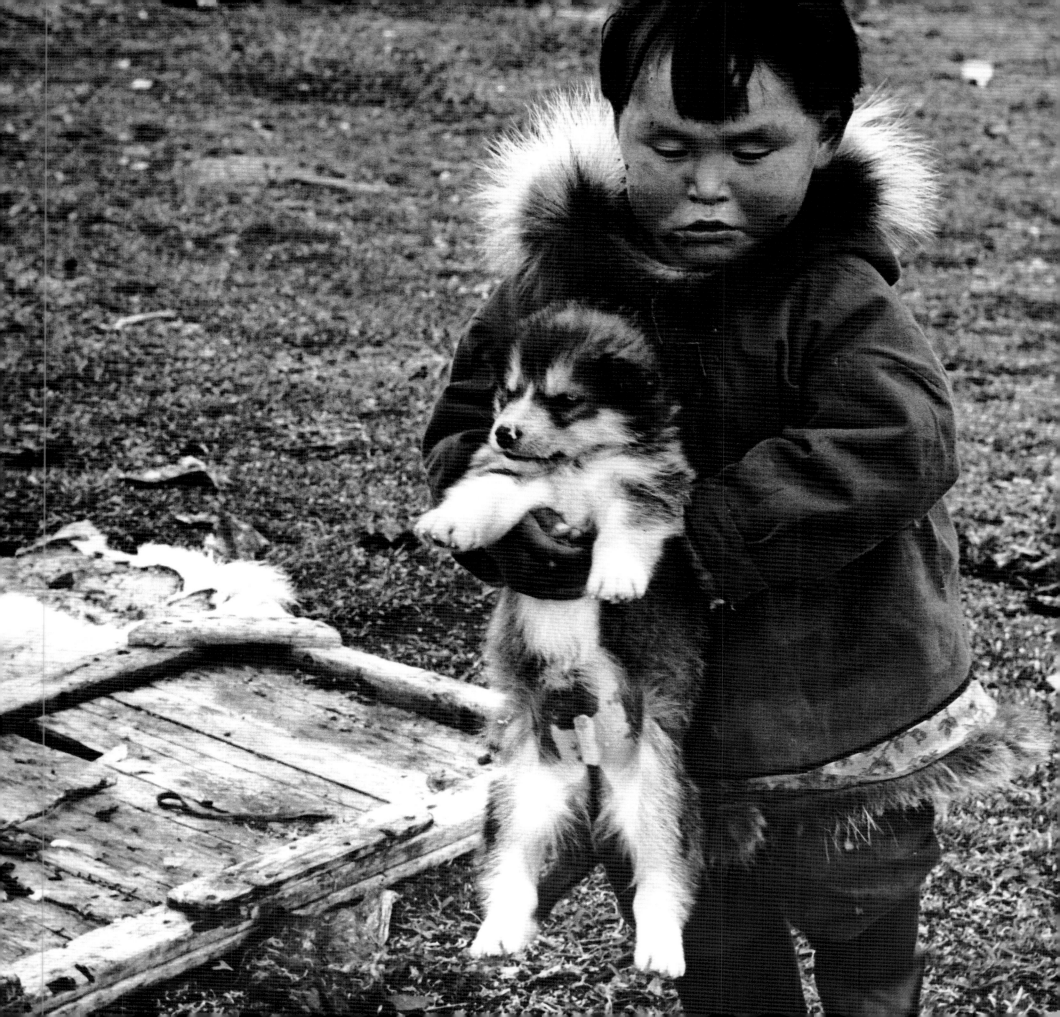

Alaskan Inuit children were collecting
seaweed at low tide on very slippery rocks.
A few fell into the water and got wet. It was
fun and funny and one of the girls burst out
laughing, with the sparkling sea behind her.
This is on Little Diomede Island in the middle
of Bering Strait, between Alaska and Siberia,
America and Asia, where I lived for six months
with the best and most traditional walrus
hunters of the Arctic.

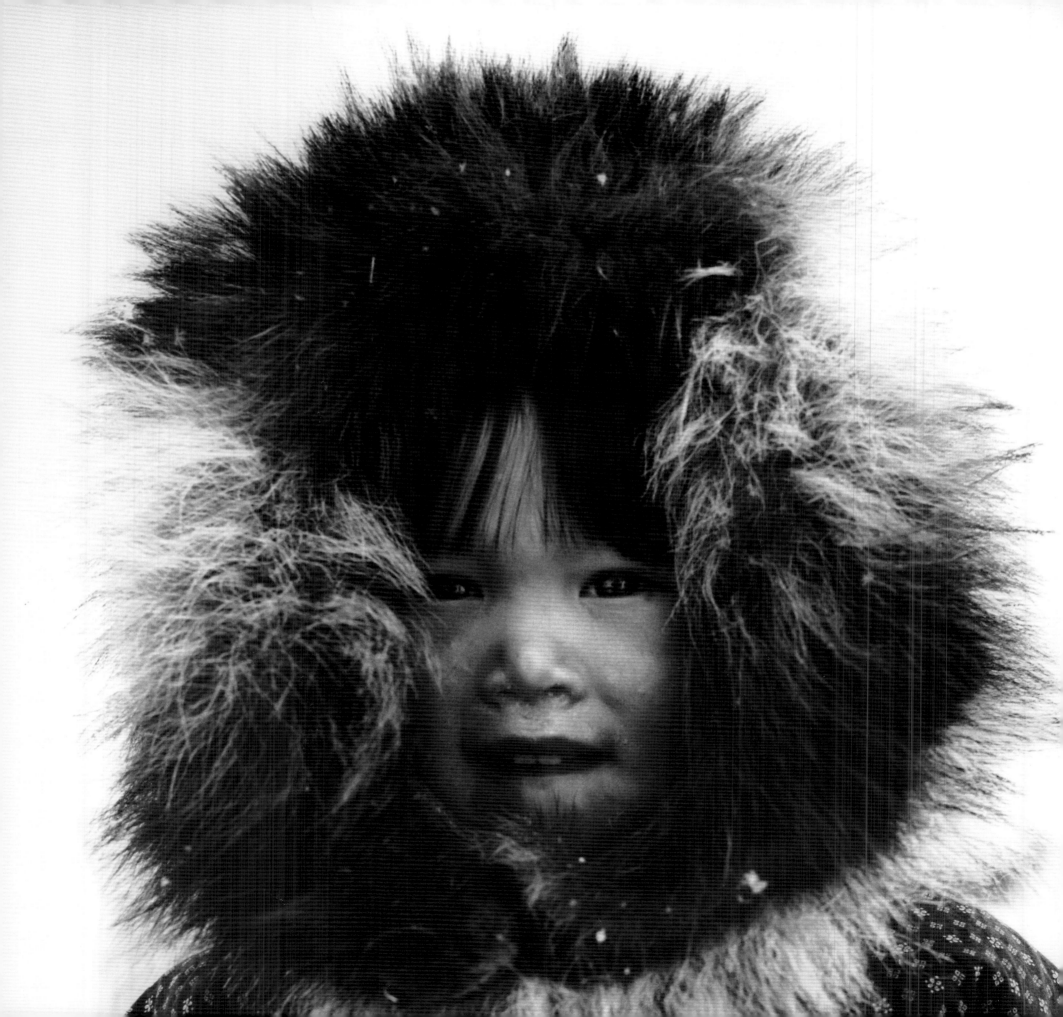

Left: She was a darling child, but very shy. Linda Kayouina had lived all alone with her parents at their remote camp on the Arctic coast, about 100 kilometres from our Bathurst Inlet camp. They came in spring by dog team for a visit, and five-year-old Linda, who had grown up without other children, was initially bewildered by our camp's 11 children. At first she stared shyly at them. Gradually she began to join their games and the shyness fell away in the great happiness of being with other children.

Right: As the father walked down to the sea ice facing the village of Qaanaaq in northwest Greenland to load his dog team sled, his little daughter followed, carrying his gloves and the case with his binoculars. In late winter and in spring she had gone with her parents on long hunting trips by dog team. Now, in early summer, the sea ice was weak and dangerous and her hunter-father left alone.

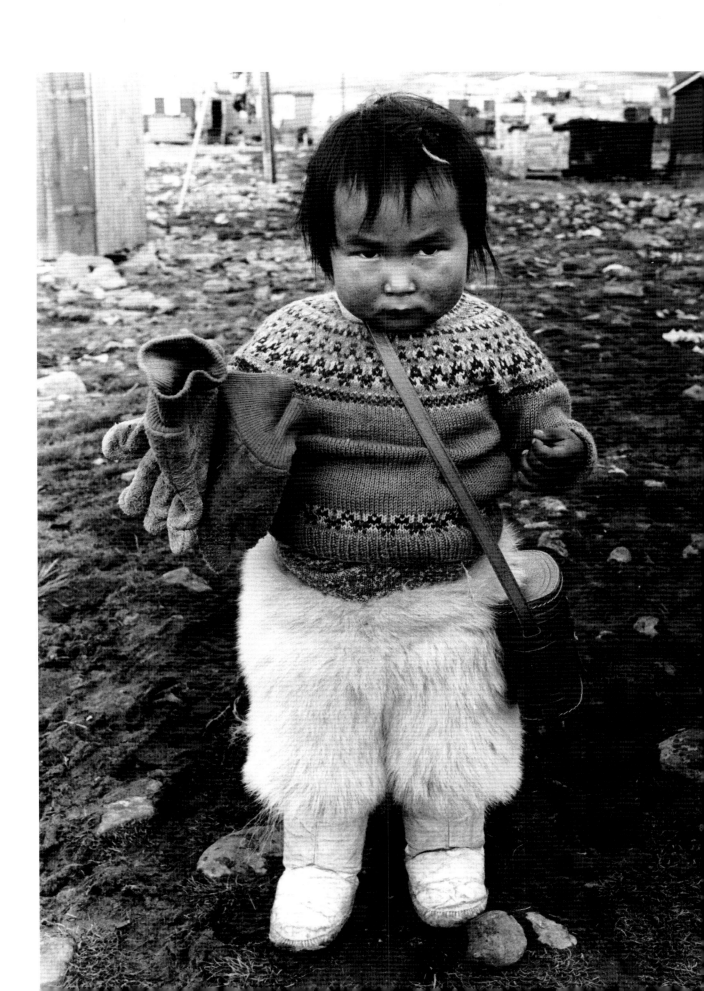

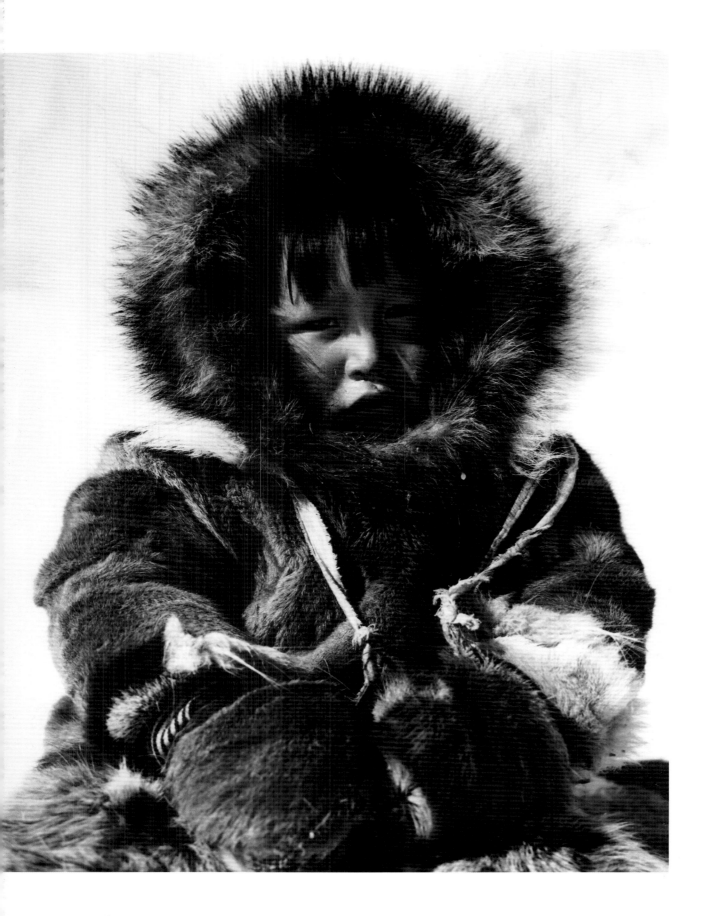

Left: For the Inuit Arctic life was made possible by their superb Arctic clothing. Three-year-old Oched at our Bathurst Inlet camp, in full furs, could play outside all day at -20° C or even -30° C and be comfortably warm. He wears inner and outer parkas and pants made of caribou fur, thick fur mitts, outer sealskin boots with caribou-fur inners, and the most perfect parka ruff in the North, made of wolverine fur. Other furs mat when moist. Wolverine fur does not and the hoarfrost formed by breath can easily be brushed from it.

Right: By the 1980s most Inuit had left the land and their ancient camp sites and had moved into the new settlements of the North, with houses, schools, community halls, clinics, and churches. Traditional Inuit life as it had existed for thousands of year ended abruptly. It was during a service at the church in Apex Hill that I took this picture of the Inuit woman sitting next to me holding her little boy, quietly serene, like a gentle Arctic madonna and child.